FORMS OF TRADITION IN CONTEMPORARY SPAIN

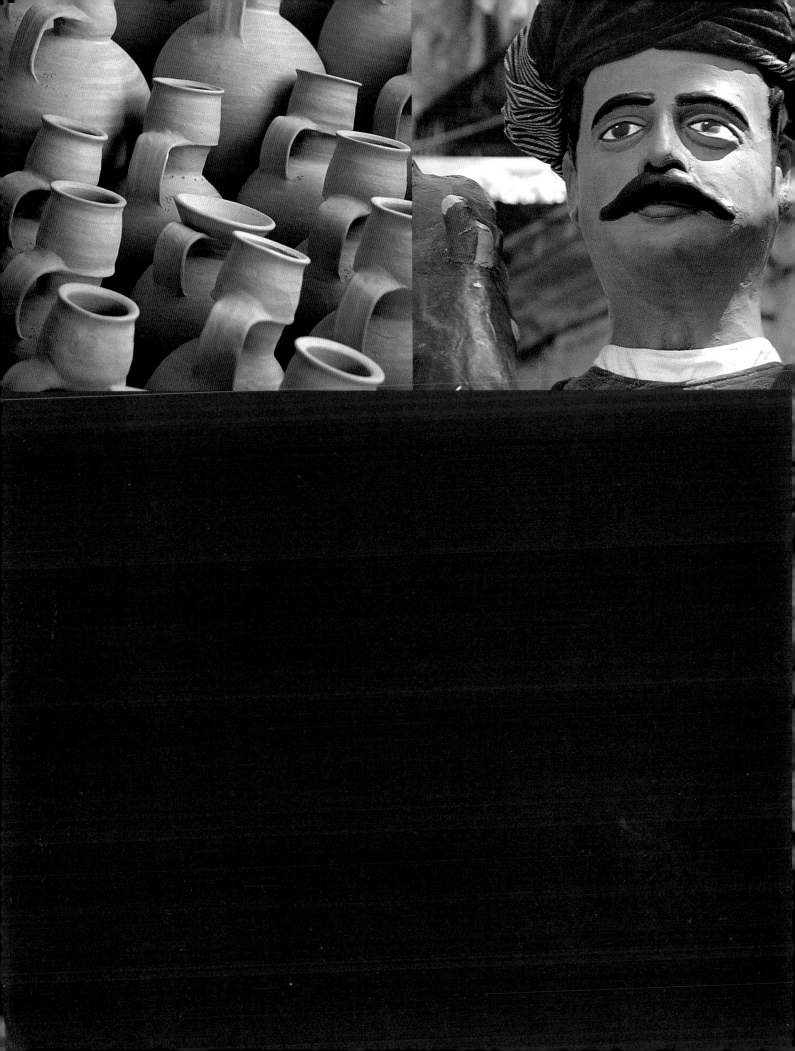

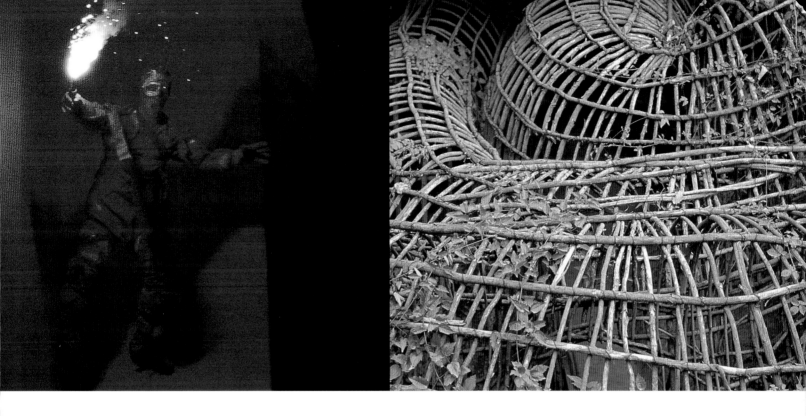

FORMS OF TRADITION
IN CONTEMPORARY SPAIN

Jo Farb Hernández

UNIVERSITY PRESS OF MISSISSIPPI
AND SAN JOSÉ STATE UNIVERSITY

To Jany +
Sena
with all best
wishes for a
wonderful Spanish
adventure!

San José State
UNIVERSITY

This book is copublished with the Natalie and
James Thompson Art Gallery, School of Art and
Design, San José State University.

www.upress.state.ms.us

Designed by Todd Lape

The University Press of Mississippi is a member of the
Association of American University Presses.

Photographs by Jo Farb Hernández unless otherwise noted

First edition 2005
∞
Library of Congress Cataloging-in-Publication Data

Hernández, Jo Farb.
 Forms of tradition in contemporary Spain / Jo Farb
Hernández.— 1st ed.
 p. cm.
 Includes bibliographical references and index.
 ISBN 1-57806-750-2 (cloth: alk. paper) — ISBN 1-57806-751-0
(pbk. : alk. paper)
 1. Decorative arts—Spain—History—21st century. 2. Folk
art—Spain—History—21st century. I. Title.
 NK999.H47 2005
 745'.0946'090511—dc22 2004026688

British Library Cataloging-in-Publication Data available

EVELIO LÓPEZ CRUZ

DAVID VENTURA ı BERTRÁN AND **NEUS HOSTA ı PASQUAL**

13

57

CONTENTS

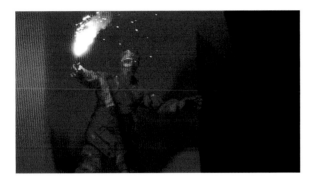

LES GÀRGOLES DE FOC

JOSEP PUJIULA I VILA

ACKNOWLEDGMENTS

This project grew on me like Josep Pujiula i Vila's monumental art environment . . . little by little, until it had grown so large that it practically took over my life (or so my family would claim)! And although this component of it has finished with the publication of this book and the accompanying exhibition at San José State University, I know that I will continue to follow these artists, watching them work and seeing their arts evolve.

My first thanks must go to the artists, who, although perhaps initially wary of my enthusiastic interest (and overwhelming ignorance), supported my efforts by providing me with answers to even the most detailed questions, dug out old newspaper clippings, posed for photographs, and gave me free access to their studios and files.

I met Evelio López Cruz and his family as Sam, Larissa, and I were taking a sightseeing trip to central Spain in the fall of 1999; we'd headed for Mota del Cuervo knowing that it had been a great pottery center but, given the dire pronouncements of the published scholarship, not knowing whether any potters were still working in the traditional mode. Evelio told us later that we were intriguing enough that he figured it was worth a day's lost work to talk to us and show us around; little did he know then that I would still be asking questions six years later. He has been unflaggingly cheerful as I examined all aspects of his work. He

Author and daughter inside Josep Pujiula i Vila's labyrinth, 2000.
Photograph: Sam Hernández

has patiently recorded dimensional measurements for vessels that had always been sized by capacity rather than centimeters, coiled pots, pulled handles, loaded kilns, showed us his clay field, and demonstrated various facets and tasks of his profession. All quotations or comments by the artist included herein, unless otherwise noted, were recorded as part of extensive interviews in September and November 1999 and July 2004 in his studio, a 2002 interview in Argentona during a national ceramics fair, and numerous telephone interviews and mail contacts between 1999 and 2004. His wife, Loli; his mother and father, Dolores Cruz Contreras and Santiago López Contreras; and his children also merit my thanks for their graciousness and hospitality.

David Ventura and Neus Hosta were friends of a friend of a friend, who introduced us because he thought we'd find them interesting. We were immediately impressed with David and Neus's meticulous craftsmanship and wealth of knowledge about local legends and symbolic representations, and they soon become major resources as I expanded my knowledge about Catalan traditions. Savvy and smart, they have become our friends as well, as they welcomed our interest, hosted visitors we brought from the United States, demonstrated techniques, identified local proclivities, and recounted folk tales. They willingly let me dig through and copy old press clippings, drawings, and photographs, and, due to our relative proximity to their studio, graciously received us again and again. All quotations and information in this chapter are from our numerous discussions and correspondences between 2000 and 2004. A special smile goes to little Violetta.

During my first couple of *correfocs* organized by Pere Casellas and the Gàrgoles de Foc of Banyoles, I tried to stay out of the way. Calculating the best distance to capture a good photograph while avoiding major burns to myself or damage to my camera, I dodged sparks while running dangerously close to the spinning *carretilles*. Somewhat shyly,

I poked my camera at the "devils" while they were getting organized at the beginning or as they puffed on cigarettes, relaxing with relief after the event was over, and I soon found myself laughing out loud as they clowned for the photos. Our friend Melo later introduced us to Pere, and he and all of the members of the Gàrgoles went out of their way to make us feel part of the group, inviting us to rehearsals, to out-of-town events, and to pre- and postperformance meals. They opened up their private spaces to us for documentation and trusted in our understanding of the complexity of their activities. They sat for formal interviews as well as more informal sessions, and Pere answered phone calls, mail, and e-mails from 2000 through 2004, directing me to other resources and links that would help me to contextualize and interpret their extraordinarily potent performances.

"Discovering" Josep Pujiula's phenomenal art environment was one of those "eureka!" moments as we sped down the road in the summer of 2000 to visit some of the western villages in the La Garrotxa region of the Pyrenees. There is no surer way for me to get whiplash than to see such a construction out of the corner of my eye, but even more eye-catching was the creator himself, shirtless in the warm Catalan sun, hammering in the unfinished towers almost a hundred feet up in the sky. Given the proximity of his work to the freeway, Josep never lacked for sightseers and tourists, and he was friendly and welcoming from the first moment we met him and asked to sit down and talk. He was surprised, I think, to see us again the next year and soon realized that our interest was more than a passing touristic gambol. I conducted an extended series of formal and informal interviews with him during the summers of 2000, 2001, 2002, and 2004, and all otherwise unattributed quotations from him used here are my translations of his words either from these interviews in Spanish or from the Catalan in which his written recollections were self-published in 2001. Further interviews and fact-checking were done with

Pujiula's daughter, Montse Pujiula, and her husband, Carlos Vila, from 2001 through 2004 as well as with Pujiula's friend Toni Carbonell in 2001. I am truly grateful to Josep and the others for their gracious and willing support of my efforts and particularly to Carlos for sharing his photographs of the burn, which took place midsemester, when I couldn't get away.

I tried to stop the impending disaster of the dismantling of Pujiula's masterpiece by contacting Seymour Rosen, Founding and Executive Director of the nonprofit organization Saving and Preserving Arts and Cultural Environments (SPACES), who used his extensive contacts to solicit letters and support from an impressive number of illustrious art supporters, unfortunately, however, without success. John Maizels, editor and publisher of *Raw Vision* magazine, also quickly responded to my impassioned concerns and quickly rearranged an upcoming issue to include my narrative of Pujiula's work and troubles (fall 2002). This article, the first published on Pujiula's work, introduced him to a worldwide audience, and I was both charmed and gratified when, at year end, a writer on an international internet listserv about "self-taught artists" included Pujiula's work among those that had affected him most deeply that year. My thanks to all of those who wrote letters of support for Pujiula; to John Maizels for publishing not only the initial article but a summary of subsequent events in the following issue; and to Randall Morris of New York's Cavin-Morris Gallery, for using the outsider art Web site he manages to publicize the need to try to influence the Catalan authorities. Jean Soum of Archilibre, at the School of Architecture in Toulouse, and Marta Torres of the Amics de les Cabanes, from Barcelona, also valiantly supported efforts to derail the destruction of Josep's magnum opus.

Many other individuals supported my efforts in a variety of ways. Philippe Deney, the friend and neighbor who first introduced us to Ventura and Hosta, saved newspaper clippings regarding Josep's predicament and facilitated our lives in Spain in every possible way; Melo Ortiz Torres of L'Abeurador in Banyoles introduced me to everyone I needed to know, e-mailed me updates of events, and smoothed the way for countless informal meetings and interviews. Lourdes and Pere of Can Biel served me coffee *manchados* every morning, a job later taken over by their daughter-in-law, Pilar, as I planned my field excursions and perused the local papers for folkloric events; and Rosa Rigau Noguer of La Caixa was supportive and helpful for other aspects of both this project and our larger experience beyond.

In my introductory narrative describing how we came to be so involved in Spain, I write about Horta de Sant Joan in the Terra Alta, and I want to thank again—and again and again—Mel and Leta Ramos for the generous and gracious loan of their home. My profound appreciation also goes to Jordi and Pili, to Cris and Manolo, to Rosita and Mercè, to José and Iberia, to Olga, to Alex, and to everyone else who facilitated and enhanced those wonderful days.

Numerous colleagues supported me as this project continued, and to them I owe an unqualified thanks—particularly María Antònia Casanovas, curator at the Museu de Ceràmica in Barcelona; Guadalupe González-Hontoria y Allendesalazar, director of the Museo de Artes y Tradiciones Populares at the Autonomous University of Madrid; Joan Martí Salavedra, Emili Tomé Miró, and Elena Espuny from the Museu de Ceràmica Popular in L'Ametlla de Mar; Michael Owen Jones, at the University of California–Los Angeles; Amy Kitchener, executive director of the Alliance for California Traditional Arts; Tom Seligman, director of the Iris and B. Gerald Cantor Center for Visual Art at Stanford University; and Natacha Seseña, ceramic historian par excellence. I also thank Joan-Miquel Marino of l'Agrupació de Colles de Geganters de Catalunya; Juan Manuel Ruiz de Valbuena Quejigo, webmaster of AspasManchegas.com and

Mota-del-Cuervo.com; and Josep Mª Rubiols of Servilibros for trans-Atlantic attention to my bibliographic needs. My grateful acknowledgments go as well to Joanne Allen; Olga Antón; Pedro Barriada; Ana María Carrera and Manuel Català; German De Juana; Michael Dunev; Martha Hernández; Anya, Ernst, and Waltraud Hoeller; Matt Moore; Alan Shepp; Consul Vidal; and Lluís Vilà.

Early research for this project was initially supported in part by Santa Clara University as I piggybacked on my husband Sam's sabbatical leave. I am most grateful for later direct support from San José State University through two California State University Research Fund Awards, two Dean's Fund Grant, and a generous sabbatical leave from my own gallery and teaching duties. This significant support was championed every step of the way by my indefatigable friend and colleague, Robert W. Milnes, director of the School of Art and Design, as well as by Carmen Sigler, interim provost of San José University and former dean of the College of Humanities and the Arts, and by Karl Toepfer, interim dean of the College of Humanities and the Arts. Subsequent support has come from the Natalie and James Thompson Endowment Fund.

Thanks go as well to staff from the University Press of Mississippi, particularly editor in chief Craig W. Gill, who encouraged me with this project for years before it finally came to fruition, to Alison Sullenberger, Anne Stascavage, Todd Lape, Shane Gong, and Ellen D. Goldlust-Gingrich; further thanks go to Theta Belcher and my colleagues and students at the Natalie and James Thompson Art Gallery.

And once again, thanks to Sam and Larissa, without whose help in innumerable professional, technical, and personal ways, this project would never, ever, ever, have happened . . .

I dedicate this book to them.

FORMS OF TRADITION IN CONTEMPORARY SPAIN

After an absence of more than twenty years, my first steps in Spain in 1997 were as a tourist. Visiting for a few days prior to a family celebration, I remarked on the warmth and gracious hospitality of its people, so unlike the guarded and almost suspicious visages I remembered from short stays there in 1973 and 1976. And so, two years later, I was pleased that I was able to rearrange my professional projects to share my husband's six-month sabbatical in the small village of Horta de Sant Joan, in southwestern Catalunya.[1] In advance of our arrival, my main goal was to secure our ten-year-old daughter's fluency in Spanish, as my husband pursued the creation of a new body of sculpture that had provided us with the justification for this sabbatical leave.

My language skills were better than rudimentary, but not by much. Nevertheless, I was delighted with the opportunity to live for an extended period overseas (something I hadn't done since 1973), improving my *castellano* (Spanish) and experiencing a different way of life. We were blessed with the gracious loan of a beautiful home from artist friends Mel and Leta Ramos, and we drove up to the house with a feeling of excitement and anticipation.

The old stone walls of the house—sections of which had been part of the ancient walls surrounding the village—were lovely, although we were unprepared for the quantities of dust that eroded from them daily. Because the house hadn't been lived in for two years, we swept lit-erally buckets of dust off the floors before we even felt comfortable putting our suitcases down. And the thickness of those walls, which kept the house so wonderfully cool most of the summer, were no match for the winds that howled up the narrow street after the tourists left and the darker, colder days of fall and winter descended.

We couldn't have anticipated the daily challenges of living in this new place—for my daughter, who quickly eased into the language playing with the neighbor children, it was being accepted as "just another kid and no one special"; for me, washing clothes, sheets, and towels in the bathtub and coaxing a trickle of warm water out of the shower; for my husband, the lack of electric tools and implements that he took for granted in his home studio, exponentially increasing the amount of time needed for even simple tasks. Nevertheless, these minor difficulties paled beside the wonderful events and sights that we experienced every day. Despite its remoteness, Horta boasts two distinctions that make it a tourist destination: the first as one of Picasso's early homes (the local museum honors that history, downplaying the fact that at the time the townspeople had been demonstrably antipathetic toward him and his live-in girlfriend, Fernande Olivier);[2] the second as a steppingstone to the remarkably sculpted peaks of Santa Bàrbara and Las Rocas de Benet, seductive recreation areas for increasing numbers of mountain climbers and eco-

tourists. Nevertheless, by mid-September the tourists left the village to the year-round residents (many of whom—particularly the older ones—tried to ignore visitors anyway); these old-timers tended to resist substantive changes to their activities or behavior, although they evidenced an enthusiastic willingness to assimilate the more superficial aspects of an increasingly mainstream consumerist life.

As I said a shy "Bon día" or "Bona tarda" to my Catalan neighbors, expressing an honest interest in how they lived their lives, doors began to open. As Sam worked on a sculpture in the local forge, taking more than a month to pound out steel components by hand that he could have pressed out with the machines in California within a few hours, Larissa started school in the fall, encouraged by our next-door neighbor, the head of the school, María Mercedes Gil Niella. I learned to crochet with Mercè's mother, Rosita, and her lifelong friend, Iberia, bringing our chairs out into the streets to gossip, discuss upcoming *festas,* and keep an eye on all those who passed. (Although somewhat unnerving to those of us accustomed to more anonymous urban settings, this scrutiny freed Sam and me from worry about Larissa playing around town with her friends: there were innumerable pairs of observant eyes making sure that all was well.) But it was not really until the fall, after the tourists left and the days started cooling off, that we began to see the deeper aspects of traditional town life unfold. Iberia's blue-eyed husband, José, proudly drove off to his fields in his John Deere tractor each dawn (having replaced his burro not so very many years before), teasing us into helping him with the backbreaking labor of his grape harvest and patiently posing as we photographed him pressing the final gleanings literally by hand to make a sweet wine enjoyed locally. Rosita let me use her treadle sewing machine to make a traditional-style jacket for Larissa to wear during the annual Festa Major, and

coached me in a variety of other skills, including putting up olives, sharing local recipes, and basic Catalan. And when the weather started getting really cold, she brought us stacks of blankets and helped us to hang them up over the interior doorways to cut that piercing wind as it flew between the cracks of the doorjambs and the old stones.

When friends from back home would ask me how I spent my days, it was hard to explain that it took several hours each morning just to shop—going to the itinerant market twice a week to see if anything new had been brought in; going to the baker's house for the steaming flat *estirados* (rich flat breads made with olive oil), to Pepita's for eggs and olive oil, to Paquita's for meat or to "the other" Mercedes's for fish, to Tere's for general groceries. We made a big lunch for Larissa when she returned from school for her afternoon meal and siesta, helping to translate her math "story problems" from Catalan to Spanish and then into English so we could try to pick up the clue that would help her solve them, and then getting her back to school for a couple of hours in the late afternoon. But I was also noticing the persistence of earlier ways of life, and in between the chores I was reading up on Spanish traditional arts and customs as I saw them unfold in front of me.

Almost every door or window was framed with handmade ceramic containers, now frequently used as flowerpots but elsewhere still serving as storage for grains or other foodstuffs. In garages or sheds I saw old ceramic water jugs, heavy yet elegant ware formerly used by women to bring water up Horta's steep and narrow stone streets from the municipal wells to their homes. And every fiesta day was enlivened by the dancing of the huge, stately papier-mâché *gegants* figures and their more manic big-headed attendants, the *capgrossos.* The former honored the peasant laborers in their traditional costumes, while the latter depicted cubist-style characters derived from

Picasso's paintings, in deference to one of the town's famous sons. I learned to dance the *sardana* with the others in front of the twelfth-century church, counting the steps under my breath and concentrating to get the dance right in front of my neighbors and new friends, and Larissa (in her new costume) and I danced the *jota* for the Festa Major after practicing our moves with the others for several evenings at the local community center. But it was probably not until my first night of *correfocs*, the incredible, primal spectacle of "devils" brandishing fireworks pursuing us down the tight, winding streets, that I fully understood what a gift this was, this time spent in a place where my eyes and ears, unaccustomed to and yet enthralled by the sights and sounds I was encountering, could see and hear the merging of traditional with contemporary, of time-honored reiteration with innovative creation, of past with present.

We all cried as we left Horta that December: it had been a life-changing epoch for each one of us. Larissa did learn to speak Spanish—so fluently, in fact, that she sounds better than her father, who spoke it first as a child. Sam experimented with media and forms that provided a successful new avenue for his sculptural explorations upon his return. And I was fired up to try to understand and put into context the tremendous potency manifested by these unself-conscious displays of traditional heritage that provided a consistent—yet continuously changing—cohesiveness for Horta's residents and extended family members, despite the internationalizing and homogeneous consumerist appeals of the twenty-first century.

After that sabbatical leave, we couldn't stay away. Although we'd tried to purchase a house in Horta, we couldn't find one that would suit both our current needs and our fantasy of a future retirement getaway, so we ended up buying an old stone farmhouse further northeast in Catalunya. This area, near France and the

Mediterranean and therefore less remote, had been so long and so cyclically contested by succeeding armies that it was even more obstinately Catalan than Horta's Aragonese border region had been, and traditional arts and *festas* abounded. Participating in such activities and behaviors as running the *correfocs* and even dancing the *gegants*—eminently political acts immediately subsequent to Franco's death, when previously forbidden public manifestations of such events riotously blossomed along with newly found freedoms—were by now more calmly resolving into a sphere that can be described as genuinely folkloric. Young adults my daughter's age had no personal knowledge of the repressions of the Franco regime, so their participation in dancing the *gegants,* learning to play the reedy *gralla,* and dressing up as devils and "running with fire" was less a political statement than a willing and enthusiastic involvement in a heritage that centered them with a profound sense of their sociocultural identity at the same time that it gave rein to their individual energies and creativity.

The danger, of course, for one so newly introduced to "exotic" cultural manifestations, is that "dead ritualisms" (Erikson 1977) will be mistaken for functional components sustaining group identification or that "invented traditions" (Hobsbawm and Ranger 1983) will be misinterpreted as authentic performance. Having done fieldwork in FYR-Macedonia and Bulgaria in the early 1970s, concentrating on how political and social changes affected traditional folklore, I was particularly sensitive to the instances of self-serving political co-option or governmental exploitation of collective street performance, to the strategic rhetoric of tourist offices trying to lure visitors from the sunny coasts to the less traveled interior through *turismo rural,* to intrusive television news cameras during fiestas inciting overextension or extreme distortion of participant behavior, and to the casual cynicism of the "nouveau mod-

erne" nonparticipants who regard such community events as the perfect excuse to get out of town or go on vacation. Nor could I ignore certain synthesized or revivalist elements that have been consciously added to "round out" the cultural or artistic experience, for all of these influences and detractions certainly exist, newly institutionalized in differing degrees of acceptance and success. While describing the visual and performance arts that I study here as "traditional," I do not mean to suggest that they do not reveal significant differences in comparison with historical manifestations of the heritage out of which they grew; how could it be otherwise, given the longevity of their practice? Nevertheless, as the artists continuously reinvest their energies at the same time that they are continuously re-creating and revitalizing their output, there is a substantive level of authenticity—a gut-level honesty—that trumps nagging issues of broken chains of transmission or changes in end users or disposition of their works.

Although the performance events that I study in this book, for example, are rooted in centuries-old processions and symbols, ancient provenance does not need to be the sole requisite determinant for either authenticity or traditionality, for later components can become equally compelling and valued. Despite the fact that dance historians have pegged the choreography of the Catalan *sardana* to a specific composer and date, for example, its widespread popularity among young and old, male and female, urban dwellers and villagers; its constant reiteration on Sundays, holidays, and special events; and, indeed, the aural and somatic transmission of its style and steps have come to define it as a "traditional" dance, for this is how its practitioners experience it. That some may disparagingly characterize such an event as a response to contemporary social and/or emotional needs (Handler and Linnekin 1984) rather than a link to shared experiences or events of the past is irrelevant, for the contemporary performance event itself, connecting materially, socially, and psychologically with its practitioners, defines both the intensity and the continuity of its cultural standing.

Spain is an increasingly secular country. The thousands of cathedrals, churches, and *ermitas,* empty most nonfiesta days except for sightseers, are only one manifestation of the results of exploding tourism, international economic and political mainstreaming, and expanding literacy and scientific understanding. The national government has played a role as well, reducing the number of religious holidays in an effort to increase workdays and boost economic production, concomitantly disassociating itself from the Catholic Church, notoriously recalled as a close partner to Franco's dictatorship.[3] This confluence of elements has significantly contributed to the growing lack of interest in the formal or liturgical aspects of the Church's activities. Yet our visceral needs for collective connectivity and even for rite and ritual have changed little: even if we rely on television soap operas to provide a sense of continuity and evoke emotive empathy, political propaganda to delineate good from evil, and online greeting cards to mark celebrations and rites of passage, the functions they play are the same as those provided by religious processions, traditional dance-dramas, and days of feasting and fiesta, although the depth of these popularized experiences—individually as well as collectively—is certainly weaker. It is rare, in fact, to find Spaniards who completely ignore one end of that spectrum or the other; it is more likely that they simultaneously and naturally participate in a diverse variety of both contemporary and traditional components of social communality and identity, albeit at different depths or levels. This is how we absorb change, share celebrations, delineate what is routine from what is special, and manifest our humanity:

linking our individual lives with the collective, defining and orienting ourselves, in part, through the "sense of place" that grows out of our community as we, in turn, fertilize and nurture that growth.

Interestingly, although this secularization is marked by a decline in belief in God and a concomitant decline in attendance at formal Masses and services, Spain has seen an extraordinary revival in popularized religion—or perhaps more precisely, what historian José Vericat has called "religious nostalgia" (quoted in Stanton 1999: 30)—that has turned it into a country of fiestas. This has been abetted by the decentralization of certain powers from Madrid to the autonomous regions, a phenomenon that has inspired communities to revitalize local traditions or festivities that had previously been subsumed to vetted pan-Hispanic events promulgated by Franco's centralized regime. (Not coincidentally, this transfer has resulted in the correlation of certain nominally "religious" activities with local or regional political struggles.) During the summer, in particular, a weekend without a *fiesta mayor* (or, in Catalunya, *festa major*) within the immediate region simply does not exist. These fiestas are usually linked to the village's supernatural patronal benefactor—that is, the locally venerated saint or virgin—and although they typically include a Mass or religious procession, the percentage of time and energy that is expended on this component of the weekend's festivities pales in comparison to the secular, street-centered activities that are also scheduled. The fiestas serve as umbrella frameworks for the manifestation of a range of traditional and folk arts and events as well as for those that are distinctly mainstream contemporary; although the different events may attract varying degrees of attention from different audiences, neither their widely divergent natures nor their blurring of the boundaries between sacred and profane are seen as paradoxical. Thus, a *cobla* of

musicians that plays *sardana* compositions may follow a High Mass and may precede a DJ playing disco or hip-hop; a performance of the town's century-old monumental papier-mâché *gegants* may follow a competitive card game or fishing contest; the awesome and "diabolic" *correfocs*, running with fire, may take place after a community sausage feed, reach its zenith in the *plaça* in front of the church, and finish in time for the performance of an internationally touring rock and roll band. This is true all over Spain, as *jotas, sevillanas,* and other dances typical to each area (as well as games and other traditional activities) appear widely and are smoothly segued into more contemporary manifestations. Those who participate see neither contradiction nor disconnect in these juxtapositions.

Particularly as far as performative aspects of communal events go, even as individuals initially engage themselves consciously, they soon are unself-consciously becoming part of the event, not just attending but transforming themselves from role-playing actors into creators as the parallel actions of their neighbors and friends build together to produce an authentic phenomenon. Present time recedes as the collective unconscious of past iterations of the event play out, provoking the requisite emotions—joy, fear, admiration, assurance, chagrin, or relief—that are as cathartic as they are legitimate. The authenticity of the experience evokes a desire to experience it again. This does not imply a static or reflexive replication of activity but rather, in contrast, such a lively response that the next performance is necessarily modified. And as the individual is fulfilled through participation in symbolic behavior, it strengthens the sense of *communitas* (Turner 1974) and cyclically provides an additional motive for future reenactment and renewal. Even with the more static visual arts, the process of engaging oneself in sharing an artist's creative productions can be cathartic, whether

the object of interest is a traditional form or a more personal and innovative one.

My professional work to date has focused on straddling aesthetic boundaries, disregarding theoretical categories in an attempt to free the discussion of artistic production from stultifying constructs that may be helpful to art historians, folklorists, or critics but that are of little relevance to the creators or generally to their communities or clients. In this project, too, I hope to dissolve abstract discipline- and genre-based classifications in favor of a more realistic and expansive interpretation of the myriad of influences on each creative act. Because I am married to an artist, we are always meeting many other artists, but among those that I came to know in Spain, I decided to focus my study on four who work in widely divergent genres and media, balancing tradition with innovation in different ways. These artists reveal significantly different approaches to the creation of their art as well as to use of and investment in it by community members. By not restricting myself solely to either visual arts or performance events I have been able to engage in a broader vision than that which is bounded by media or genre categories; by studying groups of artists as well as individuals I have been able to evoke shared qualities as well as idiosyncratic personal discourse. Such is the range of artistic manifestation within this purview that it seems appropriate to posit a "continuum of traditionality" to chart the varied responses of these four artists to their art and to their communities; each can therefore be seen as emblematic of a wide range of creative work that describes alternate modalities of the most salient feature of folk and traditional art, an integral relationship with its culture.

This book, therefore, is composed of a series of four case studies. To partners making the large *gegants* and *capgrossos* and a group of "devils" that organize and facilitate the *correfocs*, I have added individual visual artists at both ends of my theoretical continuum: one an extremely traditional potter; the last the creator of an idiosyncratic art environment, the kind of monumental structure more often appreciated by contemporary art aficionados than folklorists. Beginning documentation on the potter in 1999 and the others in 2000, I have returned annually since then for three months of in situ fieldwork, supplemented with secondary research the rest of the year. Through technological data, contextual evidence, and stylistic analysis, I compare and contrast the role and production of these artists' contemporary aesthetic creations to local historical manifestations of these and related arts. I have cast a wide net in my interpretation of creative or functional differences from historical works by exploring the range of possible or potential influences on the artists: idiosyncratic or personal modifications are explored as well as those resulting from cultural, economic, or social changes; governmental promotion of these arts; transplanted elements resulting from artistic exchanges at regional fairs; and introduction to diverse traditions through travel, books, tourist commissions, and the like.

My methodology for this research and analysis has been three pronged, following the logic of the project as well as the challenges and rewards of approaching this topic from both sides of the Atlantic:

1. Primary fieldwork in Spain. To facilitate the interview process, I developed a detailed questionnaire tailored to each artist, exploring the history of the craft or performance event of each—for example, family or village tradition, how the skill was learned, details on gathering and processing the raw materials, the physical description of each workshop and the scope of work (including localized names,

categories, and dimensions of each kind of object produced), all aspects of the production and marketing processes, sales/client information, the artist's comparative analysis of aesthetic and functional values of the art, future of the tradition, contemporary tastes, economics, and so on. The interviews were carried out as the artists worked, for these discussions were extensive and took many visits. I returned to the artists again and again—in person, by telephone, fax, mail, and e-mail—to clarify my understanding of their activities and check my assumptions. Each was more than gracious, incredibly generous with his or her time, and empathetic both to my primitive *castellano* (a nonnative language for me as well as for some of the artists, whose primary language is Catalan) and to my novice attempts to understand, explicitly deconstruct, and systematically analyze something in which they were so organically—indeed, so viscerally—involved. I supplemented the interviews with full visual documentation: photos, videos, site plans, and sketches, selections of which are reproduced herein.

2. Secondary research in libraries, museums, and private collections in Spain. Comparing and contrasting the contemporary works by these artists to historical treatments within the same genre has been crucial to an understanding of change and continuity over time. To that end, I accessed dozens of private and public collections, archives, and libraries of numerous individuals and organizations all over Spain. I spoke and corresponded with librarians, curators, museum directors, collectors, and educators, and their in-depth support was invaluable as I worked to extract the specific information I needed from the voluminous amounts of quality documentation available for my review. I followed their leads, pondered their suggestions, and rethought my assumptions, and I

remain monumentally grateful to them both for their prior work in the field and for their enthusiastic encouragement of my efforts.

3. Background research and comparisons with secondary materials available in the United States. In support of my activities in Spain, I have done extensive research using materials available in the United States, examining theoretical and analytical scholarship that informs discipline-specific, interdisciplinary, and cross-cultural studies in art history, anthropology, ethnography, folklore/folklife, performance studies, and the history of popular religion, including standard texts examining issues of authenticity (such as Hobsbawm and Ranger 1983), the impact of cultural tourism (Boissevain 1996), and festival politics (Brandes 1988; Guss 2000; Noyes 2003). Referenced sources include research on visual arts from pre-Roman times and related arts and performance events from the Middle Ages up to the present, thus providing an important historiographical dimension to my specific areas of study of Spain's contemporary folk and traditional arts.

Let me now introduce the artists:

1. **EVELIO LÓPEZ CRUZ,** potter, Mota del Cuervo, is a producer of unglazed earthenware vessels who learned his craft from his mother. The family history of creating this functional ware goes back for generations, and Roman-era shards regularly surfacing in his fields confirm that pottery has been made in this area for well over a thousand years. López Cruz has little interest in innovation in any aspect of his technology or production, although he is well aware of alternative options. He digs his clay by hand, builds his vessels on a pre-Christian-style wheel that does not use centrifugal force for turning, chooses to produce only styles of ware that have been locally customary, and fires his

hand-built kiln with wood. López Cruz's commitment to the historical local tradition of producing functional vessels is primary; the aesthetic specifications are so fixed in the stability of the local forms and style that they are almost a nonissue. Grounded in the creation of modest objects inspired by and responsive to the needs of daily life as they have been manifested for generations, he is proactively and unswervingly dedicated to preserving the time-honored aspects of his ancestral lifestyle and artistic production.

2. **DAVID VENTURA I BERTRÁN AND NEUS HOSTA I PASQUAL,** *cartroners* (workers of papier-mâché), Navata, are partners who produce monumental figures (*gegants*) and heads (*capgrossos*) for use in public festivals and processions. They learned their craft through oral transmission and self-teaching and produce traditional images as well as innovative aesthetic variants that remain linked to Catalan tradition. For Ventura and Hosta, too, function is important: as the heads and figures are made to be worn and danced in the streets, they must not be too heavy or unequally weighted. Beyond these elements, however, the artists concentrate fully on aesthetic and expressive value, and as consumer demand in this area tends to be more flexible than that for a water jug that holds a specified number of liters, these artists can also be more flexible. Their work specifically responds to community values and standards within the framework of rituals and festivals, yet their relationship with client and community is such that they are able to be more inventive in their approach to their objects, balancing tradition with innovation.

3. **LES GÀRGOLES DE FOC,** masked folk street theater performers, Banyoles. This group leads *correfocs*, night processions whose now-known forms retain relics of pre-Christian cults as well as later medieval elements sanctioned by the Catholic Church as it incorporated them into its own ritual framework. Dressed in homemade costumes and masks, waving wands with elaborate pyrotechnics, and accompanied by a fire-spitting "dragon," these "devils" simulate the misrule of satanic disorder. The flow of the procession is primal and visceral; the masks, costumes, fireworks, and dragon combine to create an immense albeit fluid work of art. Les Gàrgoles at once continue a tradition, revive and reintroduce it, and creatively adapt it with innovative theatrical elements and technological advances. Linked to an established cultural genre with traditional iconography, they strengthen community heritage and identity by referencing its shared spiritual culture and coordinating group participation. This performance event can be neither completed nor consummated without community involvement: standing on its own, the costumes, figures, and pyrotechnics would lack both impact and import.

4. **JOSEP PUJIULA I VILA,** art environment builder, Argelaguer. In contrast to the preceding artists, whose reciprocal relationship with their community is a crucial element in their artistic production, Pujiula is a primarily self-taught artist with a personal, idiosyncratic obsession. Working additively, reviewing and revising his creation over twenty-plus years, Pujiula constructed a monumental environmental artwork from willow and acacia branches found on-site. Until its demolition in late 2002 as mandated by the local authorities, it rose over thirty meters (ninety feet) tall and spanned one hundred meters (three hundred feet) in width, with towers, stairwells, and above all, a woven wooden labyrinth snaking back and forth for over a mile. Pujiula's sole allegiance was to his work; there was no generational transmission of production and but little based on occupa-

tional or vocational genres. His creation of one of the most spectacular "outsider" art environments to be found anywhere, in fact, defied traditional community norms of aesthetics and function. Nevertheless, although these norms were honored only in their breach, visitors' enjoyment of his construction ultimately became crucial to his inspiration and continued efforts. Function was important only insofar as the structure did not physically collapse under the weight of its visitors; expansive, expressive value was supreme.

I have organized the analytical interpretation of these artists and their work so that the methodology used and issues explored can be extrapolated from these case studies to wide theoretical cross-cultural applications across a variety of fields in the humanities and social sciences. This will have even greater import than I had suspected when I first began this project, for in the course of doing background research to contextualize these artists' works, I was repeatedly surprised at both the lack of substantive research on three of the genres (the notable exception being traditional Spanish ceramics) and, even more, the lack of attention paid to this material in museum exhibitions or academic publications in the United States.[4] Sadly, the result is a rudimentary and superficial knowledge of Spanish traditional arts among most American audiences. Consequently, most of the bibliographic references that I have found specifically pertaining to my focus in this book have been utilized in the original Spanish or Catalan; by distilling this background information into English, I hope that this book will fill a major gap in the academic art historical/folkloristic research and literature of this important area.

But really, more than that, I hope that this effort will express my honor and respect for the artists—the ones on whom I have chosen to concentrate as well as innumerable others—who have elected to focus their lives in a way that merges what has gone before with what is now and what is yet to come. This balancing act is not always easily maintained, but it moderates the stress of change and provides continuity for our increasingly troubled and anxious world. With honesty and hard work, creativity and a profound sense of history, these artists offer alternative aesthetic and cultural responses to the globalization of the new millennium. And they are only too willing to share.

A NOTE ON LANGUAGE

All interviews with the artists were conducted in Spanish—known in Spain as *castellano*—although three of the four live in Catalunya and are therefore more comfortable speaking Catalan. For the chapter on Evelio López Cruz, italicized words are in *castellano*; for the others, they are in Catalan. Secondary research was conducted in both languages. I reiterate my debt of gratitude to the artists for putting up with my imperfect communications, to Cristina Giné Miró for review of my Catalan, and to my husband, Sam Hernández, for his help in translating and clarifying the information gleaned in both interviews and library research. Unless otherwise noted, all translations are my own.

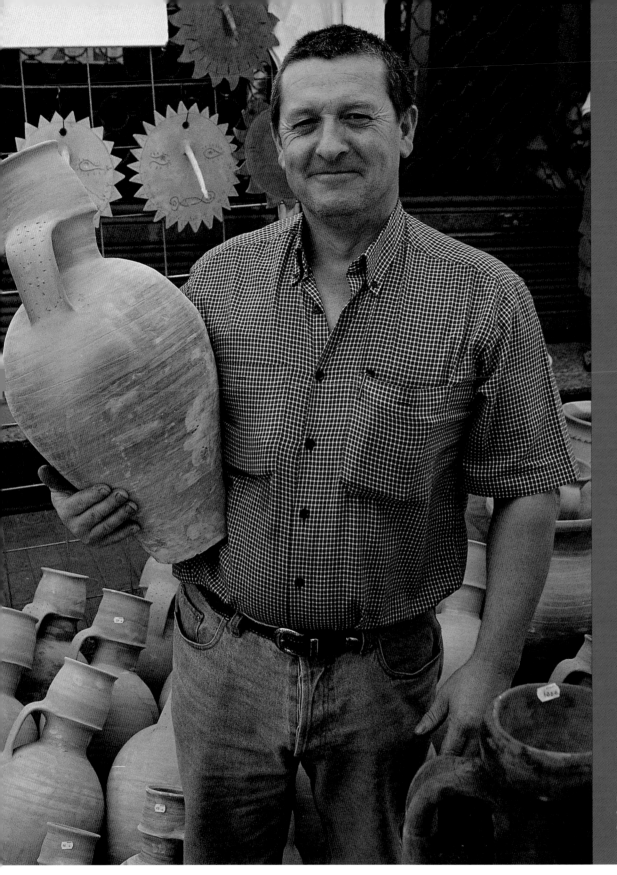

EVELIO LÓPEZ CRUZ

Oficio noble y bizarro
Entre todos el primero.
Pues para la gloria del barro
Dios fue el primer alfarero
Y el hombre el primer cacharro.

A noble and gallant occupation
First among all others.
In the ceramic arts, God was the first potter,
And man the first vessel.

—ANTONIO MACHADO

The open, high plains of La Mancha bone-chilling and windswept in winter, pulsating with heat in the summer—are not an easy read. The region's name, derived from an Arabic word meaning "wilderness," remains apt; widely spaced villages far from the cosmopolitan international partying well-known on the Spanish coasts turn curious or even suspicious eyes on foreign visitors, unimpressed with whatever pursuits have brought them to La Mancha's doors.

Whitewashed one- or two-story homes are flanked by compact walled courtyards, sheltering small work areas from the wind as well as from the view of inquisitive neighbors. Yet the superficial severity of these plains veils a rich cultural and historical heritage that, although modified due to changing social and economic circumstances and lifestyles, continues today in unassuming workshops and seemingly deserted barrios. The never-ending undulating fields of grapevines and wheat grow from land that yields the remains of sea creatures fossilized as inland seas evaporated; the russet earth also offers up shards of pottery two thousand years or more in age, a window into the millennia before our time.

HISTORICAL BACKGROUND

Even a casual visitor to Spain is immediately impressed with the breadth and depth of the country's ceramic tradition. Decorated ceramic fragments dating from the Neolithic period (ca. 5500–6000 BCE) have been found in several sites around the peninsula (Fernández Miranda 1990: 178–79, qtd. in Paulo i Sàbat and Creus i Mach 1998: 149), while significant numbers of Iberian bell beakers dating from the Copper Age (ca. 3000–2000 BCE) with incised decoration and curved bottoms have been found throughout La Mancha and the south (Pena 1997). However, despite the longevity of the Peninsula's autochthonous artisan tradition, as well as the Celtic influences from the North,[1] over time peoples living near or sailing across the European, Near Eastern, and African peripheries of the Mediterranean Sea were the most significant determinants of much of Spain's material development. In the centuries before Christ, successive waves of Iberians, Phoenicians, Carthaginians, Greeks, Romans, and Arabs, among others, crossed the sea and left their marks on the developing peninsular villages at every stage of the ceramic production and fabrication process. The result was a thriving domestic industry that provided handsome utilitarian ware for urban and rural residents alike. These visitors and immigrants imported technological advancements such as the potter's turning wheel, a crucial tool for the manufacture of ceramic amphorae used to conserve and transport wine, grains, and olive oil. It is believed that the wheel was developed in Mesopotamia during the early fourth mil-

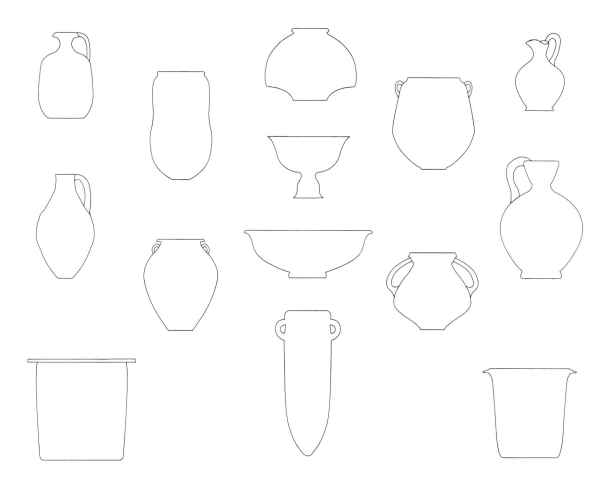

Iberian pottery forms,
500–200 BCE.
Illustration: Ilia Liu Gosen

lennium BCE and arrived on the southern Iber-
ian Peninsula with the Phoenicians by 700 BCE,
gradually migrating across the rest of the
peninsula over the next hundred years.
Another significant technological development
was the square or rectangular kiln with segre-
gated chambers, brought by the Greeks in the
latter part of this time period and supplanting
the early Celtic one-chamber circular proto-
types.[2]

Pottery manufacture in different villages on
the peninsula was organized in ways common
to eastern Mediterranean civilizations: potters
tended to group themselves within neighbor-
hoods and even on the same streets, much as in
classical Greece the ceramists resided in the
Kéramos section. Following the Roman inva-
sion at Empúries in 218 BCE and another eighty-

five years of battles until the fall of Numancia,
the local inhabitants ultimately resigned them-
selves to the forced *Pax Romana*, the first
attempt to unify the various settlements of a
large portion of the peninsula under a single
political rule. Despite this initial resistance,
thereafter residents became quick students of
Roman imports in all spheres of life, not the
least of which was pottery.

From that time to the present, vessels with a
common morphology derived from the Roman
amphora have been produced all along the
Mediterranean coast from the Ebro River to the
south.[3] These vessels have a stylized ovoid
body resting on a small base and a closed mouth
topping a high, cylindrical collar; the vertical
handles—one or two, depending on function—
describe a curve with a right angle and are

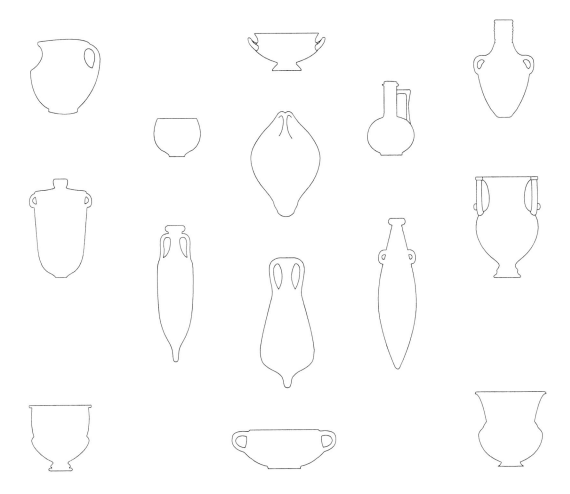

Locally made Greco-Roman pottery forms, 500–200 BCE. Illustration: Ilia Liu Gosen

melded into the typically unglazed and unornamented smooth wall surfaces. The early Spaniards were so adept at the lessons learned from Roman potters that from the first century CE onward Spain overtook Italy in the quantity of ceramic products exported. In fact, with the expanded trade between the two peninsulas over the next millennium, Italian potters became so enamored of the fine lusterwares emanating from the Spanish Levant that they attempted to replicate the advanced glazing techniques and intricate decoration. By the time of the Renaissance, this had ignited a reconceptualization of pottery as a fine art rather than a craft described in functional and utilitarian terms (Cooper 2000: 115–16). The highly respected qualities of Spanish ceramics resulted in large part from the Islamic conquest of Christian Spain, which significantly modified formal, aesthetic, and technological production between the tenth and fifteenth centuries. Unfortunately, the reverse was true as well, as the final expulsion of the Muslims in 1609–10 decimated the ceramic industry, a setback so severe that in some areas it never recovered.

ECONOMIC VARIANTS IN THE POTTERY INDUSTRY

Following schemas suggested by Arnold (1985) and others, technological development may be delineated through four distinct systems of ceramic production that broadly describe the working culture of thousands of Spanish arti-

sans.[4] These systems were not necessarily hierarchical or evolutionary, and although it was not unusual to find chronological progression from one system to another by individual potters or within villages over time, during any given period it was also not uncommon to locate examples of more than one type. Most rudimentary was the household in which those who created vessels and other ceramic objects were simply family members who did so for their own personal use; this labor typically occurred on a part-time, as-needed basis and was fit in around other domestic chores by artisans who had had neither apprenticeships nor elaborate training. Little if any investment of money or materials was made to increase the efficiency or efficacy of their labors; clay was usually dug by hand in the small quantities needed by the family group, and the work was created in multipurpose areas such as patios or kitchens and fired in pits to temperatures just barely hot enough to create impermeable, permanent ware.

The next level was a household enterprise, in which the members of the household had developed sufficient skill and expertise that they self-identified as potters and were acknowledged as such by neighbors and townspeople. They created work that they sold or traded locally and even regionally, responding to popular demand that reflected average tastes and aesthetic standards. Potters in this category still tended to work part time, and all processing of the materials and forming of the vessels continued to be done by family members, although other tasks associated with the production—from digging and transporting the clay to stacking and firing the kiln—might be subcontracted out to other workers, possibly also members of an extended family. These potters still typically used time- and labor-intensive, often inefficient techniques, but as their work was viewed as a supplementary source of income (typically secondary to subsistence

agriculture), this was not considered problematic, particularly since the time invested was rarely counted as a cost of production. Nevertheless, at this level there was an outlay of resources to support the craft-cum-occupation: for example, the purchase of raw materials or more advanced tools, the possibility of a dedicated space for working, and a firing chamber that could be defined as a kiln.

The third system of ceramic production can be characterized as a workshop or cottage industry, as for the first time in this morphology, the potter's family was fully supported through the production of ware and it no longer took a subsidiary role to other activities such as agriculture. Because of pottery making's central role for these practitioners, it was therefore essential that the numerous risks inherent in this trade be reduced as much as possible at the same time that efficiency was increased. This required greater control over the process at every stage, typically achievable only with a higher investment of time, materials, and capital. Studios separate from living quarters were built to reduce drafts and the possibility of breakage (more common if the pots were built in the same room in which food was cooked and children played, for example); kilns were refined, thus increasing the efficiency of the firing at the same time that potential risks from inclement weather during the process were decreased. This greater outlay of space, time, and funds required potters to work full time so that the amount of ware they produced was sufficient to make this extra investment profitable; no longer could they fit pottery making in between agricultural needs or familial responsibilities: it was now a formal trade. Such specialization required a higher level of technical proficiency, but this acknowledged mastery also allowed for greater expression of creativity in making aesthetic choices and modifications.

In general, the first three systems existed concurrently in different areas of Spain, driven

by population growth, local demand, and the availability and quality of raw materials, until the last years of the nineteenth century, when a relatively small number of businesses forged ahead to become large-scale ceramic industries. With further efforts to maximize output, minimize risk, and optimize efficiency to lower the production cost per piece and increase financial return, a workshop could evolve into the fourth and final system of this schema: a full-scale, full-time industry. At this level, nonfamily members were employed to work in all aspects of all tasks, and a specialization of labor was developed that relied on a widespread distribution system, essential to provide sufficient markets for the greatly increased numbers of works produced.

This development did not change the fact, however, that both fabrication and firing techniques tended to remain fairly—or even, depending on the area, completely—static through these years and beyond. Evolution of crafts and trades tended to be slow and relatively constant until the Spanish Civil War and the onset of World War II; these upheavals resulted in familial breakups and a decimated countryside, changes that forced many rural residents to move to the city. At the same time, increasing industrialization brought "unbreakable" plastics and aluminum containers to the most remote areas, and, little by little, utilities and running water were extended into rural homes. Together, these developments delivered a series of forceful blows to the traditional way of life, with its requirements for numerous and varied pottery vessels serving a wide range of utilitarian functions. Manufacturing advances enabled new capital-intensive factories to produce certain objects similar to those traditional potters had created by hand—flowerpots, water jugs, and the like—but their reduced production costs competitively undercut the sales prices of the cottage industries and made it difficult, if not impossible, for these potters to compete in

the marketplace. Cast cement containers soon began to be used for water and wine storage in fields and warehouses, exacerbating the assault on a modernizing home life with a parallel strike on agricultural, storage, and distribution sectors as well. By the late 1960s and 1970s, every article or book published on the topic— and all of a sudden, there were a raft of them— hurried to document the "dying" tradition before it "drained" away into history.[5] The only direction this tradition could take, it was assumed, was toward extinction.

In many cases, this turned out to be a correct prognosis. Potters' sons and daughters had other ideas about lifestyle possibilities than following their parents into a dirty, labor-intensive occupation that promised only dwindling sales and declining opportunities. Some artisans' children emigrated to cities in search of greater opportunities; others stayed in their hometowns but turned to other vocations with greater likelihood of profitability. Numerous "extinct" pottery villages in Spain were quickly researched, documented, and mourned: because many such "centers" included only a single workshop, the death or retirement of a working potter in a remote area would signal the end of that unique local tradition.

Paradoxically, the pottery market rebounded in other areas, thanks to an increased interest manifested by urban professionals, romantics, antiquarians, and collectors and fueled by municipal governments that saw a chance to piggyback on the national tourist office's "España Desconocida" (Unknown Spain) marketing program by scheduling summer fairs and producing glossy brochures. This produced its own changes, of course, not all of them positive, such as the wholesale purchasing of clay bodies or glazes in "artistic centers" that make every potter's work in that region look alike, and the modification of types of wares produced, sometimes with aesthetically horrific results. The increasing conventionality of these

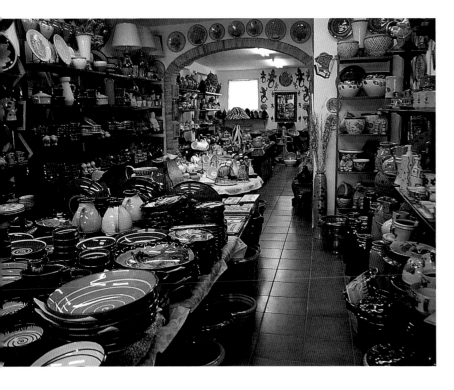

EVELIO LÓPEZ CRUZ
A Revolution in Pottery Tradition

The subject of this study is an anomaly: a potter working today within a tradition once considered extinguished yet bucking some of that tradition's major paradigms so that he can continue to produce ware consistent in quality and design with that produced by generations of family members who preceded him. Evelio López Cruz, a potter in the small La Mancha village of Mota del Cuervo, has quietly mounted and succeeded with a veritable sociocultural revolution. However, in contrast to the break with the past attempted by most revolutionaries, López Cruz's goal was having the freedom to creatively work within his ancestors' aesthetic, occupational, and domestic traditions.

Mota del Cuervo, a village of some 5,600 inhabitants located under the shadow of the windmills made famous by Cervantes's Don Quijote, was once widely known for functional unglazed ceramics that were sold and traded throughout central Spain. Oral tradition affirms that the pottery industry in this village, located in the southwestern regions of the Manchegan province of Cuenca, resulted from the resettlement a thousand years ago of Roman potters in the nearby Celtiberian city of Segóbriga, where they updated the earlier Celtic and Visigoth technologies, giving rise to an industry that at one time boasted as many as 1,500 people working in upward of a hundred pottery studios.[6] The first written mention of potters in this region comes from the 1478 *Libros de Visita* of the Military Order of Santiago (defenders of the Christian faith and fighters against Islam), although a more complete record is found in the 1578 royal census ordered by Philip II, *Las Relaciónes Histórico-Geográficas,* which notes that some two hundred residents of Mota "earned their bread" by working with clay (Cano Adillo et al. 1990: 21). They grouped themselves in the "Barrio de

production-line wares is particularly distressing given the remarkable historical distinctiveness of Spanish ceramics: in the prewar periods, scholars documented more than two hundred different styles of water jugs alone (Torres 1982: 21). Indeed, the role of the potter within the culture has fundamentally changed as the initial functional purpose underlying and justifying the craft has been for all intents and purposes eliminated. The potter now provides decorative works for anonymous nonpeer audiences, more often than not of a higher socioeconomic level and not even sharing a common language.

This monumental shift has not been uniform, of course. In some areas, as older potters stopped working, younger relatives or new revivalists took up the craft. Some designed completely new forms, glazes, and decorative objects that display little or no relationship to any traditional genre, instead referencing a mainstream international decorative crafts aesthetic. Others, however, have persevered, following in the path of their predecessors.

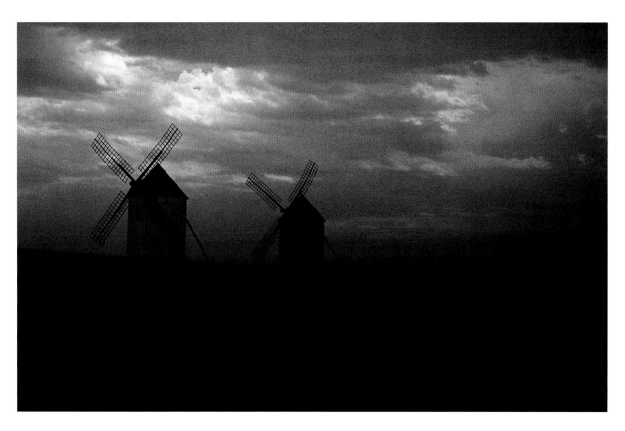

Windmills at dusk, Mota del
Cuervo, 1999.

Alfarería," at the southeastern edge of the vil-
lage, on the slope of the hill where the famous
windmills still turn.

In the twelfth century, Mota was on the
"frontier" between Christian and Moorish
Spain (Cano Adillo et al. 1990: 18), so it is no
surprise that it retains many Arab elements.
What is still called the potters' neighborhood
had, in centuries past, been the Muslim quar-
ter; the word *alfarería* (pottery), is of direct
Arabic derivation.[7] Although scholars have not
determined beyond doubt whether the major-
ity of Mota's early potters were "Moors," in
recent years there has been significant in-depth
scholarship exploring the Muslim links of
Castilla–La Mancha's pottery communities.
Mota's Barrio de Alfarería is thought to date
from the time of the Mudéjars (from the Arabic
mudayan, meaning "those who were permit-
ted to stay" during the period of the Recon-
quest), as the urban structure of the *barrio,* the
morphology of the vessels, and the processes

employed to create them are "typically Arab"
(Rodríguez Molina 2002: 26). Clear aesthetic
similarities—both formal and decorative—can
be noted between early pottery fabricated by
Arabs in the collections of Castilian archaeo-
logical museums and works from the nearby
village of Villarrobledo (only forty-five kilome-
ters [twenty-eight miles] from Mota), renowned
for the production of monumental *tinajas* used
for wine storage. A historical study of this town
(García Gómez 1993), which was administered
by the provincial Moorish seat in Alcaraz dur-
ing the time of the conquest, recounts that sev-
eral hundred Muslims relocated there following
the massive deportations of Arabs from
Granada beginning in 1570. A consistent factor
in these relocations was that the newcomers
tended to group themselves somewhat on the
outskirts of their newly adopted towns; if they
were potters, they would have been closer to
the fields from which the clay was extracted,
and this location would have reduced the

annoyance to the townspeople resulting from the smoke and flame emanating from the kilns built adjacent to the potters' homes and studios. It has also been recorded that in the last fifteen years of the sixteenth century, there were fifteen heresy trials of Mota's "Moors," and with the expulsion of the Muslims during the time of Philip III, fifty-five people were expelled from Mota alone (Cano Adillo et al. 1990: 21).[8] In Villarrobledo, only four potters were tried within the Tribunal of Cuenca during the Inquisition, but all four were Muslims.[9] A final bit of evidence for this thesis is found in a 1751 history that reports without annotated comment that the period of Villarrobledo's greatest prosperity dates almost exactly from the arrival of the Muslims from Granada, which helped increase Villarrobledo's population to 4,000, to their final expulsion in 1610, when the population dropped precipitously to 2,230 (Cavallería y Portillo 1751, qtd. in García Gómez 1993: 32).[10]

Historical data confirm that hundreds of people were involved in Mota's pottery trade in earlier years, and by the eighteenth century it was the town's most extensively practiced trade. However, the street signs pointing to the Barrio de Alfarería in Mota del Cuervo are somewhat of an anachronism now, although the street names—including El Torno (the wheel), Los Hornos (the kilns), Las Tinajas (the large storage jars), and Los Cantareros (the potters, a word primarily of local usage derived from the Spanish word for the staple of the local pottery tradition, the *cántaro*, or water jug)[11]—still recall the products and processes of this occupation. Although during the 1930s and '40s potters produced a sufficient quantity of vessels so that each of the seven local kilns could be fired weekly, by 1967 only about thirty working potters remained (Seseña 1997: 221), and production had drastically declined. The number of potters dwindled to five by 1982 (Sempere 1982a: 215) and to only one family in 1993 (Seseña 1997: 221). At least by the early 1980s, the remaining potters had a somber view of the future of their craft: all were by then in their fifties or older and knew of no one in the younger generation who showed any inclination to succeed them in their line of work.

Spain has been notable for its "macho" tradition, with the man representing the family's public *cara* (face) to the outside world through his labor and consequent economic ties.

Typical street, Mota del Cuervo, 1999.

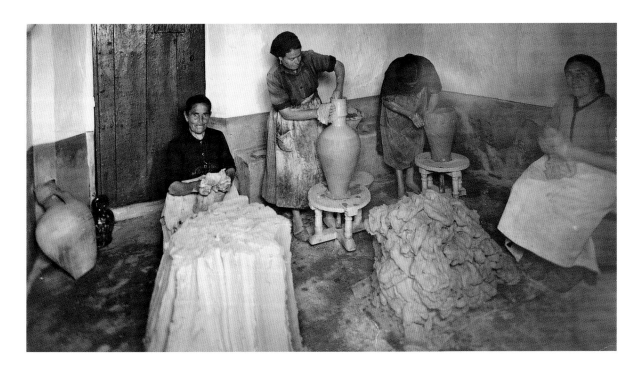

Potters at work in kitchen, Mota del Cuervo, 1963. Photographer unknown; private collection

Although Spanish ethnographers such as Caro Baroja (1957: 29) and ceramic historians such as Cooper (2000: 8) have suggested that during the Neolithic period women were responsible for pottery production, during historical times Spanish pottery families were, as a rule, generally headed by men. Although women would often participate in a variety of functions, including the laborious work of processing the clay after it was brought to the workshop as well as decorating the pottery, helping to load and unload the kiln, and selling the finished products, they rarely were the primary creators of the ware. In most parts of Spain, the potter's occupation passed generationally to the male heirs, so lack of sons often effectively extinguished the occupational lineage from any given pottery family (Lizcano Tejado 2000: 54), although on rare occasions the inheritance did pass to a daughter if there were no sons and if she married a potter (Schütz 1993: 26).

Quite uncharacteristically, therefore, the unglazed pottery vessels that were made in Mota del Cuervo and used in every household throughout Castilla–La Mancha were produced and fabricated by women.[12] It was a craft for which they were well suited, tied as they were to the household by familial and child care responsibilities. The potteries were all physically located in their homes; the typical workshop was in the kitchen, where the women could produce their ware, watch the children, and cook, a classic example of the second type of ceramic production system discussed above. Once a piece of pottery was started, it required consistent although not exclusive attention, so this work could be done at home and was compatible with household chores that restricted absences yet could be interrupted and again easily resumed without loss or damage. Further, given that women of child-rearing age tended not to participate as full-time agricultural workers as a result of domestic obligations, their craft could contribute to the family income without running the risks inherent in a sole reliance on activities other than those associated with subsistence agriculture.

Most of the women in preceding generations on both sides of Evelio López Cruz's family were potters; Evelio's mother, Dolores Cruz

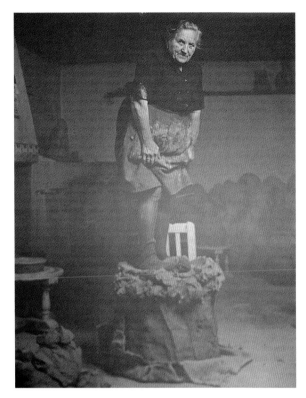

Dolores Cruz Contreras, mother of Evelio López Cruz, *pisando* the reconstituted clay, ca. 1990. Photographer unknown

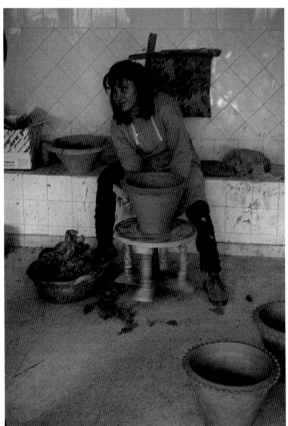

Dolores "Loli" Sandoval del Olmo, wife of Evelio López Cruz, 1999.

Contreras (b. 1923), who occasionally still produces today, worked alongside her mother and two sisters, having started to help by mixing clay with her feet at the age of seven (Guerrero Martín 1988: 135). But none of the next generation of girls in the village showed any real interest. Dolores's daughter (Evelio's sister) worked for a short while but then gave pottery up as too hard and dirty. This generation of women was also discouraged from following their mothers' trade because they came of age just as running water was beginning to be installed in all the homes, thus reducing the need for the women to go to the municipal wells for water. The price of the water jugs, along with other locally produced pottery, plummeted.

The women potters of Mota had always enlisted their children in helping with the preparation of the clay; in particular, they played an important role by helping to *pisar* the clay—that is, to tread on the piled mound of wet clay to mix it. In the past, families without young children were even known to "rent" them from neighbors for this job—dirty and hard for the adults but rather fun as far as the children were concerned. Carving out a place for the young to help in the family craft, however, contributed to lower school attendance and illiteracy, particularly among girls (Cano Adillo et al. 1990: 39). It was therefore not unusual that during his childhood, Evelio López Cruz, born in 1958, both helped his father farm and helped his mother by mixing and wedging clay. However, because in Mota the actual production of pottery was always a task left to the women, it would not have been socially appropriate in the eyes of the community for him to get involved in the physical creation of the work despite the fact that men had historically been involved in digging the clay, gathering the combustibles, firing the kiln, and marketing and selling the finished products. Therefore, at age thirteen, following four years of *colegio*, López Cruz began working as an *albañil* (construction laborer). He

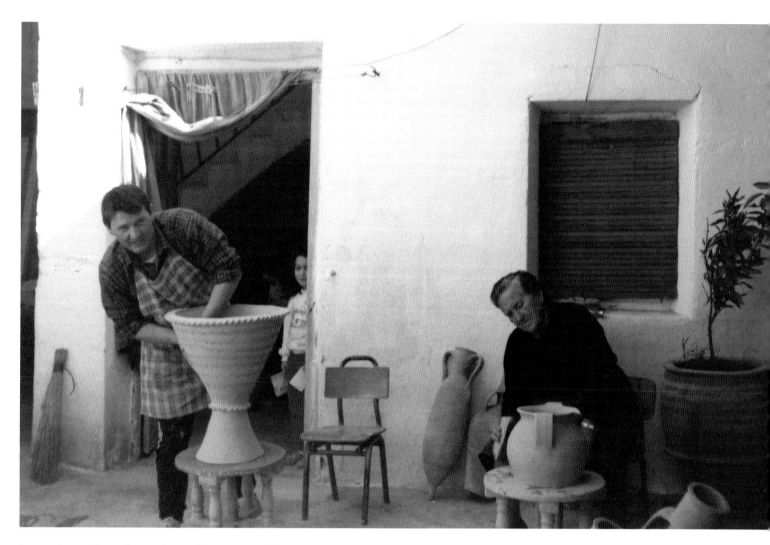

López Cruz and his mother,
Dolores Cruz, coiling vessels
in the courtyard of their
home, 1990.
Photograph: Loli Sandoval
del Olmo

learned on the job working for various firms, building everything from houses to roads, and for a time he traveled by car or truck as far as Madrid and even Barcelona to work on large projects with up to five hundred other men. After working for many years for others, he decided to become his own boss in this same line of work, which he did for several years. He also worked his father's small field for some nine years during this time.

In 1985 the Consejería de Cultura de la Junta de Comunidades de Castilla/La Mancha (the regional cultural council) and the Ayuntamiento (municipal offices) of Mota del Cuervo, concerned about the dwindling numbers of working potters, offered an apprenticeship course for twenty-five young people in hopes of arresting the decline of the local pottery tradition.[13] At the age of twenty-six, with a wife and young daughter, López Cruz decided to take this six-month Seminario de Expresión Plástica. The sponsors of the seminar paid the four or five male and the twenty female students to attend, but among all of those taking the course, López Cruz was the only one who decided to return to the pottery tradition of his maternal ancestors, bucking social and cultural tradition in the interests of individual expression and economic growth.[14] Even today, after two decades in the craft, he feels compelled to comment about the prevailing local understanding: if a man actually produced pots—as

opposed to being involved in other, more "manly" aspects of the trade—his sexuality was considered questionable. Yet the combined attractions of being able to work for himself, spend more time with his young family, and revive and carry on an important family and local tradition were sufficient to overcome López Cruz's cultural misgivings. As a young married man with a new family, he had the incentive to make this dramatic change; with the luxury of refining his skills within a private and encouraging family setting, he neither publicly snubbed cultural and occupational mores nor aggressively provoked criticism. Further, working locally in an occupation that he intimately understood with people that he intimately knew did not unduly threaten his economic wherewithal: if his gamble failed, he could always revert to farming or construction labor. Nevertheless, sensitive to the cultural significance of his gender-bending "experiment," for the first five years or so, as he worked with his mother in their home studio, the family publicly said that the pots were her work rather than his. She was pleased that he had decided to follow in the steps of her trade, and he enjoyed working with and learning from her; she was truly a master, he realized. Although at first people gossiped about him for following this "feminine" trade, after they saw him working for several years, they became accustomed to—although perhaps not entirely comfortable with—this revolutionary break from local social customs.

Ironically, because one of the distinctions of the pottery from Mota del Cuervo was that it was made solely by women, local documentarians seem loathe to admit that the primary remaining producer of this traditional ware is male. Even the town's official Web site, linking to a "dossier" on the local pottery, uses the feminine noun form *cantareras* when describing the potters, explains the fact that this craft is the "exclusive task of women," and ascertains that

the "tasks of the men were to extract the clay, transport it to the house, gather and return with the combustible materials, and take care of everything pertaining to the firing and sales."[15] The implication is that women are still the potters of the town; never once is López Cruz's mutation of that heritage mentioned.

DIGGING AND MIXING THE CLAY

During the time of Dolores Cruz Contreras's major production several different tradespeople besides the potter and her family were involved in the various aspects of clay processing and ware production. In the case of the potters from Mota del Cuervo, the good sites for raw materials had been well known for at least several hundred years, but in other areas, drilling was sometimes necessary to locate appropriate areas in which to dig. Extracting the clay was done by *terreros* or *barreros*, who dug the clay from a local quarry (also known as the *barrero*), approximately two kilometers (1.2 miles) from town, and then delivered it in horse-driven carts to the exterior of the home workshop of each potter for mixing and processing.[16] Payment to the *barreros* was based on delivery rather than extraction; in 1967 a load of thirty baskets of wet clay cost 150 pesetas (about $2.50 at the time) (Seseña 1997: 221).[17] It was not unusual, however, for a *barrero* to be the husband of a potter, who then, of course, would have access to all the primary materials she needed without cost. *Barreros* also typically were part of the same family that owned the kilns.

Today, the *barreros* are gone, so López Cruz must collect his own raw materials. When he first began working, he, like his mother, purchased the clay, since the family had been too poor to own a field with clay deposits. After he married, he bought one hectare of land about two kilometers from his studio that he knew was richly underlain with natural clay strata,

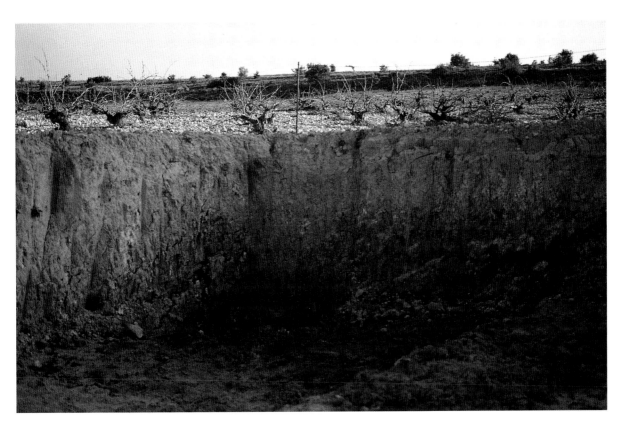

López Cruz's clay deposit on the outskirts of Mota del Cuervo, 1999.

and he now digs his own primary materials from that field.[18] This acreage is located half a kilometer from the hermitage of the Virgin of the Valley, revered as the patron saint of local potters since the fifteenth century, when she appeared to a potter in a small cave as he was digging his clay.[19] The outskirts beyond the town's populated areas had long been locally used for extracting clay; in earlier days the *barrero* would dig a deep hole and then would branch out into a horizontal vein when the appropriate strata was reached, creating "galleries" that could run up to 160 feet long (Llorens Artigas and Corredor-Matheos 1970: 13). A pulley system attached to a tripod of wooden beams was used to lift baskets of clay to the surface. This time- and labor-intensive means of extracting the clay helped preserve a more spacious area above ground for planting, but the restricted space available for working underground with hoe and pick, in addition to the long hours needed to dig out the clay, made this a difficult and backbreaking, although not particularly dangerous, pursuit.[20]

The holes made by the *barreros* began to fill in as the number of potters declined and the interest in gathering the material waned. When López Cruz bought his land, it was planted with grapes. This increased the value of the land, making it more expensive than nearby nonproducing sites, but he does harvest the grapes each year, selling them through the local cooperative to earn a small but welcome supplementary source of income. Nevertheless, the clay is more valuable to him than the grapes, so two or three times each summer he digs in open air below the surface impurities to the level of the moist strata (now between two to three meters [roughly six to ten feet] below the surface) until he has extracted a sufficient amount of the raw material for the next year's production. Although the subsurface of the entire field is clay, the top layers are contaminated with decaying vegetal matter, so he scrapes them off

with his tractor to access the lower layers: the deeper he digs, the better and more pure the clay is. However, because below three meters he would hit water and have to move to another spot, he follows the vein horizontally, as *barreros* did in days past. As the quarry itself is always somewhat wet, extraction during other seasons would be impossible, as he would get bogged down in the mud. With hoe and shovel, he loads a trailer hitched to the back of his van with the pure wet clay. Three or four trips are usually required to gather what he needs.

In mineral terms, clay is a product of the decomposition of feldspathic rock. White or grayish-white when pure, it absorbs color from the particular impurities of its specific location and can range in hue from light yellow to deep red. Clay is composed of silica (at least 50 percent, acting as the melting agent that produces the hardened glasslike product), aluminum (at least 15 percent, serving as a nonplastic, refractory material, providing strength and improving workability, decreasing shrinkage rates and facilitating drying), water (between 3 and 5 percent, providing elasticity), and other minerals, of which iron oxide tends to be the most important. López Cruz's clay also contains limestone and bicarbonate; these nonessential components add to or detract from the clay's plasticity and strength and may act as colorants depending on their proportion and distribution. An unpublished doctoral dissertation (cited in García Gómez 1993: 13) that examined different Spanish localities and the qualities of their clay deposits determined that among the best on the Iberian Peninsula were found in Mota del Cuervo and Villarrobledo, an essential ingredient in the long-term success of these pottery centers. According to the Geologic and Mineral Institute of Spain (IGME), these clay deposits owe their quality to outcroppings of Jurassic era deposits with a depth of some forty meters (130 feet) (García Gómez 1993: 59). Within these deposits, the various clay strata formed.

Dried, crushed clay temporarily stored in the studio prior to rehydration in plastic *pilones*, 2004.

The fundamental composition of clay's flat, platelike particles imparts two inherent properties that have contributed to the continuity of the technical processes associated with its use over time and space: its plasticity and its capacity for hydration. The latter enables added water to electrically bind to the molecules of silica and aluminum without causing the clay body's molecular composition to deteriorate; the former enables shapes to be created that remain permanent following drying and firing. Clay of medium plasticity can absorb and conserve up to 70 percent of its weight in water; the higher this proportion of clay to water, the greater plasticity and capability for manipulation but also the more extensive time needed for drying and firing, the greater the shrinkage rate, and thus the greater the risk of cracking and breaking during these processes.

López Cruz brings the wet clay back from his quarry and mounds it up in his studio, letting it dry out completely. Although his clay is sufficiently pure that he does not need to supplement it with additional materials, refractory or otherwise, it still needs to be thoroughly dried out so it can be broken into small chunks with

a metal hammer (*mazo*) to crush (*machacar*) and mix (*amasar*) it to achieve a uniform and homogeneous mass. He stores it in its dry state, hydrating only the amount that he needs as he needs it, typically between four and five hundred kilos (roughly 900 to 1,100 pounds) per week, an amount sufficient for the creation of approximately forty standard water jugs or their equivalent. To reconstitute the pulverized dried clay, it is usually placed in half of a *tinaja*, a large storage jar known as the *pilón* (or *pila*) when it is used in this manner, although because his workshop is in transition (see below), he is currently using large plastic receptacles.[21] This process is known as *empilar:* he slowly adds water, letting it sit for ten to twelve hours before working it for five or six days, compacting it into a *pasta* as he mixes it until it has the right level of plasticity for modeling. Scientific studies have found that the strength of prefired greenware is significantly improved if the clay is so completely saturated that water fully penetrates and becomes adsorbed on all molecular surfaces; such strength is necessary to prevent slumping during and after modeling and to enable the piece to withstand the rigors of transporting, stacking, and firing. After the dried clay has completely absorbed all of the water, he pulls the clay out with his hands, piling it on top of a thin layer of ashes laid out on his workshop floor to prevent the clay from sticking. Due to its purity, straining and rehydrating of the clay are not necessary. He lets the water evaporate until the clay mass is the right consistency for working.

The mixing of the clay typically occurs in his studio unless there is temporarily no room there (as can be the case when a large amount of greenware is drying, for example); at those times, he mixes the clay outside in the courtyard, weather permitting. The ashes are laid down on the floor so the wet clay will not stick, and then López Cruz heaps the clay with his hands (*se amontona*) into a mound approximately one meter (three feet) high (a *torta*) prior to mixing it with his feet (*pisar*) in the manner learned from his mother and grandmother. Barefoot, he stomps on the mound, compressing it. As the mass compacts vertically, it is horizontally displaced into a larger circular slab, so periodically he jumps down to the floor, and pushes back inward with his knee, mounding the clay at the edges back toward the center to restore the vertical compactness of the mass. At regular intervals he will peel off sections and throw them back on top of the mound, after which he will climb back up and tread on it again, working his way around the mound in a circular pattern. Ideally, after the *pasta* has been *pisado*, it is left to rest overnight and is then *repisado* two or three times more. Once mixed, the clay is stored in a block, a *pisa*, in the corner of the studio, covered with plastic, which maintains the necessary moisture level until he is ready to use the clay. In the days before plastic, wet sacks or cloths were used to retain moisture in the stored clay.

The selection of the clay and its careful mixing are crucial to the quality of the pottery, and impurities are removed at every stage of the process, from the time he quarries the clay through the fabrication process. After he has finished *pisando* the mound of clay, he peels off slabs from it, forming round masses known as *pellas*. Each load of clay reconstituted in the *pilón* yields approximately forty to sixty *pellas*, which in turn are divided and rolled out into about 120 *rollos*. With both hands, López Cruz works through the *pellas*, compressing and pinching them, digging out little rocks, fossils, organic matter, and sticks. The term for removing the impurities from the clay is *esgorullar* (*jorullar* or *engorullar* are also used): using the index fingers and thumbs of both hands, chunks of the *pellas* are broken off, squeezed, and flattened. This is an indispensable process because any foreign matter can cause lumps as he builds the vessel or, in the worst case, can

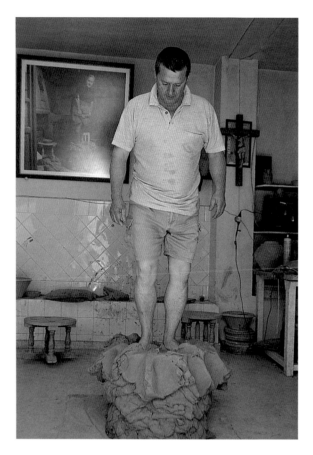

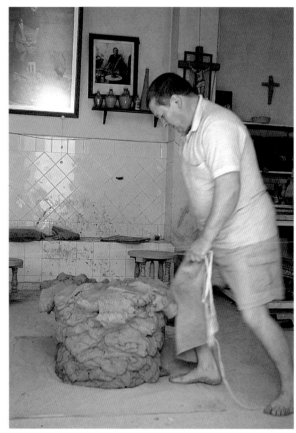

Top Left: López Cruz *pisando* the clay, 2004.

Top Right: Compressing the clay mass during the process of *pisar*, 2004.

Bottom Left: Tossing compressed clay masses back onto the pile to *repisar*, 2004.

Bottom Right: Completed *pisa* after several rounds of *pisando*, 2004.

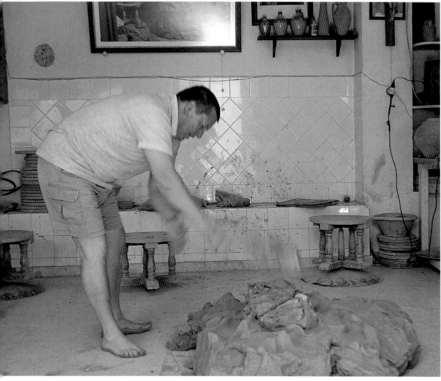

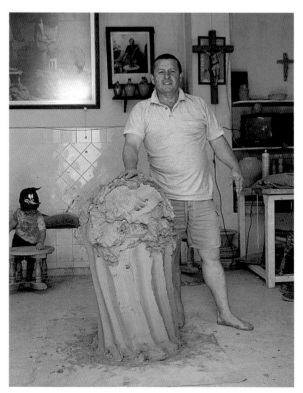

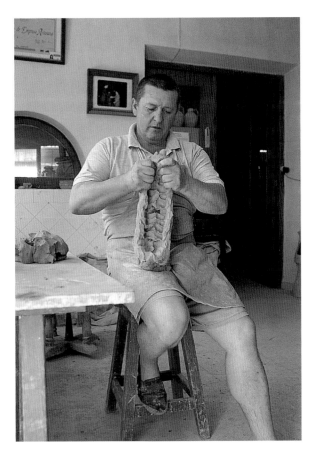

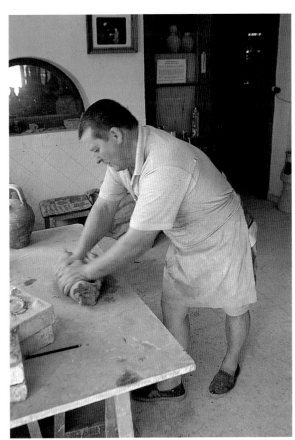

cause ware to explode during the firing due to uneven rates of expansion and contraction of the nonhomogeneous materials. Although the clay has been mixed by *pisado,* compacting it with his feet, he must also now wedge it by hand (*sobar*) on one of the low tables in his studio; this provides yet another opportunity to remove any remaining impurities, mix the clay into a homogeneous paste, and press out any air pockets. Just enough clay is wedged by hand to provide for his work that day.

López Cruz's workshop measures ten by five meters (32.5 by 16.25 feet), a two-story building that he and his wife, Dolores Sandoval del Olmo (Loli) built around 1995. Until that time, they worked where López Cruz's mother had worked, in the kitchen of the family home on the Plaza de la Cruz Verde. Dolores Cruz never had a separate room or studio for making pottery within her house, although now when she wants to work, she uses the wheels in López Cruz's new studio. Adjoining is a six meter (19.5 foot) square sales/storage room for the finished bisque-fired ware. The workshop has a fairly low ceiling and only small windows to minimize air currents or excessive dry cold during the winter months, both of which would precipitate cracking and breakage of the unfired ware. The workshop contains two tables and a low ledge about 45 centimeters (17 inches) high and forty centimeters (16 inches) wide installed around one length of the room; when López Cruz's wife and children make pottery, they pull their wheels up to this ledge and use it as a seat. There are a total of five low wooden turning wheels, called *rodillos.* One was his mother's and is between forty and fifty years old; another, still in the studio but no longer in use, is more than a hundred years old; the others are approximately twenty years old. Even

older wheels, in various conditions, are kept now and stored as "artistic patrimony" by López Cruz; with the exception of less elaborately turned vertical supports, they are all very much the same. The wheels were built by the local carpenter and are sufficiently sturdy that they can be passed on to the next generation; if another wheel is needed or the top disk of the wheel (known as the *suela*) needs replacing, López Cruz simply commissions a new one.[22]

The Mota wheel consists of four main parts: the foot (*pie*) or lower crossed arms (*aspas*); the axle (*husillo* or *eje*), which is inserted into a center hole, permitting it to rotate; the upper crossed arms (also known as *aspas*) supported by four vertical rods; and the *suela*, the head on which the clay is placed and the ware built.

López Cruz has two styles of wheels in his studio: two are fixed, with the axle inserted directly into the floor, and each measure thirty-four centimeters (13.385 inches) high with a *suela* diameter forty-two centimeters (16.5 inches); three others, with a lower metal base made from a tractor's plowing disk (*disco de arado*), measure forty centimeters (15.75 inches) high, also with a forty-two centimeter *suela*.[23] This newer style with the heavy *disco de arado* at the bottom became popular in the early 1970s (Albertos Solera 1978: 125); it provides additional weight and strength for the wheel and enables it to be picked up and moved: at first wheels were typically moved into and out of the kitchen, where most of the women potters used to work, but now López Cruz also transports them to fairs and expositions where he gives demonstrations. When working in his studio, however, he prefers the older-style wheel fixed into the floor, because he feels it is more secure.

Within a historical and technical schema plotting the evolution of potters' wheels, the Mota variant can be considered a transitional development between disks or wheelheads turned only by hand and those in which kick-ing with the feet sets up enough speed for the pot to be considered "thrown." It is an archaic form akin to the so-called "slow wheels" of the fourth millennium BCE in Mesopotamia, in which a stone or wooden wheelhead was inserted into the ground, pivoting on this fixed axle. Mota's wheel is based more specifically on a fifth- or sixth-century BCE Greek design that still functions more as a turning table than as a potters' wheel per se, as it generally is unable to provide a momentum sufficient for the potter to take advantage of centrifugal force. With the height of the wheel head so low, the potter must work bent over, seated for the beginning of the process or for smaller work, standing in front of larger vessels, although not on the knees as in Zamora, where a similar wheel had been traditionally used.

FORMING THE VESSELS

The three main components of the vessel fabrication process are: (1) shaping the base; (2) enclosing air, which may take several intermediate stages; and (3) garnishes and finishes, such as handles, spouts, and the lip or mouth. López Cruz begins the process of making a jug by sprinkling ashes on the wheelhead so that the clay will not stick; then, with his closed fist, he pounds a circular mass of clay onto the center of the wheelhead to form the vessel's base (*culo*, sometimes also known as the *torteja*), at the same time slowly turning the wheelhead clockwise with his left hand. (For larger pieces, he will first attach a circular wooden bat [*tabla*] to the wheelhead so that the entire piece can be easily moved off and then back onto the wheel between drying and working stages.) Already prepared from the *pellas* are some dozen or so *rollos*, thick cylindrical loaves of clay that he has previously wedged on top of a worktable; he lines them up against the wall to the left of his wheel in preparation for the fabrication of the

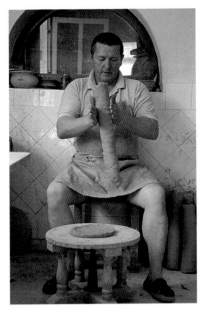
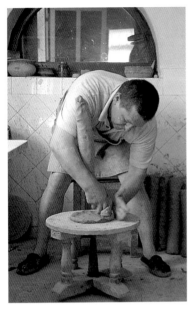
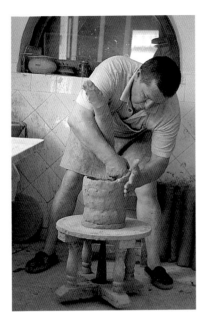

Left: Thinning *rollos* prior to beginning to coil a vessel, 2004. The *culo* (base) has already been pounded out on the wheelhead.

Middle: Adding the first *rollo* to the vessel base, López Cruz begins to coil a classic *cántaro*, 2004.

Right: Coiling a *cántaro*, 2004.

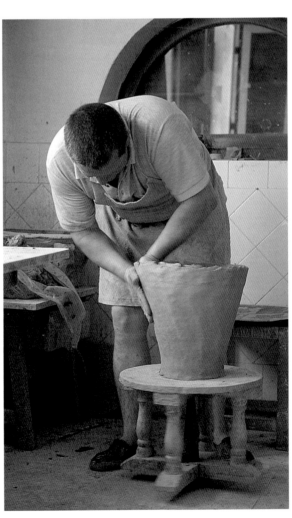
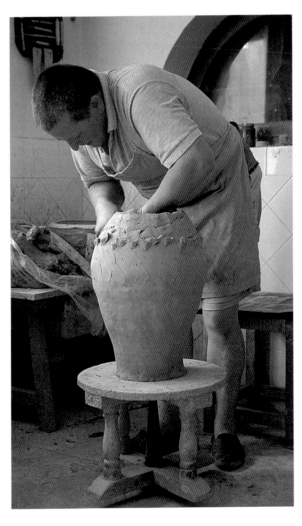

Left: Coiling a *cántaro*; flattening and widening the body, 2004.

Right: Coiling a *cántaro*; constricting the neck, 2004.

vessels. He grabs one and rolls it between his hands along its entire length to thin it to the appropriate thickness for the piece he intends to make; typical starting dimensions of the *rollos* range from forty-five to sixty centimeters (eighteen to twenty-four inches) long, with a diameter of ten to fifteen centimeters (three to six inches). He flips the end of the now skinnier *rollo* along his right arm, ending on his right shoulder, while he eases it with his right hand around the outside diameter of the base, supporting it on the outside with the flattened palm of his left hand, pressing in the coil with his right hand as he builds up the vessel wall, and simultaneously smoothing the exterior surface with his left hand. During this stage of the process, the wheel slowly turns clockwise as a result of the pushing and melding of the coil onto the clay walls, not from any kicking of the *pie* or turning of the *suela* with the hand. The rotation of the disk allows López Cruz access to all sides of the pot without requiring him to walk around in circles (a major innovation in the history of ceramics that dramatically reduced the amount of effort the potter needed to expend), yet the disk does not turn fast enough to enable him to take advantage of centrifugal force. He works on smaller pieces and the bottom sections of larger vessels while sitting down; larger pieces require that he stand to coil the upper levels of the shape. *Subir la pieza*, raising the piece, continues in this manner, with new coils added as the old ones are finished up; after he finishes several coils, he will stop and turn the pot (not the wheel) counterclockwise, scraping and evening out the exterior surface with the side of his bent forefinger, smoothing diagonally up from bottom to top. Depending on the ultimate size of the piece, this first stage of fabrication may rise from twenty to thirty centimeters (six to fifteen inches) or even higher. Only the smallest pieces would need a single *rollo* for completion; three *rollos* are typically used in the fabrication of a

classic water jug or *cántaro*. The process of coiling is termed *urdir*.

Rising from a small base, the *cántaro* widens and broadens into an ovoid shape until it becomes almost spherical at the base of the neck. The neck itself is narrow and short, moving quickly into a high, cylindrical mouth that terminates in a slightly flared but thin rim that projects slightly wider than the neck. A single wide, flat handle is attached at the base of the collar to the upward slope of the shoulder. It curves at almost a right angle and, like most of the jugs produced, has no decoration. The form is simple yet elegant, immediately recognizable as coming from Mota yet recalling the classicism of the Greek amphorae of the fifth and sixth centuries BCE. The distinctive collar was functional, formed so that the women could wrap a rope around it, let it down into a well, and pull it up filled with water without having it slip. A light orange in color after passing through the single bisque firing, the clay body reflects heat, an important quality that was a crucial component of its suitability and popularity for use as a water jug, particularly during the hot summers of La Mancha.

Only the smallest vessels without handles or spouts can be finished in one stage; all works above fifteen to twenty centimeters (six to eight inches) are built in several stages so that the clay walls can dry sufficiently to support the weight of the upper portions of the vessel. López Cruz coils five to eight bottom sections, usually all of the same type of piece; after each has reached the optimum height for its first stage, he slices them off of the *suela* with a taut string and places them out of the way on the floor of his studio to let the clay harden or "set up" to a leather-hard state before returning each piece to the wheel to continue with and finish off the desired shape. Depending on the weather, this intermediate drying stage can take hours or even days. Before returning the unfinished vessel to the wheelhead, he dips the

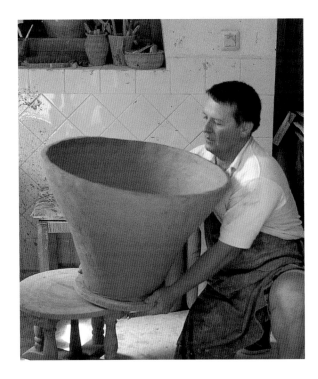

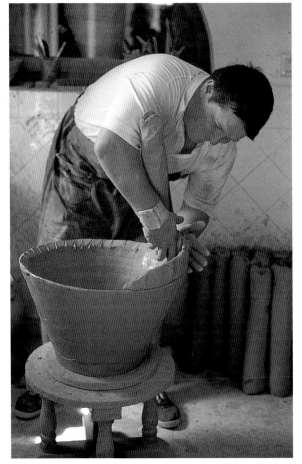

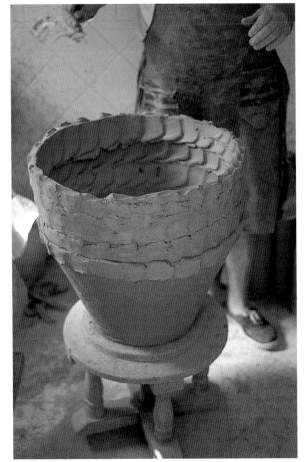

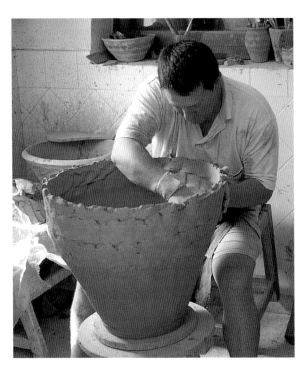

Top Left: Removing a second-stage coiled vessel from the wheelhead on the *tabla* to allow for air-drying and "set up" prior to next stage of fabrication, 1999.

Top Right: López Cruz begins the second stage of a large vessel after allowing the first part to "set up," 1999. The scored lip facilitates bonding.

Bottom Left: Pattern resulting from the coiling technique, 1999.

Bottom Right: Smoothing out the coiling pattern, 1999.

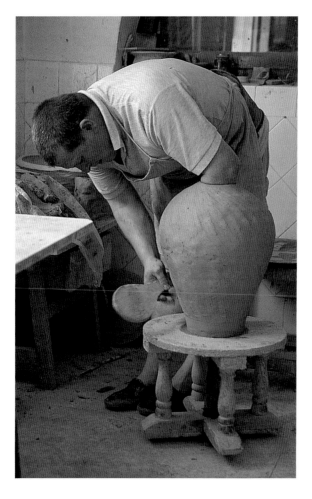

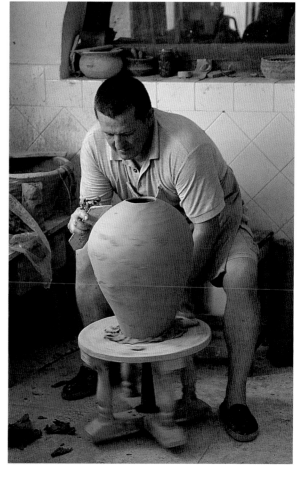

bottom in clay slurry water so that it will better adhere to the *suela.* Turning the wheel counterclockwise with his hands, he scrapes (*raer*) the walls of the exterior surface with his right hand holding a wooden rib, the *raedera,* as he supports the interior with his left hand, smoothing the surface.[24] At this time he will also use the *raedera* to remove the extra clay from the sides of the base, scraping upward on a diagonal, so that the form begins to resemble the finished shape. He will occasionally stop the wheel to remove remaining impurities (*esgorullando*) from the vessel with his fingers or with one of his tools. Next, López Cruz evens off the top by cutting with a thin, sharp pointed knife, slicing in and down from the top of the outside wall as the wheel turns slowly in a counterclockwise direction. He then incises

small slashes on this slope with an angled wooden tool to provide a rougher surface to which to adhere the proximate component. He pinches off a smaller section from one of the preprepared *rollos,* wets the top, and continues building up the vessel wall, again coiling clockwise. As necessary, he stops and turns the wheel counterclockwise, smoothing the surface walls with the index finger and thumb of his right hand. He adds additional coils as needed and for larger pieces may also add an extra coil on the inside at the joint between the two sections to secure a tighter weld.[25] He uses his hands as well as a flat wooden paddle (*paleta*) to smooth and shape the body to its desired profile, flattening the form (*ensanchar*) to fill out the body (*engordar*). In so doing, he also adjusts and equalizes the thickness of the vessel walls

and closes the pores on the clay body, thus further smoothing the surface. Most of the tools that he uses are purchased from the local carpenter, although he makes some himself, and he does have a selection of standard clay-carving tools with looped metal ends, although he uses these less regularly. Some of his tools are such a good "fit" for him that he will care for them, resharpening and shaping as necessary; others are discarded when they are no longer adequate, and new ones are fabricated. Simple instruments that supplement rather than replace the work of his hands, the majority of these tools were born out of the agricultural implements used by López Cruz and his neighbors in the fields. Sometimes these implements are substantively modified, but at other times they reveal little or no modification but the change of function.

The collar and mouth of the vessel may be added at this point if the work is small, or the work may be stopped and allowed to set up before he builds up additional height during the next stage. For the classic *cántaro,* this is the first time that the wheel is kicked; the right foot pushes the *pie,* and López Cruz grabs a

small piece of wet cloth (*trapo*) to smooth the surface (*dar lustre*), forming the collar and mouth (*embocar,* also called *bocar* or *abocar,* "to form the mouth") as the vessel turns quickly under his hands. The finishing of the top portion of the vessel is the only time in the process of fabricating these pieces that the wheel moves quickly enough to even approach a modicum of centrifugal force.

Any additional components are added following a second (or third or even fourth, depending on the size of the piece) drying stage. For a handle, a portion of a *rollo* is broken off and flattened and pulled or drawn down in his hands; he scores the site of the weld and moistens it, first attaching the top to the collar section, then draping the handle down and pressing it onto the shoulder of the body. Adding handles (*asas*) is known as *enasar,* and it must be done carefully, for any such juncture between two pieces of clay is potentially a weak spot; the amount of water and plasticity in both pieces must be equivalent, so that a shrinkage differential does not separate the two pieces as they dry. Conversely, the body of the vessel has to have dried sufficiently to support the pressure of han-

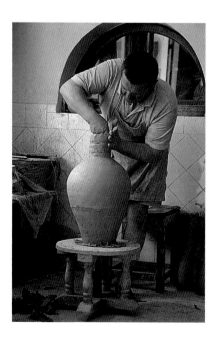
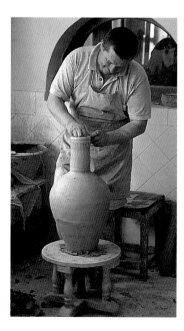
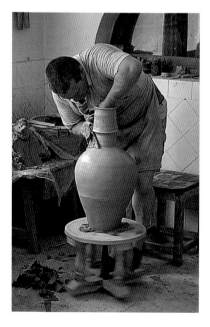

Left: Adding small coils on top of the vessel body to form the *cántaro's* neck and collar, 2004.

Middle and Right: Using the *trapo* to smooth the surface and refine the collar, neck, and mouth of the *cántaro,* 2004.

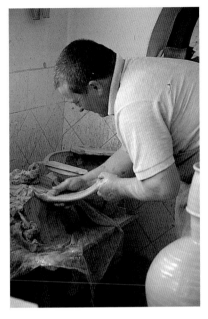
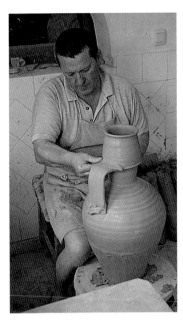
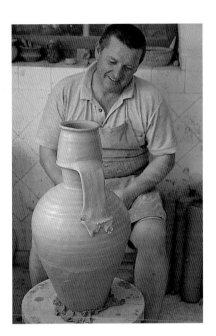
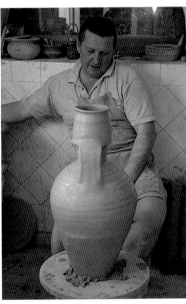
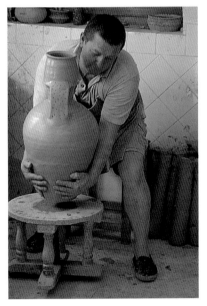

Top Left: Pulling a handle for the *cántaro*, 2004.

Top Middle and Right: Attaching the handle to the vessel body, 2004.

Bottom Left: Smoothing and polishing the body, 2004.

Bottom Right: Removing the finished *cántaro* from the wheel, 2004.

dle application without undue deformation. After the handles are attached, the entire vessel body is smoothed with the *trapo*; the smooth finish he achieves is facilitated by the uniformity and plasticity of the clay body itself, providing a poreless and soft surface. He can typically produce between twenty-five and thirty *cántaros* at a stretch, coiling them the first day and scraping them and adding the neck, mouth, and handle the next.

Pottery made in Mota del Cuervo has never been glazed, and any decoration was historically only incised, using the fingertip or a piece of a comb or similar utensil, or by fluting the rim as a border design (*bordecejo*) while the not-quite leather-hard vessel was turned slowly on the wheelhead. Befitting its functional purpose as well as the low prices for which this ware sold, these simple designs were added rapidly, evidencing little care or precise craftsman-

Evelio López Cruz's mark.

Dolores Cruz Contreras's mark.
Illustration: Sam Hernández

guishing her work from the work of other potters with whom she would sometimes share a kiln rather than any attempt to value the work in an aesthetic framework. (In a break from tradition, she has signed her most recent vessels with her full name in cursive, however, a result of the changing clientele and the different way in which the work is now perceived.) Other potters' symbols included a single dot or a thumbnail impression, subtle marks almost invisible to an outsider.

The *cántaro* (water jug) for which Mota del Cuervo was renowned varied in capacity between four and sixteen liters (roughly 1 to 4.23 gallons): vessels were not measured by height or width but by volume. Opportunely—but hardly coincidentally—the size of the standard water jug was the equivalent to one *arroba*, a now somewhat archaic but formerly common measurement equaling sixteen liters. Other standard sizes were the *cantarilla grande* (twelve liters, roughly 3.2 gallons), *cántaro de a dos* or *de jarra* (half a *cántaro*, or eight liters, roughly 2 gallons), *cantarilla de a tres* (one-third of a *cántaro*, or 5.33 liters, 1.4 gallons), and the *cantarilla de a cuatro* (a quarter of a *cántaro*, or four liters, slightly less than 1 gallon). The vessel walls were of consistent thickness throughout to standardize the capacity; in addition, areas of lesser thickness would be points of weakness and could cause cracks or breakage. Although exact dimensions are no longer quite as crucial, López Cruz still determines the capacity of his vessels by eye and feel, as did his predecessors.

Mota's simple yet elegant *cántaro* was commonly accepted as the prototypical water jug throughout La Mancha, including the provinces of Albacete, Ciudad Real, Guadalajara, and Toledo as well as the home province of Cuenca. It was so renowned that in many areas it was the custom to tell children that storks brought new babies from Paris inside a Mota del Cuervo *cántaro* carried in their beaks; parents had to

ship. Recently, however, López Cruz has been experimenting with appliquéd decorative elements (cutouts added by hand at the semimoist or leather-hard stage) and slip painting with a watery suspension of clay with a shrinkage rate equivalent to that of his own clay body, although with a deeper red, white, or black coloration. Ware is never dated, although he does sign his work with an "E" underlain with the two dots that designate his family's mark. This logo is incised into or next to the handle if there is one or else is incised below the shoulder on the body of the vessel. His mother traditionally marked her work simply with the two dots—again, below and to the right of the handle—a function of the economic obligation of distin-

break the jug open to release the baby from its confining yet protective valise (Lizcano Tejado 2000: 34). In comparison to the famous Mota *cántaro*, traditional pottery from surrounding provinces was often devalued, particularly since so many of the water jugs from these other areas came to be styled after their celebrated neighbor (Lizcano Tejado 2000: 37). Too, the local saying "de una hora a otra hay cántaros en La Mota [from one hour to the next there are water jugs in Mota]" implies the consistency and constancy of these products (Llorens Artigas and Corredor-Matheos 1970: 125).

Although the *cántaro* is considered the "queen" of the pieces produced in Mota, a variety of other types of utilitarian wares have also been produced over the years, defined by function, size, and form.[26] The relative numbers of the types of vessels produced follow consumer demand and seasonal need; traditionally, in the summer more water jugs and flowerpots were sold, while the winter saw an increase in sales of bowls and storage containers. Given the use of the same clay body for every kind of vessel

and the lack of molds or other technological assists used in production, the preparation of the clay body and the processes of drying and firing remain the same no matter what function or shape the piece may ultimately take. The Mota potter, therefore, has complete flexibility in modifying the types and quantities of ware produced at any time, with little additional cost in time or energy. Likewise, if these modifications prove aesthetically, functionally, or economically unsuccessful, the potter can easily revert back to earlier modes or choose to pursue further modifications.

The names of vessel types in Mota have incrementally changed over time as new manufactured vessels—often from foreign sources—entered the marketplace and replaced the handmade pottery. This has resulted in a gradual semantic redefinition of traditional shapes as the frequency of use of the new—and internationally more standardized—ware increased. The list of his works in appendix A, therefore, although a generally complete listing of the vessels that López Cruz has produced over the past several years, is nevertheless necessarily fluid, as he responds to market forces and changing economic factors, introducing new ware, reviving archaic pieces, and/or ceasing production of slow-moving items. With the exception of the "tourist items" discussed below, all vessels had specific domestic utilitarian functions.

Most of the items on López Cruz's list of works in appendix A were also produced by his mother and grandmother, but in addition he makes assorted little jars and vases, *paragüeros* (umbrella stands), *apliques* (hanging sconces made out of half *cántaros* in a variety of sizes whose sides have been pierced and cut to allow the passage of light), and *lámparas* (lamps used to cover hanging light bulbs, again with lateral cuts and holes and with the bottom left open to increase light passage).[27] He is newly producing a large *tinaja* with a high, deep lid (the tradi-

Three of López Cruz's two-part molds for Roman-style *lucernas* (oil-burning lamps), 2004.

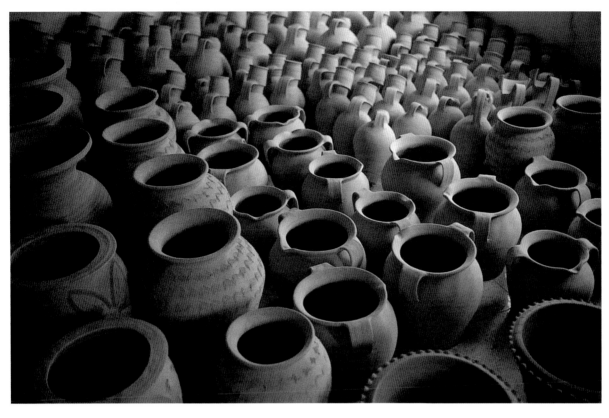

Assorted greenware drying
on studio floor, 1999.

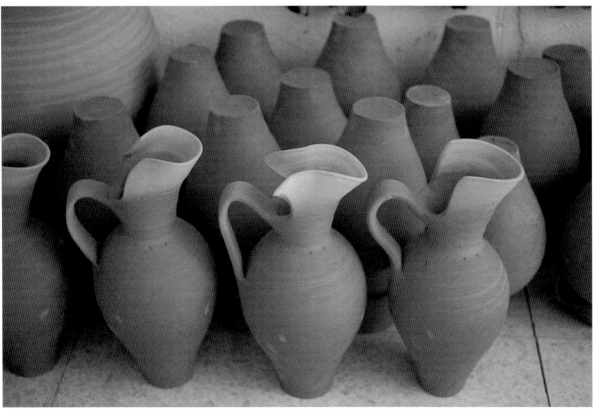

Pitchers at greenware stage
air-drying in studio, 1999.
The mouths and lips of the
different vessels display
slightly different treatments
and tend to dry more
quickly than the vessel body.

tional storage jar did not have a ceramic cover) with appliquéd decorations and two handles (eighty-two centimeters [32.28 inches] high, forty centimeters [15.75 inches] in diameter), little jugs for *aguardiente* that he paints with purchased engobes, and tiny *orcillas* perforated with holes for garlic storage. Another new item (for him) is a *zambomba,* a drum with a stick piercing the taut leather top that can be pulled out and pushed in to create a throaty, organic percussive sound, although he says people have traditionally pounded on *cántaros* to provide a rhythmic accompaniment to music or dance. For tourists, he has four main products: small scale (ten to twenty centimeter [four to six inch] high) models of the windmills (*molinos de viento*) that literally shadow his studio and define the area; hanging sundials (*relojes de sol*); reproductions of Roman era amphorae (*ánforas*); and press-molded oil-burning lamps (*lucernas*). In addition to studying the shards and pieces he dug up in his own field, López Cruz has seen examples of Spanish Roman and Iberian ware in museums and followed up with additional secondary research to create his archaic-style works. These tourist arts are perfectly suited for the romanticized souvenir desired by many travelers, not only representing the iconic image by which La Mancha is widely known (as in the case of the model windmills) but also referencing Spain's glorified days of the Roman era.

López Cruz's inspiration for creating new vessels or reviving older ones comes from a variety of market-driven sources: a buyer's commission, attempts to appeal to the tourist market, examples of works by other potters he sees as he travels to the regional and national fairs, and so on. However, although he is knowledgeable about a wide variety of ware and decorative possibilities, even maintaining his own small collection of works that he has purchased from or traded with other potters, he is disinclined to make anything that was not pro-

duced locally or that does not fit in with the traditional style of ware from his village. Viscerally understanding that part of his works' appeal is based on the traditionality of his techniques, he maintains an extremely conservative adherence to every step of the production process—including those steps that are basically imperceptible to the consumer—as well as to the ultimate form or function of the ware.

However, he is less rigorous in one area: whereas his mother and grandmother needed to maintain the thinnest vessel walls possible for each given type of ware, he is less attentive to this. When people were hoisting a full sixteen-liter *cántaro* in the fields, for example, it was important to keep the vessel weight as low as possible; placement of that same size *cántaro* on a patio filled with flowers or hanging on a wall does not warrant the same consideration. Because ultimate use of the ware now tends to be decorative rather than functional, the bases and walls can be thicker and heavier without concern. He has not, however, evidenced a degradation of the traditional vessel form, as has been the case in certain other pottery centers within Cuenca province that have moved toward shapes that are less technically difficult and labor-intensive to fabricate.[28]

DRYING AND FIRING

The greenware is thoroughly dried in rows on the workshop floor in an area without drafts; this permits a slow, even evaporation of the capillary water, which minimizes cracking and warping. If climactic conditions are so extreme that the ware might dry too quickly, it may be loosely covered with plastic to extend the drying process. The vessels are typically inverted after the tops have begun to lighten in color, indicating that they have given up most of their moisture at room temperature. This also facilitates uniform drying, for the base of the vessel, resting

on the ground, has a much lower rate of evaporation than the upper areas, which are exposed to air currents. The bases also tend to be thicker than the shoulders, neck, and rim, which also inhibits their drying at the same rate.

During the final drying process, the works are moved out into the courtyard to finish drying in the sun. During Mota's pottery heyday, the potter's tasks ended there, as the pots were taken to a *hornero* (also known as an *enhornero*) who owned and fired the kilns (the second part of the process where men became involved). The *horneros* charged five pesetas to load each piece into the kiln and ten pesetas to unload each piece (Seseña 1975: 208) at a time when a standard *cántaro* of one *arroba* could be sold for a maximum of sixteen pesetas, approximately ninety-six cents.[29] (The *horneros* charged to unload the piece even if it blew up, was damaged, or collapsed during the firing.) In addition, the custom of *cobrar la poya* was practiced: of the approximately 250 *cántaros* in each kiln load, the *hornero* would keep a percentage in partial payment for his services.[30] López Cruz remembers that some *cantareras* had no means to transport their greenware to the kilns for firing and consequently sold all their pieces—at a commensurately lower price—to the *horneros*, who then transported the greenware to the kilns and fired, marketed, and sold it, keeping whatever profits were generated.[31]

Because it was rare for a single potter to be able to fill a kiln, two or more women typically shared each firing. The necessity of firing in a common kiln engendered a system in which vessels were measured through a system of accounting based on the comparative size of the ware in relationship to the standard *cántaro* size. This enabled the *horneros* to equitably distribute the kiln's capacity and its associated costs among those potters whose works were included in each firing. For example, five *arcabuces* equaled two *cántaros*, three *tiestos* or four *cantarillas* equaled one *cántaro*, and so

on (Schütz 1993: 23). The kiln capacity was based on twenty-fives, so that four twenty-fives were a *pico* (25 percent of the kiln's capacity), and two twenty-fives were a *medio pico*, or one-eighth a kiln load. Using the *cántaro* as the basic unit, with proportional measurements developed above and below this size, one potter's *cántaro*, for example, could be matched by four *cantarillas de a cuatro* from another, and so on. Approximately a hundred *cántaros* occupied the space of one *pico*, and four hundred *cántaros* were a full kiln load (*horna*). When space allowed, the owners of the kilns would also burn limestone rocks at the bottom of the kiln chamber to obtain the *cal* used to whitewash the walls of village homes (Cano Adillo et al. 1990: 30).

In earlier years, several *horneros* owned and managed communal "Arabic style" vertical updraft kilns with a single central chimney, one of which, the Aniana or Gorra kiln, was located right next to the Cruzes' workshop on the Plaza de la Cruz Verde.[32] Formerly owned by López Cruz's grandfather, Ramón Gorra, after his premature death in 1972 it passed to his uncle, who then sold it to the Ayuntamiento to avoid "losing the tradition," for all of the other local kilns were being torn down to build houses. Even the Gorra kiln was "in ruins" for some time, and then, with the help of one of the researchers studying pottery in Spain, López Cruz's father, Santiago López Contreras, convinced the local authorities to restore this 4 x 3 x 3 meter (roughly 12 x 9 x 9 foot) kiln as a local monument (Sempere 1982a: 215). When the renovations were completed (renovations that were apparently so extensive that although the kiln is said to have been on this site since time "immemorial" it is described as "new"), the women again used it to fire their pots, with no charge levied by the Ayuntamiento in the interest of preserving the tradition. Located so close to the Cruzes' home and studio and owned by relatives, this kiln was used frequently by

Aniana kiln owned by López
Cruz's grandfather, Ramón
Gorra, 1963.
Photographer unknown;
private collection

Gorra's kiln, 1999. The
subsurface firebox is used
to stoke the kiln.

Dolores Cruz, but by the mid-1970s, with the decline in popular demand for the ware, all of Mota's remaining potters together were only firing about three times a year. López Cruz still uses this kiln in early summer when he is firing his biggest loads in preparation for the summer fair season. Because the works are not glazed, each piece requires only a single firing to the bisque ware stage.

The bulk of his firing, however, occurs in a kiln that he originally built around 1992 within his studio compound. It is stone on the outside and a refractory material on the interior. The mortar used to hold it together has a high proportion of sand, which helps it to resist damage during the high temperatures of the firing. He learned how to fire from some of the old *horneros* in town, all of whom have now retired or died. López Cruz's kiln measures approximately 3.6 meters (almost 12 feet) high, 2.1 meters (6.825 feet) wide, and 2.8 meters (9 feet) deep on the exterior. The interior chamber in which the ware is stacked, the *cámara de cocción*, is 1.6 meters (just over 5 feet) high, 1.7 meters (5.5 feet) wide, and 2.1 meters deep; it is vented through a 50 centimeter (approximately 19.7 inch) high *boquilla* or *tiro* in the vaulted center, which draws the heat up a 16 meter (52 feet) high chimney, which remains open during the firing, providing excellent draw and air circulation for the firing chamber. Below this chamber is a firebox with an arched opening (the *caldera* or *cámara de combustión*). This firebox, which measures 1.5 meters (4.875 feet) high, 1.8 meters (5.85 feet) wide, and 2.7 meters (8.775 feet) deep, is partially dug into the ground to conserve as much heat as possible, decreasing the time needed for firing and contributing to a better draft; nine 12 x 12 centimeter (4.72 inch square) vent holes (the *lumbreras*) in the floor of the firing chamber permit the passage of flame and heat from the firebox below. The actual opening into the firebox through which brush and wood are shoveled is

López Cruz's kiln in his studio yard, 1999.

a relatively small 40 x 40 centimeters (15.75 inches).

The vessels are stacked in the kiln next to his workshop after they have been thoroughly air-dried; this process cannot be hurried, for inadequate or uneven drying during this stage can lead to an increased risk of breakage during the firing as a result of excessive shrinkage or the development of steam within the pores of the clay body. The thoroughly dried greenware is stacked upright inside the kiln chamber, the bottom of one piece fitting into or resting on top of the piece below. Smaller pieces are carefully fit in sideways or placed inside of larger ones, and little shards of bisque ware (broken pieces from previously fired vessels) may be placed in between vessels to stabilize the stacking or to assure the proper flow of air during fir-

López Cruz's kiln, in ruins following a 2003 storm, 2004.

ing. While loading the kiln, López Cruz constantly tests for stability as he attempts to maximize the space within; kiln shelves are never used. Precise placement of the greenware is crucial, for the shrinking of the ware as it comes to temperature can amplify any imbalance, be it of an individual vessel or of the stacking itself: the physical ordeal of the firing is enough to cause an imbalanced work to move or collapse, which can then itself damage many other works in the same kiln load. Further, because the heat source comes from below, those vessels that are placed lowest in the firing chamber will receive greater amounts of heat. It is important to maintain equilibrium in the firing, therefore, so that the lower pots are not overfired (resulting in warped or melted ware) while the upper levels are underfired (threatening consistent vitrification and porosity levels). It is not unusual for López Cruz to lose one or two pieces from each load; depending on the kind of damage, he

may destroy the work or sell it more cheaply as a "garden decoration." Subject to such regular extremes of heat, the kiln, too, always needs attention; he is constantly repairing it. The lower chamber needs the most attention, but he also periodically repairs the arch, the floor, and the walls. In fact, during the summer of 2003, his kiln developed a major crack that caused it to collapse during a violent thunderstorm and effectively prohibited firing in that kiln during the following year. A complete overhaul, essentially rebuilding from the ground up, will be required.

López Cruz generally fires every six to twelve weeks, depending on the weather and how fast the pieces dry as well as how long it takes to produce a full load; he can fire up to 500 pieces at a time in his grandfather's old kiln, now owned by the Ayuntamiento, and around 250 pieces in his own. Agricultural and family needs or fiestas interrupt the production

process but do not unduly disturb the pace and rhythm of his work. After the pieces are loaded, the kiln's front opening is walled up and sealed with wet clay wedged into the openings between purchased bricks constructed from clay and straw. A second door flush with the exterior walls (a steel door in his private kiln, a defunct hay thrasher or *trillo* on the Gorra) is closed, and hay and brush are used to start the flame in the firebox. Whatever kind of combustibles he can gather—typically reeds from the nearby river-banks, pine branches, and agricultural debris such as olive branches, grapevine cuttings, and so on—are used for the firing; *pegar el horno* is the process of starting to throw the brush and wood into the firebox, with the help of a *hurga*,

a pronged iron fork some five meters long, or with *hurguetes*, smaller forks. The ultimate color of the bisque ware is determined by the kind of combustible used as well as the physical composition of the clay body.[33] The smell of the burning brush is often quite aromatic.

Stacking or loading the kiln may take a full day; the actual firing begins on the next day. After bricking up the door and before lighting the fire, a short entreaty may be uttered for success in the firing. Not described as a prayer per se, it is more an acknowledgment of all of the things that could go wrong and a fervent hope that they do not.[34] Preheating (*caldear*) the kiln to approximately 200 degrees Celsius to drive out the remaining molecules of water in the

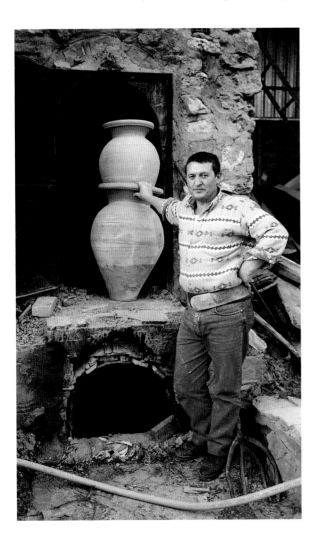

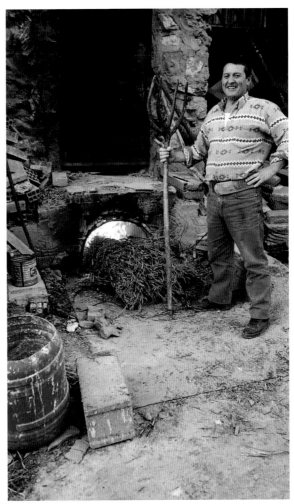

Left: Stacking vessels in preparation for kiln loading, 1999.

Right: Preliminary stages of firing: *pegando el horno,* 1999.

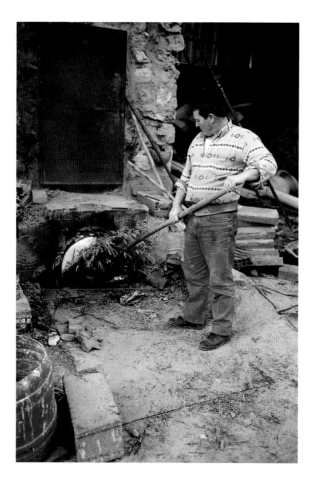 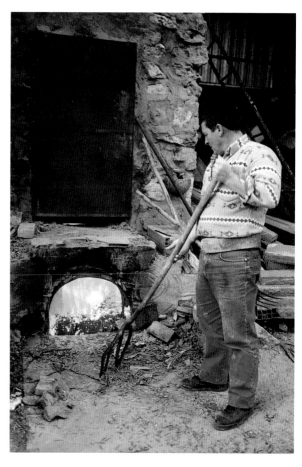

Preliminary stages of firing:
pegando el horno, 1999.

clay body again depends on the weather; it can take twenty hours in the winter but only two in the summer. Following this preheating stage, the single firing to the bisque state typically takes eight or nine hours in the winter, five to six in the summer. At approximately 650–750 degrees Celsius, irreversible molecular change takes place as the chemically bound water burns off, after which the clay has vitrified and can no longer be "slaked down" or return to a plastic state. The interior vaulted shape of the kiln and the open *boquilla* force the heat and flame to recirculate throughout the chamber, which expedites the temperature rise. Minding the strength of the fire takes the most energy— particularly in the winter, when the process also requires more fuel—and depends on the type of the combustible: reeds and grasses burn with a hotter, quicker flame but require seem-

ingly endless labor to maintain. Usually using a combination of fuel materials, López Cruz does not really need to babysit the kiln until the flames start shooting out of the top, an indication that the kiln has almost reached the final temperature. At this point it is necessary to really stoke the fire (*atizar*); he is still helped occasionally by his father and more often by his wife, so that the final high temperature can be reached. He does not need to hold the kiln at this temperature, just to ensure that it has been reached in all corners of the firing chamber. (As with most kilns, the interior chamber does not maintain a uniform temperature; his is hotter at the bottom.) He measures the interior temperature of the firing chamber by eye, according to the color and length of the flames shooting out of the top and the final disappearance of all carbon residue from the interior kiln walls; no

pyrometric cones or thermometers are used for greater precision, nor are they needed. The temperature peaks between 800 and 900 degrees Celsius; at this point, the clay body has undergone a final molecular change, resulting in vitrification and the properties of hardness, compactness, and impermeability that are associated with fired pottery. At 1180 degrees the clay body would melt, so he must ensure that the interior chamber's temperature does not rise too high. A higher temperature also reduces the porosity of the vessel, so maintaining the absolute functionality of the *cántaros* and *botijas* requires a careful watch on the chamber. López Cruz describes the attainment of proper temperature within the kiln's firing chamber as "cuando están riendo [when the flames are laughing]."

After the high temperature has been reached and combustibles are no longer being pitched into the firebox, the top of the *boquilla* and the opening in the firebox are covered to enable the kiln to lose temperature slowly, thus avoiding breakage or cracks that would come with too rapid a cooling cycle. (Simply allowing the fire to extinguish itself would cause this rapid cooling, for as soon as the fire dies, outside—colder—air would be drawn into the firing chamber as a result of the considerable draft that is still present at that stage, thus causing breakage due to thermal contraction.) Closing the kiln's apertures extinguishes the fire by depriving it of oxygen; it dies quickly, first by utilizing the remaining oxygen in the chamber's atmosphere and then by pulling molecular oxygen from the clay bodies of those vessels closest to the fire, resulting in darker (that is, reduced) stains on the ware. Cooling down takes twenty-four hours or more during the summer, sometimes as few as twelve during the winter. López Cruz typically begins to unload the kiln (*deshornar*) while the vessels are still warm, around 100 degrees Celsius. He removes the bisque ware from the top of the

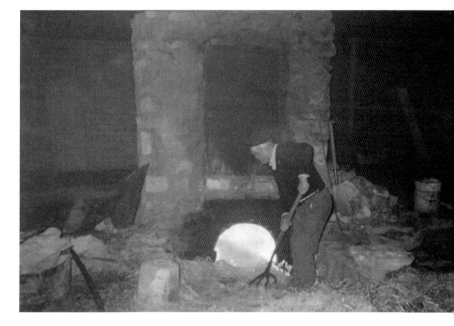

kiln through the open *boquilla* first, either using an iron hook or grabbing the pieces by their handles. After he can no longer reach in from the top, he comes around the bottom and unbricks the lateral door, continuing and then completing the unloading from the front. His wife, children, and other family members will usually help in this process, thereby minimizing the amount of climbing up and down from

Top: Santiago López Contreras stokes the kiln toward the end of firing, ca. 1992. Photograph: Evelio López Cruz

Bottom: The final moments of firing, when the flames are "laughing," ca. 1992. Photograph: Evelio López Cruz

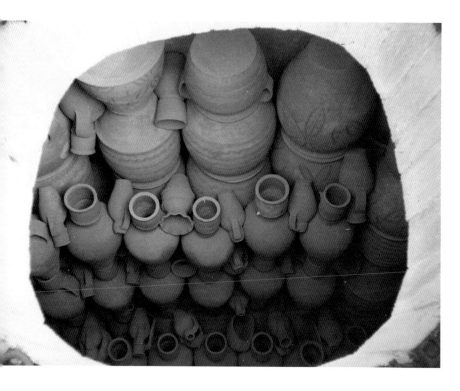

Top: View from the open *boquilla* down into the kiln after firing, ca. 1992. Photograph: Evelio López Cruz

Bottom: Unloading fired bisque ware, ca. 2003. Photograph: Loli Sandoval del Olmo

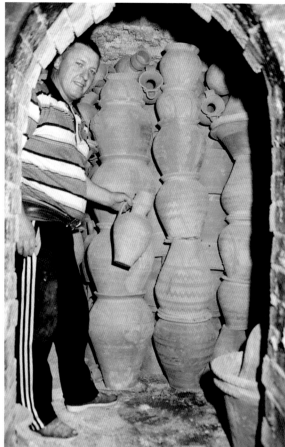

on top or inside of the kiln. When he uses the larger kiln in the Cruz Verde plaza, the bisque ware is loaded back into his van for the short drive to his studio; the greenware had been brought to the kiln in the same manner.

SALES AND MARKETING

Although López Cruz is clearly the driving force behind the pottery production in his household, the business license is in his wife's name because pottery is still locally considered to be a woman's occupation. This license (the Titulo de Empresa Artesana) costs approximately two hundred euros (two hundred fifty dollars) annually, and López Cruz must pay an equal amount to the Mutualidad Laboral de Trabajadores Autónomas for insurance to cover pension and disability. Loli handles all the paperwork for the licenses, taxes, and so on. "The more you sell, the more the government takes," he complains, for his business taxes are based on his kiln capacity and type of objects he produces. Nevertheless, he enjoys his work, particularly the independence it gives him, and concurs with his mother that collecting olives or working in the fields is harder, colder work. Interestingly, however, she has complained that she is sick of hearing that she is an artist when she was never able to make a lot of money in this vocation, which is hard and dirty.[35]

López Cruz's mother and the other women potters of the last generation created enough work at their peak to fire fifteen or twenty kilns annually (Guerrero Martín 1988: 135), but they made pottery only during the late spring and summer months. It was difficult to uniformly dry the greenware during the frigid winters, which brought increased risk of cracking and breakage; spring was for helping with planting and autumn for helping with the harvest.[36] In contrast, López Cruz works in his pottery studio all year. He also earns a small amount from

Sindi and Silvia, daughters
of Evelio López Cruz and
Loli Sandoval del Olmo,
1999.

the harvesting of the grapes growing on top of his quarry, sold through the wine cooperative in town, but this is clearly a subsidiary activity. He is comfortable with the quantity and quality of the pottery he makes; he feels he is making as much as he needs to, for he sells everything, and he is not interested in expanding or adding new helpers at this time (an exceptional step, in any event, for the earlier generations of potters as well: the low income generated by the production of the ware never justified additional paid laborers). He does have regular help from his wife; his two daughters and older son have helped during the summer;[37] and his younger son, still too young to produce the ware, is just starting to help by *pisando* the clay. López Cruz sells their work alongside his own, signing them all with his mark, although he can determine by looking which works were fabricated by which family member.[38]

His best-selling object continues to be the "queen," the standard *cántaro.* This was true in

decades past, when his mother and grandmother worked, as it is today, despite the fact that with domestic running water, women no longer need to go to the public fountain with their *cántaros* to bring water into their homes. Furthermore, irrigation has suppressed the need for water wheels in the fields or for large vessels for storing water. Historically, however, men would load burros or donkeys with a bulging cargo of jugs and buckets, packing them with dried grasses to cushion the ride; they sometimes traveled in pairs or groups of three, riding to neighboring areas to sell their wares before returning for another load. Knowing their market, they would load up buckets (*arcabuces*) for water wheels for the villagers who worked the fields around Toledo or Ciudad Real; larger storage jars (*tinajas*) for cities like Madrid and Albacete; *cántaros* for the dry Manchegan towns like Puertollano or Almagro; and small storage jars (*tinajas pequeñas*) for around Hellín, where they were needed for the storage of

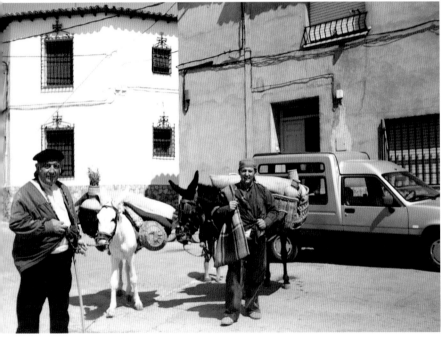

Top: Santiago López Contreras's sales cart, now stored in López Cruz's studio, 2004.

Bottom: José Pedroche and López Cruz as *aguadores*, selling water in Mota del Cuervo *cántaros*, ca. 1980. Photograph: Loli Sandoval del Olmo

selling locally he would sometimes exchange the pots for other needed items, including vegetables and other foodstuffs. Toward the end of his selling days, however, López Contreras began to work more extensively with resellers and store owners and solely on a cash basis, for declining demand hampered his ability to sell or even trade the ware. By the mid-1970s, sellers in large cities were beginning to market the work to collectors for decorative purposes, far surpassing sales to local buyers who would use pieces for their traditional functions. Thanks to increased and facilitated transportation options, these buyers would travel to Mota to choose and transport the ware, rather than waiting for the pottery vendors to come to them. Local sales by this time accounted for less than 10 percent of total sales (Albertos Solera 1978: 154), and those purchasers were primarily neighbors of very advanced age who had used such pieces all of their lives.

López Cruz, too, hits the road to sell his pottery: he drives his truck (a Ford Transit with a 2,900 kilogram payload) all over Spain to four or five of the regional and national ceramics fairs, including noted fairs in Argentona (Catalunya),[39] Oleiros (Galicia), and locally in Cuenca (Castilla–La Mancha). He typically returns to the same juried fairs year after year, occasionally accompanied by his wife, one of his children, or a friend or relative who will help sell the truckload of pots, the equivalent of a single full kiln load. He is occasionally asked to do demonstrations at the fairs; he complies but does not particularly enjoy doing it. The increased range afforded by his motor vehicle—in contrast to the animal-pulled carts of his parents' generation—has obviously increased the diffusion of his works to greater numbers of viewers and buyers.

López Cruz estimates that during the summer the number of works he sells directly out of his home studio, despite its remoteness, is equivalent to those he sells at the fairs. He aver-

olives. López Cruz's father, Santiago López Contreras, hitched up his mule and cart and traveled alone throughout La Mancha and as far as Madrid, selling Dolores's pots as she stayed home with her domestic and child care responsibilities. In the earlier days—as in preceding generations—he sold directly to individuals, setting up his wares in the town plazas. When

ages about fifty studio visitors per week; the hotel and a few stores in Mota used to carry his work, but the former now only displays a few pieces of glazed work from other Spanish ceramic centers, and the latter have closed. Historically, sales from the Mota potters were direct, not through galleries or other intermediaries, and in this way—as in almost every other aspect of his approach to his craft—he prefers to retain as much of the tradition as he can. Nevertheless, he is clear about the fact that almost all of his output ultimately goes to tourists for decorative purposes, and he is proud that his work has traveled all over Spain, to France, Germany, and even to the United States. Although he does not directly articulate it, it is clear that at least a modicum of his success has resulted from his direct family lineage of creating this traditional-style ware. During the late 1960s, '70s, and '80s, ethnographers and art historians hurrying to document the declining pottery tradition in Mota were often directed to his mother, Dolores, and, pleased with the attention, she submitted to numerous interviews, so both her comments and photographs of her at work appear in almost every reference work on the local tradition. With the rising emphasis on individualism that fueled the increasing tendency to reclassify this work from an anonymous craft to an art created by folk masters, the family name became synonymous with and perhaps even came to epitomize Mota's functional pottery tradition.[40] Therefore, it is not surprising that the new breed of collectors would prefer to purchase works by a "name artist" who came by his trade in the "traditional" manner rather than work by a member of a less recognized—and less published—pottery family. Paradoxically, this emphasis on the individual was practically nonexistent throughout most of the decades—if not centuries—when the Mota tradition was truly thriving but emerged only toward the end of Dolores's working life, when glorifying what was assumed to

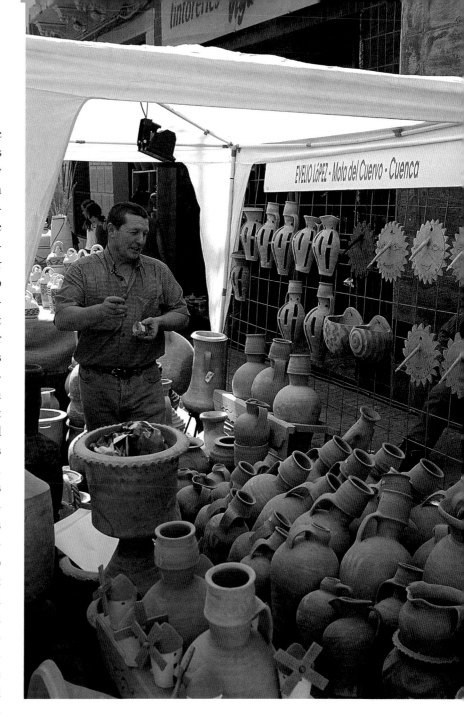

López Cruz at the Argentona ceramics fair, 2002.

be a dying tradition helped to make the work seem more special. López Cruz has been fortunate to ride the coattails of this more elitist conceptualization of the Mota ware: his family name has been essential in increasing its perceived monetary value.

Despite his work's attraction for these new collectors, his neighbors apparently have less and less use for his vessels. López Cruz grouses that his product is "so pure" that it is not of interest to locals for use in the traditional manner: most will spend much more money for

imported ceramics instead of buying his work, which he sees as having greater value. Because there have "always" been such pots in Mota, he feels, the locals do not appreciate them and do not consider them "artistic." People used their earthenware pots in the past because they had to; now that they have other choices, they prefer other options. Even in the case of simple flowerpots, his neighbors buy mass-produced factory works rather than his vessels. In the same way, he feels that the local municipal government does not really value his work or support him; the government buys a few pieces each year as gifts, but López Cruz feels that the officials do not really comprehend the significance of his role as the last potter carrying on this centuries-old tradition. Although López

Cruz's older children have learned to make pottery, he thinks it will be difficult for them, and he doubts that they will choose to earn their living by following in his path.

In his mother's day, pottery was considered simply another of the tasks that housewives did to support their families, much as they might help in the fields during harvest. Revenue earned from the production of their pottery supplemented the income produced by their husbands (who were typically farmers), but despite the fact that every member of a *cantarera*'s family was involved in some way with the various aspects of pottery production, it was said that in Mota del Cuervo no families lived off of pottery. Perhaps a vestige of Spain's macho emphasis, this statement seems absurd

in the light of studies of some of the families over time.

It may become more understandable, however, when viewed through the lens of local villagers. In many areas, the primarily male potters of Spanish society were generally neither marginalized nor privileged; rather, their vocation was considered equivalent to that of any other laborer (obrero) despite the much greater quantity of hours they dedicated to their trade (let alone its aesthetic qualities). However, other studies have suggested that even laborers such as shepherds and agricultural workers may have looked down on Spain's potters. Although working on the land has always been seen as honorable, vocations that required the use of the hands "inspired scorn and sometimes even repulsion over the centuries" (Bennassar 1979: 121).[41] Some scholars have speculated that such sociocultural discrimination against this group of artisans living in a segregated area of town may have been exacerbated by residual racial discrimination from the times when potters and their families were perceived to have Islamic ties (García Gómez 1993: 118–22). This hypothesis may be supported by the great number of Spanish vocabulary words from Arabic derivation pertaining to such manual, technical occupations and, at least from the point of view of Christian Spaniards following the Reconquest, the associated negative connotation such occupations retained as emblematic of the work of the defeated.

More specifically in Mota, the women potters were disrespected, even scorned, for the assumption that they shirked their household and familial duties to work at such a dirty task.[42] Low levels of social respect or status may have been exacerbated by the fact that illiteracy rates among Mota's women potters were extremely high, even in comparison with other townswomen: the census figures from the years 1930–60 indicated that seventy-five of every one hundred illiterate women in town

were potters (Contreras Zarco 1993: 20). Further, their system of counting relative space in the kilns was ridiculed as primitive, indicative of a cultural inferiority (Albertos Solera 1978: 160). Although these prejudices seem to have been generally overcome as the disappearance of all of the cantareras has stimulated a romantic gloss on their activities, residual bias no doubt still colors contemporary response to López Cruz's efforts.

DECLINE OF THE TRADITION

The pottery of any given region traditionally both served and was conditioned by the local way of life. Given the porosity of the local clay body, which permitted a consistent evaporation and thus cooling of the vessel's contents, the traditional production of Mota del Cuervo focused on the cántaro (water jug), for in days gone by, the majority of the residents of La Mancha spent most of their time working their fields, and they needed to carry water with them because springs and rivers were scarce. Although the sales of pottery to locals as part of a traditional economic system brought proportional prices significantly lower than these same types of ware garner today, these expenditures nevertheless represented a major component of familial expenses. The reluctance of owners to discard older vessels and buy another when one would break—substantiated by the number of such vessels that were repaired with hand-wrought staples—amply illustrates the great importance placed on these pieces. Luckily, interest in this ware from outsiders coincided with its practical obsolescence within the local Manchegan communities; today, López Cruz estimates that only a maximum of 2–3 percent of his clientele purchase his pottery with the intent to use it in accordance with its original function; the rest buy items as mementos, as souvenirs, as decoration.

This changing reality cannot help but condition the potter's response to his work. With the economic revolution building on the earlier sociocultural one, each now augmenting the other in a continuing upward cycle, the fundamental purpose for the creation of unglazed, barely decorated, heavy functional ware no longer exists. That Evelio López Cruz has continued to sell these pieces ties into collectors' and urban professionals' imagined, nostalgic versions of rural life rather than into any experienced historical reality. Of course, as the remaining practitioners of—or even those who lived through and then moved away from—this traditional culture die off, our mental pictures of the idealized past can run freely, unimpeded by vestiges of that harsh reality, and López Cruz can continue to market his ware as a symbolic and decorative souvenir of days gone by. Part of what his clients are buying—and what they now pay extra for—is their romanticized vision of his

labor-intensive and archaic production methods, for they suggest the "good old days" that, looking back through rose-colored glasses, we define by utopian values of community, honesty, truth, hard work, simplicity, and harmony.

Although we may be grateful for his continuity of form and technology, there is nevertheless a jarring disconnect in the recognition of the essentially total change in clientele from locals to tourists as well as the significant disparity in the priorities of their purchase choices. In the days when the Cruz family ware was acquired for use, little or no attention was paid to the form or to such components as surface flashing; clients were interested in cheap, functional ware. Today, the consumer is much more conscious of these aesthetic aspects, as the value of the vessels' use decreases in inverse proportion to their decorative value. As such, the pots of Mota del Cuervo have moved from utilitarian craft to "art," becoming a cultural marker that

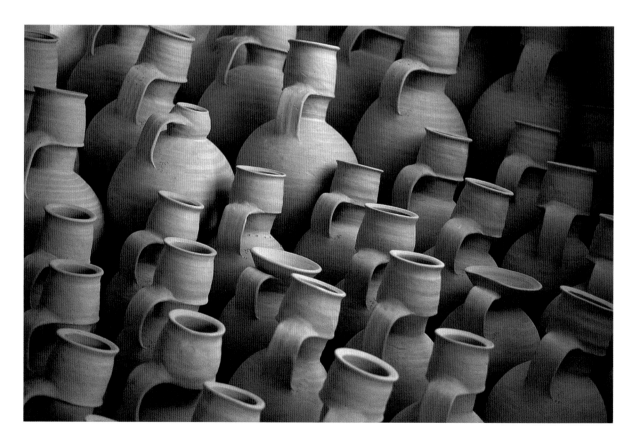

Fired bisque ware *cántaros* stacked in studio prior to sale, 1999.

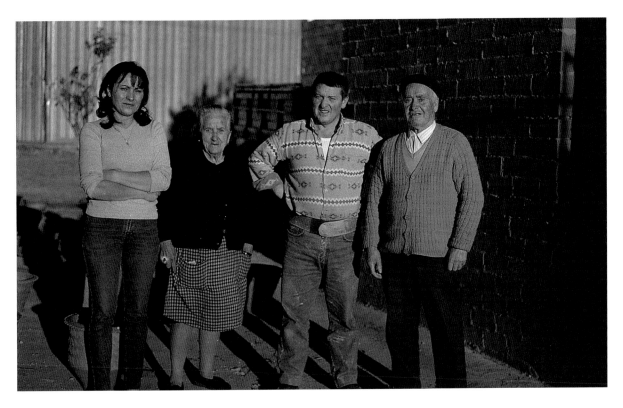

From left to right: Loli Sandoval del Olmo, Dolores Cruz Contreras, Evelio López Cruz, Santiago López Contreras, 1999.

visually represents and identifies the image of Mota to the world. However, this new designation does not require the continuation (or continuity) of work by the succeeding generation. Passing through new experiments with form in the 1960s, near death of the trade in the 1970s, and a generally unsuccessful—except for our one current potter—attempt to resuscitate the tradition in the 1980s, the sense is that only a few extra decades have been wrested away from a predetermined fatality.

This quandary is shared by creators of other previously functional crafts that have morphed into decorative arts. Now that the specific purposes inspiring the initial creation and determination of forms have essentially been eliminated, the choices facing the artisan are, with a broad brush, either the calcification of the traditional forms or innovations so radical that they move beyond the genre of traditional arts

to the contemporary art vein. Replication of traditional forms for nontraditional purposes—using a model of the past to model the future, to paraphrase Moeran in his study of folk potters of Japan (1997)—allows us to deceive ourselves that the old way of life and the need for these works still persists and retains vitality at some level. But they do not, beyond the annually diminishing miniscule number of older clients who buy and use this ware simply because they have always done so. Evelio López Cruz doubts that his children will carry on as potters, so despite his somewhat miraculous overcoming of gender-based restrictions, his continuing innovation—within strict parameters—of his forms and the types of ware he produces, the archaic techniques he uses to do so, and indeed, his visceral enjoyment of his craft, this may, finally, be the last generation of traditional potters in Mota.

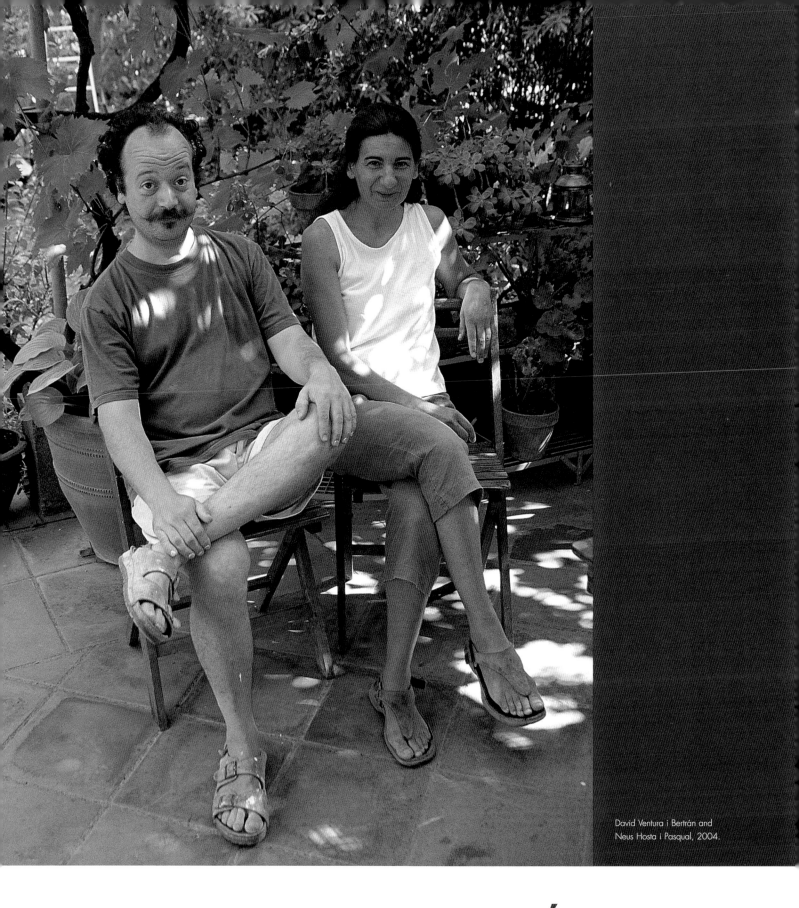

David Ventura i Bertrán and
Neus Hosta i Pasqual, 2004.

DAVID VENTURA ı BERTRÁN
AND NEUS HOSTA ı PASQUAL

No el deixis els costums vells per novells.

Don't set aside old customs for new ones.

—CATALAN PROVERB

Gegants: Vertical figures with human characteristics whose measurements considerably exceed those of individuals with normal dimensions, guided from within by a single person in order to participate in festivals and celebrations; a festive symbol of the collective.

—Jan Grau and Albert Abellan

It is said that the *gegants*[1] of Catalunya—some 3,000 mute yet evocative personages—could visually tell the history of the region without words, so widely and truly do they represent the occupations, legends, symbols, and identity of the region's people. The above definition, proffered in 1997 by the quasi-governmental II Congress on Popular and Traditional Catalan Culture, hints that these monumental figures are more than a mere festive accessory brought out for a few hours several times a year. It would be more explicit, perhaps, to note that they are affectionately regarded by many as a physical and conceptual personification validating and ensuring the continued viability of history, of tradition—indeed, of a way of life. Corporeal amalgamations revealing complex technical mastery of a variety of media, these secular icons nevertheless remain incomplete and unfulfilled without the performative aspect of social participation. As such, they harbor a pleasurable weight of personal, familial, and community memories while concomitantly sustaining the promise of heritage secured for future years.

Despite the depth of *communitas* engendered by these papier-mâché figures, by the mid-1970s their artisan creators were regretfully viewed as being stuck in an occupation that was inevitably fated to disappear with increasing modernization. In 1973, only thirty villages in all of Catalunya presented and "danced" their *gegants* in open-air gatherings called *trobades*. In remarkable contrast, by 2002 there were more than 350 such gatherings held, an annually increasing figure and a striking manifestation of the fever to recover and strengthen local traditions that engaged almost every Catalan village subsequent to Franco's death. Today, in many areas the concept of the village festival has become inseparably linked to the imagery and potency of its hometown *gegants*; further, the figures have become so intimately (re)connected to their communities that increasing numbers are being individually profiled in historical monographs.[2]

HISTORICAL BACKGROUND

In the form that we know them today, the *gegants* emerged as one of the popular "flourishes" added to enliven the festival of the Eucharist—*el Corpus*—as a result of Pope Urban IV's 1264 proclamation establishing the Holy Acts (Actes Sagramentals), solemn one-act plays

with religious themes. The Church had previously celebrated Corpus in a maudlin and severe fashion, focusing on the pain and suffering of Christ's Passion. Many parishioners found this approach unappealing, however; still in the syncretistic mode of combining pre-Christian beliefs and rituals with the new ones introduced by the Catholic Church, followers preferred the exultation of such indigenous observances as the vernal equinox or the summer solstice, accompanied by dances, bonfires, and special foods.

Selected maquettes for completed *gegants,* 2002; 30–40 centimeters high.

The laypeople—generally more tolerant, humanistic, and secular than the strictly theocratic and intolerant clerics—were not inspired by the Church's sad and negative commemoration of one of the most important days in its calendar.

Pope Urban's proclamation came at an unstable moment in Church history, a time marked with dualities, reforms, and counterreforms that sought to absorb, replace, counteract, abandon, and modify behaviors that the ecclesiastical hierarchy deemed profane or heretical. This religious turbulence disturbed many followers, and some seemed ready to discontinue their adherence to Catholic precepts and return to calendar-based autochthonous ritual behaviors and relationships. Worried that significant numbers of believers would be lost to the "official" religion, the Church fathers realized that to teach their doctrine to largely illiterate folk, to retain current followers, and to attract new ones, certain compromises would have to be made. Following the examination, analysis, and final approval of Belgian nun Juliana de Bétine's visions and revelations in 1230, Dominican theologians grasped the importance of promoting their beliefs in a more appealing manner. Among other changes, they recast the eucharistic festival by moving it to a new date at the beginning of the summer season, separating it from the sadness of Easter week, and reintroducing it as a joyful expression in Christ's name. By so doing, the Dominicans consciously linked the Corpus observance to the practice of ancient propitiatory rituals that marked the passing of spring to summer, anticipating the pleasure of the harvest. The 1264 proclamation outlined new ways of celebrating the Eucharist and mandated their adoption within all of the areas under the Church's dominion.

As further described in chapter 3, Pope Urban's Acts provided an immediate liturgical validation that allowed for numerous and diverse civic, religious, and traditional elements to be appended to the Corpus celebrations. Rein-

forcing Urban's proclamation, in 1317 his successor, Pope John XXII, handed down a bull specifically establishing the procession as an important component of Corpus. The original intent was to publicly parade the Host within an elaborately ornamented monstrance, thus inspiring religious fervor while reemphasizing Church doctrine and biblical history through a parade of assorted characters. Too, it was meant to prove that the God of the official religion was the most worthy God, demonstrated by the fact that the Church now admitted and welcomed figures and animals that had been venerated in archaic or "pagan" sects. In 1320 Barcelona became the second city in the Catholic world to begin celebrating the holiday in this way, leading by example for other Catalan localities.[3]

Although the procession was but one component of the new Corpus observances, it quickly became one of the most significant, representing the means by which a variety of other elements were widely and popularly promoted and diffused. Parading through neighborhood streets was conceived as a broad-based strategy to include a range of festive ingredients characteristic of other celebrations and belief systems, a way of pleasing and involving as extensive a following as possible. This new attitude was an alternative approach to the Church's vexing and ongoing dilemma caused by the people's continuing interest in such "survivals." For a thousand years beginning in the fourth century, ecclesiastical officials beginning with St. Augustine passed edicts, presented sermons, and decreed penances in an effort to prohibit such activities—apparently for the most part in vain. However, if the clerics had hoped that their new course of action would reduce the importance of those beings by casting them as merely supporting characters in the drama of Christ's life, the end result was completely contrary: the Corpus processions instead became the adhesive that preserved and maintained the splendor and diversity of pre-Christian religious manifestations.

A wide assortment of quasi-theatrical components were thus added to enhance the sacred aspects of the procession, including symbolic musical, visual, and theatrical links to the natural calendar, fertility, and the cycle of life. Floral arrangements and eggs were commonly represented, as were elements of fire and water. In addition to such emblematic imagery, the processions became an opportunity to acknowledge those people who had played an important role in the life of the community. Noble births and deaths, coronations, and marriages were acknowledged; also recognized were local authorities, members of occupational guilds,

Ventura and Hosta's *gegants* Selma and Nazari of Navata lead a processional, followed by Figueres's *gegants* Salvador Dalí and his wife, Gala, at Lladó's Festa Major and *trobada de gegants*, 2003.

religious brotherhoods, and secular organizations of all types. All carried the standards and symbols of their offices and proudly wore their special uniforms or costumes with great pomp and circumstance, vying to look the best and provide the most dazzling entertainment for the crowds of onlookers.[4] As the processions grew more elaborate in the fifteenth and sixteenth centuries, individual artisans and groups signed detailed written contracts with the sponsoring municipalities to assure the proper presentation of the different components, including dances, plays, altars, dragons, floats, and *gegants.*

Most important for this discussion, however, was that a significant component of the Corpus procession referred to ancient myths and local folktales. Constructed wicker or papier-mâché[5] dragons, giants (initially, men on stilts with long costumes),[6] eagles, and other fantastic or mythic creatures were included; the Church typically attempted to suppress their original symbolism, linking them to analogous beings, personages, or saints found within Catholic liturgy and scriptures. By so doing, officials hoped not only to visually educate the populace to Church teachings but also to simultaneously wean people away from any unorthodox or "heretical" beliefs.

Speculation on the nature and role of these indigenous creatures has been mixed. Some scholars have suggested connections between the Catalan *gegants* and earlier mythic progenitors—including the earth mother Gaia and the giant Cyclops of early Greece. Others, noting that the biblical Goliath was featured in the Barcelona Corpus processions beginning in 1391 (accompanied by a young "David" until 1586, when he was replaced by a female consort), have preferred to look for evidence within Christian iconography. Additional theorists have suggested that there was no comprehensive canon attached to the monumental figures seen in the early Corpus processions but that the *gegants* were lesser creatures representing a diverse

array of ideas and images. As such, they could easily be absorbed as the Church recast them as allegorical beings whose purpose was to communicate, as they expressed it, the "omnipotence of the Creator and the triumph of Christ." A fourth hypothesis has been that the *gegants* devolved from the extraordinarily tall Middle Eastern princes Gog and Magog (mentioned in the Bible as well as the Koran);[7] as the *gegants* were visually and performatively associated with the *tarasca* dragon, they were thought to represent the Antichrist, and they participated in the Corpus processions to showcase the defeated or enslaved enemies of Christianity (Very 1962: 78–79). The Church justified their presence, however, by informally explaining that the original four pairs of giants represented the four corners of the earth "to which Spain had carried the Catholic doctrine: Europe, America, Africa, and Asia" (Foster 1960: 195).

Such nonliturgical theatrical expressions quickly became the key to wide public participation in Corpus celebrations. Those special days when the *gegants* and associated figures were brought out became occasions for outlying peasants to travel to town and for everyone to dress up in festive attire to take advantage of the holiday and the opportunity to view the creations of some of the best and most famous artists of the era. Over time, images that were not included in Christian teachings or that contradicted Church dogma—such as the phoenix, whose rebirth out of its own ashes runs counter to the Church's concepts of resurrection—were gradually displaced and removed from view.[8] Some of the generic *gegants* of earlier periods soon evolved specific linkages to particular personages, legends, or places; others developed heightened symbolic value as the Church used them to embody deadly or venal sins in an effort to emphasize the moralistic components of the processions (Varey and Shergold 1952: 21).

From the sixteenth through eighteenth centuries, assorted new figures—known generi-

cally as *entremesos*[9]—took on increasing import in the Corpus processions. First municipal interests and then occupational guilds appropriated these figures for specific purposes.[10] Not surprisingly, Corpus events became increasingly desacralized in direct proportion to the augmented interest in such popular elements; before long, the clergy were prohibited from participating in the celebration's more theatrical aspects. Although a moralistic edge was retained for some time to come, the processions became progressively less didactic and less specifically referential to biblical texts or narratives. New figures with little if any precise religious reference became ever more popular, and by 1557 there is even reference to a *geganta* or *gegantessa* (giantess) in the city of Girona. Whether the fact that no giantesses had appeared earlier resulted from the lack of a biblical female with attributes that would have inspired such construction or from the fact that as a whole the *gegants* were losing their sacred aspect and becoming more human is unknown. Sidestepping the question of origin and concentrating on function, some scholars have suggested that the addition of a giantess reinforced the symbolism of the wide-ranging propagation and diffusion of Spanish culture and religion.

Despite the popularity of these figures, the Church became increasingly concerned with the underlying non-Christian symbolism of some of these images, beings, and garnishes and sporadically attempted to limit their activities over the course of the centuries or even to eliminate them completely. This effort was periodically exacerbated by political concerns, as, for example, after the Bourbon War of the Spanish succession in which the Catalans, fighting on the losing side with the Austrians, became subject to significant repressions that culminated in the loss of many of their rights and liberties. A royal decree subsequently eliminated all of the guilds and expropriated their assets, including their *gegants* and other *entremesos*. Acting

in solidarity, the Church aggravated this matter by prohibiting their use as part of Corpus processions. In each instance, the limitation or abolition of *entremesos* and other popular "flourishes" was ignored or protested, with lay participation widely dropping off until these elements were reinstated.[11]

The Church was no doubt further troubled by the fact that during the 1800s the women in larger cities, such as Barcelona, wanting to distance themselves from the perceived dowdiness of medieval times and move into the realm of the urban bourgeoisie, waited anxiously to see the first appearance of the giantesses every spring. As befitting ladies of such noble rank, the *gegantas* were dressed in the most stylish Parisian fashions. The giantesses thus took on the civic role of social model: upper-class women patterned their costuming based on that year's designs worn by the *gegantas*.[12]

By the mid–nineteenth century, commercial interests and industrialization were further secularizing popular culture, eroding clerical power through a proliferation of neighborhood and association festivals that challenged the dominance of Church-sponsored events. Urban areas in particular often manifested decreased emphasis on religious components while retaining more folkloric or popular elements, and, in a departure from tradition, private associations, brotherhoods, and civic organizations began to commission the creation of *gegants*. These figures, along with devils and fantastic beasts of all kinds, blossomed in this liberalized atmosphere and were rapidly incorporated into a range of more secular local celebrations throughout Spain. The proprietorship of the *gegants* seemed to follow political and social swings: when the prevailing currents were antireligious, *gegants* commissioned by neighborhoods and guilds increased; in contrast, when political and social movements became more restrictive, the *gegants* were more often owned and brought out by the Church (Grau qtd. in Ibàñez 1996: 14).

Ventura and Hosta's Besalú
gegants Bernat Tallafero and
Constança with *capgrossos*,
Festa Major, Lladó, *trobada
de gegants*, 2003.

exploring, preserving, and intensifying those customs that enhanced a feeling of local and regional identity. In Catalunya, this phenomenon was advanced by the 1890 creation of the Catalan Excursion Center, which promoted a cultural tourism that particularly focused on ethnographic and folkloric diversity. Interest in such manifestations—and, indeed, in their practice—peaked at this time, with regular dances, processions, festivals, concerts, and performances scheduled throughout the year. In the fall of 1902 the first "competition" of giants was held in Barcelona in conjunction with the Mercè festival.[13] More than forty *gegants* participated, arriving primarily via train from all over Catalunya. The contest rewarded the beauty of the figures and the grace with which they were danced; accompanied by balls, serenades, concerts, and all kinds of attractions, the *concurs* was contemporaneously described as an exceptional and enthusiastically received event.

By the beginning of the twentieth century, however, some of the *gegants* were "lost." In some instances this was a result of the decreasing power of local religious authorities: if the clerics had been responsible for these figures and no civic or private association was available to undertake their support, they fell into disuse. The disappearance of the *gegants* was exacerbated first by the politics of the Second Republic, in which glorifications of kings and queens were not exactly welcomed, and then by the civil war, when some *gegants* stored in churches were bombed or burned.[14] The *gegants* were enemies of both sides of the conflict: Republicans remembered the religious origin of the figures, and Franco's victorious Nationalist troops saw the *gegants* as a cultural expression of *catalanisme* that they wanted to destroy.

After the end of the war, the surviving *gegants* were brought out to service the newly invented *fiestas de la liberación*, political festivals that glorified Franco's triumph in an attempt to

The flourishing of the fiestas and the increasing use of the *gegants* was tied to the expanding nationalism that paralleled the creation of the first Spanish republic in 1873. Although the republic lasted only two years before reverting to the monarchy, it inspired an interest in

instill legitimacy and belief in his new government. Older *gegants* were often rebaptized with new names, new personalities, and even new ethnicities to further reinforce the concept of *la unidad de España* (Spanish unity).[15] New *gegants* were needed to augment this nationalism, so stately kings and queens once again became the most commonly commissioned images, symbolizing the Catholic royalty of a unified Spain. During the time of the dictatorship, it is not surprising that these personages—representing as they did the resented collaborators of Franco's generals—were not popularly favored in such independent-minded areas as Catalunya. Unofficial festival expressions were slow to recuperate from this series of cultural manipulations and degradations.

The situation worsened for the *gegants* when, particularly during the 1950s, localized natural disasters such as recurrent droughts, freezes, or floods eviscerated agricultural production in some areas. This caused significant emigration from rural areas and small towns to larger cities, thus decreasing the population able and willing to organize and attend local festivities. Even those who remained in the villages often had to go further afield to work, a development made possible by the increasing availability and use of the motorcycle and later the automobile, which provided new employment opportunities outside one's natal community. Increased access to transportation immeasurably changed the agrarian-based personality of many rural villages as they evolved into "bedroom communities" serving regional industrial or commercial areas. An unintended consequence for workers newly accustomed to leaving home each day was the conceptual recognition that various alternatives existed beyond the village for pleasure and relaxation. No longer did all younger people automatically come home on their vacation days to participate in local fiestas, instead availing themselves of the newly accessible wider world. At

Banyoles *gegants*, Festa Major, Banyoles, 2001.

the same time, the older creators and porters were retiring or passing away. The final setback for the *gegants* during the Franco period was the decision by the Second Vatican Council in 1962–65 to eliminate all popular components of the Corpus celebration: the processions were

officially abolished, and the observance was limited to religious activities that could take place within church walls. In response, participation in all Church activities markedly dropped off during the second half of the 1960s. The Church then backpedaled, attempting to recoup public participation by having Corpus declared a civic holiday; nevertheless, the processions for Corpus, Easter week, and other formerly religious celebrations never regained their earlier popularity.[16] Most existing *gegants* were thus consigned to attics and storerooms, and few if any new figures were commissioned during these years.

An almost electric revivification of traditional elements came on the heels of Franco's death in 1975 with the easing of the repression of local aesthetic and cultural expressions, formerly subjugated to a more generic pannational and pan-cultural *Hispanidad.* Along with augmented attention to a multiplicity of localized traditions, particular interest in the *gegants* was greatly spurred in 1982 as a result of three distinct yet noteworthy events: (1) the First Congress of Traditional and Popular Culture, which recognized the importance of the *gegants* and the number of their supporters and recommended the creation of a formal, separate entity to organize, support, and promote this art form; (2) the inaugural ceremonies of Soccer's World Cup in Barcelona, which highlighted a performance by *gegants*, thus introducing them to viewers from around the world; and (3) the First International Caucus of Giants, held in Matadepera, at which viewers and participants alike were delightfully surprised by the attendance of 217 *gegants* broadly representative of a wide geographical area.

The Matadepera caucus was regarded as a defining experience for this artistic genre, so much so that some villages commissioned new *gegants* for the occasion and others renovated their old ones expressly to participate. This gathering was the formal impetus that inspired

numerous other such *trobades.* Gatherings of all sizes subsequently began to be organized several times each year by small villages and large cities alike. Transporting the *gegants* and other *entremesos* from village to village enriched, enhanced, or complemented existing local traditions and created a dynamic throughout Catalunya that resulted in incredible growth during the 1980s in the numbers and quality of *gegants* and the groups (*colles*) that commissioned and cared for them. In some instances, villages resuscitated older traditions, pulling dusty festive figures and floats out of dark storage to be shown off and danced again (sometimes following a change of costume, accessories, and/or personalities that had been effected in an effort to ride out the prohibitions of earlier political winds). In other circumstances, village elders decided that the new construction, "baptism," and regular use of *gegants* was just the thing to promulgate local legends, encourage public participation in civic events, and promote local identity: between 1980 and 1990, 827 new Catalan *gegants* were constructed (Buxó and Tous 2002: 57). In the larger cities, good-natured rivalries and competitions between neighborhoods prompted ever more elaborate festive expressions.

These neighborhood festivals—an outgrowth of and successor to those organized and led by religious leaders—ultimately developed into the contemporary phenomenon of the Fiesta Mayor (in Catalan, Festa Major) found in almost every Spanish community. Although these fiestas are now typically sponsored and paid for by municipal governments, at times they have been funded by popular subscription, with individual families asked to contribute a set amount—sometimes as much as 20 percent of the costs. This sum might be requested in one payment, but in other areas a monthly disbursement was made to support the annual event. Today, it is not uncommon for the sponsoring organization to produce a special ker-

chief, T-shirt, or cap emblazoned with the group's logo or the image of the local *gegants* to sell as a fund-raising promotion in support of the event.

CONTEMPORARY ORGANIZATIONS AND COMMUNITY SUPPORT

The individuals who make up the *colles* that maintain and present the *gegants* are collectively known as the *geganters,* a term encompassing not just those who carry or care for the figures but anyone associated with them, including the musicians who play for their dances and processions. Those who carry the figures are known as the *geganter/a* (anyone helping with any aspect of the figure); the *portant, portador/a,* or *carregador/a* (porter); or the *ballador/a* (the dancer). Not all *portadors* are *balladors:* the dancer must know the appropriate choreography for the dance and be capable

of performing it properly, and some *portadors* will only carry the figures during a parade or procession and will never dance them. In earlier times, when the *geganters* had to ask for financial support from the audience, the one who solicited was known as the *barretinaire,* as he passed his *barretina* cap for the collection. After Franco's death, these groups grew dramatically as they concomitantly experienced a change in makeup: although diverse, the new *colles* were primarily made up of younger volunteers with leftist leanings toward an independent Catalunya. No particular requirements were formally or legally essential to form such a *colla:* any autonomous group that was interested in an ongoing effort to bring the figures out and dance them could so organize. And, whereas in earlier days the *gegants* had been stored in churches and included in religious processions or stored in municipal offices and included in local or national political events,[17] with the "privatization" of the ownership of

Display of *gegants* prior to processional, Festa Major, Lladó, *trobada de gegants,* 2003.

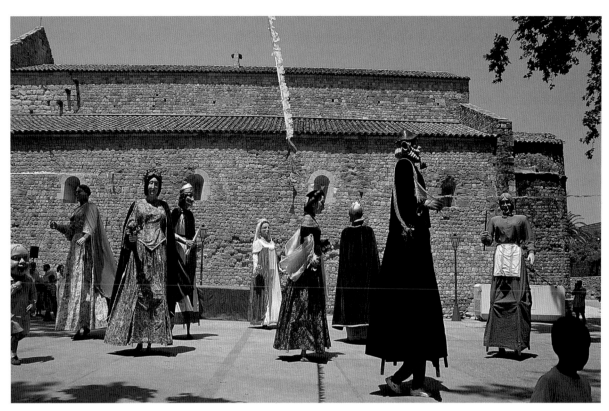

Gegants dancing, Festa Major, Lladó, *trobada de gegants*, 2003.

Reassembling *gegant* prior to processional, Festa Major, Gandesa, 1999.

the *gegants* came the private responsibility of storing these monumental artifacts when not in use. It was not uncommon for several different families to house the separate pieces—one family would take the arms, another the head, and so on. This enabled multiple households to share the honor of storing the figures while subtly acknowledging the scarcity of "extra" space in most private homes.

Not everyone associated with the *gegants* was a member of one of these *colles*, but they became an agglutinating element and basis for activity. By 1984, the 350-plus groups of *geganters*, responding to the recommendations of the cultural congress held two years earlier, decided to organize an association that would help to connect and coordinate their activities. The Agrupació de Colles de Geganters de Catalunya was formed to serve, according to the group's Web site, as a "vertebral column" for the "world of the giants."[18] Now a lively collective for almost 3,000 *gegants* and 20–25,000 people

grouped into 500 entities maintaining continuous, year-round activities, the Agrupació concentrates its efforts on promotion, conservation, and study. The organization has worked to improve the quality of the musical accompaniment, to organize resource courses, to support the formation of new *colles*, and to provide advice to the *geganters*.[19]

Today *gegants* are typically brought out for two different kinds of activities: first, festivals with a traditional origin, such as the processions during Corpus, local or neighborhood festivals, and the like; and second, modern activities such as the *trobades*, interchanges among local, regional, or even international groups that require transporting the figures to perform in other villages. Although the giants were always associated with popular festivals, the custom of carrying them to neighboring villages did not exist until the Barcelona event of 1902, and during the next eighty years only three additional community *trobades* were organized.[20] With the hundreds of annual events held today, each year a new town is honored with the designation *ciutat gegantera* (city of giants).[21] In addition to the cultural exchange, "competitions" among *geganter* groups are now often part of these gatherings: in a typical competition, each *colla* has ten minutes to introduce its figures, present a bit of historical background about them, and perform choreographed dances to musical accompaniment. Monetary prizes and/or trophies go to those groups whose *gegants* are most aesthetically pleasing and dance the best. Although the *colles* are inventive about new possibilities for bringing out their *gegants*, the Agrupació reminds participants that the *gegants* are a symbol of the festival, and "every day is not a festival day": in other words, the groups are reminded not to make the figures so commonly seen that they become ordinary and routine (Grau and Abellan 1997: 245).

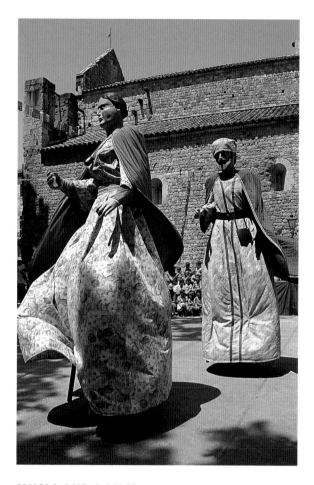

Ventura and Hosta's Lladó *gegants* Jonquera and Llorona dancing, Festa Major, Lladó, *trobada de gegants*, 2003.

MUSIC AND DANCE

For all of the complex technical and aesthetic effort that goes into the creation of a *gegant* or *geganta*, and despite their imposing presence in an upright and stationary position, they are most impressive moving down the streets or dancing in a village plaza, surrounded by their minions of seemingly miniature and innumerable humans. Yet although the particular steps of the *gegants'* dance are not unimportant, they pale in comparison to the significance of the right spirit and "feel" of the performance. Studies have described the *gegants'* steps through labanotation or other diagrammatical chronicles, but this is not, of course, how the dances are learned or transmitted. The broad outlines and patterns of the performances are viscerally absorbed through repeated viewing; the actual

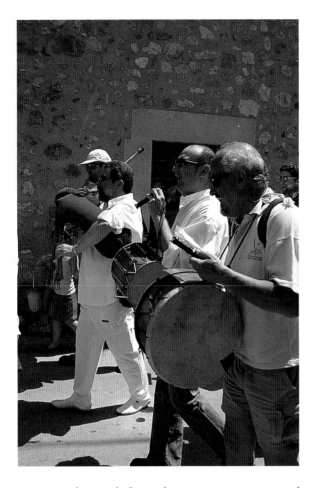

Band featuring drums (*tambors*), reeded flutes (*gralles*), and bagpipes (*sac de gemecs*), Festa Major, Lladó, *trobada de gegants*, 2003.

gralla has six holes on the top, one underneath, and two more lateral ones at the lower edge used for tuning effects. The position of the reed on the player's lips and the intensity with which the reed is blown also affect the tuning.

Scholars have differing opinions about whether the *gralla* originated in India or in the Islamic or Celtic worlds. Its use has been documented in Spain as early as the fifteenth century, and by the end of the nineteenth century it had been added to a small band (*cobla*) also including drum, flute, and bagpipe (the *sac de gemecs*, or bag of moans), which became the customary accompaniment to the increasingly popular *sardana* dance. Although solo use of the *gralla* decreased significantly through the first three-quarters of the twentieth century, the revitalization and increasing use of the *gegants* after Franco's death caused the reintroduction of this little rustic instrument. In many localities, a *cobla de grallers* is now a separate but related group to the *colla de gegants*, always accompanying it to processions, parades, and *trobades*. *Gralles* are often, although not always, accompanied by drummers of *bombos*, *tambors*, or *tabals*. Today, the musicians accompany the giants on foot, but during the eighteenth and nineteenth centuries men playing large drums commonly led or accompanied the processions on horseback (Amades 1983: 105–6). Depending on the area, the *cobla* may play traditional Catalan melodies as well as more recent compositions; rhythms include waltzes, two-steps, *jotas*, and *sardanas*.

steps are learned through a somatic process of repetition and rehearsal. The most typical and traditional giant figures are balanced on the shoulders of a single carrier, and if conflict should arise between balance and choreography, the former will most assuredly win.

Gegants may be danced to a variety of types of music, but one sound has now become standard: the strident and reedy voice of the *gralla*. The *gralla* was initially a shepherd's pipe, its strong and piercing sound played in solitude. Now, however, it has been converted into an instrument of communication whose heightened decibels call the public to join the festivities. Consisting of a wooden pipe some thirty-four centimeters (13.385 inches) long, its two octaves of sound are amplified through a double reed, which is then transmitted to the pipe by means of a small piece called the *tudell*. The

THE STUDIO OF VENTURA AND HOSTA

At the time of Franco's death, only one main enterprise in all of Catalunya still retained the technical ability to produce monumental figures in response to the need to replace those lost over time: El Ingenio, located in Barcelona's Gothic Quarter. Benet Escaler learned a papier-mâché

method at the World Exposition in Paris in 1867 and founded his small shop a year later to create all manner of *gegants, capgrossos* (big-heads), *nans* (dwarves), and other festival objects. Delfí Homs purchased El Ingenio in 1920 after it fell on hard times following Escaler's death, intending to convert the business to religious imagery; however, as the public had become accustomed to purchasing festival paraphernalia there, Homs found himself producing more giants, devils, and masks than religious objects. The shop later passed to his son-in-law, Josep Cardona, and then to Cardona's daughter, Rosa, who continues to run it today.

El Ingenio, however, is no longer the only artisan studio that includes the production of *gegants, capgrossos, nans,* and other traditional objects in its repertoire. Among these other establishments is the studio of partners David Ventura i Bertrán and Neus Hosta i Pasqual, of Navata, a small village west of Figueres in northeastern Catalunya. Ventura, born December 22, 1959, in L'Hospitalet de Llobregat near Barcelona, studied at the Escola Massana in Barcelona, concentrating in jewelry and metalwork, and then began working with his father, a jeweler, further learning to create objects out of assorted metals. During this time, puppeteer friends informally introduced Ventura to the techniques of creating puppets out of sawdust paste. He soon met an experienced artisan who had created some of the large-scale papier-mâché figures for the springtime *falles* in Valencia and immediately became attracted to this medium and its possibilities.[22] Although he began working with the puppets as a hobby, this interest overtook his work in jewelry, and after three years of working with his father he joined the Barcelona group Col.lectiu d'Animació, which created and performed puppet shows in a variety of venues. After returning from his compulsory military service in 1979, Ventura left the puppetry group and moved to La Bisbal d'Empordà.

Ventura and Hosta's 1985 *gegant* Nazari [detail]; 2.7 meters high, 20 kilos; Festa Major, Lladó, *trobada de gegants*, 2003.

Neus Hosta i Pasqual was born in Barcelona on June 3, 1960. Her father was a sculptor specializing in the creation of wooden religious objects, but with nine children, he left this occupation to fabricate window hardware, a more lucrative livelihood. Hosta studied ceramics at the Escola Massana (although she and Ventura did not meet while there) and was restoring dolls and teaching at La Bisbal's Escola de Ceràmica

Ventura and the 1995
geganta Selma, 2.7 meters
high, 19 kilos; Festa Major,
Lladó, *trobada de gegants,*
2003.

house near the church in the center of town. At first they set up a ceramics studio; within two years, however, despite Hosta's reservations, they formed the business Ventura and Hosta and gave up the bulk of their former activities to concentrate on papier-mâché (although both continue to accept occasional commissions in puppetry and ceramic doll restoration). They have three children: Eloi, born in 1984, Anna, born in 1986, and Violetta, born in 1998.

Ventura and Hosta bought and renovated their current studio in 1986; the area around their property on the outskirts of Navata was at first so quiet that they could work in the street because no cars would pass. Initially used just as their workshop, the property has since been modified to include a living area and exhibition space. They began their business by creating little paper figurines for sale in shops, easily adapting the production techniques for the papier-mâché puppets that Ventura had learned in Barcelona. These techniques were also adaptable for the creation of the larger giant figures and big-heads, so they gradually moved toward a concentration on this line of work.

The first pair of *gegants* that Ventura and Hosta made in Navata were a dark-haired mustachioed man named Nazari (bearing an eerie resemblance to Ventura) and a blond companion. Her balance was uneven, however, and she kept falling, incurring significant damage. Creatively addressing that problem, Ventura and Hosta repainted her with closed eyes, as if she were dead, and organized a big, public *festa* in which they solemnly brought her out lying horizontally on a catafalque surrounded by burning candles. Following her "death" and retirement, she was replaced by Selma, a darker-skinned woman who remains in use today. Having learned their lesson, Ventura and Hosta now always test new *gegants* to ensure their equilibrium before releasing them to clients.

At first, the pair attended numerous summer fairs, primarily selling smaller decorative fig-

when a mutual friend introduced her to Ventura. After a year in La Bisbal, they lived briefly in Llers and spent a grant-funded year in Faenza, Italy, where Hosta studied functional ceramics. Upon their return to Catalunya in 1981, they lived in Olot for a few months, then looked for a place in La Bisbal before moving to the small village of Navata, and in 1982 they rented an old

Salvador Dalí figurines, 2001; 20–25 centimeters high.

urines and attempting to secure commissions for larger works. They also created the childlike paper *ninots* (three-dimensional dolls), which were sold in local stores. Ventura's earlier experiments with that format had not sold well, and friends and colleagues counseled Ventura and Hosta to change their line of work because of a perceived lack of market for paper toys. Instead, they became so successful that the artists soon felt that they were becoming too much like a factory assembly line, cranking out innumerable examples of the same figures. Disliking that lifestyle, they consciously decided to redirect their occupational emphasis. As they have become better known for larger *gegants* and *capgrossos,* their manner of working and selling has also changed.

Ventura and Hosta now work almost exclusively on commission, an economic arrangement that not only is more akin to the commercial transactions of past artisans in this field but also enables them to vary their production while simultaneously realizing their artistic visions to a greater extent. They have substan-

tially cut back on their commercial public showings, now presenting their work at only two fairs annually that have proven fruitful in securing additional commissions: the medieval fair in Perpignan (French Catalogne) and a fair of traditional and popular culture in Manresa, near Barcelona. Ventura muses that their business is actually better without the onerous traveling with a truckload of art, for potential clients prefer visiting the studio to purchase or commission work, enjoying the sight of the creative process and the diversity of the pair's products. Ventura and Hosta's works have ended up in cities and villages all over Spain as well as in Western Europe and northern Africa.

Riding the "boom" of interest in traditional arts, actions, and performances following Franco's death provided the couple with the ability to support themselves by means of this historic art form. Within a Spain suddenly inundated by the commercial detritus of western civilization—from Barbie dolls to fast food restaurants—arose nostalgia for the products and the behaviors of earlier times. Ventura's

Ventura & Hosta
CARTÒNS

Ventura and Hosta's van
loaded with *capgrossos* for
transport to client, 2001.

mâché toys will never replace the plastic versions whose hair can be combed, whose bodies can be bathed, and whose clothes can be changed: "It could be said that we're making toys for adults," he grins. Children love the figures too, however, so each year the studio hosts a thousand or so schoolchildren on field trips, and Hosta travels to fifteen or twenty local schools to introduce students to the process of papier-mâché.

THE CREATIVE PROCESS

Until the mid-1980s, most of Ventura and Hosta's commissions for giant figures came from municipal government offices, which remain the pair's most numerous clients. However, neighborhood associations, clubs, museums, churches, schools, private and occupational groups, theater groups, and individuals also place orders. Kings and queens (specifically, *los reyes católicos*) used to be the most common *gegant* requested, particularly during the Franco period, but current fashion is for more personalized and recognizable individuals, including local workers, historical figures, and heroes from local legends and folk tales. Ventura and Hosta seem to particularly enjoy this work, which enables them to creatively explore aesthetic imagery to fit the popular conception. "Nothing is impossible," Ventura has said, "and if a model doesn't exist we will recover one from popular memory" (qtd. in Soler Summers 1994: 6).

When commissioning a new *gegant*, a client may show Ventura and Hosta a sketch or may give them free rein to render the figure. If the job is the creation of a *capgròs* that is a portrait of a particular individual—an increasingly popular commission—Ventura will often work from photos. Sometimes a village will want a certain genre of *gegant* or *capgròs:* for example, a pair of peasants, fisher folk, or typical shop-

career change from jeweler and puppeteer to creator and conservator of papier-mâché figures could not have been more perfectly timed: during their first four years together, he and Hosta eked out a hard living selling small figurines for a mere five hundred pesetas each ($3.50); now they regularly sell out editions of these small works at between thirty and sixty euros each ($40–75). Yet he understands that his papier-

keepers dressed in local costume; a pirate and a robbed victim; or a king and queen. In these instances, Ventura and Hosta often use previously created molds as a basis for the new works. Even when a *gegant* is created anew, arms or other body parts from earlier creations can be appended to the new head and personality. Nevertheless, each large figure is unique.[23]

Ventura and Hosta work closely with their clients to meet their needs. Ventura will discuss several alternate sketches with them before beginning preliminary three-dimensional representations of the image, first at a reduced size and then a second one to scale. He then models a clay sculpture, built up, if necessary, on a substructure of wood, metal armature and screening, or styrofoam; this ceramic figure will serve as the basis for the creation of a plaster mold into which the papier-mâché will be laid. The client comes to the studio to review the full-size clay model while it is still moist, when changes can still be made. Costuming and accessories—nets and needles for fishermen, crowns and scepters for kings and queens, hoes and shovels for peasants, and the like—are also essential components of this process, clarifying and defining the particular personage. It was thought to be so important for the public to recognize the symbolism and significance of the *gegants* as they passed in procession, in fact, that a 1652 regulation in Granada decreed that one of their hands should hold a placard identifying their persona; in addition, verses further describing the character were permissible if desired (Very 1962: 81).

Once definitively approved, the clay original is coated with a liquefied plaster mixture. Depending on the size and complexity of the piece, straw may be added for extra strength, and more mold sections may be required. (Ventura and Hosta's most elaborate sculpture to date was an elephant made for the circus in Reus that required the creation of more than twelve separate molds.) Generally speaking,

Top: Ventura and Hosta portrait *capgrossos* of local historical figures, 2001.

Left: Undated gegant sketch by David Ventura, pen and ink on paper, 31.5 x 21.4 centimeters.

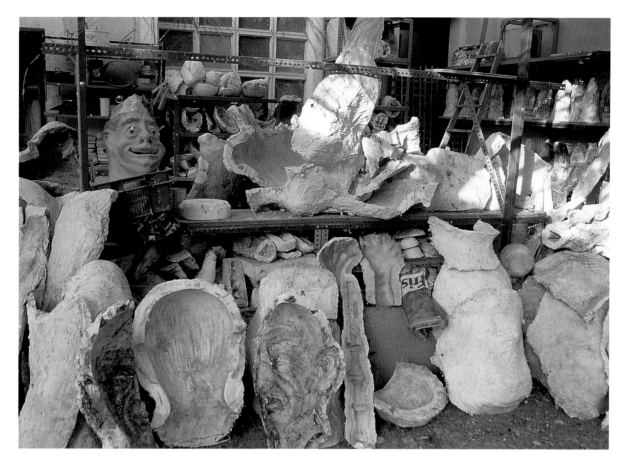

Ventura and Hosta, selected plaster molds, 2001.

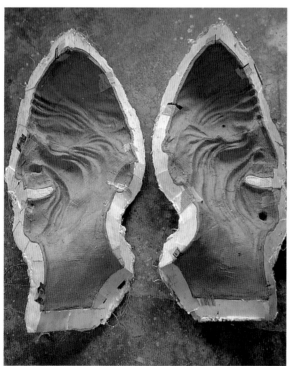

Bottom Left: Face mold for "old man" *capgròs*, 2004. These are the two front sections of the four molds necessary to complete the head. The drying paper has pulled away from the plaster mold surface and is ready to be released and removed.

Bottom Right: Front sections for "old man" (see previous image) and "old woman" *capgrossos*, 2004. All eyes will eventually be cut out to allow the porter to see through, the seams will be smoothed, and the two back sections will be added prior to painting and finishing. Photograph: Sam Hernández

Bull sketch and armature,
Ventura and Hosta studio,
1998.
Photograph: David Ventura

human figures are less elaborate structures than animals because the arms are often designed close to the body; nevertheless, several different molds are still needed for the typical parts, including the head (*cap*), the torso (alternatively known as the *bust, tronc, carcassa, gàbia, còrpora,* or *maniquí*), the arms (*braços*), and the hands (*mans*) (Corts Salvat and Toda Serra 1995: 21). Although other *cartroners* may create body parts out of fiberglass over a substructure of wood or even aluminum, Ventura and Hosta prefer to work in papier-mâché (*cartró-pedra*). It is easily malleable and relatively inexpensive, it is not noxious to work with, and it does not require elaborate tools. It is also a more traditional material. (For special projects or special requests—particularly for creating *bèsties* to be used in *correfocs* [see chapter 3]—they will occasionally use fiberglass instead of paper, but they do not like to work with fiberglass; furthermore, it increases their up-front expenses, which need to be passed along to the consumer.)

After the plaster shell has dried, it is separated from the clay original, transforming Ventura's sculpted form into a more permanent state. Next, two layers of special paper are laid into the concave plaster mold—a thin layer to better absorb the details on the outside and a thicker layer on the inside. Purchased from a specialty distributor in Valencia, this paper is also used by Valencian artisans to create *falles* sculptures. Hosta usually handles this component of the work, helped by longtime employee Mariàngeles Cros. The paper is dipped in a homemade liquid mixture created from flour,

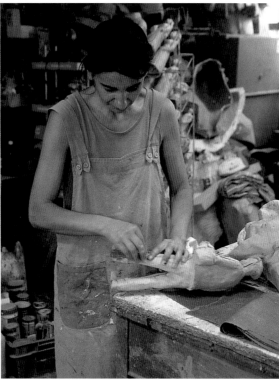

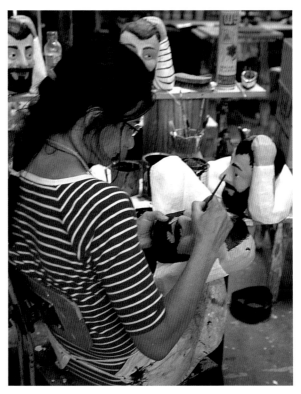

Top Left: Hosta preparing papers for a mold, 2001.

Top Right: Cros pressing glue-moistened papers into a plaster mold, 2001.

Bottom Left: Hosta joining together molded papier-mâché parts, 2001.

Bottom Right: Hosta painting small papier-mâché figures, 2001.

boiling water, and rabbit's skin glue. To further reduce the possibility of separation between the paper layers and to assure that they become a single compact mass, glue is also spread over the top surfaces with a fine brush. The ultimate size of the figure determines whether additional layers of paper will be required: *gegants* need to be sturdier than small toylike horses, for example, and consequently include more layers of thick paper.

The molds are then laid in the sun or in an out-of-the-way corner of the studio to dry. Because the plaster molds are heavy, no bands or ties are needed to hold the parts together. When the water has evaporated, the layered paper slips easily out of the plaster molds, and Hosta or Cros staples the parts together, utilizing small strips of moistened glue-covered paper to cover the seams. After the seams have dried, the staples are removed, the edges are smoothed out, and small details that would not survive the grosser aspects of the mold—for example, the tiny ears of the little horse figurines—are added individually by hand. For smaller works, when the molded paper piece is complete, a white satin latex undercoat (much like gesso but more flexible) is applied.[24] The larger *gegants* and *capgrossos* receive a coat of homemade gesso created from a groutlike substance called Blanco de España and rabbit's skin glue. This combination creates a harder, more enduring surface that will suffer less damage in the course of the regular movement and use of these works. Finally, Hosta finishes the papier-mâché portion of the *gegants* and *capgrossos* by painting them with a latex-based commercial product with a satin or eggshell finish, finished off with oil paint and two coats of exterior varnish for the larger, more elaborate pieces.[25] Details such as wrinkles, moles, hairy knuckles, and "polished" nails are the finishing touches that distinguish the *gegants'* specific personalities.

This, however, is not the end of the extensive process. Ventura and Hosta work with a

carpenter, Narcís Vilà, in the nearby village of Ordis who creates a large wooden substructure (*cavallets*)[26] that supports each giant figure. Ventura does the finishing work on these supports, padding them so that the *geganter/a* can carry the figure on his or her shoulders while remaining completely hidden underneath. These supports are typically constructed out of

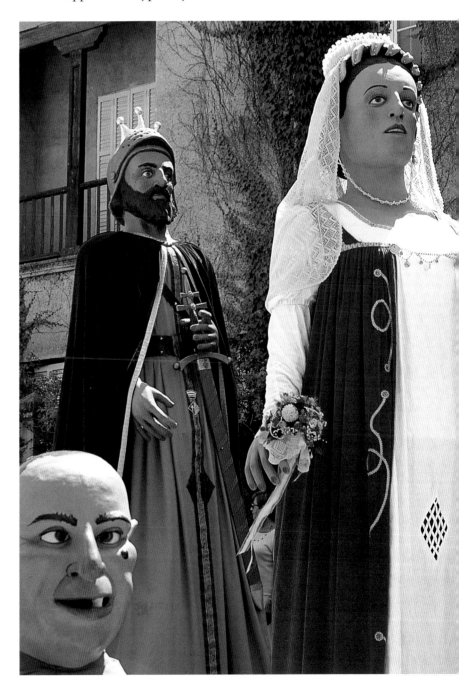

Ventura and Hosta's Besalú *gegants* Bernat Tallafero and Constança in processional with *capgròs*, Festa Major, Lladó, *trobada de gegants*, 2003. The window at Constança's groin area enables the porter to see.

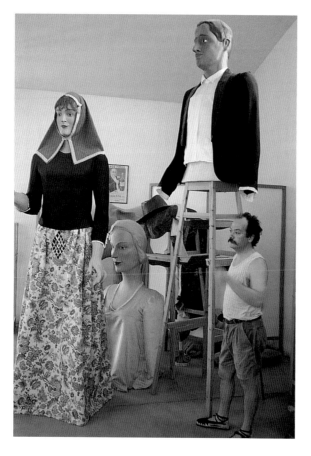

Left: Ventura with assorted *gegants*, Navata studio, 2001. The male figure on the right, without his "skirt," reveals the wooden *cavallet* substructure beneath.

lace, crocheted, or woven "window" roughly at groin or upper-thigh level to enable the hidden porter to see where s/he is going.) Hair is sometimes painted on, although for exceptional figures, Ventura and Hosta may subcontract with a wigmaker, Carmen Vilagrán, also of Navata, to create a special hairpiece out of human hair. Ventura also designs and fabricates the figures' jewelry and crowns as needed. Depending on the size of the figure, the complete fabrication can take between a week (for the small horses, for example) to two months or more for an elaborate *gegant* or *geganta*. Prices range from $6,000 or more for a full-scale giant to $400–600 for a "portrait" *capgròs* and $150–300 for a more typical *capgròs* for which a new plaster mold is not needed. Smaller figurines—including miniature-scale replicas of Ventura and Hosta's *gegants*—sell for $40–75. Although these prices have increased greatly over the past decade, they remain low given the amount of dedicated work required for design and construction.

poplar, a lightweight wood; nevertheless, the figures are still awkward and heavy, so the substructure has four legs that allow the porter to easily set the figure down between dances or processions. Ventura and Hosta also work with a local seamstress, Carmen Pineda of Navata, who creates elaborate costumes to personalize and identify the figures. As a rule, Ventura and Hosta buy the fabric needed for this part of the process in Barcelona and specifically instruct Pineda in the desired effect, providing her with detailed sketches. The costuming is an extremely important part of defining the personality of the *gegant* in terms of its role, its time period, and so on. It is also an expensive component: between seven and eight meters (7.6–8.6 yards) of satin, silk, and velvet are typically needed to create a flowing costume that will drape to the ground and hide the porter's body and legs. (The front of the costume has a

THE *GEGANTS* AND THEIR COMMUNITIES

The first time a giant figure is introduced to its community, special ceremonies take place, including a "baptism," which is usually consecrated with *cava* (Spanish sparkling white wine in the style of champagne) rather than with holy water. New *gegants* typically are presented by their "godparents," other monumental figures from the same or nearby towns. The new figures' names and personalities are often decided by popular vote, perhaps by village residents or, more selectively, by members of the *geganters* group or by the association that sponsored the construction. In Ripollet, for example, a broad public referendum was held to select the style of the *gegant* as well as its name: the "classical" option won with 53 percent of the vote (Dalmau i Corominas 1991: 4).

Names of *gegants* and *gegantas* reflect important historical figures, heroes of popular legends or biblical tales, quintessential local occupations (for example, potters, farmers, fisher folk), popular local names, names reflective of local geographical or topographic features, names of a major financial sponsor or supporter (also often known as the "godmother" or "godfather"), names honoring the eldest inhabitant, the first mayor, an Olympic champion, and so forth. Some contemporary figures reflect human constructions, such as the three *gegants* of Barcelona's Poble Sec neighborhood, which were created in the form

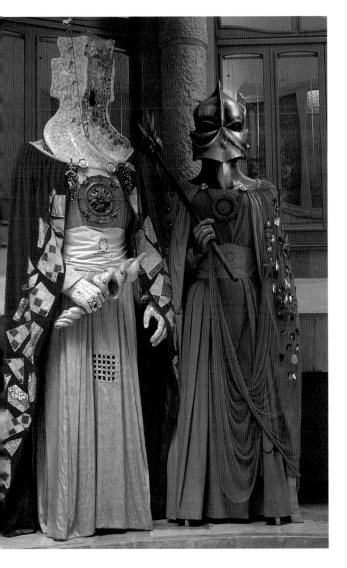

of the three industrial chimneys that configure the silhouette of the area, or the pair whose busts are in the form of the roof ornaments of Gaudí's apartment building, La Pedrera. A popular *gegant* in Reus is a Catalan guerrilla fighter, underscoring the often nationalistic bent of these sculptures. Figures of *Moros* (Arabs/Africans) have been in and out of fashion over the centuries; although they are typically regal and statuesque, with sumptuous textiles and a myriad of jewels, they allegedly were originally constructed in derisive satisfaction to gloat over the vanquished enemies of the Reconquest. However, other analyses suggest that as they dance in harmony with their Christian counterparts, the *Moros* personify the spirit of *convivencia,* peaceful coexistence with ones neighbors. Similarly, Jews and Jewesses are occasionally but less commonly created, previously as an epitome of any non-Catholic figure (that is, as an incarnation of impiety and sin) but now, in politically correct parlance, said to represent the principle of tolerance (Abadal 1995: 33).[27]

Aesthetic changes occasionally are requested if public controversy arises about their appearance. Modification of existing figures is a relatively easy process when working with the typical papier-mâché base. Hosta has had to add a king's mustache or make a queen's face look less "peasantlike"; Ventura has had to rework *gegantas'* chests, making them bigger or smaller, adding nipples, and so on.

REPAIRS AND RE-CREATIONS

The repair of damaged figures follows the same lines as the creation of new ones, and reparation and conservation represent a significant component of Ventura and Hosta's activities. Now dancing at an increasing number of events, the *gegants* are more likely to become unbalanced and fall, breaking limbs, scratching

Gegants honoring Antonio Gaudí's La Pedrera apartment building, Barcelona, 1999.

Top: Ventura and Hosta restoration of *gegant* bust, 2001.

Bottom: Ventura restoring bull (2000) prior to Fira del Foc display, 2004.

paint, and denting body parts. Prior to any repair, Ventura and Hosta closely examine the damaged pieces to ensure that the subsequent restorations match the original work as closely as possible. Dents or scratches are slowly and carefully sanded with sandpaper: particularly in the case of older figures, neither the condition nor the subsurface medium can be completely ascertained in advance. In some workshops, hands and faces were carved from wood and then painted, with papier-mâché used, if at all, for less prominent body parts or to cover the lower wooden or metal substructure. Other media used in recent years include *maderón,* a paste made from almond husks; earlier reports, such as one from Madrid in 1661, described figures made of clay or white gypsum. After the clay was fired, it was apparently immersed in boiling pitch "until it took on the similitude of wood," and the hands were lined with canvas for extra strength before being "colored glossily and adorned" (qtd. in Very 1962: 80). Whatever the original material, Ventura and Hosta fill scratches and dents with putty and then cover the entire area in gesso, finalizing it with a latex paint toned with appropriate stains or grounds matched to the existing colors. The re-creation of broken or missing jewelry is handled by Ventura or subcontracted out to a jeweler; prior to being reaffixed to the figures, the metal pieces are well cleaned, polished, and coated with a special varnish that will help preserve their appearance. A seamstress oversees the cleaning of the clothes and repairs or replaces any faulty pieces. A qualified wig-maker or hair stylist handles work on the wig.

Ventura and Hosta also receive commissions to create replicas of older figures, such as the eighteenth-century baroque-style *drac* of La Bisbal d'Empordà or the *gegants* of Girona (dating from 1843 and 1845). Such replicas are usually commissioned to provide new, stronger figures for the sometimes hazardous street dancing; when the reproductions are com-

pleted, the originals are typically retired to local museums. Replicating antique figures is somewhat more difficult than creating new works because Ventura and Hosta must protect the older structure while using it as a model for the replica. In these situations, rather than using plaster over clay, the artists cover the original *gegant* with a coat of Vaseline and then apply several coats of silicone to make the mold, from which a copy is made out of polyester and fiberglass. Manipulating the polyester and fiberglass is more difficult and "less agreeable" than using papier-mâché, but applying plaster to the original figure would damage it; the silicone, however, cleanly and easily releases from the original. Fiberglass is heavier and harder to support while dancing; however, one of its benefits is that it is more resistant to damage from such standard hazards as rain, falls, and transportation.

Although Ventura and Hosta's goal is to create a replica that is virtually indistinguishable from the original, clients at times have certain requirements that complicate the process. The commission to replicate the antique pair of giants of Girona was problematical, for example, because the client wanted the replicas to be significantly lighter than the originals so that the figures could more easily navigate the streets of the old city. The new 3.5 meter (11.375 foot) tall figures created by Ventura and Hosta weigh 40 kilos (88 pounds) each; the antique ones of the same height weigh 70 kilos (154 pounds). Full-size replicas generally range in cost from $5,000–7,000.

VARIANTS IN SIZE AND STYLE

The combined height and weight of the giant figures is such that it takes practice to hold them properly, let alone to dance them in a crowd. Balance and equilibrium are thus supremely important. Although the best arti-

sans have mastered this component almost intuitively, a strong wind can be enough to cause a preemptive cancellation of a giant's performance, for once a figure becomes unbalanced, it is almost impossible for the *geganter* to prevent it from falling. Older *gegants* are typically much heavier than those constructed now; the pair of giants from Olot dating from 1888, for example, weigh 110 kilos (220 pounds) each. Balancing these heavy figures was so taxing that the porters were said to have spelled each other every five meters (Buxó and Tous 2002: 58). And although today most carriers are volunteer members of the *colla d'amics* (group of friends) that sponsors and manages the *gegants*, historically and up through the pre-Franco era, the carriers were paid small fees for their labors.[28] Known as *bastaixos* (*bast* means packsaddle) because of their connection to those laborers who carried heavy weights, the

Manote-style gegant, Festa Major, Gandesa, 1999.

carriers were even more typically paid with a new pair of *espardenyes* (rope-soled sandals) (Buxó and Tous 2002: 58; Gamero 1994: 18).

Although most *gegants* are monumental, variations in structure or scale do appear. Examples include the *gegants de motxilla*, carried on the porter's back like a backpack (*motxilla*), with no wooden substructure; *gegants en pal*, smaller figures balanced on poles stuck into the belts of the porters; *gegants manotes*, with long, flexible arms that can whirl around, lightly slapping members of the crowd; *gegants amb cames*, lighter figures with movable legs, carried only by men; *gegants de mig cos*, figures with only half a body, thus showing the legs of the porters; and even *gegants per a nens*, small enough to be carried by children (Corts Salvat and Toda Serra 1995: 22).

NANS AND CAPGROSSOS

Since Joan Amades's pioneering 1934 study, *Gegants, Nans, i Altres Entremesos*, Catalan folklorists have followed his lead by dividing the traditions of the creation of these fantastic creatures into three separate realms: (1) the *gegants*; (2) the *nans, capgrossos*, and *cavallets* (little horses); and (3) the *bèsties*, otherworldly beasts such as dragons. Ventura and Hosta, however, as well as most other artisans in this field, are not as specialized in their labors. Ventura and Hosta typically produce two or three pairs of giants each year along with a monumental beast or two, dozens of *capgrossos*, and more than a thousand smaller figurines.

Although the *gegants* can be directly linked to the Corpus processions resulting from the promulgation of the 1264 Holy Acts, the dwarves and big-heads did not appear in popular processions until at least two centuries later; the earliest confirmed data places them in Valencia in 1559 (Pujol 1993: 5). However, not until the end of the eighteenth century did the terms *nan* and *capgròs* become commonly used to describe this particular category as a separate and integral part of festive processions (Moya 1994: 101).[29] While the terminology is often used interchangeably, the *nans* tend to include portions of the body or bust, whereas the *capgrossos* are solely an outsized head. The *capgrossos* provide a greater opportunity for personal interpretation by carriers than do the *gegants*, since more of their bodies are evident; the effect is that of a strangely deformed but pixielike creature. From the beginning, the smaller figures had a role subordinate to the giants, resulting from their size, the typically grotesque exaggeration of their features, and their playful aspects, all in contrast to the elegance and stateliness of the giants. This subordinate role also results from the fact that they often appear in pairs or in groups, preceding the giants to open up a path through the streets. This task is accomplished sometimes by dancing, sometimes with sticks or rods, playfully but surely scattering the crowds. Although scholarly texts' discussions of *nans* or *capgrossos* tend to specifically link them to and contrast them with the *gegants*, in some instances—particularly in poorer villages lacking the wherewithal to commission an expensive *gegant*—the smaller figures may appear without their larger, more majestic, counterparts. And although they appear less commonly outside of Catalunya than do the giant figures, within the region it has been estimated that more than 15,000 heads are currently extant (Carbó, Grau, et al. 2000: 13). Nevertheless, to date, a separate organization concerning itself solely with the heads has not been structured; their needs are subsumed under the Agrupació de Colles de Geganters.

By virtue of their size, the *nans* and *capgrossos* are, of course, carried differently from the *gegants*. The dwarves or big-heads, com-

pletely constructed out of papier-mâché or fiberglass with no wooden substructure, rest on top of the carrier's head, shoulders, upper back, and upper chest and, like a helmet mask, require viewing through holes cut in the head's nostrils or mouth, depending on the shape and size. If the *gegants* exude power and inspire respect, the *capgrossos* are misshapen and comical, serving as the perfect contrapuntal figure to enliven and energize the festivals with a contemporary burlesque. The *capgròs* is masklike in that it portrays a certain personality, but it is the wearer's gestures and movements that bring it to life. More than the *gegants,* who, although named and specifically identified, tend to be generally archetypical in their personas, the *capgrossos* are likely to be created with personalities drawn from contemporary culture, including caricatures of local public figures (to honor or to ridicule), cartoon characters, cur-

Left: Ventura and Hosta's
Navata *capgrossos* in proces-
sional, Festa Major, Lladó,
trobada de gegants, 2003.

Right: *Capgròs* in proces-
sional, Festa Major, Banyoles,
2001.

Capgrossos in style of Picasso's paintings, Horta de Sant Joan, 1999.

Fisher folk and devil capgrossos by Ventura and Hosta, each 50–70 centimeters high, 2001.

rent fashions, well-known images from paintings, and the like.[30] Typical figures include the "captain" dressed in a three-cornered hat in the fashion of the late eighteenth century, harlequins, Africans, peasants, Asians, and fishermen. Others reveal the two general trends in subject matter often found in such arts: satirical but generally realistic personages found in daily life, such as pairs of cats and dogs (Balaguer), girls and boys (Reus), the sun and moon (Navata), or a doctor and nurse (Tarragona); and the exotic, the exaggerated, or the grotesque, such as hunchbacks (Berga), punks and clowns (Banyoles), jesters (Vic), Frankenstein (known as Franki, in La Bisbal del Penedès), witches (La Coromina), or devils (Vilajuïga). A Mick Jagger *capgròs* is rumored to exist somewhere in Catalunya.

The cost of commissioning *capgrossos* and *nans* is proportional to their relative size and the fact that there is no need for elaborate costuming or wooden supports. Consequently, the heads are generally much more affordable and therefore more common than the *gegants* and thus are more likely to serve in a variety of more strictly ludic roles. Amades has suggested that the *nans* originally appeared in three pairs, representing the three human races descended from the three sons of Noah and their progeny after the flood, which he described as the Europeans, the Gypsies, and the Africans (Ajuntament de La Bisbal 1995: 6).

CAVALLETS

A smaller subgenre of works created by *cartroners* such as Ventura and Hosta are the *cavalls* or *cavallets*, figures of a horse's head and neck joined by a frame to its back end. In contrast to the other *entremesos*, which are typically carried from within, resting directly on a porter's head or shoulders, the gap in the middle of the *cavallet* enables it to be worn around the waist of its carrier, hung from his or her shoulders with leather or cloth suspenders. The *cavallets* were also known as *cotonines*, *cavallins*, or *cavalls cotoners*, referencing either the guild that originally performed this dance or the cotton "skirt" that formed the body of the horse and covered the thighs of the "rider."[31] Variously looking like centaurs or soldiers on horseback, these combination figures are apparently derived from a cycle of legends that hearkens back to Pliny the Elder. According to Amades (1983: 133), Pliny's *Natural History*, book 8, tells of the Sybarite army, expert and well armed, which had trained its cavalry horses to dance. In one battle, the greatly outnumbered Crotonite army had little chance of beating the mighty Sybarite warriors and consequently resorted to a ruse: their musicians began playing the Sybarite horses' dance music, causing them to dance and enabling the Crotonites to emerge victorious. In celebration of this feat, the dance of the *cavallets* came to be widely performed.

1999 *cavallet* displayed in Ventura and Hosta's exhibition room on sawhorses, which are removed during performances. Painted papier-mâché, 85 × 130 × 40 centimeters, 2004.

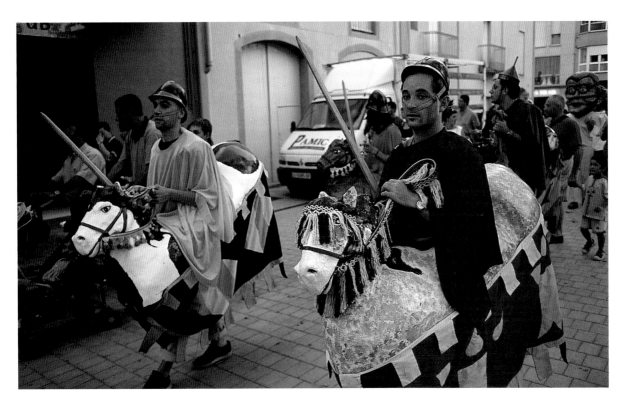

Cavallets in processional, Festa Major, Banyoles, 2000.

Cavallets and *capgrossos* at rest, Festa Major, Banyoles, 2000.

Above Left: 1981 Ventura and Hosta processional, 22 x 140 x 51 centimeters, on display in Navata studio, 2004.

Above Middle: 1982 Ventura and Hosta hooded penitents for Semana Santa (Holy Week) processional; combined piece 67 x 21 x 18 centimeters, on display in Navata studio, 2004.

Above Right: 1994 Ventura and Hosta Catalan *caganer* (shitter), 100 x 60 x 60 centimeters, on display in Navata studio, 2004.

Bottom: Ventura and Hosta *correfocs* scene, ca. 1986, 10 x 30 x 30 centimeters, on display at Fira del Foc, Banyoles, 2004

Catalan and other regional Spanish variants of the *cavallets* tend to refer more specifically to battles perpetrated by "Moors" or "Turks" against outnumbered Christian forces and often alter the trickery component to reflect a hurried but clever construction of horse sculptures, which by their great numbers scare away the invaders. A further variant depicts pirate brigades (again, usually Turkish or Berber) menacing the Spanish coastline, which is guarded by Christian cavalry mounted on horseback. The vanquishing of the evil or infidel forces is abstracted into a formalized dance, choreographed to take advantage of the illusion of the horse with armed rider. (Although cast in the role of the infidels, the Moors often have more

sumptuous costumes than the Christians do; consequently, certain performers preferred—and still prefer—to play Moors than to play victorious defenders of Spanish Catholicism.)

The persistence of this dance in Spain results in no small part from its role in celebrating the emergence of the strong Christian nation after "reconquering" the peninsula from the Muslim forces. The earliest (although unconfirmed) report of a dramatic mock battle between Moors and Christians is from Lleida (Lérida) in 1150, less than a year after the Muslim defeat there.[32] From Lleida, the dance traveled east as well as west and south across the entire peninsula as the Muslim fighters retreated in the face of the advancing Christian troops. To this end, this dance-drama functions in Spain rather like a foundational myth, although in countless iterations found in other lands colonized by the Spaniards it has taken on a broader range of meanings less tied to historical legends recounting the repossession of territory than to more generalized battles describing power struggles between the righteous and the infidels as locally and often contemporaneously defined.[33]

However, scholars have not yet confirmed whether the earliest dance-dramas included assembled *cavallet*-type constructions or simply costumed dancers engaging in mock battles. A Dutch citation from 1359 noted by De Roos does mention the constructions (qtd. in Harris 2000: 255), but although the Corpus Christi processions enlivened Barcelona streets from 1320 on, it is not clear how early the *cavallets* were used in Catalunya. The first specific documentation is the 1424 Corpus procession in Barcelona; subsequent descriptions of mock battles between the *cavallets* and "Turks" were recorded in 1443 (in Naples but organized by Catalans to herald Alfonso the Magnanimous, ruler of Aragón-Catalunya [Harris 2000: 47]) and 1448 (Amades 1983: 139) as well as frequently over the succeeding centuries. Despite

the apparent birth of this performance in either royal (Lleida) or ecclesiastical (Barcelona) arenas, by the fourteenth century its annual repetition as part of the street-centered processions during Corpus encouraged lay innovation, modification, and development, and it became more the domain of the "folk." *Cavallets* today may appear for Corpus, for the Festa Major, or for other municipal or neighborhood celebrations. The *cavallets* sometimes are used much like the *nans* to part the crowds but more often take part in choreographed "battles" in which the Christian forces emerge victorious. Similar ritualized clashes are found in southern France, Portugal, the Philippines, India, and, even more widely, across large areas of Mexico and the Americas. Many but not all of these performances use constructed representations of mounted riders.[34] In contrast to the monumental scale of the *gegants, capgrossos,* and many of the *bèsties* described below, the *cavallets* tend to be smaller than the actual horses that they represent, revealing a different but still startlingly disproportionate juxtaposition with their human porters.

Another subgenre of Ventura and Hosta's work focuses on processions, iconographic symbols of religious and secular community observances. Spain's most striking procession occurs during the Holy Week celebrations in Seville, where the penitents wear pointed hooded masks called *capirotes* (in the style later made infamous by the U.S. Ku Klux Klan). Ventura and Hosta have created this scene several times on a variety of smaller scales. They have also produced a model Procession of the Dead, a medieval ritual still performed in nearby Verges for Holy Thursday, and a miniature depiction of a *correfocs* (see chapter 3). Other intrinsically Catalan figures, such as the *caganer* (the shitter), who is found in the background of numerous Catalan images from Miró's paintings to Christmas crèches and performances, are also part of their standard repertoire.

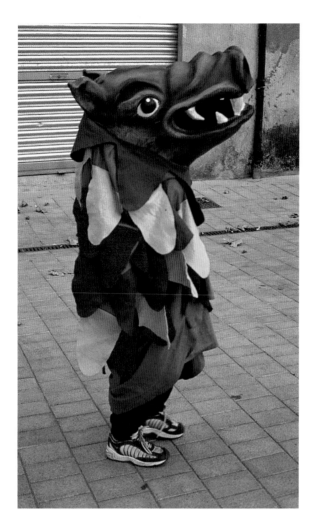

Dragon *capgròs* in processional, Festa Major, Banyoles, 2000.

BÈSTIES

Representations of diverse animals—real and imagined—have been part of Spanish processions and performances for centuries: "No hay procesión sin tarasca, ni función sin fraile [there can't be a procession without a dragon, or a service without the clergy]," quotes the Spanish proverb. Dragons have always been the most widespread creatures to appear; although in ancient times a representation of the omnipotence of nature, their inclusion in processions since the beginning of the fourteenth century is said to serve as a reminder of the Beast of the Apocalypse, the strength of the Catholic faith, and the constant vigilance that

good must maintain against evil in all its incarnations. One of the most important legends, linguistically speaking, was St. Martha's killing of a huge dragon, Tarascó. This beast is generally considered the precursor of representations of this kind, and the word *tarasca*,[35] although used particularly in reference to the dragons in Corpus processions, has, since medieval times, come to refer to a variety of monstrous animals and to symbolize all manner of satanic passions, heresies, sins, and evils.[36] Yet such representations clearly did not emerge fully formed in the Christian era; indigenous concepts of fantastic beasts go back at least as far as Celtiberian times (Caro Baroja 1957: 62, 68), while others, brought over with the Greek and Roman soldiers, became antecedents for the fusion of various malevolent beings by the Church into these singular incarnations of vice. Animals with more positive symbolic connotations, of course, also continue to be created and utilized in Catalan processions and performance events.

The range of such *entremesos* is significant and invites comparison and classification through a variety of means, although an in-depth discussion of this topic is beyond the scope of this book. Function is of primary importance: whether the creature is used in religious processions, secular parades, street theater, *correfocs*, or a combination of these events. So too is the symbolic source: whether it emanated from a traditional local or national legend, whether it is a contemporary theatrical innovation, whether it has social or occupational significance, whether it is derived from international mainstream culture, and so forth. The kind of music and dance that accompany the performance represent a third level of classification; a fourth is the construction/performance technique—for example, whether the creature is carried from the inside or outside, by human or mechanical conveyances, and so on. Fifth, the territory that the image covers is also

Ventura sprays an undercoat of paint onto his replica of Girona's eagle, 1992. Photograph: Neus Hosta

Eagle replica for city of Girona [detail], 1992. Photograph: David Ventura

important: whether it is used over a broad region or found only in tightly circumscribed areas, like the local representation of Count Arnau's hellish ride, described below. Despite the potential structural and aesthetic variants, however, the number of different kinds of such beasts is comparatively small and can be categorized as a few primary types that have been maintained for the past several centuries and remain popular and routinely performed and presented. The community ministry (Consell del Comú) historically distributed the responsibilities associated with each type of beast to appropriate guilds and associations; this was of great importance in maintaining the vitality of the tradition, as each guild competitively invested in the enhancement and improvement of the beasts under its care. In more recent times, municipalities, neighborhoods, or community groups have assumed proprietary inter-

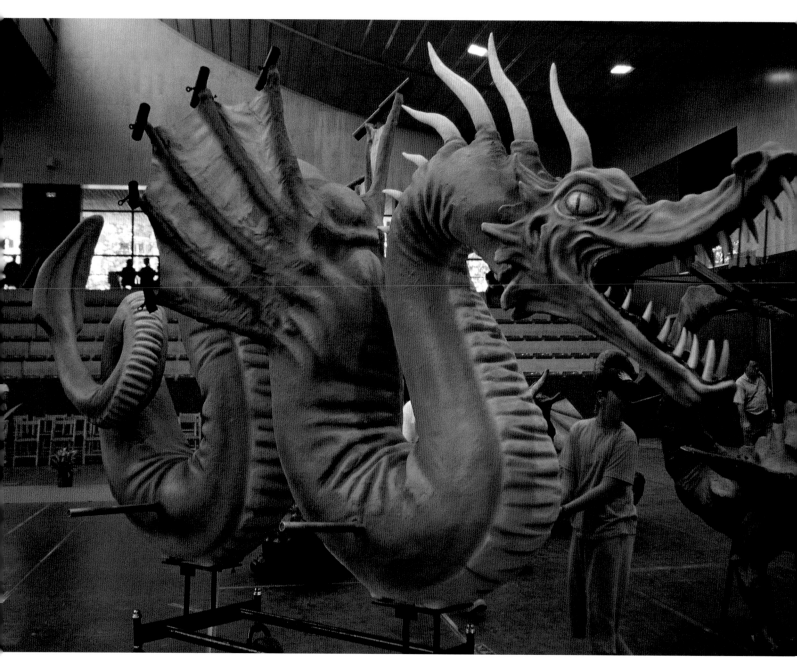

Braulio de Sant Joan Despí dragon, created in 1989 and belonging to the Colla de Diables de Sant Joan Despí; on display at the Fira del Foc, Banyoles, 2004.

est in the assorted historical or newly created *bèsties.*

L'Àliga (the Eagle): the most solemn and regal of the beasts found in folkloric processions, noted in very early sources.[37] During the Middle Ages, the Church syncretistically absorbed the eagle's pre-Christian connotations of majesty, danger, and nobility, linking it to the Pathmos eagle of John the Baptist. An eagle

was said to have marched alone in the Corpus processions of 1424, directly behind the apostles, an indication of its importance. Close to God and the angels as it soars through the air, the eagle has also retained characteristics linking it to governmental sovereignty and thus has been used to represent municipalities or regions, including an independent Catalunya as well as, more generally, Justice itself. Because

of this link, fewer eagles are found than *entremesos* of other types. During medieval times, dancing the eagle was said to be the most important symbol of hospitality that could be proffered by a city, and, alone among the *bèsties,* was retained by the municipal ministry rather than having the responsibility for its upkeep delegated to an occupational guild. However, after the second half of the eighteenth century, the eagle seemed to lose some of its specific character, becoming more akin to other processional figures. When the eagle is danced, the choreography is meant to represent the bird's flight: grave, powerful, and calm.

El Drac (the Dragon): the most commonly produced and presented beast. The earliest reference to this dark and powerful creature's appearance in public performance events comes from the fifth century. Danced as part of Corpus and other Church-related processions, the dragon symbolizes dominance over a variety of evils, both natural, such as earthquakes and plagues, and human-created, such as inappropriate carnal passions. The dragon also figures prominently in *correfocs* events (see chapter 3), where, with its devil master, it becomes "lord" of the world, at least for a night, before being vanquished by the forces of good. With numerous variants rendered over the years in illustrated handbooks and painted ceramic tiles, dragons are typically depicted as winged reptiles with large forked tails and scaly or lumpy skin. They can have as many as three to seven heads, hydralike, or simply three tongues extending out of a single gaping mouth. Although some dragons can be carried on the shoulders of one person, others need several internal or external human assistants for proper and fluid functioning. Still other examples are mounted on wooden carts resembling stretchers or on metal wheels for easier movement. Most dragons today are constructed out of fiberglass, polyester, or papier-mâché, but early examples were often canvas draped over

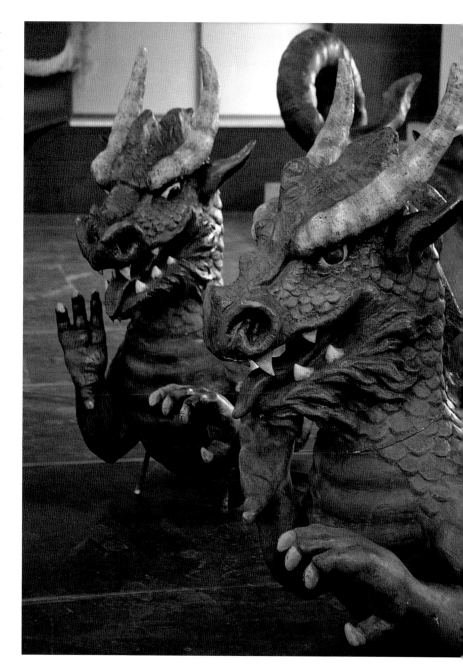

wooden substructures (Varey and Shergold 1953: 19). Those created for use in *correfocs* are accessorized with pincers for the attachment of fireworks and roman candle–like sparklers. By the late sixteenth century, the well-diggers guild was typically charged with handling these processional dragons, possibly reflecting their primal Near Eastern incarnations as an aquatic monster (Very 1962: 75).

Two of five similar dragons belonging to the Cua de Drac group of Cornellà de Llobregat. Designed by Laura González of the Taller Sarandaca in 1997; on display at the Fira del Foc, Banyoles, 2004.

La Víbria (the Female Dragon): taking its name from the Catalan word for viper or poisonous serpent, this figure dates from at least the late fourteenth century and was the responsibility of the blacksmith's guild. Aggrandized and made more fantastic through popular imagination, this winged and scaly reptilian creature typically displays wings, a serpent's tail, female breasts, and a long (and often fiery) tongue, frequently protruding from beaked lips. The *víbria* appears at times as the dragon's wife and at other times alone, when it is sometimes mistaken for the dragon itself if no breasts are evident. The *víbria* is the dragon said to have

fought with St. George and has come to symbolize the essence of evil and temptation.

La Mulassa (also known as *mula fera* or *mula guita*): another popular fantastic beast, cited for the first time in descriptions of festivities in Olot in 1444. It is a large mulelike creature whose body is draped in a wide covering; often only its head and neck can be seen. It is typically carried from within by two porters, one inside the front area and one behind. Fireworks are often attached to its mouth. The origin of this creature is unclear; some scholars suggest that it may be a modified version of the mule that assisted at Christ's birth, although that mule was depicted sympathetically and the *mulassa* is usually depicted as angry and ferocious, looking for the opportunity to pursue and hurt the onlookers; as such, it is said to be a symbol of recklessness and irresponsibility. In the Middle Ages, the *mulassa* was linked to the furrier's guild.

El Lleó (the Lion): another example of an *entremès* that took part in the 1424 Corpus processions; however, the earliest citations refer to a man dressed in costume rather than a constructed figure per se. It was worn by a member of the *blanquers* guild (the bleachers or launderers), and guild members remained responsible for carrying it when it later appeared as a constructed figure complete with royal crown. In some areas the lion figure and "wild men" (sometimes called *lleonets*) armed with clubs simulated a battle at specified points during the procession. It is a symbol of majesty, valor, and power.

El Bou (the Bull): linked to the butcher's guild and included in popular processions as early as 1464. The bull often appeared at the head of such processions, sometimes mischievously charging at the spectators and the children to open the way for the figures and floats that followed. A recent incarnation with complex symbolism is the fire-breathing *bou de foc* of Manresa, a city west of Barcelona; Ventura and Hosta

Ventura and Hosta bull, 2000, festooned with small firecrackers and attached to a cart that carries additional pyrotechnics for use in *correfocs*; on display at the Fira del Foc, Banyoles, 2004.

Left: Ventura's sketch for the female otter used in the Salt *correfocs* (see chapter 3), pen and ink on paper, 31 x 2.5 centimeters, 2000.

Right: "Baptism" of Ventura and Hosta's otter, Salt (detail), 2002.

have also created a bull for Navata, the over-sized head attached to a metal cart on wheels used to hold pyrotechnics. Many ancient peoples believed the bull to be a sacred animal, and it has been found in a variety of cultural manifestations throughout Spain, from totemic cave drawings to contemporary sports, marketing, and political representations, so its specific original meaning and origin have been lost.[38] Nevertheless, it retains its symbology as a potent, tenacious, willful creature.

La Cuca Fera: a strange creature whose name at times has been used to describe such diverse representations as dragons or assorted *tarasques.* Found earliest in the areas around Tortosa and south toward Valencia along the Mediterranean coast, the *cuca fera* looks like a huge turtle with dragon claws. Its body is formed by a covering like a turtle shell with a horned spine, and the head, sometimes movable, is that of a ferocious yet humanoid dragon. The draped cloth underneath the shell hides the legs of the porters who carry it.

Other animals are also seen, including goats, assorted birds of prey, rats, otters, and *tarasques* (with cats' heads, turtles' bodies, and scaly legs and back ends). More individualized creatures are also produced. During the summer of 2001, for example, Ventura and Hosta created a fearsome figure of a rearing animal that was half horse and half dragon. Commissioned by the small village of Gombren, located

Count Arnau's horse, created for the village of Gombren, 2001. 2.8 meters high. Photograph: Neus Hosta

The countryside was in an uproar over this immoral deed, and the people apprehended the count, condemning him for all eternity to ride his horse without ever stopping to rest. To this day, the legend says, the sound of his galloping horse is still heard in the steep mountainous passes, and people claim to catch ghostly glimpses of the hellish flames licking at his feet. Working from this legend, Ventura created the devilish, rearing animal, positioning spots at the horse's mouth and hooves for the placement of Roman candles that would overtly delineate the flaming, tortured, interminable ride of this evil noble. Such fantastic beasts are utilized in the same manner as the *gegants*—parading in procession or dancing in the plaza. The addition of pyrotechnics also extends their use so that they may introduce or participate in a *cercavila* of *correfocs* (see chapter 3).

FESTIVE IMAGERY AND THE *FESTA*

Gegants, capgrossos, and various *bèsties* do not represent a veritable chronicle of history, a purely folkloric construct, or a reinvented tradition but instead reflect aspects of all three. As authentic festival accompaniments, these figures maintain variations and emphases that change with each viewing and performance. Morphing over the centuries from embodiments supporting the Church's teachings to more secular figures connoting elements of local or regional identification and pride through a complex cycle of visual and performance elements, their contemporary potency arises from the fervor of long-suppressed cultural expressions and the rebuilding of Catalan identity.[39] Despite a broken chain of transmission in most venues, the ability to trace the evolution of this art form for at least the past five and a half centuries has provided sufficient justification for the fond adoption of *gegants*

near the "cradle of Catalan civilization" in Ripoll, this impressive figure visually recalls the famous local legend of an evil noble. The Count of Arnau, owner of vast tracts of land, was a wicked man who was said to have made pacts with the devil, defrauded his soldiers, extorted the peasants, and insisted on his right to deflower all of the local virgins. At one point he fell in love with the mother superior of the convent in Sant Joan de les Abadesses, and, unable to distract himself with other maidens, secretly kidnapped her one dark night. Soon thereafter, she was found dead, and it was thought that she had killed herself in shame.

and other *entremesos*—whether older or brand-new—as community mascots. And particularly in those areas where the same figures have formed part of community celebrations for generations, personal and familial memories are strengthened by the total sensory experience of seeing the *gegants* dance, hearing the shrill music of the *gralles* and the rhythmic pounding of the *tabals* or *tambors,* and feeling the breeze produced by the billowing costumes or the heat of the pressing crowd. These sensory memories link with other positive associative images—seeing family and friends, enjoying a holiday with feasting and drinking, and the like—to deepen the significance of each event while helping to guarantee future festive iterations.

This phenomenon provides a tremendous opportunity for the extension of creativity within parameters and expectations set by tradition and popular behavior; as such, it is a desirable occupation for artists such as David Ventura and Neus Hosta. Balancing continuity of technique, imagery, and usage with innovation in each of these areas, the pair has competently and comfortably carved out an artistic niche that reveals authenticity of tradition without stagnation. Immersed in the world of local legend and tradition, they are simultaneously part of modern life, with cell phones, Internet service, and access to and knowledge of contemporary mainstream art happenings. Ventura and Hosta see no inherent contradiction in this balance, as they are constantly and positively challenged by their medium as well as by their responsibility to their client community vis-à-vis content and visual representation. Although they have dedicated themselves to the creation of *gegants, capgrossos, nans,* and the like since 1979, "every day we learn new things," says Ventura. "The technique of constructing these figures isn't something you learn directly; it's something that you learn little by little as you work" (Pulido and Batallé 1994: 29).

Ventura and Hosta's 1987 signature piece depicting workers with *gegant* head [detail]; 173 x 70 centimeters. On display in Navata studio, 2004.

Promotional poster designed by
Jordi "Soco" Gratacós, 2001.

LES GÀRGOLES DE FOC

Diable sóc d'aquest ball,
Diable sóc i seré,
Més m'estimo ser diable
 Que aprenent de . . . sabater.

I am a devil at this ball,
Devil I am now and always will be,
and I'd rather be a devil
Than learn to be a . . . shoemaker.

—TRADITIONAL CATALAN VERSE

Catalans have been known to identify their country as *terra de pas,* the land through which people pass. Thanks to its geographical setting, Catalunya has always experienced a certain level of multiculturalism that has manifested itself in its language, its economy, and its culture. Yet besides the obvious sedimentary effect of the cultural accretions of its various inhabitants, its position as a major crossroads of military and economic transit has also resulted in a somewhat less antithetical outlook by its populace to change and modification of existing tradition. The comment by Catalan poet J. V. Foix (1894–1987), "M'exalta el nou i m'enamora el vell [I am exalted by the new and enamored of the old]" is repeated so often that it has become almost proverbial. While certain aspects of this heritage may be fundamentally conservative, people generally appear to be neither intimidated by nor overly reactive to the capacity to develop and assimilate innovations and changes. Practically speaking, this means that traditional arts and performance events can flourish within new and different contexts; so too, modifications to or innovations within the form or content of traditional arts in traditional contexts can also be absorbed. Both circumstances appear to hold true as long as these changes do not negate or undercut the fulfillment of the cultural and social intentions of the practitioners, ensuring that the modified tradition remains a part of the cultural fabric and not a tangential or irrel-evant curiosity. As Igor Stravinsky has noted, "A veritable tradition is not a testimony to an accomplished past; it is a living force that animates and informs the present" (Soler i Amigo 2001: 23).

The use of fire, one of the four fundamental elements of nature evocative of the primeval beginnings of humankind, is found in numerous traditions throughout contemporary Spain. A compelling and paradoxical element that is at once a provider and eradicator, life sustaining and destroying, object of veneration and symbol of purification, fire is honored by many cultures through creation myths that fix its origin as divine. Whether a gift from the gods or cleverly stolen from them by cultural heroes or supernatural beings, the dramatic change to all aspects of daily life resulting from the domestication of fire ensured that it would always remain vital to communal life. Because fire is the most distinctively human element of culture, it became a requisite accessory to even the most ancient of festive manifestations.

The ongoing uses of fire in Spanish fiestas can be easily seen during the solstice festivals of summer (for example, use in the burning of the *Haros* [huge, stripped fir trunks studded with branch wedges, symbols of appreciation for the gifts of the earth], fireworks, and bonfires for St. John's Day, June 24) and winter (such as the *fogueres* [bonfires] in the Pyrenean villages); the traditional *barraques* (pyramidal constructions of tree trunks, stuffed with

Les Gàrgoles de Foc,
correfocs at Festa Major,
Banyoles, 2000.

brush) of St. Anthony on January 17 in the lower Aragonese lands of the Matarranya as well as in the Mediterranean regions of the Ebre, Castelló, Valencia, and the Balearic Islands; the burning *carnestoltes* (effigy figures of Carnival); and the fiery destruction of the monumental papier-mâché *falles* in Valencia for St. Joseph's Day, March 19 (corresponding roughly to the vernal equinox). It has been suggested that a Spanish translation of the Arabic formula for gunpowder was the key to its European launch, so it is likely that the first use of explosives as part of dramatic street theater appeared on the peninsula as well (J. R. Partington, qtd. in Harris 2000: 191); one early example was its use in 1414 to heighten the impact of mock battles in Zaragoza (with fiery blasts issuing from the rifles of "soldiers" as well as from the flaming mouth of a diabolical constructed griffin). By 1436 the conversion of fire into a magic symbol used to embellish rites and ritu-

als was further enhanced by the development of firecrackers. Then as today, the explosions, smoke, and flashing lights intensified the fear, excitement, and attraction of the fire-based ceremonies for the expectant crowds. Catalans' fascination with fireworks has only grown since those medieval days: it is estimated that on St. John's Day in 1991, more than 6 million explosives were detonated across Catalunya alone (García Rodero 1994: 28).

HISTORICAL BACKGROUND

One of the most intriguing reinvigorated traditions of contemporary Spain is found in Catalunya: the *correfoc*, "running with fire." The paradoxical elements of fire, already accompanying the dramatic tradition of historical street theater, were coupled with the Christian devil, a noteworthy and ultimately

momentous modification of the pre-Christian devil that had personified those natural forces linked by fire to ancient fertility cults. As Christianity extended its political and cultural hegemony over Europe, the chthonic devil of Catalunya—whose multicoded antics also referenced the jester, the entertainer, and the host—was transformed into a monolithic incarnation of evil. Night and the moon became his symbols, in opposition to and contrast with the sun, a common representation of the power of gods and kings. This dark representation of the devil evolved again toward the end of the nineteenth century, when he began to take on characteristics that parodied the solemnity of the ecclesiastically defined struggle between good and evil. Today, the more popularly conceived image of the devil in Catalunya (as well as in other areas of Spain and beyond, including Mexico) focuses on his burlesque, naughty, vulgar, and trickster characteristics; these traits correspond more closely to the behavior of some of the "devils" in the groups that run the *correfoc* than to those familiar devils of orthodox Catholic doctrine and iconography.

Early descriptions of performances featuring devils are linked to the Holy Acts (Actes Sagramentals) promulgated by the Church in 1264.[1] Exemplifying moral acts of faith and valor, these performances were greatly encouraged and supported by the provincial religious authorities. Although the earliest Corpus celebrations in Catalunya took place within church walls, by 1320 the procession and related events had generally spilled out into the streets, and the sanctioned activities were enhanced by popular additions of dances, masks, fearsome dragonlike effigies, floats, and other embellishments. By 1387, written descriptions of the appearance of devils and angels in Tarragona's municipal festivals appear, and the detailed account of Barcelona's 1424 Corpus events describes the devil's dance (*ball de diables*) and a sword fight between devils and angels as dra-

Foc i Flama, *correfocs* at Festa Major, Horta de Sant Joan, 1999.

matic representations of the struggle between the forces of heaven and hell. Such performances were not restricted to holy days but were also associated with royal occasions. Scheduled between courses during courtly feasts, they became known by the name *entremès*, and

Foc i Flama, young devil,
Horta de Sant Joan, 1999.

until the fifteenth century, these *entremesos* were an obligatory component of every important ceremony.

By the mid–fifteenth century, a programmed circuit of costumed devils running or dancing through the streets was widely noted in numerous Catalan locales, and this formation, known as the *seguici popular,* became normative for festive celebrations of many kinds. At around this time groups (*colles*) of devils began to be formalized to complement the Holy Acts with actions intended to purify the citizens through the use of fire.[2] In some areas, costumed devils sowed disorder for weeks prior to St. John's Day, tossing firecrackers into crowds to represent the "misrule" that the devil and his followers could wreak on earth (Burke 1978: 195). Not until the end of the sixteenth century did these activities began to lose their sacred aspect, evolving into the more theatrical components of the *festa-espectacle* (festival-spectacle), which nevertheless continued to be supported and promoted by local economic, religious, and political powers (Bargalló i Vals and Bertrán i Luengo 1997: 259). However, in 1780, the Church, in either an excess of religious zeal or a reactive impulse against the more popular and less sanctified flourishes of these events, banned the use of *gegants, bèsties,* and other *entremesos* in the Corpus processions, likewise prohibiting the large St. John's Day bonfires within urban areas because of the non-Christian connotations these elements were feared to reflect (Grau i Marti 1995: 28).[3] The lay population consistently rebuffed this and other subsequent attempts to repress such popular accoutrements, but the clerics were resolute, regarding these behaviors as irreverent representations of residual pagan practices that threatened the Church's newly important distinction between the sacred and the profane. This new religious mind-set left no room for alternative gods or what were deemed heretical theologies.

Although such attempts to restrict popular activities during festival days were shared—at different levels and with different foci—by both Catholic and Protestant reformers, their efforts were neither consistent nor successful, in part because of the difficulty of reaching the expansive and often remote areas of their districts as well as the difficulty of enforcing new behaviors and attitudes in those regions. Consequently, despite a somewhat disjunctive, modified, and pieced-together chain of transmission over the ensuing centuries, the tradition of fire-carrying devils dancing and running through the streets has continued, manifesting strikingly related forms and activities despite a constant natural evolution.

Wide geographic variants of this festival element in different Catalan locales have consistently been maintained: the Tarragona region, for example, is known for formal battles

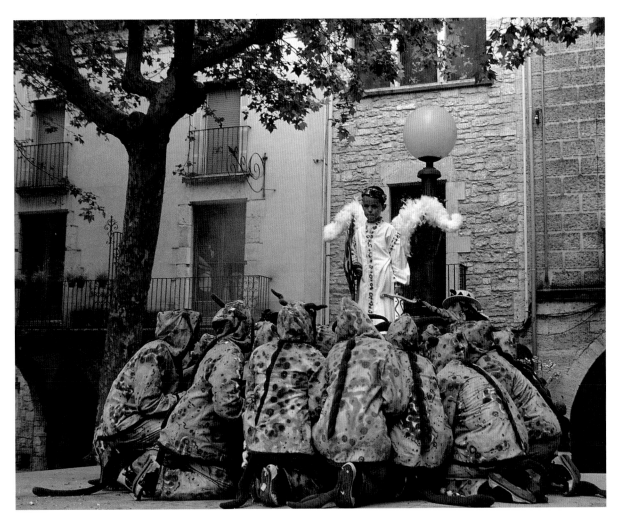

Ball de Sant Miquel, performed by the Ball de Diables de Vilanova i la Geltrú, Banyoles, 2004. This scene is toward the end of the *ball parlat*, in which the devils ultimately surrender to St. Michael.

between the devils and the archangel St. Michael, typically accompanied by the recitation of *versots*, satiric poems in traditional cadence that describe the event through a historical text, a contemporary rendition, or both. These dramatizations are often referred to as *balls parlats* and typically include the characters of Lucifer and a female devil who try to tempt St. Michael and his unwary mortal followers, aided by numerous lesser-ranked devils who fiendishly champion their ultimately unsuccessful attempts. After the second half of the eighteenth century, the moral tone of the *versots* decreased as their sense of subversive irony increased, and they began to be used satirically to taunt the established religious, social,

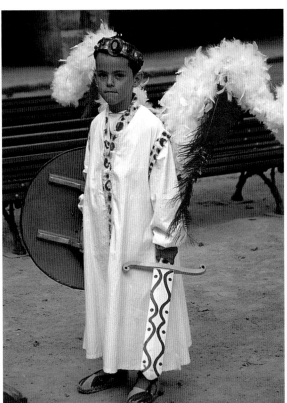

St. Michael, member of the Ball de Diables de Vilanova i la Geltrú, performing at the Fira del Foc, Banyoles, 2004.

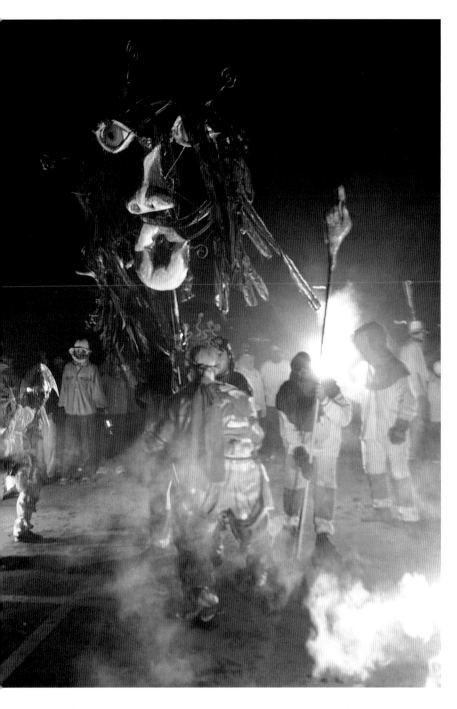

Les Gàrgoles de Foc, *correfoc* opening with monumental mask, Festa Major, Banyoles, 2003.

linked to their initial religious intent. Not surprisingly, along with the decreasing allegorical nature of the performance events came an increasing emphasis on their theatrical components. (For further information on the *ball de diables,* see, for example, Bassa 1998; Bertran, Gonzàlez, et al. 1993.)

The actual *cercavila* (running through the streets of the town, known in Spanish as *pasacalle*) remains the primary attraction of the *correfoc* in most areas today. Heightening fire's elemental attraction for humans, groups of people dressed as devils run through the streets with whirling firecrackers, directing and tempting bystanders to join the satanic frolic. The devils act as both lovers and masters of the flames, jumping through and cavorting among the blazing sparks, recalling ancient fertility cults and the untamed forces of nature. Despite what happens in other portions of the evening's festivities, there is no battle between good and evil during this segment: here the participants gaily succumb to this contrapuntal challenge to the Church's religious authority, giving in to the frenzied sensation of recaptured liberty as they race through the streets with the devils, dodge the sparks, defy the risks, and dance to the throbbing percussion of the *tambor* drums.

REFRESHING THE TRADITION

Celebration of these historical traditions, which had reached a high point in the 1880s and '90s with elaborate balls, costumes, and parades, was almost obliterated during the Franco era, when all cultural, ritual, and linguistic attributes of Catalan heritage—as well as the right to free public assembly—were formally outlawed. But within a year or two of the dictator's death and the establishment of a parliamentary monarchy in 1976–77, associations dedicated to reviving regional traditions began to resurface, and a vibrant period of cultural

and political powers in a traditionally structured verbal critique that conventional wisdom touted as the voice of popular conscience. This was exacerbated in the nineteenth century by a move toward "castellanization" of the recited verses: reworking the lines in Spanish caused them to become even more irreverent and less

renewal was launched. Many of the new groups of devils that were organized in the immediate post-Franco period were inspired—directly or indirectly—by a model inaugurated by the improvisational theater group Els Comediants in their montage "Dimonis," performed for the 1981 celebration of the patron saint of Barcelona, La Mercè, which introduced the term *correfoc* for the first time (Palomar 2002: 76).[5] This group, exploring the concept of collective theatrical experiences "with neither text nor director" since 1971, was greatly influenced and inspired by the traditional Patum festival of Berga (Noyes 2003) as well as other prototypical Catalan *festas*.[6]

Subsequently, the reinvigorated tradition of the devils spread from its original areas in "Catalunya Nova" (the regions with greater affinity to the Mediterranean than to the Pyrenees) into areas that had never before hosted these kinds of activities. During the 1960s four

devil groups were known to exist in Catalunya, with that number rising to no more than ten during the following decade. In 1985, following the manifestations noted above, forty-five groups had been formalized, and today, between the broadening of the democratic monarchy and the ever-increasing conquest of public spaces by communal urban festivals, more than three hundred such groups exist, with most flourishing outside of the original host area for this custom—the Camp de Tarragona, the Garraf, the Conca de Barberà, the Priorat, and all of the Penedès region, where it may have been specifically tied to fire rituals associated with Sant Antoní (Moya Domenech 2002: 67).

Certain social analysts have noted that such groups have grown fastest in more industrial cities and have postulated that such areas, swollen with new immigrants from rural regions as well as particularly from African nations, have a more difficult time finding non-

Correfocs at Festa Major, La Bisbal d'Empordà, 2000.

ideological yet engaging, pleasurable, and even transformative activities that can help to link disparate community elements into a more integrated, self-identified group. That the *correfocs*'s intensity and impact result from nonverbal, participatory activity is clearly important in overcoming language barriers. This conceptualization has a historical basis in works by functionalist scholars such as Émile Durkheim (1984), who argued that both sacred and secular rituals were essential to the development and maintenance of a social commonality that transcended class boundaries. Neither is it inimical to the sociological constructs of Hauser (1982: 103), who postulates that one of the "hard and fast rules" of cultural development is the concentrically increasing sphere of influence in which artistic styles geographically expand the longer they are in existence. The result is that thanks in part to the Catalan willingness to embrace legitimate change within tradition, the *correfocs* can be linked with the pieced-together continuum of traditional dramatic performance that is now entering (at least) its seventh century. Today, enlivened with spectacular pyrotechnics, the *correfocs* are presented in conjunction with municipal celebrations and saints' days throughout Catalunya. Whether produced by local groups or itinerant devils hired for the occasion, these events draw tens of thousands of spectators—more than 50,000 to the La Mercè celebration each year in Barcelona alone—to celebrate the unbridled primal magic of fire and flame.

The spark lit by the Barcelona *correfoc* ignited a wide-ranging response, not only by individuals interested in forming new devil groups[7] but also from the national and regional governments, which grasped in this enthusiasm the means to "strengthen our traditional culture and recover our lost traditions."[8] The tenuous parliamentary monarchy in the early days following Franco's death and the repulsion of his followers' attempt to destroy the fledgling democracy by coup accentuated the significance of the burgeoning efforts to revive cultural expressions after forty-some years of fascist repression. To this end, after decades of ignoring, merely tolerating, or even trying to discourage local and regional traditions, provincial governments charged themselves with fomenting, protecting, and encouraging these events. Such efforts have included means as diverse as underwriting formal workshops teaching festival arts (for example, Catalunya's FestCat, the Catalan "School of the Fiesta"),[9] disseminating model contracts that traditional performing groups can use, and instituting formal insurance and security guidelines that regulate the parameters of such performance events as the *correfoc*.[10] Today every *grup de foc* (any organization or group that utilizes fire in performances or presentations, including *colles* of devils, groups specializing in fire-breathing beasts [*bèsties de foc*], and groups that concentrate only on pyrotechnic displays without any folkloric components) is part of a legally established framework, registered with the Generalitat de Catalunya, and thus permitted to explode certain potentially dangerous classes of incendiary material.[11]

Yet despite the involvement of various levels of governmental authorities in the promulgation and presentation of such traditional performance events, they have hardly been co-opted into simply another component of official culture or transformed into state-supported tourist promotions: these events are not performed for passive, nonparticipating spectators but rather for true assemblies of collaborators whose contribution is crucial—indeed, essential—to the creation and the successful realization of the festive activity. Given the ubiquity of television and other communications, along with the redefinition of "leisure" time, it is hardly surprising that governmental cultural interests and those of the "people" would reveal certain intersections. But the fact

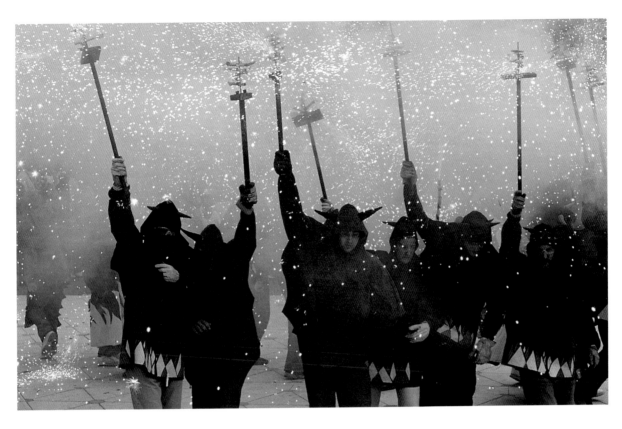

Devil group at the Fira del Foc, Banyoles, 2004.

that those who attend the *correfocs* come with the expectation of participation as opposed to simply viewing a performance is significant in maintaining these events in a "folkloric" sphere instead of devolving into mass happenings where the relationship between the individual and the activity is passive and superficial. (The complete absence of food and souvenir stands accompanying the activities of the devil group that I discuss below, Les Gàrgoles de Foc of Banyoles, for example, is an almost startling omission underscoring the events' "insider" ambience.) The spontaneity of the participants and the symbiotic relationship between the devils and the public ensures an elastic, dynamic, and liberating experience, enriching and broadening the event with each and every manifestation.

Festivals in Spain were historically planned, organized, and publicly celebrated by adult men, with women staying at home to cook and keep the special costumes sewn and clean. (In contrast, women more typically attended Masses and formal Church events.) Today, however, both young men and women participate actively in festive events and performances as musicians, dancers, and devils. The tremendous surge in all kinds of traditional public programs no doubt results at least partially from the fact that participation is no longer limited to only half the population (Stanton 1999).

The groups feel a responsibility to broaden both the appeal and the diffusion of their efforts. To this end, older groups serve as *padrinos* (godfathers) for new groups of enthusiasts intent on forming their own *colles*. A combination apprenticeship and tutorial, this oral and organic process of acquiring information and developing skills has resulted in a noteworthy spread of these performance events along with striking growth in the number of devil groups themselves. Another recent component of the learning process is the staging of meetings of

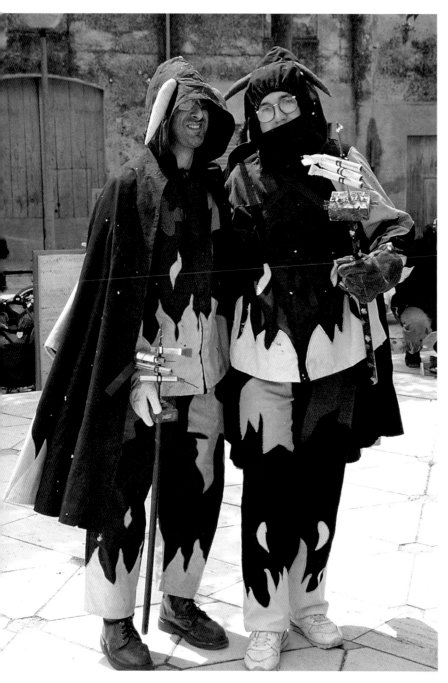

Devils from the Barcelona group La Satànica de Sant Andreu at the Fira del Foc, Banyoles, 2004.

in part, by the Federació de Diables i Dimonis de Catalunya, founded in 1998. An even larger event, the first "Fira del Foc" (Fair of Fire) took place in Banyoles in 2004, with some 4,000 devils, demons, and supporters in attendance. The federation is becoming increasingly important as both the devil groups and public participation in their activities grow stronger each year.

There are a wide variety of names for the different members of the *grups de foc*, linked to their area of activity within the event. People who light the fireworks are identified as *encenedors, fogueres, fogaires, caladors,* or *diables d'encendre* or sometimes as *botafocs* or *metxes,* referring to the fuses or lighting devices carried. People who carry the pyrotechnics along the route are described by either the job they do or the materials they use to hold the load—*repartidors, portadors, portadors de foc, portadors del carro, diables del carretó, arrossegadors, civaders, bosses, saquers, macutos,* or *llauners.* The accompanying musicians are called *músics, tabalers, timbalers,* or *percussionists.* Those who carry or steer the accompanying beast are the *portadors de drac, diables de drac, draquers, carregadors,* or *bossistes.* Those who manage different logistical aspects of the *correfocs* are known as *ajudants;* those responsible for security are members of the *cordó de seguretat;* those who bring up the rear of the procession are the *cap de cua;* those who carry water are the *aiguaders* or *boters.* The general name for costumed participants is variously *diable, dimoni, banyut,* or occasionally even *bruixa* (witch) (Bargalló i Valls and Bertrán i Luengo 1997: 268, 271).

various devil groups every year or two in various cities around Catalunya, providing opportunities for the groups to share ideas and receive updated information about new laws or rules pertaining to their activities, security or safety norms, pyrotechnic devices, and the like. These meetings are usually sponsored, at least

LES GÀRGOLES DE FOC

Les Gàrgoles de Foc (Gargoyles of Fire) of Banyoles was officially formed in 1998, a relatively recent date for the development of such groups.[12] Their membership ranges between

thirty and sixty men and women, including approximately fifteen drummers (more formally organized in 2002 as a separate group, Kokoanga Tam-Tum), who accompany the masked dancers as they run the *cercavila* with whirling sparklers and exploding firecrackers through the narrow streets of the towns and villages in which they perform. Their members also tend to be somewhat older than is typical for this kind of group; they are workers and professionals in all walks of life—including an electrician, a psychologist, an insurance broker, a carpenter, a trucker, a firefighter, and various administrators—who come together to create a communal performance event that both draws on tradition and breaks new ground with theatrical and pyrotechnical innovations. Although designed and created by members of the Gàrgoles acting as a team, the event can be neither fully realized nor consummated without the active participation of community members.

Pere Casellas, the acknowledged head of the group and a pyrotechnic expert, is involved in all aspects of the performance event. He was the inspiration for the development of the Gàrgoles, a result of his intense interest in and passion for the *correfocs* that he saw at festivals in numerous other towns around Catalunya. He joined a commission organized by the Banyoles municipal authorities to oversee and develop festivals there, including the "recovery of the lost tradition of the *correfocs*."[13] At first, devil groups from other villages were invited to come to Banyoles to lead the *correfocs*; this led to such interest and excitement among a group of young people involved in dancing the *gegants* and *capgrossos* that they decided to form a local group. They began collaborating with friends in the *colla* Els Ducs de Foc from nearby Torroella de Montgrí; Els Ducs members agreed to serve as teachers and *padrinos* for a three-year period, during which they would teach members of the fledgling Banyoles group about being "devils," including the use of appropriate pyrotechnics.

Pere Casellas and Jordi "Soco" Gratacós preparing pyrotechnics on *ceptrots* for Festa Major, Banyoles, 2002.

Casellas both directs and inspires the work of the other group members, who are responsible for various aspects of the experience. These include Jordi "Soco" Gratacós, the artist who designed the fire-breathing dragon, the masks, and the costumes, as well as the men and women who choreograph the processional focus of the event—the *cercavila*—and those who concern themselves with the firecrackers and explosives that punctuate its diverse components. Joining the Gàrgoles as individuals, the members come together to form a tightly knit group of colleagues dependent on each other for their safety, for the safety of the public participants, and for the successful festive outcome of each *correfoc*.

The municipal governments of interested villages commission *colles* to orchestrate and lead *correfocs*. The grandiosity of an event therefore depends on how much money a

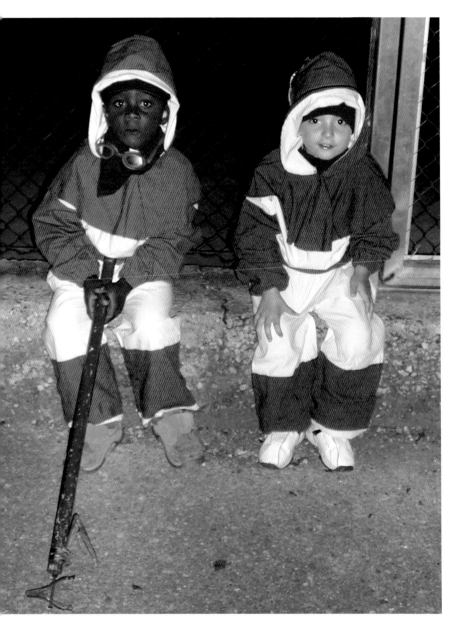

Two three-year-old devils, part of the children's group associated with the Gàrgoles de Foc, Fontcoberta, 2004.

vidual members of the Gàrgoles receive no fee for performing, so the biggest expense for the event is the pyrotechnics. The group typically saves a little from out-of-town performances to enhance their hometown event, Banyoles's annual summer festival, on which they may spend the equivalent of $8,000 but often receive only about $5,000 from the municipality. The group also raises money by operating a temporary snack stand (*barraca*) selling sandwiches and drinks near the concert grounds of the Fiesta of Santa Martirià; members of the Gàrgoles staff the stand, and its proceeds help to finance their activities throughout the year.

Colles interested in performing outside their hometowns put together a promotional packet for the Diputació of Girona's regional offices of the Generalitat's Centre de Promoció de la Cultura Popular i Tradicional Catalana (Center for the Promotion of Popular and Traditional Catalan Culture). The center organizes various materials from all interested groups in the area into a promotional book that representatives of outlying municipalities can review to choose a group that appears to meet their needs. The book includes photographs, an explanation of the structure of each group's events, price ranges, and the telephone number of a contact person. Although to date they have only worked within the province of Girona, the Gàrgoles are willing to expand their range: "If the municipality pays, we'll make the *festa*," Casellas says wryly. Such events are always organized for municipal governments, never for private parties. However, interest in the *correfocs* is so strong that the Gàrgoles have also been invited into elementary schools to provide workshops for the students, and a "correfoc infantil" of young devils (each carefully accompanied by an adult devil) took place for the first time during Banyoles's summer 2003 Festa Major.[14]

When new devils join the group, they spend their first several *correfocs* guarding the con-

municipality wants to spend. Cultural critics such as Bennassar (1979: 147) have marveled at the amounts spent on such "intangible, immaterial, fugitive creations: music and fire." He adds, with grudging respect, that a "people capable of transforming a year's toil into the frenzy of an instant, of carrying their taste for show and sound to the point of absurdity, of joyfully watching their money ascend as flame into the sky, is a people that knows the meaning of festival, that was born for festival." Indi-

tainers of explosives (as "vigilants") or wheeling carts with fire extinguishers through the crowds. Gratacós and Casellas try to work with the recruits for at least ten to twelve hours, physically showing them the "techniques" of being a good devil: the importance of body language, the exaggeration of movement, and the importance of watching out for and learning from the other members of the group. Each devil naturally approaches his or her responsibilities as part of the group somewhat differently, manifested in the distinctiveness and pace of each person's movements, use of pyrotechnics, and fire-based activities. (Pep Mendoza and Albert Masdevall, for example, specialize in blowing fire out of their mouths.)

The dancing shadows of the fire enhance the power of all of their gestures and actions.

BÈSTIES DE FOC

A distinctive component of many *grups de foc* is the use of a *bèstia de foc*, a sculpture representing a real or imaginary beast wheeled or carried (internally or externally) by one or more people.[15] The beasts' horns, mouths, claws and tails are loaded with firecrackers and roman candle–like sparklers and further enhance the *correfocs'* theatrical elements. To varying degrees in various areas, legendary, religious, mythological, and fantastic concepts are all

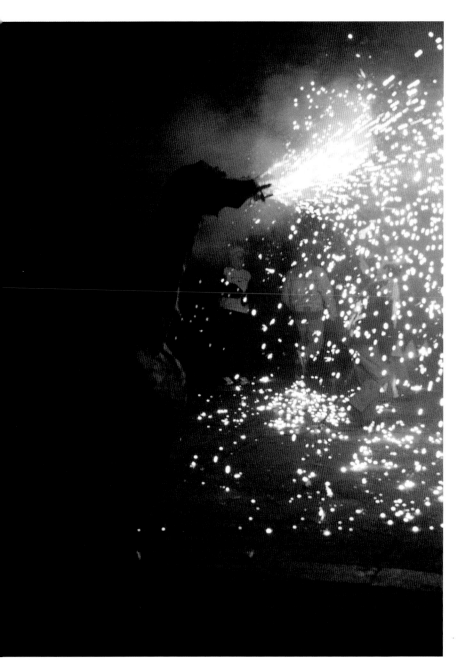

Foc i Flama's fire-spitting dragon, Festa Major, Horta de Sant Joan, 1999.

In 1995 the first Trobada Nacional de Bèsties de Foc was held, bringing together in La Bisbal d'Empordà numerous constructed creatures used in *correfocs*. Paralleling the increase in devil groups, the use of such beasts had grown so quickly and become so widespread in recent years that in 1996 the Agrupació del Bestiari Festiu i Popular de Catalunya was founded to provide technical advice and information and to serve as a sounding board, source for research and debate, and communications channel for creators, commissioners, and users alike. This organization also seeks to collectively represent the "Món del Bestiari" (the "world" of the groups that use these constructed creatures) on different community and governmental levels and to offer assorted services to support their efforts.[16]

As discussed in chapter 2, various aspects of Catalan narrative and visual culture have since ancient times represented numerous mythical and real animals, including flying horses, birds, and bulls. The most significant, however, has clearly been the dragon, the *drac*, an otherworldly fire-breathing creature that flies through the air and swims in the seas. The dragon first appeared among the peoples of Mesopotamia as a destructive force in conflict with the forces of creation; by the fourth millennium BCE it had evolved in Sumeria, Babylonia, and Assyria into a potent source of fertility whose potentially destructive powers over water needed to be propitiated by an assortment of rites and rituals. The aquatic dragon-destroyer merged at times with serpents, becoming more consistently a figure of malevolence; along with the infamous snake that caused the fall of humankind as recounted in Genesis, the dragon's sinuous tail retained a similar phallic symbol of fecundity. This belief formed the basis for the numerous European myths in which assorted saints and heroes miraculously vanquish local dragons that had tormented people by either withholding water through droughts or providing too much through

incorporated in the design of such creatures. However, unlike the groups of devils, with distinct variations in their performances broadly based on geographical areas, these beasts have become a significant and widespread phenomenon throughout all of Catalunya, with new creatures regularly being commissioned, created, and "baptized" for use as a now expected component of most *correfocs*.

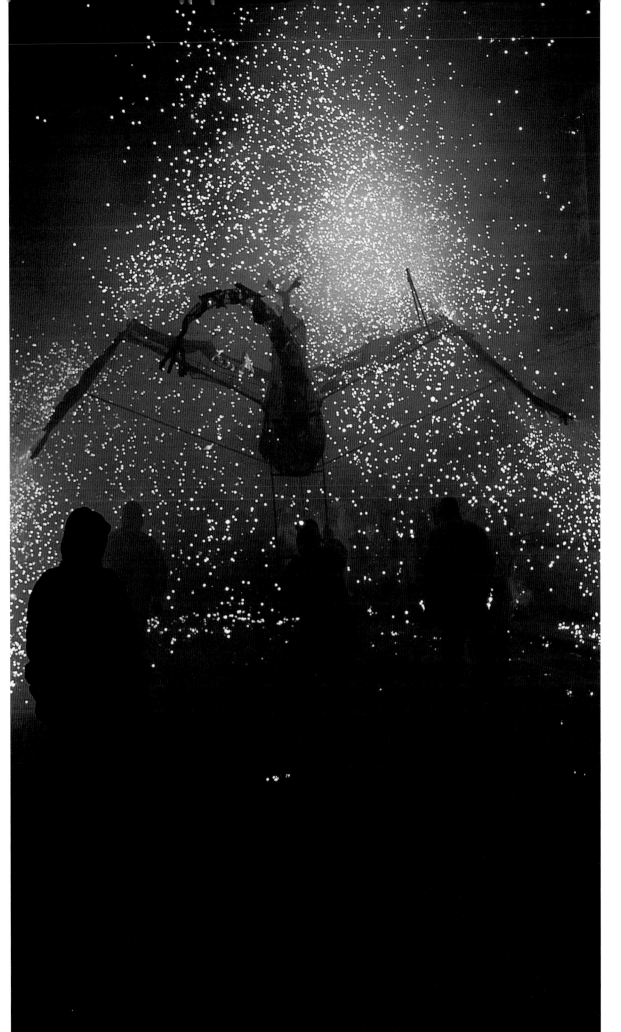

Les Gàrgoles de Foc with
the dragon El Sense Nom,
correfocs at Festa Major,
Banyoles, 2000.

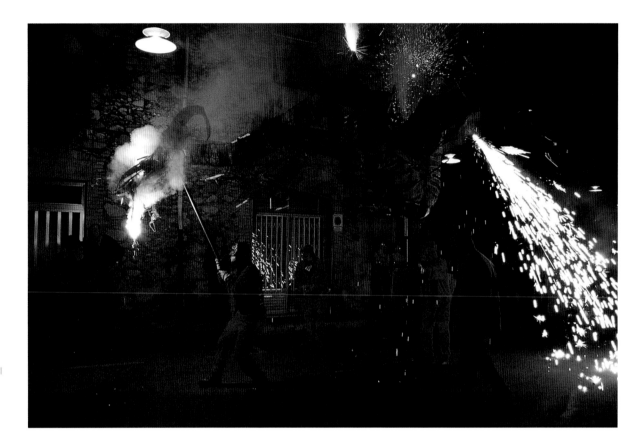

Les Gàrgoles de Foc with El
Sense Nom, *correfocs* and
"baptism" of new beast by
Ventura and Hosta, Salt,
2002.

floods: local examples include St. Emeri, who killed the dragon in Lake Banyoles, and St. Eudald, who killed the dragon of Vallfogona.

During medieval times, the various historical traits defining the dragon-serpents coalesced into a being epitomized as evil incarnate in Christian iconography. The streams of water depicted as spewing from the dragon-serpents' mouths may have been misinterpreted by later iconographers, and dragons became renowned for spitting out fire. The first recorded appearance of dragons in the Corpus procession took place in Valencia in 1400; they appeared earlier in other religious processions, including the Rogationtide processions from the middle of the twelfth century (Very 1962: 56), as well as in more secular observances, including an event honoring King Juan I in Valencia in 1392 (Varey and Shergold 1953: 19; Harris 2000: 195). Although they may have links to specific legends, dragons in general remain the exemplifi-cation of uncontrolled natural forces, which numerous legendary heroes have battled to retain or regain civil order and control for their imperiled communities.[17] The oldest documented *drac* still in use is the 1602 beast from Vilafranca del Penedès (although locals claim it has been active since the thirteenth or fourteenth century). Such fantastic creatures are designed to be as aggressive and fearsome as possible, to stimulate the imagination and conjure up the fear of the unknown at the same time that they incite pleasure in the rousing powers of the festival. The impact of any *bèstia* is significantly enhanced when it is viewed in motion, at night, under a shower of sparks, moving to the throbbing drumbeat of the processional—as designed.

The *bèstia* used by the Gàrgoles is a dragon called El Sense Nom (He Who Has No Name). (He is so different from other *bèsties de foc*, Casellas says, so indefinable, that he could not

be named.)[18] Designed by Gratacós, El Sense Nom is physically, kinetically, and conceptually very distinctive among the various beasts that accompany the *grups de foc,* for most are made out of a fire-resistant hard-surfaced polyester pulp painted with glossy acrylic paints, for a cartoonlike appearance that nevertheless inspires excitement and trepidation when the beast is loaded with fireworks and danced in the middle of exploding sparks. These other *bèsties* are typically supported on the shoulders of a single individual, who may take turns carrying the beast with other devils dancing in the processional. The Gàrgoles' *drac,* in contrast, is made of iron rods and wire covered in a semitransparent painted mottled red cloth and has moving wings and a huge head. In further contrast to many of the other *bèsties,* which are constructed in one piece, this *drac* has five separate parts—a head; a long, articulated neck; two wings; and a trunk—in addition to the wheeled steel supporting structure on which the beast rides. Consequently, it can be dismantled and transported easily in the back of the single van that also carries the Gàrgoles' costumes and pyrotechnics. It nevertheless boasts an admirable monumentality and is claimed to be the largest in Catalunya: it weighs one hundred kilos (220 pounds); is 3 meters (9.75 feet) long, 2.85 meters (9.26 feet) wide, and 2.3 (7.5 feet) meters high; and is endowed with forty points on which fireworks can be attached.

When they arrive at the site of the event, several of the Gàrgoles fit together the *drac*'s pieces. A long pole that is carried by a devil dancing in front of the moving beast supports its head and neck; two additional devils are needed to support and move each wing. The movement of the head, long neck, and the wings and the openness of the structure make it a much more dramatic presence than the typical beast found accompanying the *grups de foc.* The Gàrgoles have used El Sense Nom since 1999, and his imposing size and commanding presence have added to their performance by enhancing their spectacular actions. Before, without a beast, the Gàrgoles were "just devils," Casellas says. The *drac*'s effect has been so significant that the group is intent on adding new gargoyle helmet masks for the future, sized and worn "like the *capgrossos,*" Casellas says, "but more gothic, more technical, and enhanced with fire."

The actual fabrication of the *drac* was entrusted to Gratacós. The Gàrgoles feel lucky to have in the group someone with such skills: most *colles* need to commission a *bèstia* from artisans such as David Ventura and Neus Hosta (see chapter 2), who would charge between 3,000 and 4,000 euros for such a large creature. In this case, the Gàrgoles pay the costs of materials (about six hundred dollars), and Gratacós works without charging for his time or labor.

COSTUMES, PYROTECHNICS, AND ACCESSORIES

The Gàrgoles' costuming and accessories are crucial ingredients that create and define the appropriate atmosphere and impact of their performance events. Their current costumes, designed by Soco Gratacós, were inaugurated during Banyoles' 2002 Festa Major. These are their second complete set of costumes, for they have to be replaced regularly: although they are 100 percent cotton and are not very flammable, they are all pockmarked with holes from the flaming sparks and eventually no longer provide adequate protection from the fires. Group members democratically approve Gratacós's suggested designs before they are sent to the seamstress who fabricates them. Each Gàrgola has a costume that is individually fit, although all of the costumes and masks are kept together in the group's headquarters (the ground floor of an abandoned mill building on the outskirts of town) and remain the property of the group.

Left: Jordi "Soco" Gratacós's design for new costumes for "head" devils, 2001, watercolor and ink on paper. Costumes inaugurated at Festa Major, Banyoles, 2002.

Right: Jordi "Soco" Gratacós's design for new costumes for "those without name" who carry the dragon, 2001, watercolor and ink on paper. Costumes inaugurated at Festa Major, Banyoles, 2002.

During 2001, Gratacós designed four new costume types for the group so that members would be able to clearly distinguish each individual's activity and responsibility. Musicians wear an all-white version that is not reinforced since they typically remain outside of the immediate burn area to protect their instruments. The *cap* (chief) of each small group of five or six *gàrgoles* wears a special costume with colored cuffs that is fully double-faced with extra cloth because the leader is usually directly underneath the burning sparks. People who carry the fire-spitting dragon wear one-color costumes with layered arms and legs. And the regular demons (who are responsible for pursuing members of the public and making them run from the burning explosives) wear a

two-color costume with reinforced knees and wrists. Each costume also has a hood that covers the head and the shoulders; although the hoods are constructed identically, performers wear the garments differently: some so that they can see only down but not out, others so that their individual faces cannot be seen. Members of each different *grup de foc* wear different costumes; although most fundamentally consist of long pants and a hooded jacket or cassock, often with horns or a tail and a mask, there are an infinite number of optional accessories and accoutrements, including kerchiefs, capes, helmets, crowns, skirts, boots, bells, overcoats, smocks, and overalls. In recent years a few professionals have made the design and fabrication of devil costumes an important component of

their businesses; earlier, each devil was responsible for making his or her own according to their individual group's specifications.

Gratacós has also designed the Gàrgoles' masks. After he constructs a mold, each member of the group makes his or her mask out of papier-mâché, painting it according to the color palette Gratacós has chosen. The new masks are supported on the top and the sides, covering the face to just below the nose for maximum safety and protection. The Gàrgoles consciously decided to have all of the costumes and masks more or less the same to protect the members' anonymity, which frees the demons to act with greater abandon: the anonymity both protects them and encourages their devilish activities.

After donning his or her costume, each devil grabs a metal stick with two points on it, generally known as the *maça* or *forca* (pitchfork), onto which firecrackers, roman candles, and sparklers are attached by means of metal clips. The *forques* come in different lengths and dimensions; three or four members of the group know how to solder and fabricate the rods to members' preferences. Gratacós is currently working on some that will be topped with the skulls of lambs, which the group has slowly been gathering from local butchers. Each devil receives an initial ration of about twenty-five *carretilla* fireworks, two-part cardboard tubes with an exterior fuse that, when lit, first produce the whirling "umbrella" of fire most characteristic of the *correfocs* and then emit a large bang. They are transported in rectangular black plastic bags called *sarrons* hung from their shoulders and looped closely across their chests. As their explosives are exhausted, the *diables* pull new fireworks out of the bag and clip them to the top points of their staffs. These bags are internally reinforced on one side with planks of wood; the side with the wood is held against the body, providing a modicum of extra protection in the event of an accident with the

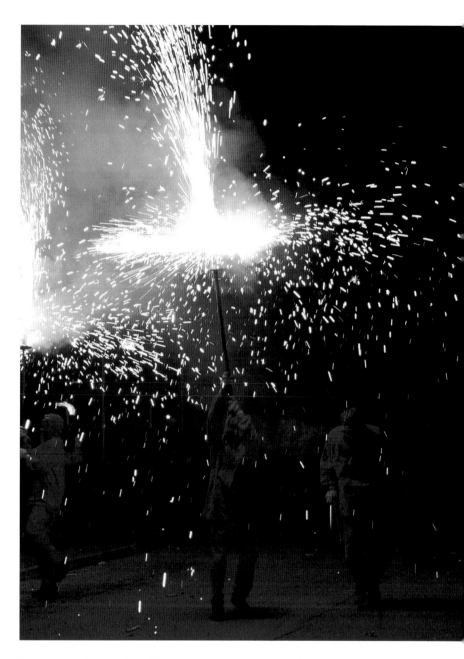

Correfocs at Festa Major, Fontcoberta, 2001.

load. The bags' shoulder straps are connected with Velcro so that the wearer can quickly strip off the bag if it catches fire. Additional protection is provided by the way the bag folds over, sealing off the firecrackers therein so that a spark cannot enter accidentally. One of the devils' most important safety rules is that they never open the bag unless they are alongside and facing a wall, thereby avoiding the likelihood of a spark entering and blowing up the

Les Gàrgoles de Foc preparing pyrotechnics for Festa Major, Banyoles, 2000. Photograph: Sam Hernández

rest of the bag. Most accidents, Casellas has noted, are caused by carelessness resulting from excess confidence. Despite their cognitive response to the possibility of disaster, the personal proximity that each devil maintains with his or her arsenal is extraordinary.

Four factories in Catalunya produce pyrotechnic material, and a variety of explosives are imported from China. The Gàrgoles explore the pyrotechnic options available at all of these factories, choosing "the best from each house," according to Casellas, to enliven their *correfocs*. They generally rely on two main types of pyrotechnics: the *carretilla* and the *sortidor*, which is typically clipped vertically slightly underneath the top of the *forca* and which shoots fire in one direction for up to half a minute.[19] The Gàrgoles typically use a subtype of the *sortidor* known as the *francès*.

Ceptrots (also known as *cetrots* or *centrots*) are special *forques* that have more clips and therefore hold many more pyrotechnic devices than regular *maces*. These *ceptrots* come in many different shapes and forms, with some holding up to a hundred different "points of fire." Some *ceptrots* are so spectacular that they are usually taken out only once or twice during the *recorregut* (itinerary), either at a special point in the performance or at the ending extravaganza. (That they are very heavy, time-consuming to load, and expensive are also factors in their rare usage during the event.) Each devil uses his or her own discretion in deciding how to load the *ceptrots* or *forques;* any combination will do. The devils always work in pairs, with one loading the firecrackers and the other lighting them with another *ceptrot* or *forca*. The decision about which firecrackers to use at what stage in the event is determined by the kind of effect desired: for example, where spectacular lighting, dense smoke, or numerous explosions are sought.

To replenish explosives during the *recorregut*, a large plastic drum (known as the *carro* or *repartidor* [distributor]) filled with about seven hundred *carretilles* is wheeled through the

streets behind the running devils. (These conveyances also vary widely among the different *colles de diables*, from sculpted animals with interior storage spaces to small metal or wooden wagons, wooden boxes, tin barrels, baby carriages, and purloined grocery shopping carts.) This tub is very well sealed, covered with wet cloth, and guarded, with the firecrackers rationed out carefully. With only a single barrel holding extra firecrackers, most pyrotechnics distributed among the devils, and the barrel outside of the "fire zone," the risk of a major explosion is diminished. As a further precaution, the novice members of the group spend several *correfocs* carrying fire extinguishers before being deemed ready to run with fire. The devil groups are cautious; very few of the seven hundred or so *correfocs* that take place each year in Catalunya result in damage claims.[20]

BANYOLES *CORREFOCS* I

A *correfoc* typically starts between 10 P.M. and midnight—rarely earlier and often much later, sometimes beginning just before dawn. Prior to the event, the members of the Gàrgoles meet at a local bar, restaurant, or community center to share a snack or a meal, hyping themselves up for the night ahead. There is obvious tension in the air, a buzz of nervous energy that infects all the Gàrgoles with the spirit of the danger that lies just ahead. "You can feel the blood coursing through your veins," says Pep Mendoza, member of the Gàrgoles whose day job is as a psychologist. "It's like being in a sauna: you are hot, sweating from wearing the costumes, from running, from the fire, and from the nervousness of the danger that something might happen, that there might be an accident. The level of tension is very high. And then afterwards, you're completely relaxed. It's like a drug. It produces a physical reaction, a high, like a drug, that helps you pass through the risks. The day

that I stop feeling trepidation, fear, and anxiety prior to the event is the day I will stop running the *correfocs*."[21] Like the psychologist he is, Mendoza further explains that running the *correfocs* brings fears out into the open so that

Marc Perez of Les Gàrgoles de Foc representing Water, descending from the roof of a building to inaugurate correfocs, Festa Major, Banyoles, 2003.

Expectant *correfoc* partici-
pants, Festa Major, Banyoles,
2001.

they can be "burned" up and eliminated. Par-
ticipation is a tonic for the Gàrgoles.

Each performance event starts out differ-
ently and is handled differently by the *grups de
foc.* Many simply start out with a spectacle of
fireworks and move quickly into the *recor-
regut.* But the Gàrgoles have a more theatrical
approach. Particularly for performances during
Banyoles's Festa Major, the Gàrgoles spend
many hours designing, organizing, and practic-
ing the dramatic beginning and ending of the
event. Casellas estimates that a ten- or fifteen-
minute opening performance (plotted out in
advance but not scripted) will require informal
group practice sessions for one or two months,
going through the movements and gestures
without the pyrotechnics. Despite these
"rehearsals," much of the event is improvised,
as it is designed, organized, and implemented
by a group that knows the strengths and weak-
nesses of each individual and has worked

together many times within the same parame-
ters and with the same general repertoire.

The *principi,* the beginning of the perform-
ance, is the event's most theatrical component.
It is choreographed in a way that will scare,
thrill, and pump up the crowd, particularly the
younger people who will run the *cercavila* with
the devils through the narrow streets. The Gàr-
goles' *principi* is never more than fifteen min-
utes long, for the eager young people are most
interested in participating in running with the
fire. The theatrical elements start out as ideas
offered up by group members, any of whom
may offer suggestions. As the ideas gel, they are
sketched out in more substance and discussed
by the group, which then apportions roles and
responsibilities. Using themes drawn from
local legends, folktales, and Catholic myths
and imagery as well as original ideas based on
the struggle between good and evil, the Gàr-
goles weave new interactive narratives that
both challenge and reinforce historical tradi-
tions. In 2003, for example, they developed a
scenario personifying the essential senses and
elements: Marc Perez embodied "water,"
Albert Masdevall was "fire," Anna Sanchez was
"light," Manel Rodríguez was "sound," and
Eduard Gifreu was "wind."

This more conceptual scheme differed signifi-
cantly from earlier, more narrative setups. Ban-
yoles's 2001 Festa Major, for example, was based
on an invented "quotation" from the diary of the
fictitious monk Friar Bertomeu dated August 11,
1501: "A group of peasants arrived at the
monastery and, while they were gathering the
corn, surprised a hellish beast hidden under-
neath some bushes. They captured him and
brought him to the monastery. The Father Supe-
rior decided to burn the beast so that it would
return to the diabolical hell from whence it had
come. The bonfire would take place that night. I
don't know. . . . I have a bad presentiment about
this. . . . What will Satan do when he sees reli-
gious men burning one of his creatures?"[22]

Using this tale as a base, the Gàrgoles coordinated the actions of all of the participants in the *correfoc*. Their performance depicted how the Catholic brothers imprisoned and began to burn the hellish beast, which then was transformed into Satan himself, invoking his malevolent devil minions to avenge this deed by invading the streets of the town and filling them with fire, destruction, and fear. At the end, the faith of the people is strong enough to vanquish the devil and destroy his evil supporters, thus resulting in a grand celebration of the populace, marked with the explosion of enormous firecrackers.

The crowd gathers in the old *plaça* of downtown Banyoles, waiting for the beginning of the *correfoc*, scheduled for 10:30 P.M. Some people come just for the experience of the theatrical street performance at the beginning; the *recorregut* and *cercavila* is only for those who are not fazed by the risk and tension of running underneath, next to, and even on top of firecrackers. Numerous families are present, with wide-eyed children perched on the shoulders of their parents or grandparents, but the largest demographic group consists of teenagers and young adults. Those who will run with the devils are dressed for the occasion: long pants, long sleeves, closed shoes, big-brimmed hats, and handkerchiefs covering their faces up to their eyes. In another context, they would look eerily like masked outlaws from Wild West movies; in the dark, the costuming will help to obscure individual identification, thus enhancing and emphasizing the social primacy of the group. It is the height of summer, and even before running or coming close to the fires, it is hot: we are sweating.

Suddenly, noise, smoke, and flame explode from one corner of the small square as the first set of firecrackers is set off, igniting a shiver of fear and excitement as the cheering crowd realizes that the event is beginning. Slowly, mournfully, a group of four anonymous figures dressed

as monks appears, flanking and wheeling a steel contraption whose substructure has been disguised and that is covered with an interlacing of reedlike branches that makes it about eight feet tall. It is very difficult to see in the dark, but a sinister, enigmatic figure appears to be seated on a platform approximately three feet off the ground within this cagelike form. Following this conveyance, six other "monks" pass, two by two, holding candlelike flares and striding silently to a dirge emanating from loudspeakers set up high in the trees of the *plaça*. The monks pass westward down the northern street of the square between the rows of onlookers and then turn toward the south, pausing in the middle of the *plaça*'s western street. Here they set the cage down, placing their flares around it on the pavement in a circle, gathering together on the far west side of the cage, away from the *plaça* and crowd. Curious yet cautious, the crowd mills around, edging closer to the mysterious enclosure.

Without warning, the monks move quickly away from the side of the cage, and numerous masked demons materialize from the opposite side of the *plaça*, carrying large flares and scattering the shrieking crowd in front of the blazing wands. Circling the cage, they bathe the ground in fire and begin to dismantle the construction, liberating the enigmatic figure from his confinement. Underneath the construction we can now see a low steel device on wheels, shaped like a horizontal barrel with only a bare minimum of tubing providing structure and support. Protruding upward from this at a diagonal is a short ladder, up which the shadowy figure slowly crawls. After creeping up the two or three rungs, he suddenly jerks to a fully upright position, extending a set of batlike wings that stretch some six feet in width. His face is masked and covered by a hood, his body clothed in a cassock belted at the waist over loose pants. All of his clothing is painted with scales and flames. Unexpectedly, he falls

straight back, arms outstretched, and three dev-ils catch him and straighten their arms, hoist-ing him high above their heads. They wave him back and forth three times, left, right, left, and then let him down onto the pavement. These three, joined by the other devils, crouch in front of this winged figure as if he were a deity; he staggers as if finding his footing and then circles around the ladder, stepping over and through the devils' flares. Helped by two devils, he mounts the ladder again, weaving and writhing as the devils begin jerkily moving the steel con-traption north along the street, swinging him around in semicircles as one pulls from the front with a rope and two others push at the sides. A bright red light shining down from the direction in which they are moving illuminates the winged creature's silhouette. His ribbed, transparent wings, masked face, and somewhat awkward movements enhance the thrilling impression of otherworldliness.

As the devils moving the creature reach the northwestern corner of the *plaça*, where the road narrows before entering the old city's tight pas-

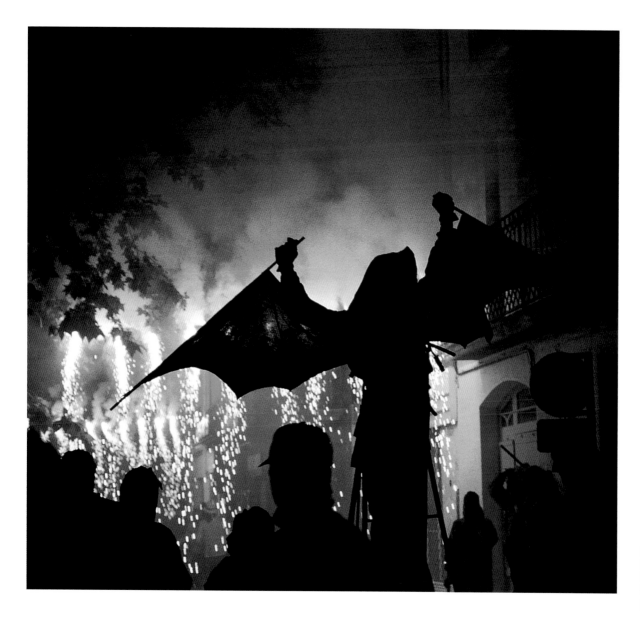

sageways, the creature turns back and slowly beckons, enticing the crowd to follow. Concurrently, a series of rocket explosions light up the *plaça* behind him, confusing the people in the crowd and dividing their attention. Firecrackers strung high above the square detonate in quick succession, leading from the main explosion back to the creature and the cheering crowd. As the multitudes shift their attention back to the creature, other devils move in front of him, lighting the way with flares, the smoke from their fires both obscuring and dramatizing the moment.

Stepping into the narrow streets, the drummers pick up the beat, beating twice on their drums, followed by first three and then seven more quick beats of their sticks on the side of their instruments. Devils are all around the creature, lighting his way and using flares and firecrackers to prevent the crowd from coming too close. Following the drummers comes the second group of devils, the *colla* Els Ducs. The crowd follows as several chains of sparklers strung across the narrow street from balcony to balcony are lit, raining fire down on the crea-

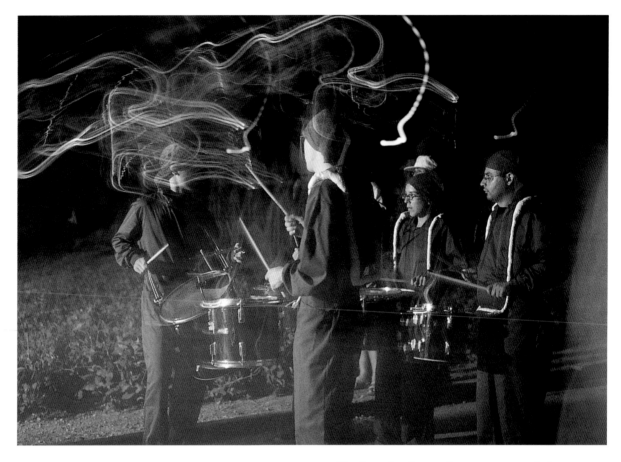

ture, the devils, and the public. The creature on top of the ladder writhes and flexes his wings as the drummers maintain the same rhythm, but now, heightening the timbre and the force, they beat the entire rhythm out on their drumheads. At this point the whirling *carretilles* are brought out to complement the *sortidor* flares. The crowd surges around the creature on all sides, jumping and dancing among the sparks, cheering with the growing intensity of the event, flirting with and tempting the devils by pressing forward and running back, blurring the lines between performer and audience. If the demons approach too closely, the less aggressive members of the crowd cower against the

wall, their backs to the street, until the immediate danger has passed; others rush in directly under the sparks, defiantly tempting the devils to unleash more of their arsenal.

The throbbing current of the snare drums beating out a repetitive and mesmerizing cadence accompanies the entire route of the *recorregut*. Although some groups may also use the reeded *gralla* or other instruments as melodic accompaniment, the Gàrgoles rely only on the *tambors*, which impart a more primal intensity to the procession and work the crowd up into a frenzy. According to Casellas, no "traditional" rhythm exists for this procession, so each group depends on its musicians to develop the appropriate drumming for the different parts of the event. The drummers periodically change the rhythm of their beat, complementing and challenging the thunder of the fireworks and the screaming rocket blasts.

Drummers accompanying the *correfocs*, Festa Major, La Bisbal, 2000.

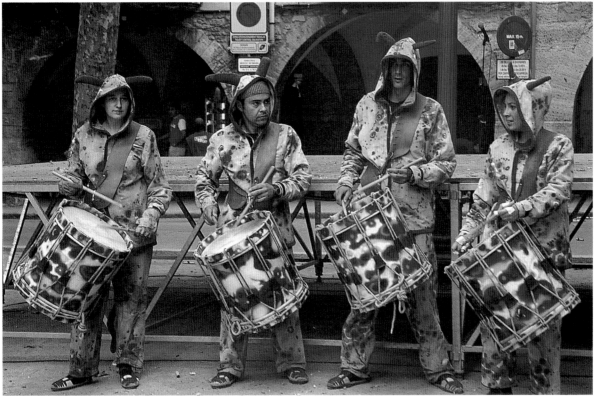

Drummers accompanying the Ball de Sant Miquel, from the group Ball de Diables de Vilanova i la Geltrú, Banyoles, 2004.

FIRE AND WATER

In the middle of the *cercavila*, there is a pause. As Casellas explains, "It's always summer. It's hot. The streets are narrow. There're a lot of people. You have to wear long sleeves, a big hat, a kerchief; you can't dress the way you would normally dress on a summer night because you'd get burned. You jump, you run, you sweat, and you get hot. So people start asking for water from the neighbors."[23]

The spectators raise their arms to punctuate their rhythmic calls for *"aigua, aigua, aigua,"* while the neighbors are tempted to respond to these petitions for water by tossing down buckets of water from their balconies overlooking the streets. But this can be dangerous, because if the water moistens the fireworks, it changes their behavior, making it impossible to predict how and when they will explode. To avoid this problem with potentially disastrous results, the Gàrgoles set aside a midway point when they bring water to the crowd. They stop the fireworks and rake the crowd with spotlights as pop music blares at rock concert decibels.[24]

With high-pressure hoses and sprinklers draped over the street or located on rooftops and balconies, the group drenches the jumping, dancing, sweating participants, reigniting rather than dousing the intensity of the event. During this time, the individual Gàrgoles can also refresh themselves with cold drinks and can reload their *ceptrots* and *forques* for the second half of the *recorregut.*

Although the practical needs of the sweating participants provide a prosaic explanation of the use of water as part of the *correfocs*, the historical and traditional associations of water with fertility and life—as both contrast and complement to the destructive yet purifying and renewing powers of fire—should not be overlooked. Immersion in water signifies a positive return to the source in a double sense, both through death, dissolving all that is impure, and simultaneously through rebirth and a renewed circulation representative of the multiple powers of life. Fire is seen as masculine, water as feminine; fire rises from the earth to the heavens, water descends from the heavens toward the earth. The power of fire is stopped by the power of water, both bringing purification and renewal if not rebirth. Not coincidentally, the drenching of the runners takes place in the small Plaça de Santa María, directly in front of one of Banyoles's old churches, conceptually and cyclically linking this dousing to the Catholic baptism, itself a syncretistic connection to the ancient magical uses of water.

BANYOLES *CORREFOCS* II

Beginning with a booming barrage of *petard* fireworks and a mass of whirling, burning *carretilles* mounted on one spectacular multilevel *ceptrot*, the second half of the *cercavila* mimics the first, with the crowds trying to squeeze through the narrow streets as the devils ply

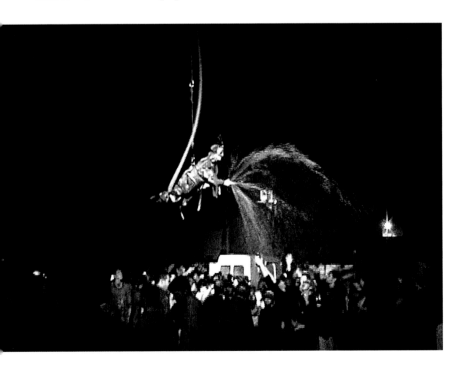

Marc Perez of the Gàrgoles de Foc representing Water, dousing the crowd during the mid-point of the *correfocs*. Festa Major, Banyoles, 2003. Photo: Sam Hernández

them with firecrackers and explosives, teasing people out from behind protective shields and chasing them with directed streams of fire and sparklers. Now, however, with their clothes soaked, many of the participants seem to dance and leap into the sparks with even greater frenzy. The streets, too, are slick with water and consequently are more slippery and dangerous. The procession advances slowly through the old streets, past windows and doorways covered with cardboard and other makeshift protective shields, until the participants are herded into another small square. Here the winged creature dismounts from the ladder onto a wooden platform that has been set up in advance. He runs back and forth across it a couple of times before remounting the ladder, one leg hooked over the top rung and arms (that is, wings) outstretched. As he moves to the sidelines, the balance of the devils push toward the center of the *plaça*, unleashing a huge array of fireworks and sparklers as the crowd skips and jumps to the throbbing drums.

There is a constant ebb and flow as the throng swarms closer to the devils and then recoils, backing away from the assault of flame. Although the progression may at first seem chaotic and haphazard, participation in multiple *correfocs* reveals a certain coordination of movement, with the devils prompting and the participants responding, much like a singing call and refrain. In a particularly typical move, devils waving *maces* with *carretilles* are surrounded by small crowds of up to a dozen young people, clinging to and jumping in with the devil directly under the sparks. Next there is a meeting of the winged creature and the *drac*. They stagger toward each other in the *plaça*, the dragon's head extended and swinging back and forth as if searching for a target, his wings ablaze with rockets and sparklers. There is no confrontation, simply a meeting, acknowledgment, and then passing, two creatures of the dark reveling in their mastery of the night.

Correfocs participants, Festa Major, Banyoles, 2003.

These creatures steer the crowd towards the Plaça Perpinyà, where the grand finale will take place. Although this square is somewhat smaller than the central *plaça* where the *correfoc* began, it is unencumbered with trees, benches, or other urban niceties as it primarily serves as a parking lot. A large elevated stage has been set up (musicians will later play there), but first comes the grand fireworks spectacle. Earlier in the day, members of the Gàrgoles had spread a thousand small, round Chinese explosives across the *plaça* floor. One end of the chain is lit, and the explosives ignite each other in a domino effect, propelling people shrieking in every direction as they try to avoid the firecrackers exploding literally under their feet.[25] Sparklers having been stretched on wires across the *plaça* from balcony to balcony and rooftop to rooftop simultaneously shower sparks down on the crowd. In addition, *carcasses*, explosives shot out of special fifty, sixty, and seventy-five millimeter tubes, shoot out toward the sky. It is terrifying, nerve-racking, intense, and visceral, yet it is merely a prelude to the tremendous simultaneous explosions of fireworks detonated

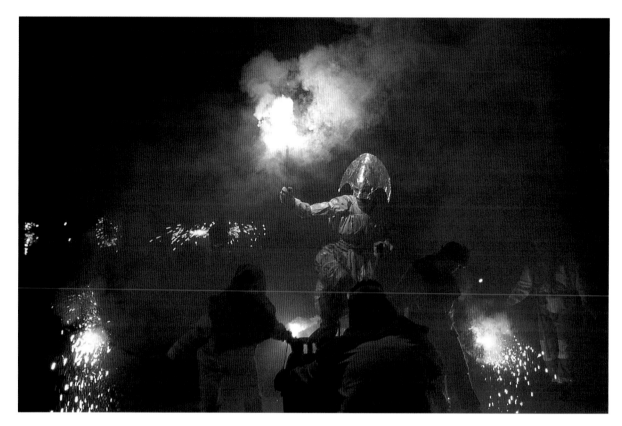

Anna Sanchez of Les Gàrgoles de Foc representing "Light," Festa Major, Banyoles, 2003.

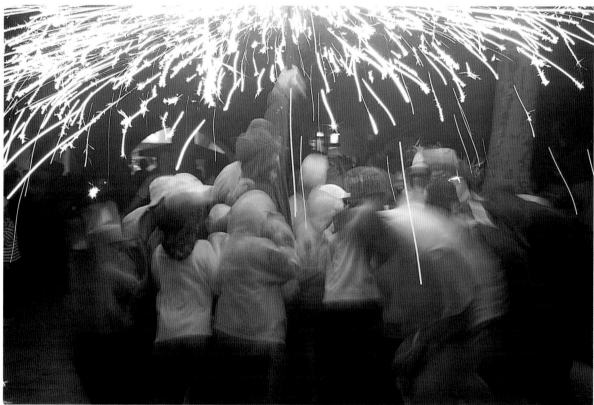

Participants dancing with devils from Les Gàrgoles de Foc, Festa Major, Banyoles, 2003.

Les Gàrgoles de Foc relaxing after end of *correfocs*, Festa Major, Fontcoberta, 2000.

directly over the heads of the participants in a glorious, frightening display of the best of contemporary pyrotechnics that signals the dramatic end of the night's event.

A typical *correfoc* may last 1.5–2 hours, including the theatrical beginning, the explosive ending, and the running of the *cercavila.* In some towns, the *correfoc* may serve as a prelude to a performance by a rock, pop, or even country band; these concerts may begin at around 1 A.M. and continue for another couple of hours. Participants who do not wish to stay for the concert head to bars or restaurants, still high from the intensity of the earlier event. Moving away from the route of the *recorregut,* participants recognize each other by their "costumes": people are sweaty from the run and dirty from the residue of the sparks that have fallen on top of them. Many proudly sport significant holes in their hats and long-sleeved shirts. A sense of collec-

tive *communitas* remains for the rest of the evening, resulting from the shared experience of having "survived" the intense, hypnotic event.

After the *correfocs,* the ambulances and first aid stations disappear; they are always parked in predetermined spots along the route, as mandated through the Generalitat's rules governing such activities, but again, injuries usually amount to nothing worse than a turned ankle or a slight burn. The Gàrgoles themselves, drenched in sweat and relief, regroup to change out of their costumes, gather their implements, and discuss the evening's activities. They usually go out together for a late dinner or at least for drinks, replaying the highlights, reliving any accidents, and teasing each other about the audacity, daring, and nerve (or lack thereof) displayed. Their spirits are high, and it is almost morning before most of them can return to a more relaxed state.

Protecting windows and
doorways before *correfoc*,
Banyoles, 2004.

COMMUNITY RELATIONS, IDENTITY, AND INTEGRATION

The Gàrgoles organize and produce between ten and fourteen *correfocs* each year, all during the summer months. "It's enough," Casellas says; if *correfocs* were held more frequently, the people would not "respond." Some of these performance events are organized by the Gàrgoles alone, while others involve other *colles*, particularly Els Ducs, which comes every year to the Banyoles *festa* and which joins the Gàrgoles to travel to other towns. Although the Gàrgoles are conceptually free to produce any kind of event, many of the logistical components are strictly regulated by rules set by the Generalitat. These include clearly announcing and publishing in advance the route of the *recorregut* and indicat-

ing the sites for the first aid stations, ambulance waiting areas, and stages of the event (for example, where the water will be released). This formal reminder to the public and the neighborhood residents also prohibits all parking along the route and recommends the complete covering of windows and doors with nonflammable materials, the lowering of shades and awnings, the removal of any hanging laundry or banners from balconies, and so on.[26] Because these events are formally sanctioned by the Generalitat and the municipal governments and because rules for neighbors, runners, and onlookers are carefully, specifically, and publicly delineated, claims for damage are minimal: if people are warned about the risk yet choose to ignore the rules, they are considered to be accepting responsibility for the results.

In addition to the *correfocs*, the Gàrgoles organize or participate in a variety of other events each season, both in Banyoles and beyond. During the summer of 2002, for example, they participated in the "baptism" (with Spanish *cava*, sparkling white wine, not holy water) of a new *bèstia* (created by Ventura and Hosta) for the *colla* in Salt, near the provincial capital of Girona, and collaborated on an innovative project, "El Foc de Castell," the Castle/Tower of Fire, with the local *sardana* dance group for another special event, which was so successful that it was repeated again in the summer of 2003. In this latter collaboration, the Gàrgoles' actions were adapted into a more choreographed show for an appreciative but nonparticipatory audience. The future development of such innovative partnerships will be interesting.

Much as an ad hoc collection of relatives and/or friends would have joined together in the past to use the slow agricultural seasons to become "professionals" in organizing and leading traditional performances, dances, and *balls*, so too do today's Catalans come together to form *colles* to organize *correfocs* and other

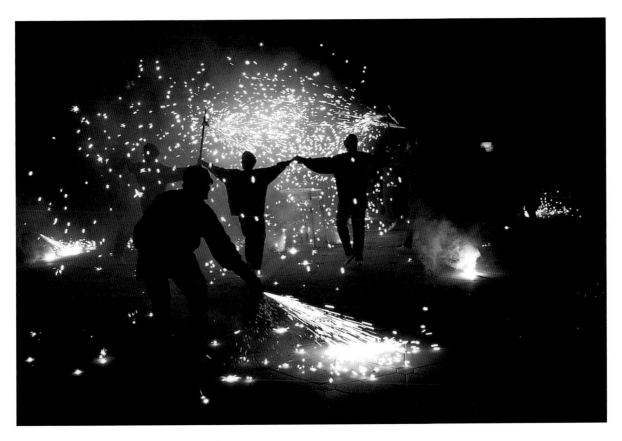

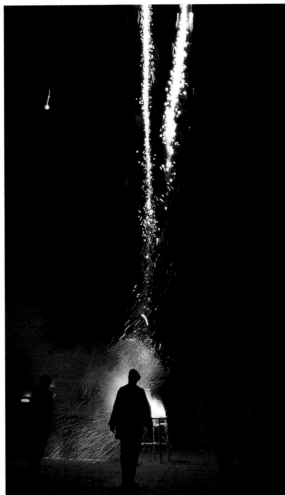

Les Gàrgoles de Foc and *sardana* enthusiasts from the Foment de la Sardana de Banyoles combine dance and fire in the Castle of Fire, Banyoles, 2002.

events. These enthusiasts could never live professionally off of their efforts; the recompense comes in a different form. For members of the Gàrgoles, it is a thrill, it is an artistic experience, and, not incidentally, it is an activist gesture flaunting and reclaiming their cultural heritage. Outside observers and functionalists describe the event as a safety valve, providing an opportunity for participants to let off steam, contain disorder, and channel the liberating sense of group effervescence that might, in another context, be detrimental to the community and the state. Pointing to numerous ritualistic occasions of misrule recorded in Europe between 1500 and 1800, analyst Max Gluckman has noted that "the lifting of the normal taboos and restraints obviously serves to emphasize them" (qtd. in Burke 1978: 201). Although some true rebellions significantly were not co-opted by ritualistic performance during this time as well, there is no doubt that there is at least a

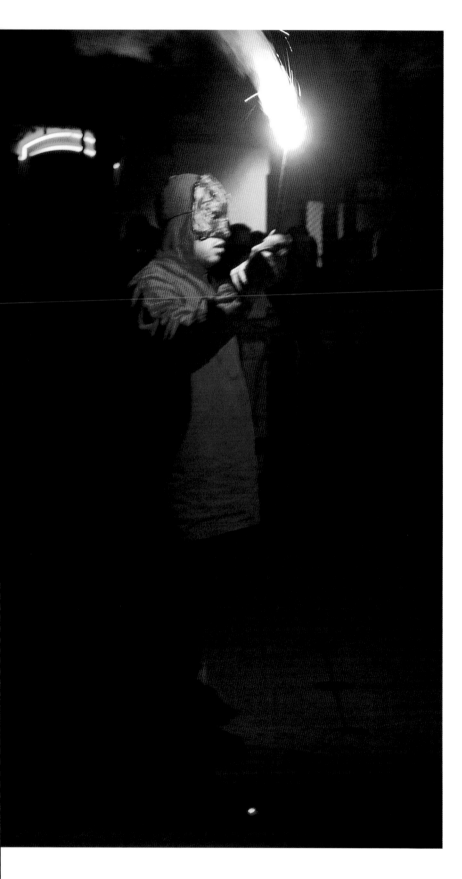

modicum of both sense and truth to the functionalists' interpretation: the rate of violent assaults in Catalunya today falls far below that of most similarly developed regions.[27]

The *correfocs* may also be interpreted in a way similar to Victor Turner's (1974) analysis of religious pilgrimages in reference to Arnold van Gennep's (1960) theories, first published in 1909, regarding the three distinguishable stages of the *rites de passage:* separation, marginality, and reintegration. Individual anonymity promoted by the concealing clothing and masking—necessary, of course, to prevent burns—separates each person from his or her identity, equalizing all participants without regard to social status, age, or gender. The tension of the event destroys the barriers usually erected to maintain people's physical and psychological distance. As the devils take over, creating a different social structure from that which is customary, many participants tend to bond with the performers, looking to them for direction and leadership. This introduces the equivalent of the second stage, marginality, in which, as the old environment falls away, a new one is created and a new community is built based on what would commonly be considered violent or sacrilegious behavior. This is particularly relevant to those parts of the event that mimic ecclesiastical rituals or take place at the front door of the local church. This stage can be terrifying; it goes against everything people rationally know to avoid. Yet this "crisis" of individual and social identity will ultimately lead to the final stage of reintegration with the "ordinary" community as the sensory overload of the denouement produces a catharsis that is a satisfying emotional and spiritual reaffirmation of its rightness and potency, and of pride and relief in belonging. If this performance event did not produce such a gratifying collective response, it is unlikely that it would have persisted over time to such an extent that it can be experienced as authentic and traditional.

Yet, clearly, this is not all it is. Given the rebirth of such performance events as the *correfoc* in the heady days following Franco's death, the early proponents looked deep into the past to make connections, find inspiration, and identify their efforts as a contemporary iteration of centuries-old Catalan activities.[28] It is not coincidental that some of the kerchiefs and T-shirts worn by the community participants are emblazoned with slogans proclaiming the goal of an independent Catalunya; although perhaps reduced to a more subconscious concept among today's younger runners and devils,

there can be no doubt that the instigation for many of the *colles* in the 1970s, '80s, and early '90s was as a proud and public cry for political and cultural recognition, if not independence. Noyes emphasizes the sociopolitical aspects of the devils as she interprets the tremendous upsurge in their activities as a "nonverbal expression of political resistance" during the transition from Franco's dictatorship to democracy. "In a context of forced Mass attendance and a dictator who described himself as the Lord's Anointed," she continues, "'we wanted to be in hell.' Catalan devils wear firecrackers

Les Gàrgoles de Foc, Festa Major, Fontcoberta, 2000.

Previous Page: Les Gàrgoles de Foc, Banyoles, 2002.

Assorted members of
the children's and adults'
group, Les Gàrgoles de
Foc, Fontcoberta, 2004.

very close to the body, and confronting physical fear was an important part of the experience for people trying to break out of the habit of physical submission" (2002). Enhancing civic pride, reveling in the newly available ability to take over public spaces in legal public assembly, people viewed the *correfocs* as a badge of Catalan identity, an active and participatory ritualized manifestation of a newly incarnated yet historically related secular creed. But as the younger generation becomes more confident in their Catalan-ness—as it has become the default language in which school is taught, commerce is negotiated, and street signs are posted—people continue to practice this reinvented tradition less as a political statement and more because it is fun.

The *correfoc* is not a handmaiden for a separatist ideology; it has become a signpost of community identity on a more visceral level and can absorb a variety of multidimensional and multicoded manifestations, intents, and agendas. This phenomenon results from the capacity of such events—via the unleashing of "collective effervescence" as well as the practical difficulties of determining individual identity in the crush of noise, smoke, and sweating bodies filling the dark and narrow streets—to transcend boundaries of gender, class, background, ideology, and insider/outsider status. Instead, conceptually as well as practically, the *correfocs* encourage a focus on the group's social identity and the exhilaration offered by physical action and reckless abandon. Such a dynamic collec-

tive performance, ritualized yet improvisational, has become the defining mechanism for an instinctive and embracing public bonding. The physical manifestations are so seductive, so involving, so visceral, that after a single *recorregut* even nonnative outsiders can feel that they have been doing this forever.[29]

Neither a pristinely preserved survival of centuries-old traditions nor merely an alcohol-induced contemporary street "happening" of political, social, or religious rebelliousness, the *correfoc* is a unique and, on a certain level, improvisatory amalgam of culturally embedded influences, legacies, customs, and rituals. Each *recorregut* is different, an ever-shifting combination of historical moves and contemporary fashions, personal tastes and developing concerns; these changes occasionally decrease the event's effectiveness but more often enhance, refine, and polish it and provide inspiration for the next time. The *correfocs* are the perfect illustration of the customary description of the Catalan's personality: *Seny i Rauxa,* one who can combine craziness with common sense, emotion and passion with reason.

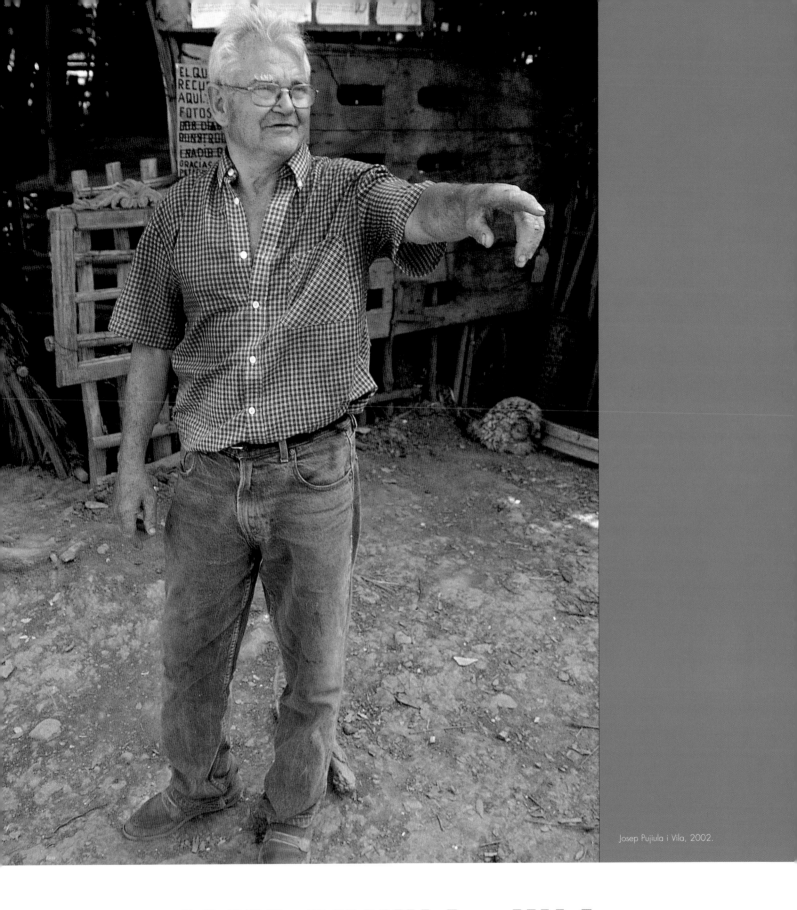

Josep Pujiula i Vila, 2002.

JOSEP PUJIULA i VILA

For almost twenty years, a spectacular and arresting art environment rose alongside a curve in the shallow Fluvià River in northwestern Catalunya. Nestled among the medieval villages of La Garrotxa, this fantastic, sprawling construction at once harmonized and collided with the well-worn stones, deep valleys, and verdant dormant volcanic cones of its surroundings. Locally known as a *parc salvatge* (wild park) or *poblat salvatge* (wild village), seven soaring towers, innumerable bridges, shelters, walkways, stairwells, and, above all, a labyrinth more than 1.5 kilometers (approximately 1 mile) long comprised the most extensive incarnation of the labors of Josep Pujiula i Vila. The entire intricate construction covered just barely over one hectare of land, and the towers soared some thirty meters (almost one hundred feet) high, jauntily capped by Catalan flags and banners. It had been the world's best jungle gym, the most unaffected open-air sanctuary, the most devilishly enjoyable maze, the "Sagrada Familia of Art Brut," in a Madrid newspaper's appropriate aesthetic and conceptual reference (Casasses 2001) to one of Spain's most recognizable architectural treasures, the Barcelona cathedral designed by Antoni Gaudí.

ART ENVIRONMENTS

Although we can now define a worldwide genre of such monumental structures,[1] the threads that bind these personal, idiosyncratic works to a shared folkloric tradition may seem superficially tenuous. In almost every instance, case studies of individual art environments reveal the labors of a single, passionate worker (an artist in my eyes, but often not in those of the creator), typically—but not always—begun in the later years of his or her life. Developed additively and organically, without formal architectural designs or engineering plans, these constructions are generally immobile and monumental in scale or number of components; they owe less allegiance to folk, popular, or mainstream art traditions and the desire to produce anything functional or marketable than to personal and cultural experiences, availability of materials, and a desire for creative self-expression.

The contemporary art world, in fact, seems to have taken more notice of such structures and environments than have folklorists anchored to academies or museums, possibly in part because of the fact that the constructions or their creators have often been equated with a certain degree of eccentricity. Rather than maintaining, expressing, and passing on shared community values, these creators may have generated a certain degree of discord or opprobrium within their communities. In addition, monumental constructions or sculptures made out of recycled materials (particularly materials that might be described as "trash" or discards) have not, until very recently, been readily desired or acquired by collectors or museums, since such works do not fit the traditional

form—or scale—of "Art."[2] Historical articles and documentation generally have presented this kind of work, if it was noted at all, as an esoteric curiosity, and the authors were often condescending or derisive about what were frequently described as "follies." In the mainstream art world, concepts of "environment" have emerged as a generally accepted genre only since the 1950s, despite heralded earlier experiments such as Kurt Schwitter's celebrated *Merzbau* of 1923.

In folkloristic terms, however, concepts of place have had significant historical resonance. Numerous folklorists (for example, Evans 1972; Relph 1976; Ferris 1982) have noted the importance of place in the development of a sense of self and community and how the physical attributes of the creator's surroundings play an important role in shaping creative output. Too, although each environment displays a personalized form, traditional and traditionally learned construction techniques and occupational skills as well as, in many cases, reference to orally transmitted myths, legends, and tales convey folkloric characteristics. Each art environment is a singular, personal act, yet it also has social and cultural implications, defining as it does a new identity for the creator-artist within his or her community. Documenting and preserving the cultural heritage of these environments is an essential component of these holistic concepts of the sense of place.

Nevertheless, if we describe a continuum of traditionality, marked in broad strokes by the artists explored in this book, Pujiula's work clearly occupies one extreme. Exploring his efforts, however, reveals a clear and intriguing transition in his conceptualization of his work vis-à-vis his relationship to his community. This set of connections echoes those of the artists in the three preceding chapters whose work is more overtly based in tradition. In this transition we see that the earliest incarnations of Pujiula's constructions on this site were fab-

ricated in secret and were intended to be private, hidden from public gaze. In its last years, the monumental configuration of the phenomenal labyrinth and its accompanying towers, bridges, and cabins loomed high over a major east-west thoroughfare and was liberally flagged to attract attention, with a parking lot and picnic tables that permitted—indeed, invited—public viewing and lingering.

Although monumental environments such as Pujiula's are typically so idiosyncratic and personalized that a valid argument can be made for excluding them completely from the "folk art" canon, a myriad of examples of undisputedly defined folk art creations exist within the same genre, and any differences are in degree only. The elaborately painted Merry Cemetery in Maramures, Rumania; home altars found worldwide, from the modest to those that take over entire rooms; garden ornaments that move beyond basic birdbaths, fences, and wishing wells to elaborate yard shows, gazebos, or grottoes; decorative wall treatments that become an obsessive surface covering for floors, ceilings, and furniture as well—all these creations find a place on the continuum between a traditional act and one that is purely personal. As the Catholic Church regards individually created shrines and grottoes as a nonthreatening deviation from established theological rite and architecture, welcoming such sites within the fold of appropriate religious observance, so too many of these secular, individual creative acts likewise diverge from more traditional expressions only in terms of scale.

EARLY WORK

Josep Pujiula i Vila was born on May 31, 1937, in the village of Argelaguer, a tiny hamlet tucked into the foothills of the Catalan Pyrenees in Spain's northeastern corner. Inexorably tied to the place of his birth, he was nicknamed El Gar-

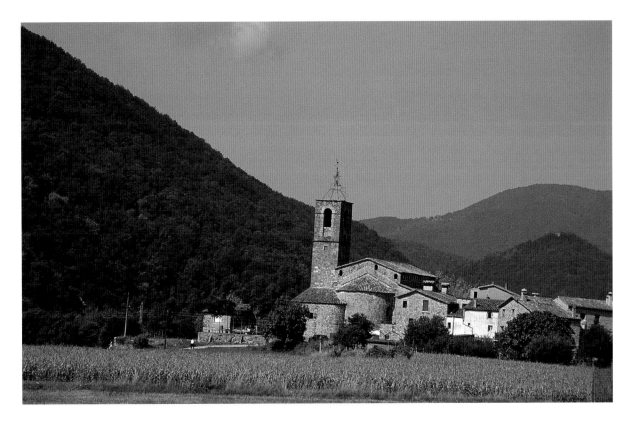

Village of Argelaguer, 2001.

rell, after the family house in which he was born. He attended school in his neighborhood of Sant Jaume until the standard age of thirteen.

Pujiula became a metal turner, apprenticing in two textile factories and learning all aspects of the job literally from the ground up (sweeping the floors) before becoming an *oficial de primera* (foreman). He later worked fifty hours a week in Ramon Massanella's small factory in nearby Sant Jaume de Llierca. Pujiula married Teresa Blanch while in his late twenties and moved to her nearby village, Castellfollit de la Roca; their daughter, Montse, is now a physician in the town of Salt, near the regional capital of Girona. Yet although working long hours and spending time with his wife and child would seem to provide sufficient activity to fill a young man's days, Pujiula wanted more: more excitement and more entertainment. However, he couched these desires in terms of something that he could "profit by doing," by which he did not mean something that would bring him

monetary rewards but rather something that would be edifying for him and perhaps for his family, friends, and community as well. Working inside all day and not enjoying spending time in bars after work, he wanted to do something with the "maximum possible action and in the fresh air." Unlike certain other artists of this ilk, who have constructed their monuments to retell local histories,[3] comment on social or political issues,[4] or glorify religious belief,[5] Pujiula had no initial intent other than to entertain himself and occupy his free time.[6]

Creators of such monumental environments rarely conceptualize the entirety of their labors in advance. Pujiula is no exception and, in fact, his earliest projects were not even architectural or sculptural but rather involved the creation of a variety of vehicles. Specifically designed for self-amusement and a natural outgrowth of his machinist background, these conveyances were developed over about ten years. His first project was the fabrication of a "boat" created from

Top: Spring at Font de Can Sis Rals, 2002.

Bottom: Pujiula's "improvements" to spring, 2002.

two tin pipes and boards and outfitted with the motor from an Ossa motorcycle. It was small enough for him to transport in the back of his Citroen 2 CV, and for approximately two years he maneuvered the craft up and down the winding Fluvià River. However, he spent many hours nursing the motor through untold numbers of breakdowns, and local fishermen scolded him for noisily disturbing their pursuits. He decided to cease his activities with this vehicle to avoid being seen as a "nuisance," but he realized that he "could never stop making things."

His next project was the transformation of an old Vespa motorbike into an amphibious recreational vehicle. He outfitted it with five 50- and 100-liter drums, along with a replacement front tire from a small Guzzi motorcycle so that he could both float down the river and maneuver on land. He was careful to leave the river when the fishermen appeared, powering up across the riverbanks onto dry land. He recounts numerous adventures and accidents with this amphibious crossbreed, including a near-death experience after unceremoniously pitching into the water with it from nearby cliffs. He tinkered and fussed with the vehicle, finding ways to help it maneuver better, sometimes in his off hours and sometimes while at work, provoking warnings from his fellow workers about incurring the boss's wrath.

He continued to imaginatively retrofit several additional all-terrain vehicles and even developed a hidden motocross circuit on which he and other local daredevils would ride through the trees and around the riverbanks in this mountainous region. Although he and his friends enjoyed the circuit, they were always trying to evade the police, as the breakneck rides were noisy and disruptive to the neighbors. A chance discussion in which a friend offered Pujiula the right to ride his horses tempered but did not put an end to these activities; although Pujiula called a halt to the motocross

circuit to enclose an area in which to run and stable the horses, he also bought another motorbike so that he could travel in this way when he tired of horseback riding. He and his friends would take their bikes all over the mountain trails, then stop for lunch at a local hostel, regaling each other with tall tales of all of the "crazy things" they'd done on the road.

Pujiula began his "rancho" for the horses at the edge of a small pond formed naturally by a spring known as Font de Can Sis Rals, whose clear waters were caught and held by the slow meandering of the shallow Fluvià River. He had enjoyed this spot for many years, fishing and swimming there as a child. Although the property was owned by the family of the mayor of Argelaguer, with their home contiguous to the site, Pujiula decided that he would make a mud-and-stick dam to create a nicer swimming area and would put a pipe into the spring to draw water out and create a natural shower. Ignoring any problems that might predictably arise from his trespassing, he continued mulling over potential improvements to this beautiful area and decided that it would be lovely to bring in some ducks to add to the natural charm. But the ducks would need to be protected from their natural predators, he realized, so he decided to construct a little building (*barraca*) where the ducks could eat and grow.

He scavenged wood from the surrounding area and improvised the little duck shed without sketches, plans, models, or permits. Indeed, he had to keep everything well camouflaged so that the owner of the land did not become aware of these illegal "improvements." After a bloody accident involving one of the horses, he decided to give up on them completely, to "dedicate himself only to the ducks, and to construct a park." Immediately thereafter his efforts expanded exponentially; he began to work a couple of hours after leaving the factory each day and five hours on Saturdays, as he explained in a small self-published anecdotal account of

Sign identifying Pujiula's "wild village," 2000.

his labors: "I also realized that I could keep a goat there and so right away I started to build the shed and the enclosure for the goat. But the thing was going to get bigger, because a little while later a friend gave me some pigeons, and so then I had to make a cage for the pigeons. There I also had small chickens and geese, and more, in the cage with the pigeons I also had a partridge, two doves, and four quail. It's curious, but between one thing and the other I passed four years doing all this, and no one knew it was there" (Pujiula i Vila 2001: 25).

No person, perhaps, but the wild animals roaming the forested mountains were immediately aware of the aviary, and Pujiula began having problems with these predators. He would arrive after work to find the enclosure breached, with dead birds and stolen eggs; the

Lower north side of structure,
2000.

ducks, however, seemed to take care of them-selves: "everything was following its natural form, as was demonstrated by the ducks. They defended themselves perfectly well, and when they felt scared, they'd dive underneath the water so no one could get them." Soon he added two burros, constructing an enclosure for them as well.

Despite the difficulties in ensuring the safety of his growing menagerie, Pujiula continued to enjoy himself in this secluded forested setting with the enhanced swimming hole. "There-fore," he recounts, "I continued to construct more cabins, now with one excuse, now with another." As his construction grew, it became visible from the road, and people started to stop by to see what he was doing. With the enclosed animals and the pristine pond, it began to achieve some degree of local renown, especially among mothers and their young children. He continued to build, adding a new little cabin assembled from scavenged materials and then a hanging bridge across the duck pond between the cabins on either side of the water, with yet another small house on top of the bridge itself. Some publicity about his constructions appeared in a local magazine, significantly increasing his audience. "It's just my hobby," he said to those who asked (Batallé Prats 2001: 2): "it pleased me that so many people came, because they liked it and I saw that they found it good. . . . [I]t pleased me to keep constructing and to never stop, and people would donate things to me that I could always use" (Pujiula i Vila 2001: 28).

A friend of Pujiula from Castellfollit pur-chased an old building, full of furnishings for which he had no use, and offered Pujiula the unneeded doors, windows, tables, and other wooden objects. With these three or four truck-loads of wood and fixtures, Pujiula began con-struction of his first building for humans on this site. He rigged up a way to level the floor, utilizing two old electric-line posts as a base for

support, and developed the structure into a three-story house, "with doors and windows all over everywhere." He improvised as he built: "It is certain that when I began one thing, I never knew how it would end up. I always worked by improvising with the amount and

Entrance on western facade, 2000.

Western facade. The prepared limbs in the foreground were added to the structure's heights the next day, 2000.

type of wood that I had." He added a deck and an area for outdoor cooking, and his wife, daughter, and friends would come out on weekends to pass the time and have a barbecue. Not surprisingly, the owner of the land soon heard about what Pujiula had done and came to see the creations; subsequently, contrary to Pujiula's fears, the owner encouraged further construction efforts. With this nagging concern relieved, Pujiula covered the interior walls of the rooms with paintings depicting different views of the structures and the animals. A diving board for the pond and river rafts made out of bundles of wicker further enhanced the weekend hideaway. At its most expansive, twelve small buildings of locally gathered or scavenged wood, roofed with heather branches, stood on this forested site of little more than a hectare.

As more and more people learned of and began to visit the park (people "of all classes," Pujiula stressed), and he saw how they enjoyed themselves, he started constructing new amenities specifically with the visitors in mind. He added a covered picnic area with tables and benches that could comfortably accommodate twelve people, balancing a hanging hammock on top, to his own and his visitors' delight. Groups of young people would come with their guitars and linger for hours.

Happy at the enthusiasm of the increasing numbers of visitors, he decided to install a donations box so that people who wanted to leave a few coins for the continued maintenance of the ever-growing "attractions" could do so. Because he scavenged most of the construction materials, his expenses were few—primarily food for the animals, hardware, and small tools—yet the increasing numbers of animals and his continuous building required more money than he could afford on his small salary. He immediately began to collect 1,000–1,500 pesetas ($8–10) each week, more than 500,000 pesetas (approximately $3,500) during the time that the box was installed. He

Central towers, 2002.

calculates that he used more than 60 kilograms (132 pounds) of nails for construction, plus such other materials as wire and saw blades, so the extra funds enabled him to buy items that he

otherwise would not have been able to afford and were therefore essential to the expansiveness of his creations.[7]

One of his purchases was a fully outfitted and decorated cart to which he would hitch a burro and take children for rides around the park. This activity proved so popular that he was hired three times to drive brides and grooms through the town streets, to the enjoyment of the townspeople. He also bought a tractor and made a road connecting the two sides of the park. He then built a shed for the tractor and one for hay storage, the latter tied directly to the barriers on the side of the county road. Although the public works and roadways officers had turned a blind eye to his constructions up until this point, they immediately made him remove the shed, which was at road level and could be a distraction and danger to the traffic. He realized at once that he should not have built the structure there, castigated himself for building without first thinking things through, and removed it to avoid additional problems with these authorities.

Pujiula next erected his first tower, which he envisioned as a spire from which he could observe the surrounding foothills of the Pyrenees, a place above the trees where he could enjoy the sun. He built this and two subsequent towers on top of existing trees, with no part of the towers touching the ground, to prove to a doubting friend that doing so was possible. High on top of the first tower he installed a truck wheel; people who managed to scale the heights would bang on it, ringing it as if it were a bell.

INCREASING CHALLENGES

Visitors' enjoyment of his efforts motivated him to continue to build. Yet along with the increased attendance came associated problems. By the mid-1980s, he began to find garbage left over from people's picnics, including beer bottles and, more disturbingly, syringes and even human feces.[8] He did not mind that people began spending the night in his cabins, even when someone brought a mattress and left it there, but the syringes were a greater worry. His retreat became a draw for "undesirables" and vagrants, who, without oversight or prohibition, freely indulged in extended orgies of sex, drugs, and alcohol. Pujiula calculated that over time, more than three hundred visitors spent the night in his house without his permission. He realized that he needed to be more vigilant about his visitors, and he soon found himself spending his time policing the area rather than amusing himself by building cabins and playing with the animals.

He protested that although he did not really care what people did, their liberties should not result in the destruction of his work. At times, he felt like he was being specifically targeted by all the "current tribes" of lowlifes: "those that don't give a damn, pill-poppers, thugs with sticks or razorblades, skinheads, hobos, and others [*passotes, pastilleros, porreros, maquineros, rapats, ruteros, bacaleros*]" (Pujiula i Vila 2001: 55). They would steal the money from his donations box and break into visitors' cars, stealing clothes, equipment, and even eyeglasses and a bicycle strapped on top of one auto. Pujiula was depressed, thinking that instead of making a lovely park where people would be able to have a good time, he had created the "perfect trap" where thieves could operate easily while visitors were viewing his constructions. "Good" people stopped coming to the park, wary of being robbed. Furthermore, because the undesirables had ripped out many of the niceties there, burning the benches and dismantling parts of the buildings, the entire site became much less inviting.

One winter morning he went to the park, ready to continue building with the full load of acacia branches that he had cut and brought up

to the site the previous day. When he arrived, he saw that the wood had been used to start a bonfire, which had been further fueled by a bench that he had constructed for visitors' use. He also discovered that the door to the burro and goat cages had been broken and left open and that the animals had escaped onto the street. He surprised four young men who had clearly spent the night at the site; startled, one rose up and punched Pujiula in the nose. Disoriented, Pujiula fell back, but was pummeled again in the face before the hoodlums ran off. He reported the incident to the Guardia Civil but was told that they could not help him because the incident had not happened on his property. He decided to burn the structures down and then bury them, the only way, he thought, to terminate the hooliganism once and for all. He began to do so on what he thought was the last "burn day" of the season,

but he had miscalculated, and the police soon came and made him put out the fire. He told them why he was doing it, hoping to garner their help and sympathy, but again they told him that they could not do anything about it. He began to feel as if no matter what happened, he would bear the difficulties and suffer the consequences and that the true perpetrators of any misdeeds would escape scot-free.

Pujiula also began to have problems with his wife, who complained about the hours that he was spending there "for nothing" because people came and destroyed his constructions. Further, she was upset because she could not get him to do projects at home but he would "work like a burro" at the park. He was always late for meals, and she objected to the inordinate amount of time she spent washing and mending clothes dirtied and ripped during his labors. She also worried that someone would get seri-

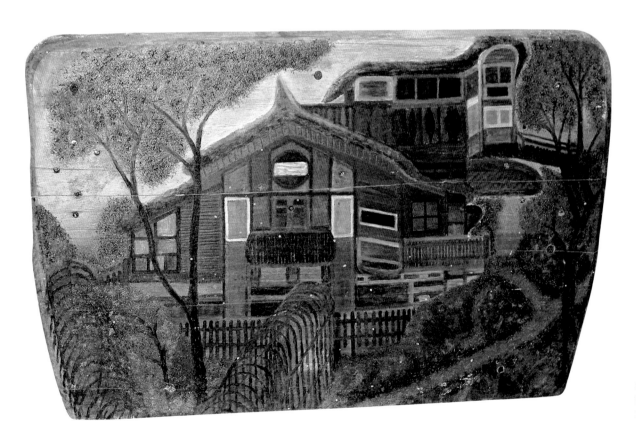

Untitled [house at Can Sis Rals], acrylic on wood, 28 x 44 centimeters, 1988 or 1989.

ously injured at the park, and because he had no permission to build, his "caprice" would ruin them. Pujiula knew she was right, but he could not give up his work because, despite the frustrations, he still enjoyed himself there so much. His solution to her complaints was to use money from the donation box to buy her an expensive leather jacket. He reasoned that although this was not directly related to the park per se, a gift to appease his wife would make it easier for him to work there, and the gambit apparently worked—their relationship became more tranquil, although she continued to worry.

In late 1988, Pujiula was diagnosed with thrombosis and complete bed rest for several months was prescribed for him. Unable to stop "making things," he was pleased when his daughter provided him with paints and canvas board, and he created numerous paintings during his convalescence on a variety of themes, including plants, animals, and his wooden structures. Moving on to painting on particle board and wood after he exhausted the canvas board, he wrote that these paintings would provide a record of what he had created; by changing his medium, he could avoid incurring further problems with the people who wanted to destroy what he had created.

His problems did continue, however. In the early 1990s he received an official notice that his construction was dangerously close to the high-tension wires that stretched over the property and thus constituted a public danger that had to be removed. He thought he could head off these concerns by putting up a sign that read "Private Property. I am not responsible for any accident," and he removed a small piece of the house to lower it slightly, dismantled one tower, and made several other minor modifications. He heard nothing else about the matter for a year, when he received a letter telling him that he had eight days to level the three-story house, photograph the demolition, and submit the pho-

tos to the industrial delegation in Girona, the regional capital. He decided to hang a copy of the letter at the entrance to the park so that visitors would understand why he had taken the house down. Before the demolition, which took place in May–June 1994, the mayor's son suggested videotaping the park to record the structures. Delighted at the prospect, Pujiula put on a loincloth and started acting like Tarzan, climbing the trees and playing with his goat. Some young friends later made a second film with Pujiula playing Tarzan, the wild man persecuted by civilization, and to this day, he is referred to as the "Tarzan of Argelaguer."

Despite such diversions, he was very upset about the demolition, and he became further distraught when one morning he arrived at the park to find that someone had stolen his beloved goat, La Chula, and his female burro, Linda. "I never thought [these kinds of things] would happen [here but that they would] only happen in American movies," he lamented (Pujiula i Vila 2001: 49). Frustrated and disappointed, he swore that he would build no further improvements to the park now that the house had been taken down.[9] He put up a sign to say good-bye to the many people who had helped him and who had inspired him to make the park: "This park has broken me. . . . I don't want people to come any more because something bad might happen to them. Thanks to the people who have visited and who have respected my work. Private property."

THE LABYRINTH AND TOWERS

Despite his vows to the contrary, Pujiula found that he could not stop working at the park: eight days after demolishing the house, he was back at work. He decided to make a tunnel within the hedges to facilitate his passage to the area where he had hidden his boat and amphibious Vespa in the days when he was

keeping his work there secret. He gathered long, slim acacia and willow branches, bending them and linking them with wires. The hedge grew up over the entwined branches, covering the construction and forming a tunnel. He then realized that he could utilize this technique to make it more difficult for vagrants to reach the remaining towers. If so much effort were required, he reasoned, people who just wanted to sit up there and drink or use drugs or to use the wood for fires wouldn't bother. He decided he would build a labyrinth with a single entrance and a single exit that would serve to guard the sole access to the towers.

He rather feverishly began adding "tunnels"—woven passageways created by the flexible, curved slender branches of the saplings, each tightly wired to its neighbors and completely enclosing the pathways with ovoid arches. Some ten years after he began this phase of the project, an ordinary-sized adult could pass upright through some sections where footsteps had worn deep ruts into the earth, but most of the sections of the labyrinth required people to walk bent over, sometimes almost crouching. The labyrinth was complex, with intertwined paths, yet the openness of the construction enabled visitors to see contiguous pathways as well as nearby bridges, stairs, and the towers, now numbering four. The convoluted and intricate nature of the construction, however, often prevented people from figuring out how to reach or approach even adjacent points. The cagelike warrens twisted and turned back on themselves, dead-ended, and forced people up and down ladders and through doorways. It was easy to get disoriented and lost. Pujiula indulged his puckish sense of humor by placing chairs at some of the dead ends, with signs telling visitors that if they couldn't get out, at least they could rest. In other places, he stuffed old pairs of pants and shoes with straw to simulate dead bodies lying on the ground. He rigged up other gags to star-

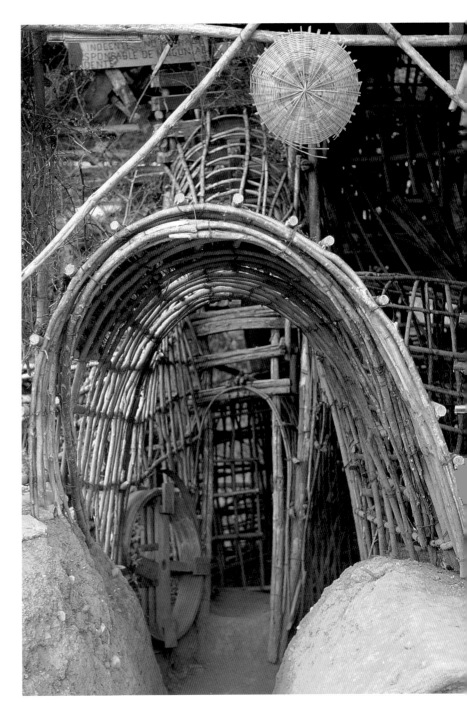

tle passersby; he did not want to be mean, he stressed, but only to tease and surprise them with a quick prank. When he felt especially mischievous, he stood to the side, waited until someone passed by, and then pulled a string to make a stuffed mannequin jump, a prosthetic limb kick, or a bell ring. He soon found that the

Entrance to labyrinth on western facade, 2000.

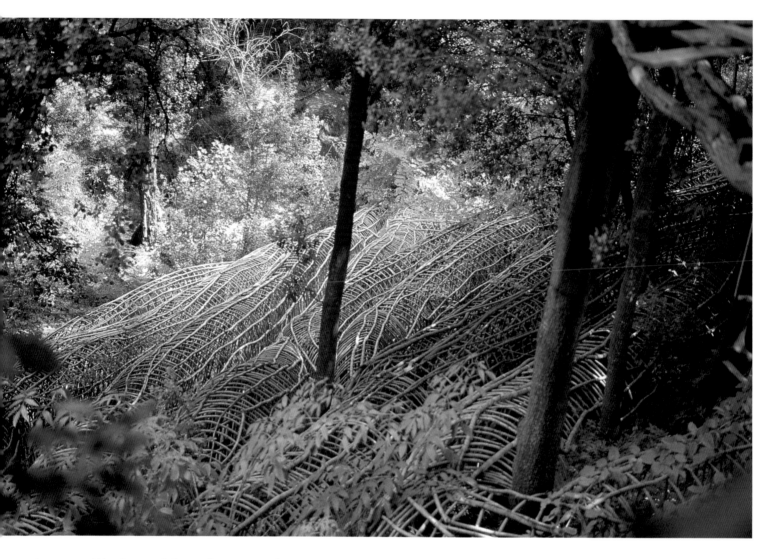

Lower section of labyrinth, 2000.

labyrinth generated visitors' most enthusiastic responses, and he delighted when people asked if they could enter, chuckling to himself that the real question was whether they would also be able to leave.

As he had predicted, "normal" people greatly enjoyed the challenge of the labyrinth, which made it more difficult to reach the towers (only about one in twenty visitors could figure out how to reach the heights), and the undesirables were not inclined to exert enough energy to discover the access path. Pujiula had a secret way of climbing to the top that circumvented the labyrinth, enabling him easily to reach the towers for further construction. He spent four to

five years in the initial phase of the creation of the labyrinth and was proud of its distinctiveness: "The labyrinth that I have here you will not see in any other place, it isn't copied from anywhere, it came from inside of myself, just by chance, and it is unique" (Batallé Prats 2001: 2).

With his towers more secured by the obstacle of the labyrinth, Pujiula returned once more to the heights, building the fifth, sixth, and seventh towers, again using the oak trees as a base so that none of the supports touched the ground. He strung covered walkways between twenty and twenty-five meters (roughly sixty-five to eighty feet) in the air to provide access between the highest points and ornamented the

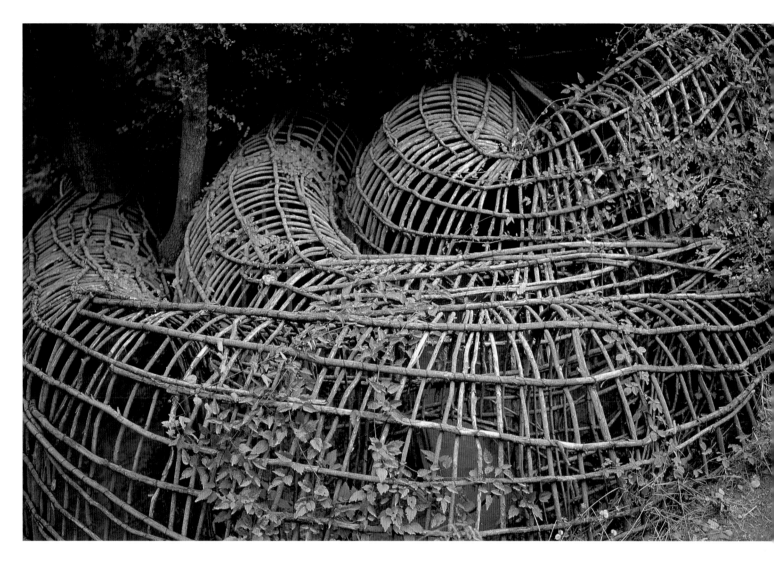

towers with found objects and gifts. The structure rose high among the supporting trees, leafy with foliage during the summer, and provided a fine view of the surrounding foothills of the Pyrenees.

THE CREATIVE PROCESS

Pujiula worked carefully, bringing up into the trees each load of raw materials and then measuring and cutting the wood with a bow saw, dropping the scraps down to the ground before gathering them later. He did not wear a carpenter's belt but filled his pockets with nails, which he used to join the branches together to shape the structures. Further reinforcement was added by lacing the cross timbers together with wire. While building, he regularly pulled and prodded the supports to test for strength, adding supplementary horizontal and vertical timbers when he felt they were needed. He knew that his construction was solid, he said, because he had seen fifty people at a time in the heights, and the work held sturdy and stable (Ponsatí 2000: 10). Despite the inherently ephemeral nature of the wood and the fact that some of the pieces had been at the mercy of the mountain winds, rain, sun, and occasionally snow for thirty years,[10] examination of the interior structure in 2002

Left: Three-level ladder
within labyrinth, 2000.

Right: One of many
dead-end junctures within
labyrinth, 2000.

Left: Chair placed at
one of interior dead ends,
2000. Sign reads, "If you
don't know how to exit,
you can sit down here."

Right: Interior passageway
within labyrinth, 2000.

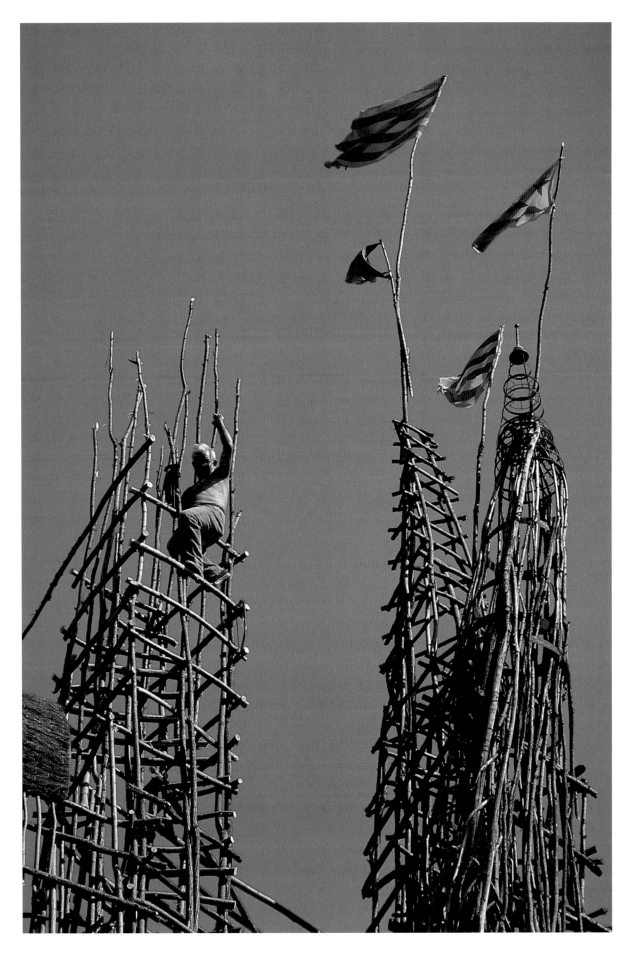

Tower construction, 2001.

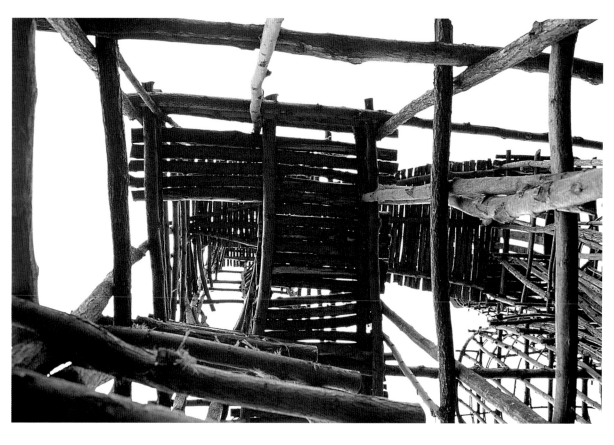

Looking up into the tower interior, 2002.

during the dismantling revealed that the acacia branches remained strong.

Unlike the factory, where everything was controlled and planned out in advance, Pujiula's work at the Font de Can Sis Rals was improvised, a method that delighted him: planning it would make it "too controlling and not fun," he said. He was never sure about the final shape of certain elements until he was actually building them: the final tower, for example, which contained an almost square viewing area more than twenty-five meters (eighty feet) in the air, rose quickly, and even when he had most of the upper-level verticals in place, he still wasn't certain whether he would finish off the top in a point or keep it squared off. Six days after he began this tower's apex, he decided it would rise to a point. Still without an overriding conceptual intent, he worked forcefully and intuitively, moving from one area to another as the ideas struck him, a somewhat erratic stream-of-

consciousness creation that could be appreciated best as a whole despite the interest and intrigue of small nooks and crannies and the impressive details of technical construction.

As he worked, Pujiula would think about the element of construction immediately ahead, juxtaposing and combining new materials with components of earlier structures that he had intended to demolish but that came to serve him in different ways. He wanted to extend the labyrinth for at least another thirty meters (approximately one hundred feet) but doubted that he could have increased it further than that because he would run out of space under the trees. After retiring from his job in 1999 at age sixty-two, he came to the park every morning, working five or six hours before breaking for the long Spanish lunch and siesta. If the weather was mild, he often returned again in the late afternoon, gathering wood from down near the river and loading it into his car (three

Second-level view of
labyrinth and walkway,
2000.

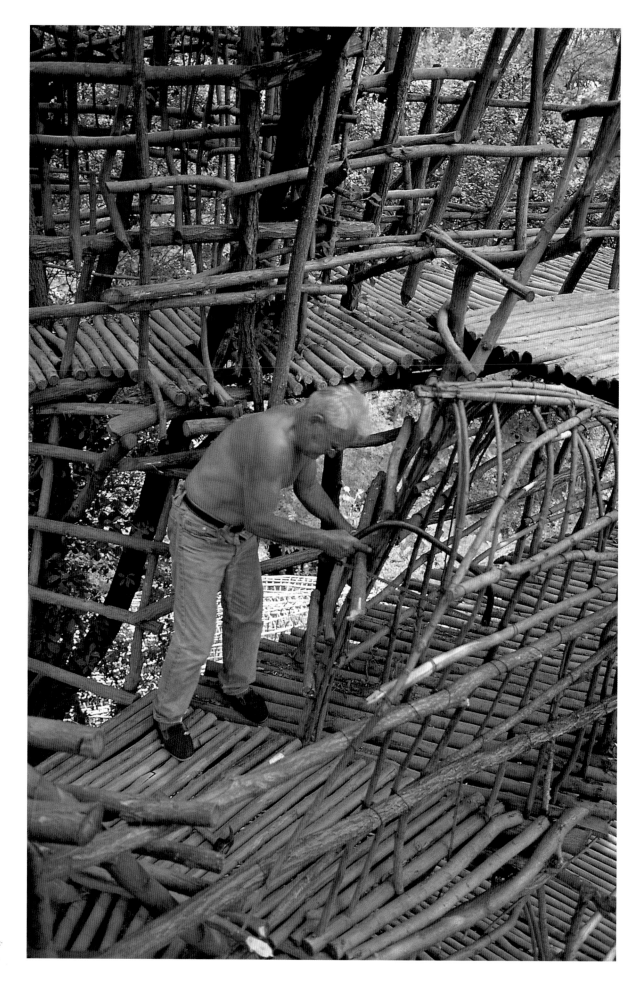

Sealing off a dead-end junc-
ture within labyrinth, 2000.

of which he ultimately ruined with this off-road bouncing and bumping), repairing, renovating, or cleaning into the shadows of the early evening. As he walked through the various parts of the structures, he was constantly checking them, picking up stray leaves or bits of garbage and noting what needed repairing or replacing. "My work is never done," he commented, but he never acted as if these ongoing labors burdened him.

THE ARTIST AND HIS COMMUNITY I

Despite the various setbacks and official rebukes, visitors from all over the world remained entranced by his efforts and provided continual encouragement both through direct comments and through notes left in his donation box, many written in languages he did not understand. He proudly flourished these documents as proof of the "wonderful things" that people said. He occasionally would stand to the side of groups of visitors, surreptitiously listening in on their opinions of his work as a means of getting "a more authentic reaction" (Batallé Prats 2001: 2). He was usually pleased with what he heard. Groups of children came on school or camp field trips, and Pujiula's work—although not his name—became widely known among northern Catalunya's art communities.

However, during the entire lifetime of the site, the administration of Argelaguer officially disavowed any knowledge of it, a situation made particularly curious because the mayor owned the land and lived so close to the site. Following the lead of many other small Catalan villages, the tiny municipality published a small tourist brochure describing its attractions, including the tenth-century hermitage of El Guilar, but failed to mention the environment described as one of the "largest spontaneous works of art in the world" (Casasses 2001). When asked about it, village officials shrugged,

"es un particulár [it's private]," clearly seeking to avoid any connection in case of accidents, problems, or lawsuits. Pujiula was frustrated that his work was respected and appreciated by tourists from afar but not by locals.

Additional trouble lay ahead. The Can Sis Rals site, situated on a bend in a major thoroughfare, was constantly being eyed by the road authorities, the electric company (due to the high-tension wires overhead), and the forest authorities, who were interested in protecting the spring and surrounding environment. Rumors flew that the highway would soon be rerouted to reduce the dangers resulting from the semiblind curve (dangers which were increased by drivers craning to see the roadside construction); the plans would take the road directly through the park. Pujiula shared this news matter-of-factly in 2001, saying that "surely when they widen the highway they will cut the tree and the structure will slide down, and with it its eighteen-plus years of park history." Although I found the labyrinth the most elegant and aesthetically significant component of the site's various incarnations, Pujiula recalled most fondly the house at the time he had all the animals: "It was more beautiful before. . . . I've thought that if I had been paid for all of the hours that I'd put into the park, I would be rich. But that wasn't what I wanted. My only desire was always to be able to work on a healthy and fun thing that would keep me occupied and entertained" (Pujiula i Vila 2001: 71–72).

Encouraged by public response to the informal verbal tours he spontaneously offered to visitors, and to document and record his construction activities in the event of future demolition, in the spring of 2001 Pujiula self-published an account of his experiences at the park.[11] Helped by Castellfollit friend Toni Carbonell and other young people from the group Lluna Plena (Full Moon), the small paperback, although only sketchily chronological, is replete with anecdotes about his adventures

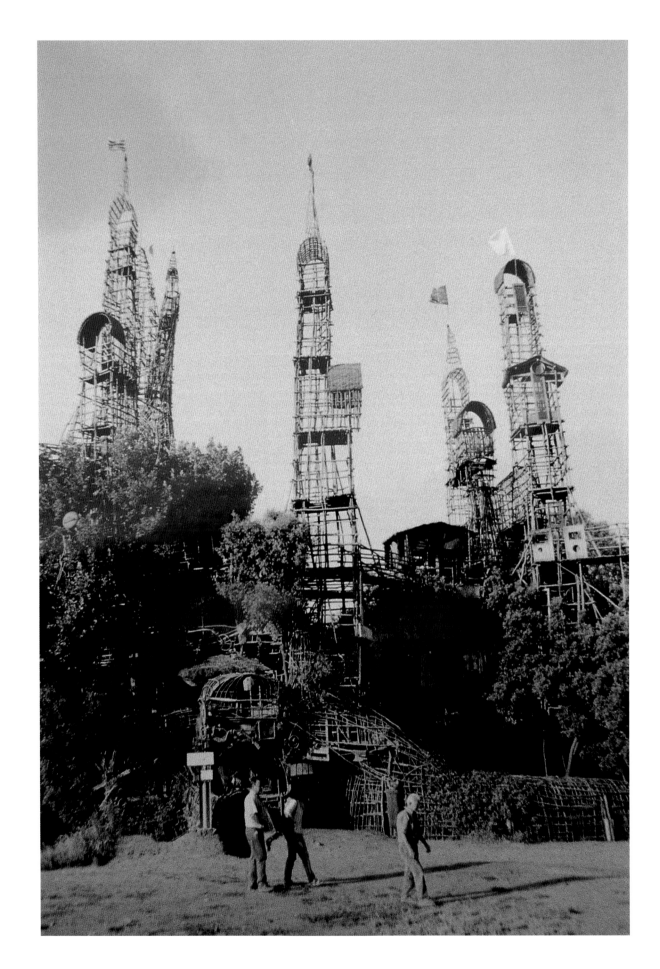

View of final phase of
west side of towers,
June 16, 2002.
Photograph: Carlos Vila

and some of the events and efforts that marked his time at the park. He intimated and Carbonell's editorial comments emphasized that the most important aspect of this history, at least in later years, was Pujiula's relationship with his visitors. Carbonell wrote,

When you pass by on the highway, you see some cabins with flags on top. When you stop to see them up close, you see a structure of timbers and branches balanced in a natural space in a natural manner.

But if you are lucky and are able to stay there a while by yourself, walking on the ground, climbing the trees, losing yourself in the labyrinths, settling down with some of the sculptures and art, you realize that you are inside of a world that you will never see in a theme park.

This is a special place, made little by little, created as a result of the relationship that exists between Josep and the visitors.

The signs and the sculptures are in a constant dialogue that are addressed to some visitor or group, reappearing in the form of a prank or a written message.

When you enter the park, you are converted into both a spectator and an actor in a living work of theater that is played out day by day without an interpreter.

The acts continue for months, years. The decorations are moved, changed, and improved little by little, with the rhythm of events, with pauses of weeks and then days of frenetic activity.

A work that no one knows when or how it began, that doesn't have rehearsals or an opening night premiere. It is always here. . . .

And no one will be able to predict when or how it will finish. (Carbonell in Pujiula i Vila 2001: 109)

Carbonell's metaphor is intriguing: it defines the viewer as participant/actor and inspiration for the artist at the same time that we ponder the artist as both spectator and collector. He was surely a spectator, viewing us viewing his work. But he was also a collector, not only of the assorted discards and gathered branches with which he created a masterpiece but also of impressions and experiences offered by his

viewers. With the collected judgments and input, he moved toward further production. And although Pujiula mourned the dismantling of the many cabins and the menagerie that once graced the site, he, like any working artist, was less concerned with the past creations than with the creations just ahead. His intense curiosity to understand the effect of his constructions on anonymous viewers nourished his muse and was significant—if not, in recent years, essential—to continued creation.

Although very satisfied with his efforts and proclaiming their uniqueness, Pujiula never thought of himself as particularly special:

I am a normal man like any other, in that in my free time I do what I feel like doing. . . . Well, okay, I am a little peculiar. To work for twenty years on land that isn't mine, very few people would do that. But the owner of the land has been very patient. As he saw that I wasn't doing anything bad and it became an attraction for the town, he saw that it was good. . . .

I do this as a hobby. I didn't start doing this for people to visit. But when people started to come it made me excited to see how they enjoyed it. Those that have destroyed things are in the minority; the majority of the people are very respectful. . . . Everyone that is here is in their own house. (Batallé Prats 2001: 3)

DEMOLITION OF THE MASTERPIECE

It is unlikely that, left alone, Pujiula would have ever "finished" with his work on this site. Yet on June 18, 2002, he began the process of dismantling the entire construction, the result of a meeting held the week before with representatives of the Generalitat of Catalunya and the mayor of Argelaguer, the owner of the land on which Pujiula had—illegally and without permission—built his masterpiece. The mayor and his family were concerned about public safety; particularly, the damage and liability issues should a visitor be seriously hurt while

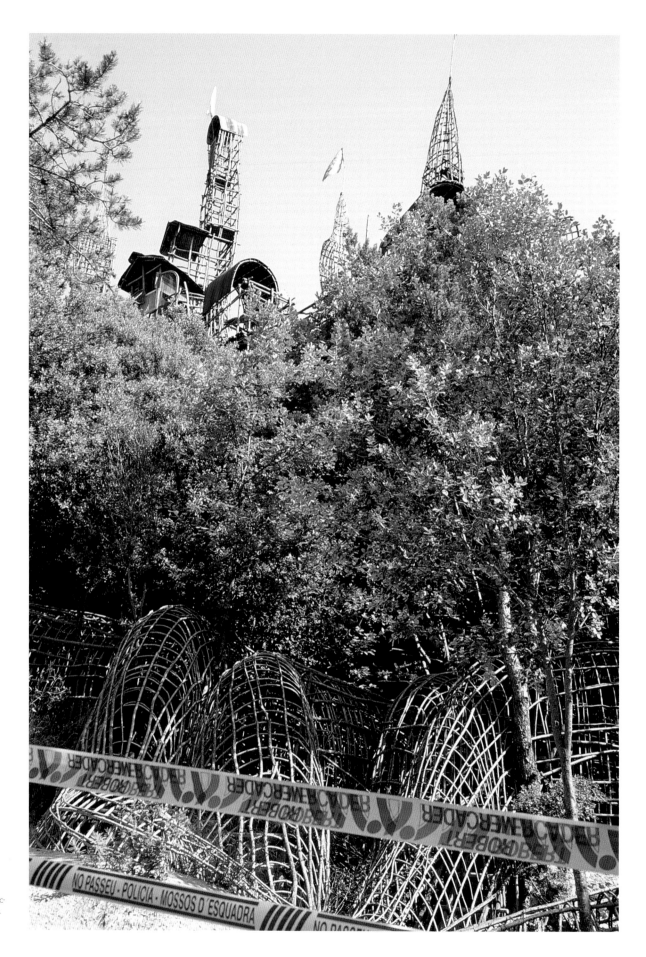

View of northern side of structure with police line prohibiting passage, June 2002.

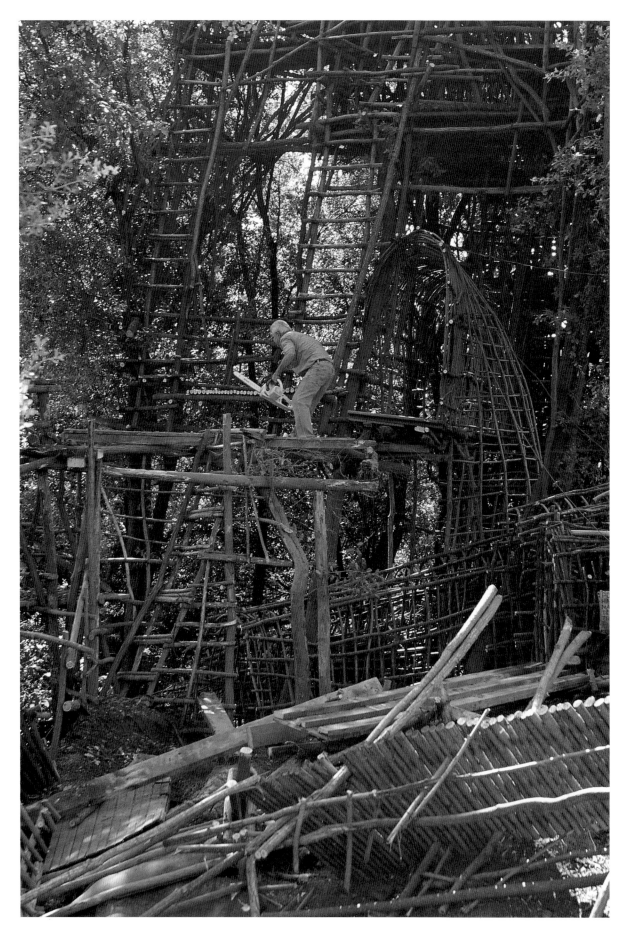

Dismantling structure,
July 26, 2002.

Dismantling structure,
July 26, 2002.

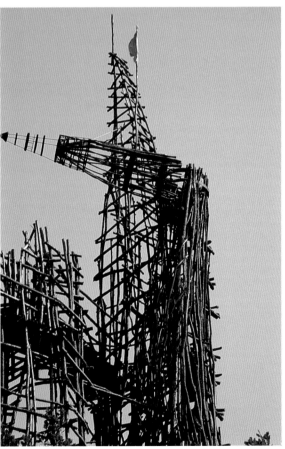

Left and Right: Removal of
one of northern tower spires,
June 19, 2002.

Top: Removing debris from towers to bonfire site, July 1, 2002.

Bottom: Looking west from tower remnants to fence of discards, July 1, 2002.

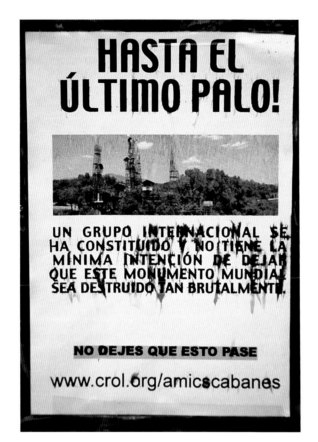

UN GRUPO INTERNACIONAL SE HA CONSTITUIDO Y NO TIENE LA MÍNIMA INTENCIÓN DE DEJAR QUE ESTE MONUMENTO MUNDIAL SEA DESTRUIDO TAN BRUTALMENTE.

NO DEJES QUE ESTO PASE

www.crol.org/amicscabanes

Posted sign from ad hoc preservation group declares, "We will fight this demolition 'Until the Last Stick!'" July 18, 2002.

climbing on the structures. Pujiula's wife and daughter shared these concerns. Furthermore, the provincial government's Department of Public Works, which has been proactively improving the infrastructure of roads and public buildings throughout the region, had indeed determined that National Route 260 needed to be slightly rerouted and widened to eliminate the dangerous curve. Not coincidentally, it was slated to be rerouted directly through Pujiula's environment, thus necessitating its demolition.

At the meeting officially confirming the directive to dismantle the monument, some discussion occurred about the possibility of preservation. However, this option was jeopardized by the interest of the Department of the Environment in the protection of the forested area around the river and by the electrical company's high-tension wires stretching across the site. Further complicating any such effort, Pujiula could not visualize his work without public par-

ticipation and interaction: he did not want a fence around the construction that allowed people to view it solely from afar. Therefore, given the complex and apparently insurmountable liability issues, exacerbated by the varied ownership, proprietary, and access claims on the property, preservation seemed unattainable.

With an almost visceral understanding that it would ultimately be impossible to fight and win the battle to preserve his work, Pujiula took up the simple tools he used for creation and turned them to destruction. Creating the work had been an adventure, he said philosophically but sadly; so, too, was taking the structure down. Nevertheless, he lamented that if he only had had another eighteen months, he would have completed what he started, rounding out his concept of a full and finished "installation."

From mid-June through October 2002, Pujiula worked every day to dismantle the structure. He started with only his handsaw, wire clippers, and hammer but soon sped up the process with a pickax and chain saw purchased with funds from the donations box. Because of the rising opposition to the demolition from international art aficionados, he dismantled it "gracefully," hoping with the removal of every section that at least some portion of his monumental work would be saved.

As he cut, Pujiula tossed the large sections of the woven wooden labyrinth, the towers, the decks, and ladders over the side to the ravine below. From there, he dragged them by hand up to the street level, pulling, hauling, or carrying them on his back. The first week of the demolition he cordoned off the area with plastic yellow police tape, but legions of visitors still came each day to the site. As he cut down more sections, he encircled the remaining structure with a new fence built from the dismantled pieces. However, even this fence, 2–2.5 meters (6–8 feet) high in some places, did not prevent visitors from entering the area and climbing into or onto what remained of the structure. Pujiula

Lighting the fire,
October 2002.
Photograph: Carlos Vila

worked early in the morning, as he had when he was first building the work. By noon, when visitors generally began to arrive, he quit, not wanting to police the area but also not wanting to have to worry about hitting a visitor as he tossed the fragments down. Predictably, visitors picked up pieces of the dismantled structure and took them as souvenirs. Pujiula shrugged off such actions, saying that his structure was like the Berlin Wall, important in its time: people wanted a tangible memento of its existence.

To save the site, an ad hoc organization, the Amics de les Cabanes (Friends of the Cabins) formed, with a Web site that advertised the demolition and requested international support for opposition to the removal of Pujiula's work.[12] We solicited and received letters opposing the destruction from interested parties from all over the world, forwarding the letters to the authorities in Girona as well as to the

village mayor. Nevertheless, on November 5, 2002, Pujiula lit the last of the bonfires and watched as it consumed what was left of this monumental and spectacular art environment, resulting in the loss of yet another graceful and idiosyncratic artistic treasure of international importance.

THE ARTIST AND HIS COMMUNITY II

In mid-2003, with the N-260 roadwork in full steam through the site where the art environment had been, Pujiula was still going down to the spring every morning. He constructed a small tower for visitors to climb after taking a quick dip in the water, although a recently installed huge cement drainage pipe and retaining wall have drastically altered the course of the river and only a small trickle of water feeds

Top and Bottom: Tending
the fire, October 2002.
Photographs: Carlos Vila

Cleared site following burn
and removal of debris,
November 2002.
Photograph: Carlos Vila

Can Sis Rals site, cleared
by road crews for highway
construction, August 2003.
Pujiula's small tower at the
spring is visible at the far right.

Site with relocated proclamation, August 2003. "Here are buried my fantasies and my dreams, but not my balls . . ."

a tiny swimming hole. Along with refining and enhancing this tower, he is working on a more private creation, confides his daughter, a place that contains his mementos and will someday hold his ashes.

It remains to be seen whether Pujiula will find another openly accessible "public" project on which to work, another way to engage in a playful yet earnest aesthetic dialogue with his viewers, for this relationship had become crucial to his efforts. With phenomenal intensity of effort and purpose as well as an admirable tenacity that allowed him to keep working despite the repeated need to dismantle or demolish components of his work, Pujiula created a special place of his own but was eager to share it with others. Unlike two-dimensional art, which can be approached and entered only metaphorically, this monumental artwork could be physically entered, and the typical viewer response was wonder and respect. Concomitantly, Pujiula's response appropriately matched that of visitors, with the understanding that by inviting us into his space, we became part of it—as viewer, inspiration, and cocreator.

Given that Pujiula's masterpiece at the Font de Can Sis Rals resulted at least partially from his being energized and inspired by public visitation and response to his work, it is ironic that this same public visitation was used as an excuse to destroy it.[13] Further irony lies in the fact that during the same year in which Spain celebrated the sesquicentennial of the birth of Antoni Gaudí, the work of another Catalan architectural innovator should be demolished in the name of progress.

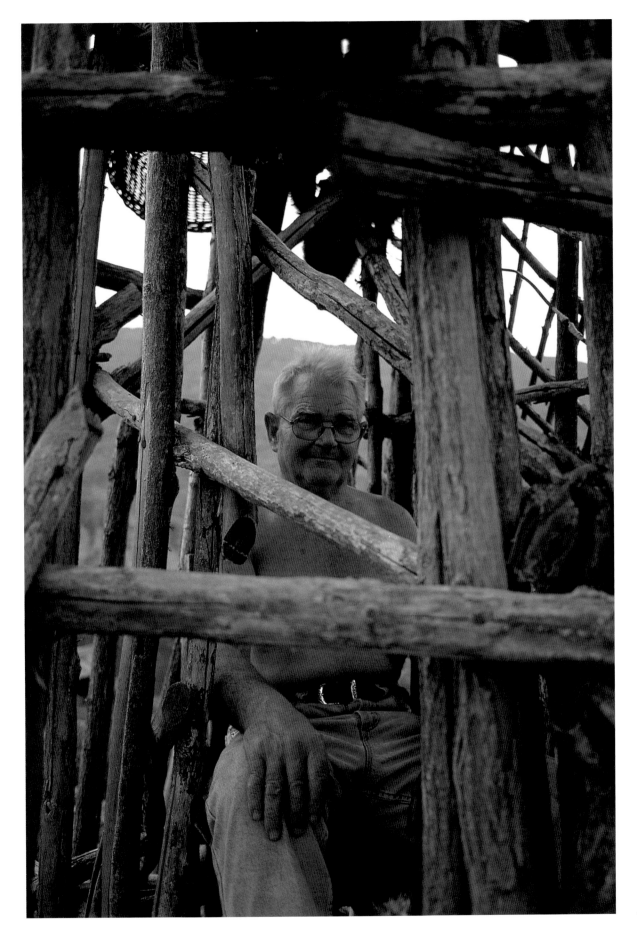

Josep Pujiula i Vila, 2000.

AFTERWORD

At least since Thomas Carlyle's 1829 diatribe decrying the mechanization of crafts and their concomitant loss of soul, urban social and aesthetic pundits have provided a steady stream of cultural criticism that has looked back nostalgically to the days prior to the Industrial Revolution.[1] Life in those earlier times, it was thought, was epitomized by the supposedly lost values of community, simplicity, hard work, and harmony, and the loss of such "traditional" communities, producers of "traditional" arts (which became known in Europe as "folk arts"), led to the increasing homogenization and soulless conventionality of factory-produced works. This nostalgia was manifested in a variety of ways, from the Arts and Crafts movement, led by William Morris (1834–96) in the 1880s and 1890s, which fostered the creation of works with a warm and handmade feel, to increasing studies by anthropologists, folklorists, and art historians of "primitive," "traditional," or "underdeveloped" peoples whose culture was perceived not to have "evolved" quite so quickly.[2] In reviewing these peoples' material productions, scholars assigned superior value to functional objects utilized in a domestic or sacred capacity that fulfilled specific social, cultural, spiritual, or symbolic uses and gave somewhat lower values to the technical or trade components that an industrialized culture would appreciate. Whether looking "back in time" or "across in space" (Moeran 1997: 17) to

these groups, many observers analyzed and interpreted preindustrial manifestations with a romantic—if somewhat fictional—glow.

I have tried to avoid this gloss, although as a Californian confronting a teetering economy, politically and religiously based terrorism, and simply the seemingly never-ending stress of trying to do too many things and take care of too many obligations in too few hours, I have to confess that I cannot claim to have been impervious to such nostalgia. Surely it must have been better "then," I have mused; surely there was a greater sense of community, arts of all kinds were more integrated into daily activities, and life was simpler.

I have therefore had to repeatedly challenge the seduction of those romanticized stereotypes while confronting the ways and means of artists who have proactively chosen to continue to produce work in ways and with means clearly referential to the utopian past about which I fantasize. Even inhabitants of the most rural parts of Spain are linked in numerous ways not only with the broader social, political, cultural, and aesthetic implications of their nation as a whole but also through similar associations with nations and regions far beyond their own. It is obviously impossible to characterize the societies within which these artists work as purely "folk," "inner-directed," or "uncontaminated"; consequently, they are neither isolated and practically obsolete survivals carrying on an impossible struggle against an

incomprehensible brave new world nor oppor-
tunists re-creating a contemporary model of a
historical manifestation that is no longer prac-
ticed in an unself-conscious manner. They are
fully functioning, fully adjusted members of
their culture, their society, and the world at
large who are, to different degrees, familiar with
the Internet, with Hollywood movies, with cell
phones. They also, therefore, represent a variety
of ways of working that may be defined as tradi-
tional—even folkloric—without discounting
both the increasing homogeneity and the global-
ization of western culture.

These artists have come to their passions in
different ways, but all these men and women
have bypassed the academies that would seek
to deconstruct their art while robbing it of that
passion. Whether it was learning from his
mother's example and critiques, as in the case
of Evelio López Cruz; from those of friends and
colleagues, as in the cases of David Ventura i
Bertrán and Neus Hosta i Pasqual and the Gàr-
goles de Foc; or from personal trial and error, as
did Josep Pujiula i Vila, mastery of their arts
came about in an almost visceral fashion: it was
absorbed by doing, not by studying. This man-
ner of transmission facilitates innovation, pro-
viding the framework but not the blueprint for
future works. This is transmission based on the
senses, not merely on words, and as recent
studies of human cognition have forcefully con-
firmed, we all learn better when we can engage
our brains with multiple sensory experiences.
The cool, smooth feel of the clay being wedged;
the weight of the *gegants* precariously balanced
on one's sweaty shoulders; the acrid smell,
heart-stopping explosions, and smoke of the
pyrotechnics lighting up the streets during the
correfocs; and the pervading uncertainty and
tension—both physical and psychological—of
creating a monument fragile not only in terms
of its slender willow branches shifting in the
wind but also in terms of its existence on a
piece of someone else's land provide layers of

memories that validate past efforts and inspire
continuing creation. When combining these
somatic experiences—the touch, the smell, the
noise, the vision—with the symbolic energies
that each artistic work or performance mani-
fests, they can indeed be powerful.

To further underscore this experiential com-
ponent of their labors, when asked to describe
the import of their work, none of the artists
responded with statistics about how many pots
or *gegants* had been made, how many perform-
ances had been presented, or how many
branches were needed to build a tower a hun-
dred feet high. Neither did they talk about tech-
niques or materials or important clients. Rather,
these artists discussed how their works were
used by or participated in by members of the
community. The creators talked about the sym-
bolic connection between the products of their
hands and bodies and the public, and each was
proud of that connection, viewing it as a gift.

In the same way, the public—that amorphous
mass of individuals with constantly shifting and
multiple identities based on the circumstances of
constantly shifting moments—can accept these
gifts without reservation or self-consciousness at
whatever comfort level each individual chooses:
as Sollors has written, our identities may be built
on "real or imagined descent, on old or newly
adopted religions, on geographic area of origin,
socialization, or residence, on external catego-
rization, on voluntary association, or on defi-
ance" (1986: 175). Consequently, during my first
summer in Spain, I felt not only as if I were
helping to create that first *correfoc* that I experi-
enced but as if I'd been waiting to do it all my
life. My participation seemed to nurture both
the event's traditionality and its continued
innovative evolution. And although Sollors
may not have been writing of interlopers such
as myself, it is, paradoxically, one of the tangen-
tially positive effects of this racing globaliza-
tion: as we become detached from the cocoon of
our "real" past, we can take on other identi-

ties—again, always shifting and changing—that somehow, amazingly, are not degraded by the superficial tenuousness of our new connections but rather respond to those multiple frameworks in which we view ourselves and enrich our worlds. "The origin of cultural practices is largely irrelevant to the experience of tradition," Handler and Linnekin have written; "authenticity is always defined in the present" (1984: 285–86).

When we participate in these kinds of cultural processes and events—even as we suspend belief in a historical time and social space beyond the daily routine—not only do we refresh and provide continuity for traditional movements, gestures, and sensations, but we essentially act as a dynamic for change, a change, in these times, that is linked to past as well as future manifestations. Cultural performances are, as Turner has written, "the eye by which culture sees itself and the drawing board on which creative actors sketch out what they believe to be more apt or interesting 'designs for living'" (1987: 24). This declaration counters the Malthusian doomsaying of a continuously downward spiral of individual anomie and societal disintegration, replacing society with the intensity of a multidimensional and multicoded collective affirmation of a positive, shared experience. This "sharing" does not imply that every individual's response to the artworks or reading of the sometimes subliminal messages that accompany these works is necessarily equivalent or even comparable; nevertheless, the diverse reactions do not diminish the potency or the authenticity of the collective experience.

There is no reason to assume that our responses today differ markedly from those in decades and centuries gone by. Historically, the artist—whether visual artist or performer—was no "mere mouthpiece for tradition" (Burke 1978: 115) but innovated within guidelines, as the artists I have studied here do. If texts or steps or forms or actions are not written down, the concept of the "right" way to do something is absurd; rather, the combining and recombining of recognized motifs and movements are the parameters of traditionality, for all that exists is the memory of these recurrent variants. Today, there are other times and places for us to savor new and different art forms, theater, and events; but as participants, as clients, and as spectators, when we want to experience again the somatic, symbolic, and emotional responses that we have experienced before, we return to the traditional arts. While appreciating the edge of improvisation that they present, we revel in their familiarity.

The *fiestas mayores* set us up perfectly for participating in these experiences: of all times in the calendrical cycle, this is when "outsiders" are most expected and can be most easily absorbed. We are invited to take part as the village shows off its piety with its Masses; its wealth with free sharing of sausages, chocolate, or *cava*; and the beauty and talent of its residents with the crowning of a festival queen and the procession of bands, floats, bull running, and competitive games. In the same way, Pujiula's monumental construction beckoned to the passersby speeding along the highway: every one of his visitors, even his family, was "outside" his creation, but all became immediate "insiders" as they physically, interactively, and distinctively enjoyed the environment that was simultaneously visual art, architecture, and performance.

Despite the manifest community associations of all of the tangible and intangible products of these artists, therefore, one cannot ignore the anonymity of at least a portion of the general audience for these works. These audience sectors may lack overt links to the arts, yet by virtue of their participation, they respond at some level to their lure. López Cruz no longer knows most of his clientele; the *gegants, capgrossos,* and *nans* are danced as

part of open, publicly advertised events; the protective coverings of those who run the *correfocs* disguise and diminish individuality while increasing the potency of the collective swelling of the crowd; many of Pujiula's visitors spoke or wrote to him of his work in languages he did not understand. How could it be otherwise, with global media, increasing urbanization, and cultural tourism changing communications, circulation, and socioeconomic structures? Yet in a very real sense, that "outsiderness" of the viewer or participant becomes irrelevant when it is confronted with the multivalent power of the sensory, collective experience, informed and enriched by the complexities and contradictions of our hybrid lives and the fusion of our blended heritages.

Adding to the multiplicity of contested symbols for a multiplicity of audiences is the fact that each of these artists has created works that reveal certain aspects of rebellion against one or more of the concentric circles of community with which these men and women have engaged. López Cruz makes pots that are comparable in form to the pots made by his mother and grandmother, yet doing so required him to challenge and transcend the sociosexual mores of his town, responding to derisive insinuations about the most personal component of his behavior simply to follow the occupation of his choice. Ventura and Hosta, increasingly tailoring their business to concentrate on the monumental *gegants* and *capgrossos*, operate within a sphere in which some of their symbolic visual references to the elusive and perhaps unattainable goal of an independent Catalunya may be seen as being in opposition to the goals of the federalized nation as a whole. The essence of the Gàrgoles' performance event is quintessentially rebellion: against the Church and organized religion, against individual identity, against societal complacency and the status quo, against the concept of "good." And Pujiula, of course, engi-

neered the ultimate act of personal defiance against long-held assumptions about property laws and community codes regarding proprietorship, against governmental and quasi-governmental entities, and certainly against what was generally acceptable as the boundaries of individual aesthetic expression.

Why should we expect that a single analysis would be appropriate for arts with such broad historical and intense cultural, aesthetic, and ideological associations? The increasingly tangled webs of interactions are complex, vacillating between elements of societal rebellion and societal solidarity, insiderness and outsiderness, implying references and inferring connections that may exist to different depths and at different levels for each individual participant—or may not exist at all. Gone are the hierarchical and progress-driven dualisms of rural versus urban, pure versus contaminated, old versus new, folk versus fake; in their place should grow a more realistic reassessment of the range of responses available to us in our multiple roles as users and creators. That the power of these arts passes through what a staid observer might point out is truly an illusion is, on the one hand, meaningless, for this "illusion" is a convergence of constantly shifting, renegotiated, and typically contradictory or even competing individual and cultural identities—a condition, frankly, that is neither an extraordinary nor an inappropriate response in these times. On the other hand, if "illusion" it is, it makes the power of these arts all the more impressive, for as we suspend our disbelief, move beyond the spatial and temporal certitudes of everyday reality, and morph—both consciously and unconsciously—from spectators into actors, we experience the magic of an authentic, complex, and, yes, traditional stream of moments as they merge, refreshed and revitalized, into future inspiration.

APPENDIX A

EVELIO LÓPEZ CRUZ VESSEL PRODUCTION

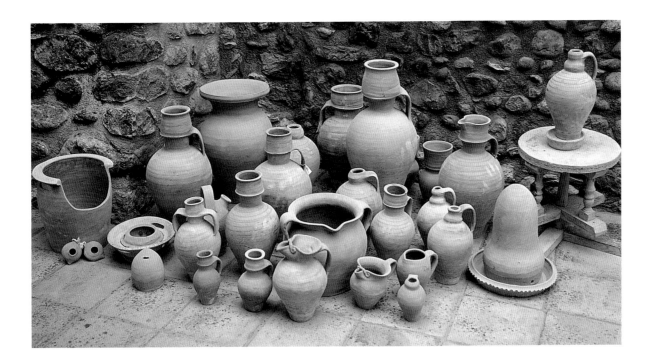

López Cruz's current production includes the vessels listed here. All measurements are fired dimensions, and there is a production margin of ±5–8 centimeters for each. If only two dimensions are given, the first is the height and the second is the diameter at the most bulbous point.

All line drawings are by Sam Hernández. Unless otherwise indicated, all vessels in photographs were created during 2004 by Evelio López Cruz.

 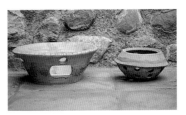

 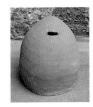

Alcancía (alcarcía, hucha): a bank, this closed vessel has a horizontal slit on the top shoulder for coins; 23 x 16 and 15 x 10 centimeters.

Anafre (anafe): a low container used for cooking with carbon, particularly during the summer to avoid lighting a large kitchen fire or for cooking outside. Traditionally a two-part container, an *anafre's* larger component resembles a low bowl with a wide lip on which sits a removable nine-hole "grill," also bowl-like in shape. The carbon is placed in the grill, and the ashes fall through the holes to the bottom of the larger component. A pot or pan is set on the top of the grill for cooking. The typical *anafre* has one hole in the side and a larger arched or rectangular hole toward the bottom of the side wall for adding combustibles. They are produced in two general sizes, higher versions measuring roughly 30 x 25 centimeters and lower versions measuring 10 x 25 centimeters.

Ánfora: a Roman-style double-handled jug with a thin, extenuated base, used to transport liquid. This form was revived at least fifteen years ago as a tourist item.

 Ánfora de vino: for wine; 100 x 28 centimeters.
 Ánfora de aceite: for oil; 100 x 28 centimeters.
 Ánfora de salazón: for salted goods; 70 x 30 cen-
 timeters.
 Ánfora de agua: for water; 60 x 30 centimeters.

Arcabuz (alcabuz, arcaduz; known in other areas as *cangilón):* a nearly cylindrical bucket with a wide mouth, used to draw water on rural water wheels.[1] A slight narrowing at the bottom of the neck that begins roughly at the vessel's midsection enables it to be securely tied to the rotating wheels. Muslim immigrants brought *arcabuces* to Spain as early as the eighth century, and the vessels were diffused throughout La Mancha as the Arabs founded settlements and developed waterworks (Lizcano Tejado 2000: 40). These are produced by López Cruz in two sizes: 40 x 30 centimeters and 30 x 15 centimeters.

Barquillo: a low, small bowl used for drinking water. It has a slightly wavy rim and often has interior decoration in the form of an appliquéd snake coiling up from the base. *Barquillos* were used to decant water from the *cántaros,* which, when full, were too heavy to lift to the lips to drink. The little clay snake at the bottom of the base reminds drinkers to look before drinking

because snakes were known to crawl into the cool, dark, wet *cántaros* in the fields. *Barquillos* were also used as drinking saucers for children or pets, usually with four equidistant spouts for drinking; 10 x 20 centimeters.

Bebedero de animales (comedero de animales): a cylindrical utensil that holds water for small animals or birds to drink from. López Cruz creates these as closed, vertical forms set on a separate lipped plate to avoid spillage: other potters produced these utensils in a single piece. A small hole in the bottom lets the water flow out into the plate yet limits the amount so that the water does not overflow; the water storage container measures 37 x 23 centimeters; the low plate on which it sits measures 6 x 30 centimeters.

 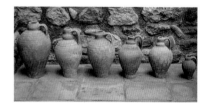

Botija de vino (cantarilla de vino): a wine jug. A small base rises to a spherical body, similar to the *cántaro,* but with a small mouth that enables the jug to be corked, thus preventing the entrance of insects or dirt when the jugs were taken to the fields. A single handle is attached at midneck, draping down at a right angle to the shoulder of the body. López Cruz produces *botijas* in four sizes, ranging from three to six liters in capacity, as well as a small one used as a toy or for fiestas.

 Botija: 47 x 27 centimeters.
 Botija de a dos: 39 x 21 centimeters.
 Botija de a tres: 35 x 18 centimeters.
 Botija de a cuatro: 30 x 13 centimeters.
 Botija de juguete: 16 x 9 centimeters.

Botija para el carro: a jug with one flattened side, two handles, and a pouring spout added at the midhandle level, traditionally used to carry on carts but now pri-

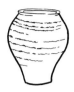

marily hung on walls as decoration. The small mouth with slightly flared rim accepts a cork. They were typically equivalent in capacity to a *cántaro de a cuarto,* but López Cruz makes them in two sizes, 25 x 21 x 18 centimeters and 18 x 16 x 12 centimeters.

Botijero (botijera, posabotija/o): a low, double-bottomed plate used to hold the *botija.* The vessel sits on the wide-rimmed top section, with a small amount of water in the lower section to maintain adequate humidity while keeping the *botija* itself dry. Small holes are punched through the top section in a decorative design, and they are made in a variety of sizes to fit the various size jars and jugs; 15 x 20 centimeters to 5 x 15 centimeters.

Botijo de agua: a water jug. Although the two-spouted, single-handled *botijo* used when numerous people will drink from the same vessel is a traditional form produced by potters in most parts of Spain, it was not historically produced in Mota del Cuervo. Nevertheless, López Cruz has begun producing them in response to customer demand; 30 x 15 centimeters.

Búcaro: a container used to store food products such as pickled vegetables, olives, dried fruits, or cured meats. Rising from a narrow base to a fully bulbous body, the

búcaro has no neck but narrows slightly to a small-rimmed mouth. Simple decorations are typically incised into the vessel walls.

> *Búcaro de pan:* equivalent to 2 *cántaros;* 40 x 40 centimeters.
> *Búcaro de aceitunas:* equivalent to 2 *cántaros;* 40 x 40 centimeters.
> *Búcaro de chorizos:* equivalent to 1.5 *cántaros;* 35 x 35 centimeters.
> *Búcaro de picantes en vinagre:* equivalent to 1 *cántaro;* 30 x 30 centimeters.

Cañador. See *jarrón de ordeños.*

Candil: an oil lamp. A squat, bulbous vessel with an extended spout into which a cotton wick is inserted. López Cruz produces these in three styles; two made to hang on the wall with a perforated vertical handle, and one that sits on a horizontal shelf or table. He also produces variants with both closed and open spouts; the latter produce a larger flame that burns more brightly but burns out faster; 16 x 16 x 10 centimeters.

Cangilón. See *arcabuz.*

Cántaro (cántaro grande, cántaro mayor): the archetypal water jug, with a capacity of 16 liters, a quantity formerly known as one *arroba.* Rising from a small base, it widens until it is almost completely spherical at the beginning of the short neck. A wide, cylindrical mouth terminates in a raised border slightly wider than the neck. A single handle begins at the base of the mouth and attaches to the vessel's shoulder. *Cántaros*

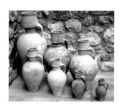

were used to bring water from wells to houses; women usually drew the water and transported it on foot, although *cántaros* were also transported by carts or animals in wooden supports called *aguaderas* or *aguarones* created for that purpose; 60 x 30 centimeters.

Cántaro super grande: Sized larger than was normally used, primarily targeted for the tourist trade; 70 x 30 centimeters.

Cantarilla grande: 12 liter capacity; 55 x 30 centimeters.

Cántaro de a dos (jarra grande, medio cántaro, cántaro de jarra): 10 liter capacity; 50 x 25 centimeters.

Cántaro de a tres (jarra de a tres): 7 liter capacity; 42 x 22 centimeters.

Cántaro de a cuatro (jarra de a cuatro): 4 liter capacity, one-fourth of a *cántaro*; 35 x 18 centimeters.

Cantarilla: 1 liter capacity; 25 x 18 centimeters.

Cantarilla pequeña: .5 liter capacity; 20 x 10 centimeters.

Cantarilla de vino. See *botija de vino.*

Cántaro de aceite: an oil jug, similar in form to the standard *cántaro*, with the addition of a small spout at one edge of the rim; 50 x 25 centimeters.

Cántaro de leche (cántaro lechero): a milk jug, similar in form to the *cántaro*, although with one main differ-

ence: a wider, moderately inverted conical mouth; 55 x 25 centimeters.

Cántaro: 53 x 23 centimeters.

Cántaro de aceite: 50 x 25 centimeters.

Cántaro lechero: 49 x 26 centimeters.

Colaor (colador): a large container typically used for storage of bread and grains. This vessel rises from a narrow base to a bulbous body and then narrows slightly to a rimmed mouth with no neck. The lower part may be a sharply angled inverted conical form or may more gradually widen toward the shoulders. As with the *cántaros*, *colaores* are produced in various capacities, but because the foodstuffs stored therein are dry, *colaores* are not typically measured in liters. Miniature *colaores* are also made for fiestas. *Colaores* are often ornamented with incised decorations—in recent years stylized floral designs—made by combs or pointed tools.

Colaor grande: 70 x 50 centimeters.

Colaor mediano: 60 x 40 centimeters.

Colaor pequeño: 45 x 30 centimeters.

Colaor de juguete: miniature vessels made for fiestas; 10 x 8 centimeters.

Comedero de animales. See *bebedero de animales.*

Copa decorativa: a large, footed vessel, often serving as a flowerpot or as a general household decoration. The conical foot serves as a pedestal for a goblet-shaped container, the upper portion created in three alternative variants (bulbous, flared, or straight walls) and elaborately ornamented with incisions and appliquéd bas-relief flowers, grapes, and other designs, sometimes slipped with engobes to set off the design with color. These newer-style pieces may be given as wedding presents and have been produced since the 1960s in three general sizes, 47 x 40 centimeters, 40 x 35 centimeters, and 40 x 25 centimeters.

Florero. See *maceta.*

Hucha. See *alcancía.*

Jarro (jarra): a pitcher with a narrow base, a widened body, and a slightly narrowed neck that fans out in an inverted conical shape, one side of which is modeled by hand to form a wide spout that may have a thin coil of clay laid across the opening to serve as a strainer. At the opposite side of the mouth from the spout, a single handle joins the mouth and attaches to the body at the shoulder. The *jarros* are made in two sizes: 30 x 15 centimeters (1 liter), and 17 x 13 centimeters (.5 liter). An alternative shape may include two handles and a thinner neck, sized more closely to the *cántaro de a cuatro,* with a capacity of approximately four liters; 35 x 18 centimeters.

 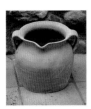

Jarrón de ordeños (cañador): a wide-based jug traditionally used as a milking pail but also used in some areas for collecting olives or other foodstuffs. The walls rise in a slightly bulbous curve up to a wide mouth, only slightly narrower than the base. Squat in profile, its low center of gravity keeps it from tipping over as it is being filled. The *jarrón de ordeños* has two side handles attached to the mouth and the shoulder and a single spout. López Cruz produces this in two sizes, the *jarrón grande,* traditionally used to milk cows (18 liter capacity), 32 x 35 centimeters, and the *jarrón pequeño,* sized for milking goats and sheep (approximately 16 liter capacity, like the *cántaro*), 30 x 30 centimeters. However, they are now used primarily decoratively and are therefore often ornamented with incised and appliquéd motifs.

Lebrillo: a wide basin used for a variety of household tasks, from slaughtering animals and salting meats to

curing olives and washing clothes. The *lebrillo* has an inverted conical shape with a broad base opening to an even wider mouth, with straight walls and a thick-lipped rim. The larger examples have two rectangular holes cut out just below the rim to serve as handles. López Cruz produces *lebrillos* in four sizes: 25 x 50 centimeters, 25 x 46 centimeters, 22 x 40 centimeters, and 15 x 35 centimeters.

Lebrillete: a smaller version of the *lebrillo;* 10 x 20 centimeters.

Llorón de pared (maceta de pared, maceta de colgar): a wall-hung flowerpot. Created in two parts that are later joined, the flat face lying flush against the wall is circular, with a hole centered close to the top rim for hanging vertically. The protruding face, with a variety of similar but elaborately incised or appliquéd decorations, is spherical and rises two-thirds of the way to the top of the wall face. It is coiled horizontally as a closed vessel, with the top section later cut away to allow for the placement of plants therein and joined to the flat wall-side component. This piece is of fairly recent production, dating no earlier than the 1960s. López Cruz produces two different sizes of these hanging pots: 28 x 25 x 14 centimeters and 25 x 18 x 10 centimeters.

Lucerna: a molded oil-burning lamp. López Cruz reintroduced this no-longer-used form after finding examples from Roman times while digging for clay in his *barrero.* These lamps are created from two-part plaster

molds that he produced from the Roman original; he presses moist clay into the mold with his fingers and later joins the two sections. The Romans originally adapted the *lucerna* in the mid–first century from a technique developed in late Hellenistic Greece, and these lamps were used for more than five hundred years thereafter (Cooper 2000: 50, 52); 8 x 8 x 18 centimeters. (See photo of plaster molds, p. 38.)

Maceta (florero, tiesto): a flowerpot. In the form of an inverted cone, with straight walls and a wide, sometimes rolled rim, often ornamented with wavy indentations. The *maceta* walls may also be ornamented with incised decorations. In the center of the bottom of the vessel is a small hole for water passage. López Cruz produces *macetas* in five sizes: 32 x 42 centimeters, 30 x 40 centimeters, 26 x 34 centimeters, 16 x 40 centimeters, and 14 x 38 centimeters.

Maceta de colgar; maceta de pared. See *llorón de pared.*

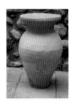

Orcilla (orzilla, orza): a large bulbous container usually used for keeping liquids or moist food products. The *orcilla* rises from a narrow base to a full body; the neck narrows significantly and then widens into an inverted conical-shaped mouth finished off with a thick rim. Although slightly smaller than Mota's *tinaja*, the *orcilla* is generally of the same shape. López Cruz produces *orcillas* in eight different sizes with varying capacities ranging from .5 to 20 *cántaros*.

 Orcilla: equivalent to 20 *cántaros*.
 Orcilla boronda: equivalent to 12 *cántaros*.
 Orcilla cuba y media: equivalent to 10 *cántaros*.
 Orcilla de carga: the most common *orcilla*; equivalent to 8 *cántaros*.
 Orcilla de tres en pieza: equivalent to 6 *cántaros*.
 Orcilla de a dos: equivalent to 4 *cántaros*.
 Orcilla de alcabuz: equivalent to 2 *cántaros*.
 Orcilla de jarra: equivalent to .5 *cántaro*.

Orinal paritório: a low tub formerly used in birthing. Production of this tub had been discontinued because it was no longer used, but López Cruz revived the form "como recuerdo [as a memento]." He has been told that it is comfortable for women in labor and that the low profile ensured that the baby could be easily caught; 33 x 30 centimeters.

Palmatoria: a candlestick holder. A low plate with a short, hollow cylinder in the center for holding a candle, with a single handle that connects the plate with the cylinder's rim. Formerly used to bring light into rooms without electricity, now primarily for decorative ambience on tabletops; 10 x 15 x 13 centimeters.

Palomera: a bird feeder. A squat vessel with a wide base, rounding to a full, bulbous body that narrows to a significantly constricted neck and slightly turned rim. Three or four arched openings are cut into the vessel walls to enable the birds to enter and eat; 25 x 25 centimeters.

Pezonera. See *tejilla de leche.*

Pila: a low, flat plate used to provide water or feed to animals. The short walls rise up just slightly wider than the broad base; 5 x 18 centimeters.

Sacaleche. See *tejilla de leche.*

Tejillas de leche (pezonera, sacaleche): small slightly ovoid containers, sold in pairs and hung around the necks of nursing mothers as an aide in nursing. A slightly extended handle is perforated to allow a cord to pass through and hang around the mother's neck; a central hole in the top fits over the mother's nipple, and the milk is extruded through a small spout at the end opposite the handle. López Cruz "recovered" this "lost" tradition at the same time that he reintroduced the *orinal paritório,* again more as a memento than with the expectation that it would serve its traditional function, although he did recently sell a pair to a young mother for use; 4 x 10 centimeters.

Tiesto. See *maceta.*

Tinaja: a large pot for storing water and other liquids in the home or for storing water in the fields for irrigation and for grazing or working animals. Water stored in *tinajas* may have been brought from wells via *cántaros* or caught from rain. The *tinajas* are often covered with wooden lids to keep dust and bugs from falling in. Like the *orcillas, tinajas* are produced in a variety of sizes measured in *cántaros.*

Tinaja grande (tino): equivalent to 16–18 *cántaros;* 110 x 65 centimeters, 90 x 60 centimeters.
Tinaja boronda: equivalent to 12 *cántaros;* 85 x 60 centimeters.
Tinaja cuba y media: equivalent to 10 *cántaros;* 80 x 50 centimeters.
Tinaja de carga: equivalent to 8 *cántaros;* 70 x 50 centimeters.
Tinaja de tres en pieza: equivalent to 6 *cántaros;* 70 x 40 centimeters.
Tinaja de a dos: equivalent to 4 *cántaros;* 50 x 35 centimeters.

Tinaja de alcabuz: equivalent to 3 *cántaros;* 40 x 30 centimeters.
Tinajilla: equivalent to 2 *cántaros;* 35 x 28 centimeters.
Tinaja de jarra: equivalent to half of a *cántaro;* 30 x 20 centimeters.

Tinaja lechera (tinaja de leche): a pot used for storing milk; lower and wider than the other *tinajas* and with a smaller mouth; 60 x 50 centimeters.

Tinaja de miel: a pot used for storing honey, similar in shape but smaller than the *tinaja lechera;* 40 x 35 centimeters.

APPENDIX B

GEGANTS AND *BESTIARI* CONSTRUCTED BY THE VENTURA AND HOSTA STUDIO

The following list designates the municipalities, with regions or countries in parentheses, that have commissioned monumental figures from Ventura and Hosta.

GEGANTS

1985 El Pla de Santa Maria (Alt Camp)
 Navata (Alt Empordà)
1988 Santa Coloma de Farners (La Selva)
 Bescanó (Gironès)
 Vidreres (La Selva)
 Lladó (Alt Empordà)
 La Riba (Alt Camp)
1989 Riudarenes (La Selva)
1990 La Cellera de Ter (La Selva)
 Esbart Joaquim Ruira de Blanes (La Selva)
 Albanyà (Alt Empordà)
 Santa Coloma de Farners, *gegantona* (La Selva)
 Yokohama (Japan)
1991 Cadaqués (Alt Empordà)
1992 Escola Les Alzines, Estampida Medieval
 "Peregrí Santiago" pilgrim (Gironès)
1993 Vilobí D'Onyar (La Selva)
 Girona, reproduction of antique figures
 (Gironès)
 Maçanet de la Selva (La Selva)
 Sarrià de Ter (Gironès)
1994 Girona, portrait of Xavier Cugat (Gironès)
1995 Dalt i Baix Figueres (Alt Empordà)
 Vilafant (Alt Empordà)
 Roses (Alt Empordà)
 La Bisbal, reproduction of antique figures
 (Baix Empordà)
1996 Castellfollit de la Roca (La Garrotxa)
 Vilajuïga (Alt Empordà)
 Sant Vicenç dels Horts (Baix Llobregat)
1997 Palafrugell (Baix Empordà)
 Salt (Gironès)
1998 L'Estartit (Baix Empordà)
 La Bisbal (potter) (Baix Empordà)
 La Jonquera (Alt Empordà)

1999 Besalú (La Garrotxa)
2000 El Vilosell (Les Garrigues)
 Sarrià de Ter (Gironès)
 Lerma, *geganta* head (Burgos)
 Els Angles (El Capcir, Catalunya Nord)
 La Batllória, portrait *gegant* (Vallès Oriental)
2001 Casino Menestral de Figueres (Alt Empordà)
 Sant Celoni (Vallès Oriental)
2002 Llança (Alt Empordà)
2003 El Port de la Selva i Selva de Mar (Alt
 Empordà)
 Narbonne (France)
 Salt (Gironès)
2004 Taltahull (France)

BESTIARI

1985 Cunit, dragon (Baix Penedès)
1990 Yokohama, dragon (Japan)
1992 Girona, dragon of the Pastorets (Gironès)
 Girona, reproduction of antique eagle
 (Gironès)
1993 Blanes (various neighborhoods), dragons
 (La Selva)
1995 La Bisbal, reproduction of antique dragon
 (Baix Empordà)
1996 La Bisbal, reproduction of antique eagle
 (Baix Empordà)
1997 Reus, "Trapezi" circus elephant (Baix Camp)
2001 Gombren, Count Arnau's horse of fire
 (Ripollès)
2002 Salt, otter (Gironès)

APPENDIX C

NORMS AND REGULATIONS REGARDING SECURITY FOR *CORREFOCS*

Summarized from a selection of *normes* (rules and suggestions) published by the Federació de Diables i Dimonis de Catalunya, the Gàrgoles de Foc, and the Informe del Servei Juridic del Departament de Cultura, organizations concerned with event safety and security.

I. NORMS OF INTERNAL SECURITY FOR *GRUPS DE FOC*

- Costumes should be made of fire-resistant material and, especially in events with heavy fire usage, it is advisable to wet costumes in advance.
- The costume should cover as much of the body as possible. Heavy socks and gloves are particularly important.
- Earplugs and eye coverings are recommended.
- Pyrotechnic materials should be held carefully to protect carriers from the "umbrella" of fire, and no more than three *carretilles* should be carried at once.
- The pyrotechnics should be the safest materials available. This should be a higher priority than that of economics.
- The different kinds of pyrotechnic materials must be kept separate from each other, as per the norms established by the Informe del Servei Juridic del Departament de Cultura.
- The *maça* should always be held high and securely enough that it does not grab or endanger anyone.
- In *cercaviles* with more than one *grup de foc* participating, each group must take care to maintain a secure distance between itself and the others.
- The carts containing the pyrotechnics must be closed almost hermetically and located a prudent distance behind the group.
- The traditional way of carrying pyrotechnics is in a bag; it should be sealed as well as possible and must always be hung from the shoulder, never slung across the chest.
- Children's groups should always act separately, only in their own village or in their own traditional *sortides* (sorties). They should always have appropri-

ate pyrotechnic material and the explicit consent of their parents or legal guardians.

II. NORMS OF EXTERNAL SECURITY

Although the internal norms of security for *grups de foc* are also the maximum guarantee of personal security for the public, some differences still exist between spectators and participants. The groups need to respect spectators if they are on the sidewalks (in wide streets) or in the crosswalks (of narrow streets). Do not pursue them. Every member of a *grup de foc* must stay on the route marked out by the organization and must not enter doorways or other similar spaces.

The organizers of the activity with the participation of the *grups de foc* must prepare their route via the following means:

- Notification to the neighborhood indicating the route, the time, the necessity of closing doors and windows, lowering blinds, protecting shop windows and display cases, pulling in awnings, and removing all clothing hanging from balconies or terraces.
- Clear and precise signage along the entire route.
- The absolute prohibition of parking along the route.
- The removal from the route of any type of object that could obstruct or endanger the participants in the *correfoc*.
- The prohibition of throwing water unless done by the group itself, even if requested by participants.
- Disconnection of all kinds of alarms.
- Placement of adequate measures for assuring public safety.
- In the event that public lighting is extinguished to better illuminate the fireworks, a minimum number of lights should remain on for public safety.

Members of the public who want to actively participate in the *correfoc* should follow the following recommendations:

- Wear old cotton or woven clothes with long sleeves and pants and avoid synthetic fibers.
- Wear a wide-brimmed hat that covers the entire head and a kerchief tied around the neck and face.
- Protect the eyes.
- Take care to cover the ears to diminish the noise of the exploding fireworks.
- Wear canvas or leather shoes, always well tied, and never wear sandals or slippers.
- Do not ask for water from the neighborhood residents.
- Obey the instructions of public health and police officials.
- Never jump between the drummers and those who carry the bags of pyrotechnics.
- Never cling to any member of the *grups de foc.*
- Never smoke near the bags of pyrotechnics or light any type of pyrotechnic material during the activities of the *grups de foc.* Private individuals and groups are prohibited from bringing other pyrotechnics to the event; only the organizers are allowed to use them.
- Always follow the instructions of the devils and the people in charge.
- Respect the fire carriers and the musicians.
- Adopt an appropriate attitude with the devils, and do not obstruct their paths or make them fall.
- Before beginning the *recorregut,* know in advance the location of first aid and police stations.
- If burned, proceed immediately to a first aid station.

NOTES

INTRODUCTION

1. I utilize the local spelling of the Catalan autonomous region (Catalunya) rather than the hispanicized (Cataluña) or anglicized (Catalonia) versions.

2. Picasso lived in Horta (known at the time as Horta de Ebro) in 1898–99 and again in 1909. Picasso's latter period there, when he was accompanied by Olivier, has been described as the "most crucial and productive of [his] career" (Rubin 1980: 120).

3. In March 2004, brutal train bombings in Madrid took almost two hundred lives. King Juan Carlos's decision to hold a high Catholic Mass to commemorate all of the victims was both surprising to cultural analysts and roundly criticized by those who would have expected a more ecumenical response to the broad-based tragedy. It was interpreted as an extraordinary response to an extraordinary (it was hoped) event.

4. Having done several in-depth projects on Mexican traditional arts over the past thirty years, I had assumed—as is widely validated by the scholarly literature in the field—an indigenous basis for the ingenuity and creativity of most Mexican crafts, notwithstanding the history of Spanish colonialism. Therefore, I have on several occasions been taken aback to find direct sources in both historical and contemporary Spanish arts for some of the styles, forms, and genres that have been widely presented and accepted in Mexico as *indio* or mestizo. That is, however, the topic for another study.

CHAPTER 1

1. In certain areas, this influence was so strong that these early peoples, a mixture of Iberian and Celtic populations, became known as the Celtiberians.

2. The adoption of technological developments on the peninsula was neither homogeneous nor consistent, however, and areas such as La Mancha were sometimes "missed" in the transmission of innovations. For example, although windmills had apparently become a staple of the landscape in broad areas from the Middle East to northern Europe between the mid–twelfth and mid–thirteenth centuries, Don Quijote's surprise at their appearance has been interpreted as testimony to the fact that they had not been introduced in La Mancha prior to Cervantes's time (1547–1616) (White 1962: 88).

3. Wright (1984) reminds us that the sharing of technology does not necessarily assume the transference of stylistic traits as well. However, it seems apparent in this instance that both technological advances and stylistic characteristics linked to shared cultural identities were transmitted to and absorbed by indigenous peninsular residents as a result of their interaction with varying traders, immigrants, and visitors.

4. The 271,000 artisans noted in a 1787 census comprised a mere 2.5 percent of the total population; their number was significantly outstripped by the number of domestic servants, who comprised a full quarter of the day laborers at that time (Bennassar 1979: 104).

5. In one classic example of this romanticized despair, Ramos Pérez (1976: 47–48) wrote of the women potters of Pereruela, "Estas mujeres, hoy con muchos años y poca esperanza de que nadie las siga en su oficio, se extinguen como cabos de vela a la luz indecisa de un ocaso cercano, son las últimas plañideras de un arte, de un oficio, de un modo de vida que a solas con la miseria, las ha hecho sobrevivir [These old women, with little hope that anyone will follow them in their work, are being extinguished like ends of a candle in the hesitant light of an approaching sunset. Alone in their misery, they are the last mourners of an art, an occupation, a mode of life that enabled

them to survive]." Later in the same volume (201), the author described the last *ollero* of Toro: "Hoy el señor Félix está solo, ninguno de sus hijos ha querido aprender el oficio de la rueda y todos han emigrado hacia el Norte. El señor Félix ha quedado triste y solo como en un romance, y me cuenta que muchas veces, al salir a la puerta de su obrador, mirando a la vega del Duero a su paso por la ciudad, se entristece y algunas veces ha llorado, pensando que nadie va a vivir allí, ni va a mover la rueda a su suerte, y lo dice, y lo entendemos, que muchas veces solo, tremendamente solo, como un alma en pena perdida entre las páginas bellas y gloriosas de la historia, ha hecho piezas que llevan lágrimas suyas [Now señor Felix is alone. None of his sons wanted to learn how to make pottery and all of them have emigrated toward the north. They have left him sad and alone, and, as in a ballad, he tells me that many times, upon leaving the door of his workshop, looking at the fertile plain of the Duero River as it passes by the city, it saddens him, and sometimes he cries, thinking that no one will live there any longer, or come to turn the potter's wheel as it is meant to be turned, and he says— and we understand—that many times, alone, completely alone, like a grieving soul lost between the beautiful and glorious pages of history, he has made pottery which bears his tears]."

6. Evelio López Cruz, interview by author, September 1, 1999.

7. Philologists have surveyed the thousands of words of Arabic origin found in the Spanish vocabulary; intriguingly, the majority are technical words associated with production and construction of all types. This phenomenon has given rise to theories about the relationship of the early Hispanic Christians with their Muslim neighbors as well as hypotheses regarding the relative values placed on different responsibilities and obligations of the two different ethnic groups (Bennassar 1979: 125–26).

8. Local conventional wisdom, however, "remembers" that half of the town left during these expulsions; both Jews and Muslims are grouped within this unfortunate outcast mass (Evelio López Cruz, telephone interview by author, February 22, 2004).

9. Some vocations apparently did not particularly draw the Inquisitors' interest; it has been suggested that potters may have been one of these lucky groups. García Gómez (1993: 31) hypothesizes that the low numbers of potters brought to trial may indicate that they were arrested for reasons unrelated to their vocation, such as making heretical statements in public.

10. García Gómez has been convinced beyond doubt that the establishment of "Moorish" settlements in Villarrobledo is linked to the origins of pottery there.

11. The noun *cantareros* is also used in other villages, such as Cespedosa de Tormes (Salamanca), where the pottery production also focuses on water jugs; see, for example Bofill Catala, Hernández Ramos, and Latre González 1991: 65.

12. As late as 1974, the fact that women were potters in Mota del Cuervo was apparently not widely known by ceramic scholars (Reese 1974; Seseña 1967, 1975). In addition to Mota del Cuervo, in all of Spain there were apparently only three other areas where women were the primary potters; corroborating Caro Baroja and Cooper's hypotheses mentioned above, Cortés, Arnold, and others believe this to be a residual archaism reflecting more "primitive" times. Women were potters in Zamora in western Spain (Moveros and Pereruela are two villages where the female pottery tradition continues, although it had formerly also been practiced in the villages of Muelas del Pan and Carbellino de Sayago); Galicia in the northwest (the towns of Portomourisco, O Seixo, and Gundibós, all now "extinct centers"); and in the Canary Islands (including the villages of La Degollada, Hoya de Pineda, and Atalaya on Grand Canary Island, Acentejo on Tenerife, and Chipude on Gomera), where they modeled figures without a wheel. However, it was not unheard of for individual daughters of potters to make pottery even in areas where the tradition was primarily masculine, and if a potter was away for any reason— military service, working out of town, or traveling to sell ware—his wife would often mind the studio while he was gone, doing everything except actually throwing or modeling the pots. See Lizcano Tejado 2000 for Ciudad Real; Schütz 1993 for Asturias; Seseña 1975 for other areas in La Mancha and beyond. It is nevertheless important to stress the strong general distinction between those few areas where the woman's primary role was as the potter and the majority of regions, where women played a role within a primarily masculine pottery tradition as helpful wife or daughter, "peon," decorator, seller, and, of course, consumer.

13. The School of San José in the provincial capital of Cuenca may have been the inspiration for this course. Prior to this time, all apprenticeships had taken place within the family home studio, most often with sons (or, in the case of Mota, daughters), although other younger relatives might also take advantage if their interest lay in this direction. For the first time, this school developed a two-year program to teach pottery outside of the traditional family sphere. From 1954 to 1965, it

offered a year of general courses followed by a year in which the student learned how to create simple forms and decorations, advancing in the later courses to the more difficult forms of traditional pottery. It was not a great success, however, for according to school records only two students dedicated themselves to pottery as a career after finishing the course, and one of them stayed to work with one of the school's professors. Although it was intended as a course for the entire region, analysts determined that it had neither short- nor long-term influence on either the techniques or the types of pieces that continued to be made in the area. Following the closing of the pottery component of the school in 1965, it rededicated itself to becoming a school for auto mechanics (Albertos Solera 1978: 158–59).

14. Numerous scholars have documented similar circumstances worldwide, with economic forces ultimately trumping the forces of cultural conservatism and tradition every time; see Foster 1962: 150–53.

15. Dossier Ceramikarte.com, "Las Cantareras de Mota del Cuervo."

16. Both *terrero* and *barrero* were terms used to refer to the physical site from which the raw material was extracted as well as to the worker who did the extracting. In neighboring areas, the quarry itself was also known as *terrero, cantera,* or *mina.*

17. In the neighboring province of Albacete, expenses associated with each load of clay brought to the potters were divided into three components: the cost of the clay itself, the transportation cost, and the excavation costs. Each of these components presumably was either owned or handled by a different individual, accounting for the separate cost breakdown (Lizarazu de Mesa 1983: 287).

18. He uses this pure clay to fabricate all his pottery, although he also periodically buys some red and black clay from a supplier in L'Hospitalet, near Barcelona, for use as decorative elements or to be slaked down into slip for use as a decorative paint.

19. The connection of this Virgin with potters was so strong that from 1675 on, any head of the Cofradía (including *alcalde, mayordomo,* or *padre*) was required to be a potter. The little cave where she is said to have appeared contains numerous vessels made by López Cruz as well as older pieces by earlier potters, representing offerings from the faithful. Other areas honored a variety of local saints as patrons of pottery. For example, from Sevilla to Agost, Santa Justa and Santa Rufina were widely revered by potters from the sixth century on; in Alba de Tormes, the patron is Santa Apolonia; in Traiguera, it is San Jaime; in Navarrete, La Bisbal, and Verdú, it is San Hipól-

ito; and in Miravet and Tivenys, it is Santo Domingo (Schütz 1993: 12–13; Bofill Catala, Hernández Ramos, and Latre González 1991: 171).

20. To maximize working hours during the optimum seasonal periods for extraction, those digging in the lower strata—in areas such as Villarrobledo, running as deep as forty or fifty meters—were said to have had their lunch delivered to them in these baskets rather than surfacing for a rest (García Gómez 1993: 77).

21. López Cruz is considering installing a rectangular, cement-lined trough in one section of his workshop during its future renovation. This type of subsurface *pilón* is found widely among potters in various parts of Spain.

22. The *suela* is the component of the Mota *rodillo* that requires replacing most often as a result of the scraping to which it is subjected with the tools used to refine the foot of the vessel.

23. In Pereruela (Zamora), where the same type of wheel is used (there called a *rueda*), the axle was traditionally inserted into a large, flat, and round rock that secured the wheel but also maintained its portability (Cortés 1954: 150).

24. The *raedera* is typically made of beechwood, although iron scrapers were sometimes used for larger works (Schütz 1993: 22).

25. This may occasionally also be done at the base to ensure that the walls strongly adhere to the *culo.*

26. In keeping with Kempton's (1981) distinctions between "folk" and "devised" classifications, the descriptive categories delineated here are not absolute. In other words, one potter's *cántaro* might very well be another's *botijo,* as intermediate qualifications and gradations blur the identifying lines between types. Although certain "distinctive features" such as size, number of handles, presence or absence of spout, and so on tend to be persistent category determinants, even these features do not guarantee a discrete typological definition.

27. The three main types of ware López Cruz's mother and grandmother produced were the *cántaro* (water jug), the *tinaja* (large storage jar), and the *maceta* (flowerpot). Each was produced in a range of sizes, most of which were called by distinctive names.

28. The literature is peppered with examples of forms and functions of traditional arts being modified by artists attempting to accommodate the differing demands of predominantly urban audiences outside the artists' culture group. See, for example, Abramson's (1976) study of Sepik shields; Graburn's (1976) discussion of Eskimo carvings; Moeran's (1997) study of folk potters in Japan.

29. Extrapolated from documentation about prices of *tinajas* in Villarrobledo (García Gómez 1993: 146–47, 157ff).

30. The number of pots "paid" to the *horneros* for their services is in dispute; the local municipal office has described it as five or six (Cano Adillo et al. 1990: 30), while others have recorded nine (Seseña 1997: 228) or ten (Schütz 1993: 23); however, López Cruz felt that the number was closer to twenty-five. It was also possible to pay the firing fee in cash, a value equivalent to the number of *cántaros* that had been agreed upon (Valero Zarco 1993: 36), although this rarely occurred.

31. Selling greenware to those who fired the kilns was apparently more common in Pereruela, one of the villages in the Zamora region where coiling pottery was also done exclusively by women. Scholars have suggested that selling the greenware was a response to the fact that only fourteen kilns supported the work of forty-six pottery families in town at midcentury (Cortés 1954: 145).

32. The kilns were known by the names or nicknames of their owners. In Mota, the kilns belonged to Salomón Estiraza, on the Calle de las Cuevas; to "El Vete," on the Calle de las Afueras; to "El Jorquillo," in the Sendilla; to "El Zato"; to Chulán (also known as Conejo); to Bufa; to Gil (who owned two); and to Braulio. The one called Aniana was owned by López Cruz's grandfather, Román Gorra, and was located in the Plaza de la Cruz Verde (Mazuecos 1972; Valero Zarco 1993: 35). This kiln was also known by the surname of the owner, Gorra.

33. *Broza* brush gives a bigger flame but less heat, and the resulting color of the ware is paler, while the *sarmiento* gives less flame and more heat and the pieces acquire a rosier coloration. When the flames directly touch the pieces placed in the lower part of the kiln, they acquire gray or black tones. López Cruz likes these unplanned blushes (as do most contemporary collectors), but they were seen as less desirable in earlier days.

34. López Cruz has implied that after Mota lost so many neighbors and potters (Jewish and Muslim) during the period of the Inquisition's greatest excesses, local interest in religion waned significantly, and he denied having any interest or belief in the efficacy of any such invocations himself. In other parts of Spain, this momentous occasion was variously observed by crossing oneself, reciting a Catholic prayer, mentioning the name of the potters' patron saint, or drawing a cross on the kiln wall. At times, superstitions were associated with the firing, such as the taboo against the presence of menstruating women during any of the associated labors (Bofill Catala, Hernández Ramos, and Latre González 1991: 171), a prohibition that has also been noted among the Dowayo people of Cameroon (Barley 1994: 88) and others. When asked if there were any such superstitions in Mota, perhaps accounting for the fact that the men had the responsibility for firing, López Cruz demurred, saying only that this type of work was too hard for women to do. However, he did admit that women were supposed to absent themselves from the firing: they shouldn't even be close, he said. Nevertheless, his wife, Loli, helps him with all aspects of this process.

35. María Dolores Cruz Contreras, interview by author, November 26, 1999.

36. Given that business taxes, computed each year in January, were based on production output, some scholars have suggested that reducing the workload during winter months also helped to reduce the payment of the annual *contribución industriál* (García Gómez 1993: 56).

37. It is unlikely that his elder daughter, who married in December 2003, will continue to return to the workshop to help.

38. The ability of artists and artisans to recognize and identify the work of their local colleagues by visual clues such as details of form, marks left by hands or tools, and the specificity of treatment of such tertiary components as handles, spouts, and lips, rather than by signatures or personal marks, has been reiterated numerous times in the literature. See, for example, Graburn's (1976) discussions of Eskimo soapstone carvers; Moeran's (1997) discussion of Japanese potters. Browsing in an antique store near the Argentona ceramic fair with López Cruz one afternoon, we ran across a classic Mota *cántaro* that was perhaps eighty years old. Hoisting it up and turning it around, he immediately identified it as the work of one of his aunts. This ability to distinguish whose work is whose has been described as particularly acute among illiterate artisans, who are more sensitive to unwritten evidence (Graburn 1976: 21).

39. An ancient Catalan tradition holds that on August 4, St. Domènec's Day, it is important to bless the waters in all fountains and wells. Further, purchasing a new water jug for this day is said to keep one's water fresh and pure all year (Paulo i Sàbat and Creus i Mach 1998: 293–94). A clear boon to potters, this tradition has been refreshed with Argentona's elaborate pottery fairs, held each year on the first weekend of August.

40. This special attention no doubt led to a certain degree of competitiveness among Mota's potters that barely existed before. A negative force vis-à-vis the community as a whole, it would be a fascinating subject for future research.

41. Noting that the common procedure for amassing wealth includes reinvesting a percentage of net profit in the business at hand, Bennassar (1979) argues, as have others, that Spaniards in general have been more interested in flaunting and consuming profits rather than seeking to reinvest to accumulate even more. This disdain for manual labor thus has exacerbated any ethnically related contempt that may have previously existed.

42. The low social position of potters is not restricted to this area of Spain, nor is it delimited necessarily by the gender of its workers. Several studies from disparate parts of the world—including Mexico, Peru, Africa, India, and Tibet—have found a similarly low social status among potters working in domestic studios in areas that are primarily rural and agricultural; see Arnold 1985: 197; Barley 1994: 63–64. Other scholars have hypothesized that this status was not restricted to modern societies. Although working from circumstantial evidence, Cooper (2000: 19) has interpreted the location of specialized ceramic workshops on the outskirts of villages during the early dynastic period in Mesopotamia (third millennium BCE) as indications of a low social position; Hodges (1974) has argued that the dirty and utilitarian quality of the medieval potter's work as well as the fact that descriptions of it are lacking in the few extant craft handbooks from the Middle Ages point to the same conclusion. This lower social position was not universal, however; particularly in those cases where the products either were used for ceremonial or ritual uses or were adorned with motifs referential to myths or legends, potters enjoyed a much higher social status; again, see Arnold 1985: 197.

CHAPTER 2

1. *Gegants* are also known as *homenots, homenassos, figurots,* or *ninots.*

2. See, for example, Cuéllar i Bassols (1990) on the *gegants* of Olot; Corts Salvat and Toda Serra (1995) on those of Riudoms; Ibàñez (1996) on Sabadell; Rumbo i Soler (1995) on Berga.

3. Other unsubstantiated claims for primacy regarding Corpus celebrations have been extended by Toledo, Sevilla, Girona, Vic, and Valencia. However, although these cities may have marked the occasion with feasts, current scholarship has not dethroned Barcelona from its position as the first to realize a procession (Very 1962: 4–6).

4. As the importance of the processions increased, so did the rivalry between competing guilds and parishes to produce the finest entertainment and processional components. The competition ultimately became so antagonistic that in 1556 "strong measures," including imprisonment of some of the most rowdy marchers, were required to restrain the outbreaks of violence, and by 1622 a document intending to circumscribe processional behavior delineated the appropriate roles, responsibilities, and privileges of each guild (Very 1962: 40).

5. The Muslims knew of and used paper as early as the eighth century but apparently did not bring it to Spain until about four hundred years later, when the first paper mill known in the western world was installed in Xátiva, near Valencia (Institución de Viana 1983: 1).

6. The earliest confirmed documentation of constructed giant figures as we think of them today is still being debated. Very (1962: 79) suggests that a "device" or "effigy" of the giant Goliath was included in Barcelona's Corpus procession in 1391; according to folklorist Joan Amades (1983: 58), a 1588 performance in Valencia included *gegants* from Castile, while *gegants* appeared in Catalunya in Girona in 1593 and finally in 1601 in Barcelona, accompanying the procession of the canonization of Sant Ramón de Penyafort. If evidence is ultimately uncovered that the 1391 Goliath was a construction, it would be the earliest reference we have to this tradition. The next documentation is from a 1430 procession in Belgium (Grau i Marti 1996: 11) and from the Netherlands in 1447 (Harris 2000: 196). Numerous citations referencing giant figures begin appearing by the mid–fifteenth century in England, France, and Germany as well; in the sixteenth century, we find records from Italy, Poland, and Switzerland; in the seventeenth, from Austria and Russia (Grau i Marti 1996: 12). Harris has noted that the areas where *gegants* are still actively "danced" today correspond to the medieval trade route between Spain and northern Europe: skirting then-enemy France (where the only two *gegants* that have been documented in the entire country were from Nice and Provence [Amades 1983: 48]), travelers would pass the major cities of Barcelona, Genoa, and Trent.

7. Gog may also have been confused with King Og of Bashan, described in Deuteronomy as the last of a race of giants (Very 1962: 79).

8. The following chapter examines the Christianization of the Catalan devil and how the struggle between assorted devils and angels was emblematic of the Church's strategy of absorbing local traditions to serve its needs and teach its truths.

9. The term *entremès* first appears in writing in 1381,

describing components of the coronation parade of Queen Sibil.la. It had been the custom, during grand royal feasts, to separate each course with a short theatrical or musical piece; the descriptive name *entremès* specifically referred to the timing of the appearance of these works between courses. Because of the resemblance of these performances to other secular productions, the name was extended to refer to any theatrical representation of short duration, including, particularly, the processional figures of Corpus (Amades 1983: 12).

10. The eagle, or *Àliga,* symbol of the municipality, was the one creature whose use was retained solely for use by the civic entity and was never appropriated by any guilds or religious brotherhoods.

11. At one point, for example, the Church tried to separate the Corpus procession of *entremesos* by having it precede the religious procession by one hour; predictably, the public flocked to view the first parade but left before the religious procession started. After 1798, as another example, although the *gegants* were once again able to "officially" join the religious processions, they were no longer permitted to enter the churches. For further information on the development of Corpus and how it related to popular processions, see Very 1962; Grau i Marti 1996.

12. In contrast, the costuming of the male *gegants* changed less often (Dalmau i Corominas 1991: 3; Very 1962: 26, 80). Somewhat earlier, this fashion statement was provided by a stylish figure seated on the back of the dragon in the Corpus processions (Very 1962: 70–71). A seventeenth-century verse requested, "Si vas a los Madriles / día del Señor / tráeme de la Tarasca / la moda mejor [If you go to Madrid, she asked the Señor, bring me back the best (latest) fashions from the Tarasca (dragon)]" (Juderías 1912: 87–88, cited in Varey and Shergold 1952: 22).

13. Mercè is Barcelona's patron saint, and her feast day is celebrated during the week of September 24.

14. One high-profile case occurred in Santa María del Mar, where the basilica and the *gegants* stored therein were burned in May 1937.

15. In La Bisbal d'Empordà, for example, the "Moorish" figures were repainted and recostumed as Spanish Catholic kings, and the Barcelona pair, originally christened Jaume I and Violant in recognition of early leaders and cultural heroes of Catalunya, were rebaptized as Fernando (Ferdinand) and Isabel (Isabella). Not until 1986 were the Barcelonan giants' original Catalan names restored. Such personality changes were not unknown prior to this time, however, as the giant figures were periodically renovated according to popular tastes and fashion.

16. Today, the few towns and villages that retained such popular celebrations have become renowned as governmentally recognized events of "national interest."

17. In the past, some municipalities designated special buildings for the storage and display of *gegants,* for example, Barcelona's Casa dels Entremesos, which dated from at least 1439.

18. At the same time, a group specific to the Barcelona *geganters* was formalized (La Coordinadora de Geganters i Grallers de Barcelona), and two years later a group specific to the southern Catalan regions was launched (La Coordinadora de Geganters i Grallers de les Comarques Meridionals). These separate groups continued until 1989, when they began to work together, inspired by the ceremonies surrounding the centennial of the birth of folklorist Joan Amades.

19. This organization has recommended a more formalized infrastructure for the *colles,* including naming officers and delineating their particular responsibilities. These are suggested recommendations only, however, not requirements for membership. For further information on the Agrupació de Colles de Geganters de Catalunya, see its Web site, http://www.gegants.org/agrupacio.html.

20. The three *trobades* took place in Sabadell in 1930, Terrassa in 1950, and Tarragona in 1951. In addition, there was a *trobada* for the opening of the Poble Espanyol, part of the Barcelona International Exposition in 1929. As such, precursors for today's interchanges do exist. However, the historic gatherings included greater emphasis on introduction, presentation, and dancing of the *gegants* than on the competitive component more common to the *trobades.*

21. Special programs are planned by these honored cities, including *trobades* with large numbers of *gegants.* The largest event to date was apparently Matadepera's second international *trobada,* which took place in 1992, a decade after the first, and which featured 647 *gegants* from eleven countries, including 425 from Catalunya (Buxó and Tous 2002: 59).

22. The *falles* are celebrations that take place for St. Joseph's Day (March 19) in which large grotesque or humorous caricatures constructed from papier-mâché are exhibited in Valencia's streets and squares. Following a week of festivities, all of the *falles* are publicly and spectacularly burned, except for the winner of that year's competition, which is added to the collection of the local Museu Faller.

23. Even the smaller models produced in great numbers often differ from each other: one figure may

have a mustache, while another does not, costuming details or hair colors may be changed, and so on. Hosta makes these changes while painting almost without noticing: it helps prevent her from becoming bored.

24. Ventura and Hosta use a commercial brand of undercoating, La Pajarita.

25. Similar surface finishing also occurs in the creation of figures of saints and has been used in Catalan studios for centuries (Cuéllar i Bassols 1990: 27). Connections between the construction and finishing techniques of sacred and more secular figures, therefore, would be likely.

26. As discussed later in the chapter, these supports share the same name as the small horses utilized in mock battles. These substructures are also known as *potes* and *bancades.* Other artisans use supports of aluminum and even iron, despite the greatly increased weight.

27. Ironically, the two *capgrossos* that accompany the two Jewish giants of Vilajuïga are a devil and a goat.

28. The strong *portadors* of pre–civil war Riudoms apparently earned three pesetas each for their labors (Corts Salvat and Toda Serra 1995: 54), and Barcelona's municipal records contain numerous references regarding payments to those who carried or dressed the giant figures in the seventeenth century; see also Amades 1983: 62; Very 1962: 47–49.

29. A c*apgròs* may also be known as *cabeçut, cabet, cabolo, cabut, caparrás, caparret, caparrot, caparrut, nano, esparriot,* and, in Spanish, *cabezudo* (Corts Salvat and Toda Serra 1995: 23).

30. In Horta de Sant Joan, for example, the village in Catalunya's Terra Alta region where Pablo Picasso lived for two periods during his early years, the *capgrossos* include cubist-style representations of figures from Picasso's paintings.

31. By the end of the nineteenth century, harness makers may have taken over sponsorship of the *cavallets* (Very 1962: 34).

32. Although this report of a mock battle to help celebrate the wedding cementing the alliance between Catalunya and Aragón is repeated in numerous scholarly texts, Harris (2000) points out that the reputed original source, no longer extant, has never been corroborated, and the next documented simulated combat between Moors and Christians does not appear for 150 years.

33. Significant scholarship has explored the variants of the dances of the Moors and Christians; see, for example, Foster 1960; Amades 1966; Bernabeu 1981; Driessen 1985; Guss 2000; Harris 2000.

34. These ritualized battles in Spain have been linked to passages in the life of St. Sebastian as well as to St. George; in contrast, those of Mexico are generally linked to St. James, colloquially known as Santiago or Santiago Matamoros (Killer of Moors), who is said to have interceded at a crucial point in a legendary battle, enabling the Christian troops to claim a divinely supported victory. See Harris (2000: 44) for the rather convoluted history of St. Sebastian's attachment to this cycle of narratives.

35. The word *tarasca,* which appears for the first time in 1530 in Sevilla (Varey and Shergold 1953: 19), has a surprisingly etymologically unclear provenance, although it may come from the French Provençal *Tarascon;* see also Very 1962: 58–60, for more detailed discussion of the possible connections.

36. The term *gomia* was also in widespread usage during the fifteenth and sixteenth centuries; it later took on a secondary meaning referential to a long-toothed, ugly, old witch who was folklorically invoked to frighten children into good behavior (Very 1962: 63, 66).

37. The earliest reference to a constructed eagle may date from 1399, when such an object was loaned from Barcelona to Zaragoza for the coronation of King Martín.

38. Despite numerous examples of ancient and indigenous bulls, Catholic revisionists have associated this animal with the one said to have accompanied the godly procession in Bethlehem.

39. See Harris 2000 for a discussion of the "hidden transcripts" that often underlie the more overt aspects of festival manifestations.

CHAPTER 3

Epigraph: This was a typical taunting late-nineteenth-century verse parodying the formerly solemn and symbolic struggle between good and evil. This example was collected in the areas of Vendrell and Arboç (Bargalló i Valls 2002: 3).

1. As discussed more fully in chapter 2, these acts were originally mandated in a papal bull issued by Pope Urban IV and were specifically ordered to be performed for the celebration of Corpus Christi, the festival of the Eucharist, after its date was repositioned to coincide more closely with the summer solstice. Events and processionals initially performed specifically for Corpus later spread to include a wider range of days as well as a wider range of dramatic presentations.

2. Although fire is rather generically considered to be a positive, purifying, and protecting element, there have been specific benefits associated with the fires at St. John's Day, the summer solstice, and, since the fourteenth century, the rescheduled celebration of Corpus Christi. Should one choose to

jump over the flames on this night, the following benefits, among others, will supposedly accrue (after Julio Caro Baroja): protection from certain illnesses, curing of ailments, expulsion of germs, protection from evil spirits and animal injuries such as snakebite, expulsion of witches and thieves, avoidance of accidents, certainty of marriage (young women only), protection from violent storms, and assurance of a good harvest (summarized in Stanton 1999: 61).

3. The "cultural reformers," described by Burke (1978: 203) as "puritans" because of their focus on religious purification, cast a wide net in attempting to vanquish elements that either retained traces of "pagan" activities or stimulated the populace to overindulge in licentious behaviors. His incomplete list of objectionable activities includes "actors, ballads, bear-baiting, bull-fights, cards, chapbooks, charivaris, charlatans, dancing, dicing, divining, fairs, folktales, fortune-telling, magic, masks, minstrels, puppets, taverns, and witchcraft."

4. Several scholars have clarified that the historical rebellions led by the devils did not target religion or the belief in God per se but rather criticized the religious institutions and sacramental doctrines that constricted both sacred and secular activities and behaviors. At the same time, while in pre-Franco years a decrease occurred in interest in Church matters, manifested by decreasing attendance at Mass and in taking communion, interest and participation in folkloric traditions (even those originally based within the rubric of the Church) remained at extremely high levels (Pinnie 1996: 121). Today, with Church-related activities at an all-time low and with an autonomous Catalunya within a democratic Spain co-opting at least some of the separatist motivation for antigovernmental fervor and demonstrations, residual "rebelliousness" has become both more abstract and more amorphous, although possibly no less fervent.

5. Although this improvisational piece was produced in Spain for the first time at these Mercè celebrations, it premiered at the Carnival in Venice earlier that year. The Mercè festival is the most elaborate of the many festivals celebrated annually in Barcelona. Now less a religious than a civic occasion (although special Masses and processionals do take place), the holiday is replete with feasting, dancing, homecomings, and, of course, *correfocs*.

6. The quotation appears at http://www.comediants.com/pagines/esp/pags/quisomesp.htm.

7. Historically, devils organized themselves into groups that were linked to a certain trade guild—particularly that of the *boters* (who made wine or water containers)—or were volunteers paid by such guilds to perform at the festival (Palomar n.d.: 3). Scholars have also noted the "well-known Catalan propensity to band together in voluntary associations" in discussions of groups practicing folkloric and popular traditions (Brandes 1991: 65). Brandes particularly cites Oriol Pi-Sunyer's *Nationalism and Societal Integration: A Focus on Catalonia* (Amherst: University of Massachusetts International Area Studies Program, 1983) in this regard.

8. The quotation is from the 1982 mission statement of the Traditional Culture Research Group of the West; for further information, see its Web site, www.terra.es/personal/parabolo/diables/historia.htm.

9. FestCat, dispersed around diverse areas of Catalunya, is a unique study program consisting of hands-on learning of activities seen as central to the maintenance and promulgation of traditional Catalan fiestas "in all of their diversity." FestCat comprises four different "schools," located in a different villages and with concentrations on dance, games, music, and an overview of various manifestations of traditional culture, respectively. The intent is to acquaint the younger generation with the diversity of traditional cultural expressions so that these students can go back to their homes and refresh the traditions there. The FestCat programs are managed by the Center for the Promotion of Traditional and Popular Catalan Culture, located in Barcelona. For further information, see http://cultura.gencat.net/cpcptc/festcat/.

10. For regulations regarding *correfocs*, see resolution 452/V of the Catalan Parliament (April 1999), http://www.readysoft.es/festafoc/documents.decret.html.

11. The regulation regarding explosives, approved December 5, 1991, establishes categories of pyrotechnics based on their load. *Grups de foc* are permitted to utilize materials falling under classes I and II (those with a maximum combined detonation of between fifteen and twenty grams, depending on the type); the use of materials in class III is restricted to professionals from pyrotechnic factories, who are the only ones legally permitted to utilize these explosives as part of an event staged by a *grup de foc*.

12. Although the group name denotes a more neutral being, the members are also rather interchangeably described as devils and demons.

13. Pere Casellas, e-mail communication with author, November 4, 2002.

14. The development of children's groups performing *correfocs* became a controversial issue in 2003–4, as Catalan law officially prohibits the use of certain classes of pyrotechnics by anyone younger than fourteen. This is in contrast to the laws of the majority of the Spanish autonomous communities, which permit such use above the age of eight. As part of the events of the 2004 Fira del Foc, delegates officially proposed changes, and received a provisional response from representatives of the Generalitat that they were open to changing the law. Doing so would bring the 1,500 boys and girls now affiliated with fifty different devil groups in Catalunya into legal compliance (Mas 2004: 4).

15. The use of the term *bèstia* consciously refers to the medieval tracts discussing the symbolic representation, description, aesthetics, and costuming of festival bestiary.

16. For further information, refer to the organization's Web site and its varied links, http://www.lafura.org/bestiari/.

17. The widely spread tales of dragons representing the unbridled forces of nature being tamed by civilization are identified as Aarne-Thompson folktale type #300.

18. Pere Casellas, interview by author, Banyoles, August 12, 2002.

19. Numerous other types of pyrotechnics are utilized throughout the different parts of the *correfocs*. For a complete listing of materials available to the *grups de foc*, see the Web sites of such Catalan fireworks companies as Pirotècnica Catalana and Antiga Casa Manel Estalella.

20. Pere Casellas, interview by author, Banyoles, August 12, 2002.

21. Pep Mendoza, interview by author, Banyoles, July 6, 2002. Similar reactions to such events are recounted by Noyes (2003) in her study of the Patum in Berga; her informants there describe their participation as an "addiction."

22. Pere Casellas, e-mail communication with author, November 4, 2002.

23. Pere Casellas, interview by author, Banyoles, August 12, 2002.

24. At the *cercavila* during the 2001 Festa Major, the break started out with the original recorded version of "You're Sixteen, You're Beautiful, and You're Mine" and then moved into well-known local pop and more traditional tunes. Many participants sing along.

25. Although individually these fireworks have only a small load, when so many are detonated at a single time, the effect is enormous. The Gàrgoles refer to these fireworks as *formatges* (Catalan for "cheeses") because they resemble a common cheese. (Pere Casellas, e-mail communication with author, November 4, 2002).

26. The covering of windows and doors remains a source of complaint, particularly for many businesses lining the route. Stores typically stay open until 8:30 P.M., and in Banyoles the *correfocs* usually start around 10:30. In those two intervening hours, the businesspeople need to cover all of their doors, their wide display windows, and their awnings. The sparks from the firecrackers burn at seven hundred degrees centigrade; when they hit glass, they stick, engraving a notch that cannot be removed.

27. The United States routinely reveals overall violent assault and murder rates three to four times that of Spain; see, for example, the data at www.nationmaster.com.

28. Noyes (2002) has cautioned researchers to be wary of glibly cementing connections to past manifestations; she characterizes those who claim links to pre-Christian traditions as "left-wing nationalists" and those who allege medieval associations as "conservative nationalists," each group following its political assumptions and prejudices to validate participation.

29. See Noyes 2003 for her discussion of "embedded memory" as pertains to the Berguedan Patum.

CHAPTER 4

1. There are no reliable figures for how many such art environments (extant or destroyed) have been created all over the globe. According to the nonprofit Saving and Preserving Arts and Cultural Environments (SPACES) archives in Los Angeles, more than nine hundred sites exist in the United States alone.

2. In the past few years, a few museums have begun to add to their permanent collections pieces separated from these environments. In almost every instance, this process has engendered debate about contextual issues, with the ideal of maintaining the complete work in situ challenged by the increased protection (at least parts of the environment would be) afforded by removing the items to a climate-controlled facility. Related concerns include the irrefutable change to the art environment if it is statically maintained and frozen on-site at a given moment in time, no longer a work in progress constantly in flux and dependent on the artist's changing visions. The U.S. institutions that have such works in their collections include the American Folk Art Museum in New York City; the American Visionary Art Museum in Baltimore; the High Museum in Atlanta; the John Michael Kohler

Arts Center in Sheboygan, Wisconsin; the Lehigh University Art Galleries in Bethlehem, Pennsylvania: the Milwaukee Art Museum; the Oakland Museum of California; and the Smithsonian American Art Museum (formerly the National Museum of American Art) in Washington, D.C. Public collections in Europe and Asia also include the works of environmental artists; for further information, see Maizels 2002.

3. For example, Fred Smith (1886–1976) of Phillips, Wisconsin, included statues commemorating a famous local double wedding, his hardworking logger buddies, a prize-weight muskie, and local Indian elders among the more than two hundred figures in his Wisconsin Concrete Park. Smith's work, which was purchased by the nonprofit Kohler Foundation and gifted to the county in which it is located, is thoroughly treated in Stone and Zanzi 1993.

4. Samuel P. Dinsmoor (1843–1932), of Lucas, Kansas, may be one of the better-known environmental artists who utilized his constructions as an opportunity to voice his social and economic views. The complex figurative sculptures surrounding his "stone log cabin home" propound his Populist opinions on labor, banking, government, and religion. An early but still complete account of Dinsmoor's Garden of Eden may be found in Blasdel and Larson's essay in Friedman 1974 as well as in Dinsmoor's self-published account, *Pictorial History of the Cabin Home*; a reprint of the original pamphlet is available at the site.

5. Howard Finster's (1915–2001) Paradise Garden in Pennville, Georgia; Father Mathias Wernerus's (1873–1931) grottoes in the Holy Ghost Park in Dickeyville, Wisconsin; and Leonard Knight's (b. 1931) Salvation Mountain near Niland, California, are but three examples of extensive environments created with the intent to enhance worship and religious fervor. As Baptist preacher Finster is quoted as having said, "One night I asked what I had preached on that morning and everybody forgot my message. And that's why I decided to build my garden, so they can't forget" (Doss 2000: 69). For additional information on the midwestern sites, see Stone and Zanzi 1993; for Finster, see Peacock 1996; for Knight, see Yust 1998.

6. I am not contending that Pujiula is the only artist without a paramount, central conceptual overlay. French postman Ferdinand Cheval (1836–1924), who built his Ideal Palace in Hauterives, France; Nek Chand's (b. 1924) vast expanse of figures in his Rock Garden in Chandigarh, India; and Sam Rodia's (1879–1965) Towers in the Watts area of Los Angeles are only a few examples of creators inspired by more personal experiences or the desire to leave their mark. For Cheval, see Jouve, Prévost, and Prévost 1981; for Chand, see Aulahk 1986; for Rodia, see Hernández 2001. Maizels 1999 provides a good introduction to a variety of art environments.

7. Pujiula i Vila (2001: 56) listed what he bought with the donations, including two burros, two goats, two carts with garnishes, more than a hundred ducks, at least fifteen sacks of oats for the burros, sixty kilograms of nails, tools, and a tractor.

8. Always resourceful, he made a hanging toilet, which he labeled with a sign that read, "If you do your business here, you won't find shit on the road." Some men apparently used it, but women would not because the device hung three meters (almost ten feet) off the ground.

9. Sympathetic to his frustration, one of Pujiula's friends offered to let him billet his burro on some nearby land outside of Tortellà. He accepted because he felt that at least the animal would be well pastured and safe. The owner of the property then suggested that Pujiula build a little shed so that he could come there and pass the time with the animal. Delighted, Pujiula went to gather acacia wood and began construction on the cabin. Because it was near the road, people could see him working, and they started complaining to the owner of the property, saying that Pujiula's work had brought drifters and undesirables to Argelaguer and would now attract them to this area. Swayed by local opinion, the owner changed his mind and told Pujiula to dismantle his structure. He swallowed his disappointment, told his friend that he was getting good at destruction, and demolished the building.

10. Some branches had been used in the menagerie enclosure prior to the beginning of the cabins, houses, towers, and labyrinth.

11. Published in an edition of five hundred, this small paperback written in Catalan is divided into two parts, the first intended as a chronological narrative "done from memory" and the second as a photodocumentation of the park, targeting its three major aspects: (1) the relationship with the visitor; (2) contemporary views; and (3) images of the different spaces in the structures. Included are reproduced letters and published articles about Pujiula's work as well as snapshots that visitors sent back to him. Although an indispensable aid in my research, the book is somewhat

difficult to follow because of the personalized and idiosyncratic nature of the writing as well as the rather free-form chronology.

12. SPACES's executive director, Seymour Rosen, among others, was instrumental in helping to raise awareness of and solicit support for this campaign.

13. A further irony is that the destruction so polarized the village of Argelaguer that it became a major issue in the next mayoral campaign. Pere Oliveras, the mayor who forced its dismantling, declined to stand for reelection and later admitted that he regretted his actions.

AFTERWORD

1. Thomas Carlyle, "Signs of the Times," *Edinburgh Review* 59 (1829): 439–59.

2. The assembling of European collections of cultural materials from Africa, the Americas, and Oceania began as early as the sixteenth century (Hiller 1991: 185).

APPENDIX A

1. Beginning around the time of Christ, the harnessing of water power and the dissemination of the water wheels from the Middle East across Europe and northern Africa was a technological milestone that resulted in profound individual and societal changes. Probably most far-reaching was the facilitation of land cultivation, which contributed to greater agricultural production and hence greater longevity as a result of better nutrition. Water wheels also ameliorated the particularly onerous task of transporting water long distances to homes, thus allowing women in particular more time and energy to pursue other tasks and crafts. See White 1962: 80.

BIBLIOGRAPHY

GENERAL WORKS

Alford, Violet. *Pyrenean Festivals: Calendar Customs, Music and Magic, Drama and Dance*. London: Chatto and Windus, 1937.

Abramson, J. A. "Style Change in an Upper Sepik Contact Situation." In *Ethnic and Tourist Arts: Cultural Expressions from the Fourth World*, ed. Nelson H. H. Graburn, 249–67. Berkeley: University of California Press, 1976.

Azevedo, Milton A., ed. *Contemporary Catalonia in Spain and Europe*. Berkeley: Gaspar de Portolá Catalonian Studies Program, University of California, 1991.

Bennassar, Bartolomé. *The Spanish Character: Attitudes and Mentalities from the Sixteenth to the Nineteenth Century*. Berkeley and Los Angeles: University of California Press, 1979.

Bensusan, S. L. *Home Life in Spain*. New York: Macmillan, 1910.

Boissevain, Jeremy, ed. *Coping with Tourists: European Reactions to Mass Tourism*. Providence and Oxford: Berghahn, 1996.

———. *Revitalizing European Rituals*. London and New York: Routledge, 1992.

Brandes, Stanley. *Power and Persuasion: Fiestas and Social Control in Rural Mexico*. Philadelphia: University of Pennsylvania Press, 1988.

Browne, Ray R. *Rituals and Ceremonies in Popular Culture*. Bowling Green, Ohio: Bowling Green University Popular Press, 1982.

Burke, Peter. *Popular Culture in Early Modern Europe*. New York: New York University Press, 1978.

Caro Baroja, Julio. *Análisis de la Cultura: Etnología, Historia, Folklore*. Barcelona: Talleres Gráficos Rubiralta, 1949.

———. *España Primitiva y Romana*. Barcelona: Editorial Seix Barral, 1957.

Coad, Emma Dent. "Artistic Patronage and Enterprise Culture." In *Spanish Cultural Studies: The Struggle for Modernity*, ed. Helen Graham and Jo Labanyi, 373–76. New York: Oxford University Press, 1995.

Congrés de Cultura Popular i Tradicional Catalana. *II Congrés de Cultural Popular i Tradicional Catalana: Ponències*. Barcelona: Departament de Cultura de la Generalitat de Catalunya, 1997.

Durkheim, Émile. *The Division of Labor in Society*. Ed. L. Coser. 1893; New York: Macmillan, 1984.

Erikson, Erik Homburger. *Toys and Reasons : Stages in the Ritualization of Experience*. New York: Norton, 1977.

Fábregas, Xavier. *El Llibre de les Bèsties: Zoología Fantàstica Catalana*. Barcelona: Edicions 62, 1983.

Fernández, Josep-Anton. "Becoming Normal: Cultural Production and Cultural Policy in Catalonia." In *Spanish Cultural Studies: The Struggle for Modernity*, ed. Helen Graham and Jo Labanyi, 342–46. New York: Oxford University Press, 1995.

Foster, George M. *Culture and Conquest: America's Spanish Heritage*. New York: Wenner-Gren Foundation for Anthropological Research, 1960.

———. *Traditional Cultures and the Impact of Technological Change*. New York: Harper and Row, 1962.

García Martín, Pedro. *El Mundo Rural en la Europa Moderna*. Madrid: Historia 16, 1989.

Graburn, Nelson H. H., ed. *Ethnic and Tourist Arts: Cultural Expressions from the Fourth World*. Berkeley and Los Angeles: University of California Press, 1976.

Guss, David M. *The Festive State: Race, Ethnicity, and Nationalism as Cultural Performance*. Berkeley and Los Angeles: University of California Press, 2000.

Handler, Richard, and Jocelyn Linnekin. "Tradition, Genuine or Spurious." *Journal of American Folklore* 97 (1984): 273–90.

Harrison, Richard J. *Spain at the Dawn of History: Iberians, Phoenicians, and Greeks*. London: Thames and Hudson, 1988.

Hauser, Arnold. *The Sociology of Art*. Chicago and London: University of Chicago Press, 1982.

Hiller, Susan, ed. *The Myth of Primitivism: Perspectives on Art*. London and New York: Routledge, 1991.

Hobsbawm, Eric, and Terence Ranger, ed. *The Invention*

of Tradition. Cambridge: Cambridge University Press, 1983.

Juderías, Julían. *España en el Tiempo de Carlos II el Hechizado.* Madrid, 1912.

Mitchell, Timothy. *Violence and Piety in Spanish Folklore.* Philadelphia: University of Pennsylvania Press, 1988.

Moore, Sally F., and Barbara G. Myerhoff, eds. *Secular Ritual.* Assen, the Netherlands: Van Gorcum, 1977.

Moya, Bienve. *El Carnaval: La Festa de la Transgressió Popular.* Barcelona: El Periódico and the Generalitat de Catalunya, Departament de Cultura, 2000.

Oettinger, Marion, ed. *Folk Art of Spain and the Americas.* San Antonio: San Antonio Museum of Art, 1997.

Pinnie, Lawrence J. *The Passing of Spanish Traditionalism: Deprivation, Transformation, Credence.* New York: Vantage Press, 1996.

Puig i Gordi, Lluís, ed. *Les Festes a Catalunya.* Barcelona: Centre de Promoció de la Cultura Popular i Tradicional Catalana, amb la Collaboració de la Generalitat de Catalunya, 1999.

Rubin, William, ed. *Pablo Picasso: A Retrospective.* New York: Museum of Modern Art, 1980.

Sollors, Werner. *Beyond Ethnicity: Consent and Descent in American Culture.* New York: Oxford University Press, 1986.

Stanton, Edward F. *Handbook of Spanish Popular Culture.* Westport, Conn.: Greenwood, 1999.

Turner, Victor. *The Anthropology of Performance.* New York: PAJ, 1987.

———. *Celebration: Studies in Festivity and Ritual.* Washington, D.C.: Smithsonian Institution Press, 1982.

———. *Dramas, Fields, and Metaphors: Symbolic Action in Human Society.* Ithaca and London: Cornell University Press, 1974.

Van Gennep, Arnold. *The Rites of Passage.* Chicago: University of Chicago Press, 1960.

Varey, J. E., and N. D. Shergold. "La Tarasca de Madrid." *Clavileño* 4 (1953): 18–26.

Very, Francis George. *The Spanish Corpus Christi Procession: A Literary and Folkloric Study.* Valencia, Spain: Tipografía Moderna, 1962.

Way, Ruth. *A Geography of Spain and Portugal.* London: Methuen, 1962.

White, Lynn, Jr. *Medieval Technology and Social Change.* New York: Oxford University Press, 1962.

TRADITIONAL CERAMICS

Albertos Solera, María Dolores. *Estudio Etnográfico de la Alfarería Conquense.* Cuenca: Excelentísima Diputación Provincial, 1978.

Arnold, Dean E. *Ceramic Theory and Cultural Process.* Cambridge: Cambridge University Press, 1985.

Barley, Nigel. *Smashing Pots: Works of Clay from Africa.* Washington, D.C.: Smithsonian Institution Press, 1994.

Bofill Catala, María Victoria, Luciano Hernández Ramos, and Gloria Latre González. *La Alfararía de Alba de Tormes.* Salamanca: Diputación de Salamanca, 1991.

Bover i Pagespetit, Andreu. *La Ceràmica.* Girona: Diputació de Girona/Caixa de Girona, 1993.

Breslin, Lucy. "Spanish Folk Pottery." *Ceramics Monthly* 37 (April 1989): 52–57.

Breslin, Lucy, Marcia Selsor, and Beal Mossman. "Spanish Folk Pottery—Part Two." *Ceramics Monthly* 37 (May 1989): 44–49.

Cabasa, Santi. "The Last Tinajeros." *Ceramics Monthly* 38 (March 1990): 44–48.

Cano Adillo, Petra, María Pilar Contreras Zarco, et al. *Alfarería Popular en Mota del Cuervo.* Cuenca: Diputación Provincial de Cuenca, 1990.

Carrerero Pérez, Andrés, and Carmen Ortiz García. "Alfarería Popular en la Provincia de Córdoba." In *Etnografía Española 3,* 7–144. Madrid: Industrias Gráficas Caro, 1983.

Cavallería y Portillo, F. *História de la Muy Noble y Leal Villa de Villarrobledo en la Provincia de la Mancha Alta en el Reino de Toledo.* Madrid, 1751.

Contreras Zarco, María Pilar. "La Alfarería en Mota del Cuervo." In *La Mujer en la Alfarería Española,* ed. Ilse Schütz, 20–21. Agost, Alicante: Museo de Alfarería, 1993.

Cooper, Emmanuel. *Ten Thousand Years of Pottery.* Philadelphia: University of Pennsylvania Press, 2000.

Corredor-Matheos, José, and Jordi Gumí. *Ceràmica Popular Catalana.* Barcelona: Edicions 62, 1978.

Cortés, Luis L. "La Alfarería en Pereruela (Zamora)." *Zephyrus* 5 (1954): 141–63.

———. "Alfarería Feminina en Moveros (Zamora)." *Zephyrus* 9 (1958): 95–107.

Curtis, Freddie. "The Utility Pottery Industry of Bailén, Southern Spain." *American Anthropologist* 64 (1962): 486–503.

DossierCeramikarte.com. "Las Cantareras de Mota del Cuervo." http://www.mota-del-cuervo.com/dossierceramikarte.asp.

Fernández Miranda, M. *Manual de Prehistoria e Arqueología de la Península Ibérica.* Madrid: UNED, 1990.

Fernández Montes, Matilde, and María Ángeles Morcillo Parés. "Alfarería Popular en la Provincia de Jaen." In *Etnografía Española 3,* 145–262. Madrid: Industrias Gráficas Caro, 1983.

Foster, George M. "The Sociology of Pottery: Ques-

tions and Hypotheses Arising from Contemporary Mexican Work." In *Ceramics and Man*, ed. Frederick R. Matson, 43–61. Chicago: Aldine, 1965.

García Gómez, María Dolores. *Cuatro Siglos de Alfarería Tinajera en Villarrobledo*. Albacete: Instituto de Estudios Albacetenses de la Excelentísima Diputación de Albacete, 1993.

González Martí, Manuel. *Cerámica Española*. Barcelona: Editorial Labor, 1933.

Guerrero Martín, José. *Alfares y Alfareros de España*. Barcelona: Serbal, 1988.

Hodges, H. "The Medieval Potter: Artisan or Artist?" In *Medieval Pottery from Excavations: Studies Presented to Gerald Clough Dunning*, ed. Vera I. Evison, H. Hodges, and J. G. Hurst, 33–40. London: John Baker, 1974.

Kempton, Willett. *The Folk Classification of Ceramics: A Study of Cognitive Prototypes*. New York: Academic Press, 1981.

Lizarazu de Mesa, María Asunción. "Alfarería Popular en la Provincia de Albacete: Estudio Etnográfico." In *Etnografía Española 3*, 265–384. Madrid: Industrias Gráficas Caro, 1983.

Lizcano Tejado, Jesús María. *Los Barreros: Alfarería en la Provincia de Ciudad Real*. Ciudad Real: Diputación de Ciudad Real, 2000.

Llorens Artigas, José, and José Corredor-Matheos. *Cerámica Popular Española Actual*. Madrid: Editorial Blume, 1970.

Lorenzo, Rosa María. *Alfares en Salamanca*. Salamanca: Centro de Cultura Tradicional (Diputación Provincial de Salamanca), 1999.

Martín, Concepción, Manuel Fernández-Miranda, María Dolores Fernández-Posse, and Antonio Gilman. "The Bronze Age of La Mancha." *Antiquity* 67 (March 1993): 23–45.

Mazuecos, Rafael. "Hombres, Lugares y Cosas de la Mancha: Alfarería." *Apuntos para un Estudio Medico-Topográfico de la Comarca*. 35 (November 1972). http://www.mota-del-cuervo.com/ alfareria.asp (September 28, 2003).

Moeran, Brian. *Folk Art Potters of Japan: Beyond an Anthropology of Aesthetics*. Honolulu: University of Hawaii Press, 1997.

Moreno Nava, Lorenzo. *Villarrobledo Tinajeros y Tinajas*. Villarrobledo: Gráficas Ruíz, n.d.

Nonell, Carmen. *Cerámica y Alfarería Populares de España*. León: Editorial Everest, 1984.

Paulo i Sàbat, Josep, and Joaquim Creus i Mach. *Terrissers i Terrisseries d'Esparreguera*. Esparreguera, Barcelona: Gràfiques Llopart Penedès, 1998.

Pena, Rafael Garrido. "Bell Beakers in the Southern Meseta of the Iberian Peninsula: Socioeconomic Context and New Data." *Oxford Journal of Archaeology* 16 (1997): 187–209.

Pérez Camps, Josep. "La Producción Tinajera de Villarrobledo en 1959, Segun una Recopilación de Datos Conservados en el Archivo de Alfons Blat." *Forum Cerámico* 3 (July 1994): 14–22.

Pericot García, Luis. *Cerámica Ibérica*. Barcelona: Ediciones Polígrafa, 1977.

Ramos Pérez, Herminio. *Cerámica Popular de Zamora*. Zamora: Imprenta Raúl, 1976.

"Recuperando el Pasado." *La Gaceta de Salamanca*, June 12, 2004, p. 19.

Reese, Claudia. "Women Potters in Spain." *Ceramics Monthly* 22 (October 1974): 28–33.

Rodríguez Molina, María José. *Guía de Patrimonio Arquitectónico de Mota del Cuervo*. Mota del Cuervo: Ayuntamiento de Mota del Cuervo, 2002.

Romero, Alfonso, and Santi Cabasa. *La Tinajería Tradicional en la Cerámica Española*. Barcelona: Grupo Editorial Ceac, 1999.

Santanach i Soler, Joan, Joan Rosal i Sagalés, and Montserrat Suñol i Ferrer. *La Ceràmica de Quart en la Memòria Viva: Els Obradors*. Quart: Ajuntament de Quart/Associació de Terrissaires Artesans de Quart, 1998.

Schütz, Ilse, ed. *La Mujer en la Alfarería Española*. Agost, Alicante: Museo de Alfarería, 1993.

Sempere, Emili. *Rutas a los Alfares*. Sabadell: El Pot Cooperativa, 1982a.

———. *La Terrissa de les Terres de l'Ebre*. Barcelona: El Tinter, 1982b.

Seseña, Natacha. "La Alfarería de Mota del Cuervo." *Revista de Dialectología y Tradiciones Populares* 23 (1967): 339–46.

———. *Barros y Lozas de España*. Madrid: Biblioteca Básica R.T.V.E., 1976.

———. *Cacharrería Popular: La Alfarería de Basto en España*. Madrid: Alianza Editorial, 1997.

———. *La Cerámica Popular en Castilla la Nueva*. Madrid: Editora Nacional, 1975.

Shepard, Anna O. *Ceramics for the Archaeologist*. Washington, D.C.: Carnegie Institution of Washington, 1976.

Torres, Pablo. *Cántaros Españolas 1*. Madrid: Editorial Artemos, 1982.

———. *Cántaros Españolas 3*. Madrid: Editorial Artemos, 1985.

Valero Zarco, Arturo. "Entrevista a Estefania, Una Cantarera de Cuerpo Entero." *Aspas Manchegas* 2 (April 1993): 33–36.

Van der Leeuw, Sander Ernst. *Studies in the Technology of Ancient Pottery*. Amsterdam: Huisdrukkerij Universiteit van Amsterdam, 1976.

Wright, R. P. "Technology and Style in Ancient Ceramics." In *Ceramics and Civilization*, vol. 1, *Ancient Technology to Modern Science*, 5–25. Columbus, Ohio: American Ceramic Society, 1984.

GIANTS AND BIG-HEADS

Abadal, Elisabeth. "Artistes del Cartó." *El Punt,* September 13, 1994, p. 34.

——. "Els Nous Gegants de Vilajuïga es Van Estrenar a la Festa de Lladó." *El Punt,* July 11, 1995, p. 33.

Abellan, Albert, and Jan Grau. "Bestiari." In *II Congrés de Cultura Popular i Tradicional Catalana,* 99–105. Barcelona: Departament de Cultura de la Generalitat de Catalunya, 1997.

Ajuntament de La Bisbal. *Bèsties de Foc.* La Bisbal: Ajuntament de la Bisbal, 1995.

Ajuntament de Riudarenes. *Notes sobre els Gegants de Riudarenes.* Riudarenes: Ajuntament de Riudarenes, 1989.

"Als Vells Gegants els Renten la Cara i els Pentinen." *Diari de Girona,* October 27, 1990, p. 11.

Amades, Joan. *Las Danzas de Moros y Cristianos.* Valencia: Institución Alfonso el Magnánimo, 1966.

——. *Gegants, Nans i Altres Entremesos.* Barcelona: Consol Mallofré (Arxiu de Tradicions Populars), 1983.

Bellés, Dolors. "Un Taller de Navata Restaura els Gegants Antics de Girona." *El Punt,* April 16, 1993, p. 32.

Bernabeu Rico, José Luis. *Significados Socials de las Fiestas de Moros y Cristianos.* Alicante: Publicaciones de la Universidad Nacional de Educación a Distancia–Centro Regional de Elche, 1981.

Bosch, Imma. "Incendien, de Matinada, un Dels Gegants de Girona." *El Punt,* November 5, 1994, p. 44.

——. "La Trobada General de Geganters Gironins Es Farà al Juny a Vilobí, Nova Vila Gegantera." *El Punt,* May 12, 1995, p. 46.

Bouso Mares, Félix. "Girona Tindrá Sis Gegants i Onze Capgrossos." *Diari de Girona,* November 4, 1993, p. 27.

Buxó, M. Jesús, and Meritxell Tous. "Gegants y Capgrossos: La Concreción Artesanal del Imaginario." *Narria* (2002): 55–61.

Canales, Claudia. *¡Arde Judas! La Colección de Diego.* Mexico City: Instituto Nacional de Bellas Artes, 2002.

Céspedes, David. "Signen el Conveni per a la Recuperació de l'Antiga Parella de Gegants de Girona." *Diari de Girona,* October 27, 1993, p. 5.

Carbó, Amadeu, Jan Grau, et al. *Caps, Nans, Capgrossos, Esparriots a Catalunya.* Barcelona: Agrupació de Colles de Geganters de Catalunya, 2000.

Cordomí, Xavier. *Altíssims Senyors, Nobles Bèsties: Imatgeria Festiva de la Barcelona Vella.* Tarragona: Edicions El Mèdol, 2001.

Corts Salvat, Joan R., and Josep M. Toda Serra. *Gegants i Capgrossos de Riudoms: Una Panoràmica Actual del Món Geganter Català i Internacional.* Tarragona: Edicions El Mèdol, 1995.

Cuéllar i Bassols, Alexandre. *Els Gegants d'Olot: 100 Anys.* Olot: Impremta Aubert, 1990.

Dalmau i Corominas, Jordi. "Gegants a la Plaça." *Diari de Girona: Domincal,* May 26, 1991, pp. 3–5.

Dols Rusiñol, Joaquim. "Un Rerafons de Comparsa i Cap-Gros." *El País,* April 29, 1984, p. 2.

Driessen, Henk. "Mock Battles between Moors and Christians: Playing the Confrontation of Crescent with Cross in Spain's South." *Ethnologia Europaea* 15 (1985): 105–15.

Ferreira Juli. *Els Gegants de Figueres.* Figueres: Brau Edicions, 2002.

Gamero, Jordi. "1a Trobada de Dracs Centenaris, a La Bisbal." *El Punt,* December 31, 1994, p. 44.

——. "Fal.lera Gegantera." *Presència* 30 (September 18–24, 1994): 14–24.

"Gegants." January 19, 2000. http://www.ajberga.es/lapatum/gegants_s.htm.

"Els Gegants d'Albanyà." *Hora Nova,* August 16–22, 1994, p. 20.

"Els Gegants de Cadaqués." *Hora Nova,* September 20–26, 1994, p. 38.

"Els Gegants de L'Escala." *Hora Nova,* August 30–September 5, 1994, p. 19.

"Els Gegants de Figueres." *Hora Nova,* August 9–15, 1994, p. 23.

"Els Gegants de Lladó." *Hora Nova,* August 23–29, 1994, p. 18.

"Els Gegants de Navata." *Hora Nova,* September 13–19, 1994, p. 18.

"Els Gegants de Reus." January 19, 2000. http://www.readysoft.es/carrutxa/festam/gegants.html.

"Gegants i Gegantes." *El Cric,* no. 73 (December 1995): 11–18.

Gil, Quim. "La Bisbal es Prepara per Convertir-se en la Capital de les Bèsties del Foc." *El Punt,* June 17, 1995, p. 42.

Gil i Bonancía, Miquel. "Carme 'Caretes i Carotes.'" *Diari de Girona,* February 18, 1990, p. 21.

Grau, Jan, and Albert Abellan. "Gegants i Nans." In *II Congrés de Cultura Popular i Tradicional Catalana,* 241–54. Barcelona: Departament de Cultura de la Generalitat de Catalunya, 1997.

Grau i Marti, Jan. *Gegants.* Barcelona: Editorial Columna, 1996.

Gumbau, Alfons. "El Cartó Està de Moda." *Presència* 24 (February 14, 1988): 40–43.

——. "El Museu de Joguets Exposa la Iconografia de les Processons." *Diari de Girona,* May 13, 1987, p. 29.

——. "Processons de Paper i Plom." *Presència* 23 (May 24, 1987), pp. 11–14.

Harris, Max. *Aztecs, Moors, and Christians: Festivals of Reconquest in Mexico and Spain.* Austin: University of Texas Press, 2000.

Ibàñez, Marta. *Gegants de Sabadell: 150 Anys d'Història.* Tarragona: Edicions El Mèdol, 1996.

Institució de Viana. *Artesanía en Papel, Pasta de Papel y Cartón.* Pamplona: Institució de Viana, 1983.

Madrenys, Pere. "Restauran els Gegants Vells de Girona i en Faran una Rèplica." *El Punt*, December 3, 1992, p. 36.

Maher, John. "Sheffield City Morris in Manresa, Catalonia." September 11, 2001. http://emrs.chm.bris.ac.uk/morris/Giants/Manresa.html.

Moya, Bienve. "Apunts per a una Crònica sobre els Nans o Capgrossos de la Festa Tradicional." *Revista d'Etnologia de Catalunya* 4 (February 1994): 92–109.

Neal, Avon. *Ephemeral Folk Figures.* New York: Clarkson N. Potter, 1969.

Puig, Pere. "Reialmes de Cartró." *Presència* 26 (February 11, 1990): 8–11.

Pujol, Magda. "Ninots Sorgits del Fang." *Diari de Girona: Dominical*, May 2, 1993, pp. 1, 3–5.

Pulido, Ivan. "Demètria Romanyac ha estat la 'Padrina' que ha fet Possible que es Bategin els Gegants de Roses." *Hora Nova*, April 11–17, 1995, p. 24.

Pulido, Ivan, and Marc Batallé. "Els 'Pares' dels Gegants." *Hora Nova*, October 4–10, 1994, p. 29.

Reig, Blanca Sala. "Les Figures de Cartró Pedra de Ventura i Hosta, a l'Antaviana." *Hora Nova*, August 23–29, 1994, p. 17.

Rosa, Josep Maria Joan, Eduard Márquez, and Ventura i Hosta. *Nadal 2000/Navidad 2000.* Figueres: Museu de Joguet de Catalunya a Figueres, 2000.

Rumbo i Soler, Albert. *Història dels Gegants de Berga.* Berga: Berimpres, 1995.

Soler Summers, G. "Los 'Dimonis' y 'Caganers' son Piezas muy Tradicionales." *Diario de Mallorca*, December 3, 1994, p. 6.

Trillas, Joan. "La Replica del Drac de La Bisbal ja és a Punt." *El Punt*, June 7, 1995, p. 39.

———. "Neus Hosta i David Ventura." *El Punt*, June 12, 1995, p. 40.

"Uns Desconeguts Cremen el Gegant Xavier Cugat, Exposat a l'Ajuntament." *Diari de Girona*, November 5, 1994, pp. 1, 6.

Ventura & Hosta Presenten . . . Figures i Objectes de Cartró. Salt: Casa de Cultura "Les Barnardes," 1990.

Vila, Alícia. "Carme Moya i Salvá." *El Punt*, November 8, 1993, p. 57.

Vila, Cristina. "Descentralitzen les Fires de la Santa Creu amb Actes als Barris." *El País—Empordá*, April 9, 1996, p. 31.

Vila, Gemma. "L'Ajuntament Encarrega la Restauració dels Gegants Antics a un Taller de Navata." *Diari de Girona*, April 11, 1993, p. 8.

———. "El Cartró Pedra: El Retorn d'una Activitat Artesana." *Diari de Girona*, December 18, 1987, p. 8.

CORREFOCS

II Congrés de Cultura Popular i Tradicional Catalana. "Resum de Conclusions." January 11, 2000. http://etnocat.readysoft.es/documents/conclusions.html.

Agrupació de Bestiari Festiu de Catalunya. January 7, 2003. http://www.lafura.org/bestiari/.

All, J. Sergneri. "La Merce—Fireworks in Barcelona, 9/22–9/24/1995." February 13, 2000. http://www.grammarian.com/pyrotechnic/merce2.htm.

Atienza, Juan G. *Fiestas Populares e Insólitas.* Barcelona: Martínez Roca, 1997.

Bargalló i Valls, Josep. "La Cultura Popular Participativa." In *II Congrés de Cultura Popular i Tradicional Catalana*, 45–64. Barcelona: Departament de Cultura de la Generalitat de Catalunya, 1997.

———. "De Quan els Diables Parlen." September 23, 2002. http://www.lafura.org/arxius/diables/doss13.htm.

Bargalló i Valls, Josep, and Jordi Bertrán i Luengo. "Ponència Específica de l'Àmbit de Grups de Foc." In *II Congrés de Cultura Popular i Tradicional Catalana*, 257–72. Barcelona: Departament de Cultura de la Generalitat de Catalunya, 1997.

Bargalló i Valls, Josep, and Montserrat Palau. *Ball de Diables de Torredembarra.* Tarragona: Edicions El Mèdol, 1997.

Bassa, David. *Les Colles de Diables al Vallès Oriental.* Granollers: Gràfiques Garrell, 1998.

Bertran, Jordi, Xavier Gonzàlez, et al. *El Ball de Diables de Tarragona: Teatre i Festa a Catalunya.* Tarragona: Edicions El Mèdol, 1993.

Blanch Itxart, Jordina. *Tocats de Foc: Simbologies Festives i Víbries Ancestrals.* Tarragona: Edicions El Mèdol, 2003.

Brandes, Stanley. "Catalan Expressive Culture and National Identity." In *Contemporary Catalonia in Spain and Europe*, ed. Milton A. Azevedo, 62–69. Berkeley: Gaspar de Portolá Catalonian Studies Program, University of California, 1991.

Capmany, Aureli. *Costums i Tradicions Catalans.* Barcelona: Editorial Laia, 1982.

Centre de Promoció de la Cultura Popular i Tradicional Catalana de la Generalitat de Catalunya. "Proposta de Decret Pel Qual Es Regulen les Actuacions dels Grups de Foc en les Celebracions Populars i Tradicionals." January 11, 2000. http://www.readysoft.es/festafoc/documents.decret.html

Coordinadora de Colles de Diables, Barcelona. January 11, 2000. http://www.readysoft.es/festafoc/cdb/index.html.

"Els Correfocs Podrien Ser Festa Nacional Patrimonial." *Diari de Girona,* July 11, 2004, p. 15.

Cucurull Miralles, Victor. "El Teatro de Raíz Popular en Catalunya." September 20, 2002. http://suse00 .su.ehu.es/euskonews/0131zbk/gaia13106es.html.

Dalmau i Corominas, Jordi. "Gegants a la Plaça." *Diari de Girona: Dominical,* May 26, 1991, pp. 3–5.

Diables de la Creu Alta. "Manual del Bon Diable." September 11, 2001. http://personales.mundivia .es/fideus/comser.htm.

La Diabòlica de Gràcia. "Benvingut al Racó de la Diabòlica de Gràcia!!!" January 10, 2000. http://www .gracianet.org/diabolica/.

Durkheim, Émile. *The Division of Labor in Society.* Ed. L. Coser. 1893; New York: Macmillan, 1984.

Espiga, Francesc. "L'Entrevista: Pere Caselles [sic]." *El Punt,* July 8, 2004, p. 64.

Esteban, Rosa. "L'Equívoca Representació." September 23, 2002. http://www.lafura.org/arxius/diables/ doss1.htm.

Federació de Diables del Baix Llobregat. *Historia de los Diables en Catalunya.* February 14, 2000. http://personal4.iddeo.es/sinyol/federacio/ castella/index.htm.

Federació de Diables i Dimonis de Catalunya. "Contracte de Realització de Correfoc." September 20, 2002. http://www.fddc.net/comisions/juridica/ contracte.html.

García Rodero, Cristina. *Festivals and Rituals of Spain.* New York: Abrams, 1994.

Grau i Marti, Joan. "Focs de Sant Joan." January 7, 2003. http://www.festes.org/festes/article1.htm.

———. *La Nit de Sant Joan.* Barcelona: Editorial Columna, 1995.

El Grup de Recerca de Cultura Popular de Ponent. www .terra.es/personal/parabolo/diables/historia.htm.

Mas, Orriol. "Reclamaran el Reconeixement dels Correfocs com a Festa Nacional Patrimonial en la Fira del Foc de Banyoles." *El Punt,* July 8, 2004, p. 4.

Moya Domenech, Bienve. "Apuntes sobre los Diablos de Fiesta en Cataluña." *Narria* (2002): 62–68.

———. *Calendes: Impressions sobre Mites, Festes, i Celebracions Catalans.* Tarragona: Edicions El Mèdol, 1996.

Noyes, Dorothy. "Charivaris and Correfocs." Online posting, November 2, 2002, Publore Listserv. PUBLORE@lists.nau.edu.

———. *Fire in the Plaça: Catalan Festival Politics after Franco.* Philadelphia: University of Pennsylvania Press, 2003.

Palomar, Salvador. "Las Fiestas y El Fuego." *Narria* (2002): 69–77.

———. "Diables a Catalunya." September 23, 2002. http://www.lafura.org/arxius/diables/doss12.htm.

Sánchez, María Angeles. *El Bien y El Mal en la Tradición Festiva Española.* Salamanca: Diputación de Salamanca, 1995.

Soler i Amigo, Joan. "Correfoc." In *Enciclopèdia de la Fantasía Popular Catalana,* 181. Barcelona: Editorial Barcanova, 1998.

———. *Cultura Popular Tradicional.* Vol. 20 of *Enciclopèdia Bàsica de Catalunya.* Barcelona: Liberduplex, 2001.

Xaldiga, Taller de Festes. "El Correfoc de Manresa." February 14, 2000. http://www.minorisa.es/ manresa/xaldiga/correfoc.html.

ART ENVIRONMENTS

"Adéu a les Cabanyes del Garrell." *L'Argelaga* 10 (December 2002): 5.

Alsina, Susanna. "El Promotor Tanca al Public el 'Parc Selvàtic' que va Construir a Argelaguer." *El Punt,* May 25, 1990, p. 9.

Álvarez, Alfredo. "El Pueblo Más Salvaje No Aparece en Ningún Mapa." *Tiempo,* June 21, 1999, p. 12.

Amics de Les Cabanyes. "El Castillo de Acacia." July 17, 2002. http://www.crol.org/amicscabanes.

Aulahk, Malkiat Singh. *The Rock Garden.* Ludhiana: Tagore, 1986.

Balés, Fidel. "Tarzan a Can Sis Rals." *El Punt,* August 18, 1988, p. 10.

Batallé Prats, Iolanda. "El Tarzan d'Argelaguer." *Diari de Girona Dominical,* April 22, 2001, pp. 1–3.

Bonaventura, D., and G. Esteba. "El Poblat d'Argelaguer Hauria de Ser Monument Nacional." *Diari de Girona,* July 16, 2002, p. 37.

Carreras, Esther. "El Rec de la Font de Can Sis Rals Es Converteix Ara en un Laberint Selvàtic." *Diari de Girona,* June 27, 1999, p. 10.

Casas, Jordi. "En Tarzan de la Garrotxa." *El Punt,* June 19, 2002, p. 10.

———. "Ja No Queda Ni Rastre del Poblat i el Laberint de Fusta d'Argelaguer." *El Punt,* November 14, 2002, p. 11.

Casasses, Enric. "Bulliment del País." *El Mundo,* May 5, October 12, 2001. http://www.el-mundo.es/ 2001/05/05/catalunya/990898.html.

Colla Lluna Plena. "Persones 'Aspres.'" *Basalt* 73 (April 2001): 23.

"La Distracció Causa Accidents davant el Poblat d'Argelaguer." *Diari de Girona,* May 11, 2002, p. 8.

Doss, Erika. "Religious Dimensions of Work by Contemporary Self-Taught Artists: Speculations on New Methodologies and Perspectives." In *Negotiating Boundaries: Issues in the Study, Preservation, and Exhibition of the Works of Self-Taught Artists,* 68–74. Sheboygan, Wis.: John Michael Kohler Arts Center and Kohler Foundation, 2000.

Evans, E. Estyn. "The Cultural Geographer and Folk-life Research." In *Folklore and Folklife,* ed. Richard M. Dorson, 517–32. Chicago and London: University of Chicago Press, 1972.

Faura, Ramon. "El Tarzán de Argelaguer y la Acequia de Can Sis Rals." *Quaderns d'Arquitectura i Urbanisme* 10 (March 2004): 36–52.

Ferris, William. *Local Color: A Sense of Place in Folk Art.* New York: McGraw-Hill, 1982.

Friedman, Martin, ed. *Naives and Visionaries.* Minneapolis: Walker Art Center, 1974.

Guinó, Àgata. "Creen una Plataforma per Conservar les Cabanes d'Argelaguer Quan Ja s'estan Desmuntant." *El Punt,* July 9, 2002, p. 12.

Hernández, Jo Farb. "Josep Pujiula i Vila." *Raw Vision* 40 (fall 2002): 24–29.

———. "Watts Towers." *Raw Vision* 37 (fall 2001): 32–39.

Hernández, Jo Farb, John Beardsley, and Roger Cardinal. *A. G. Rizzoli: Architect of Magnificent Visions.* New York: Abrams, 1997.

Jouve, Jean-Pierre, Claude Prévost, and Clovis Prévost. *Le Palais Idéal du Facteur Cheval.* Paris: A.R.I.E. Editions, 1981.

Maizels, John. *Fantasy Worlds.* Cologne: Benedikt Taschen, 1999.

———, ed. *Raw Vision Outsider Art Sourcebook.* London: Raw Vision, 2002.

Martínez Ribas, Inés. "Tarzan de les Mones en Fa de les Seves a la Garrotxa." *El Periòdico de l'Estiu,* August 22, 1999.

Masó, Meritxell. "Comença el Desmantellament del Laberint d'Argelaguer." *Diari de Girona,* June 19, 2002, p. 14.

———. "El Constructor del Poblat d'Argelaguer Incendia les Restes." *Diari de Girona,* October 17, 2002, p. 11.

———. "El Poblat d'Argelaguer Acull els Últims Visitants abans de la Seva Desaparició." *Diari de Girona,* July 15, 2002, p. 4.

———. "El Poblat i el Laberint de Fusta d'Argelaguer s'han de Desmantellar." *Diari de Girona,* June 18, 2002, p. 19.

Navarro, Emilio. "Laberinto Vegetal." *Clip* 13 (July–August 2000): 76–77.

Peacock, Robert. *Paradise Garden: A Trip through Howard Finster's Visionary World.* San Francisco: Chronicle Books, 1996.

Ponsatí, R. "Josep Pujiula, l'Home de les Cabanes." *L'Argelaga* 7 (May 2000): 9–11.

Pujiula i Vila, Josep. *L'Home de les Cabanes.* Argelaguer: self-published, 2001.

Relph, Edward. *Place and Placelessness.* London: Pion, 1976.

Soum, Jean. "Une construction Fantastique en Catalogne." October 21, 2001. http://archilibre.free.fr/labyrinthe/josep.html.

Stone, Lisa, and Jim Zanzi. *Sacred Spaces and Other Places: A Guide to Grottos and Sculptural Environments in the Upper Midwest.* Chicago: School of the Art Institute of Chicago Press, 1993.

Yust, Larry, and Leonard Knight. *Salvation Mountain: The Art of Leonard Knight.* Los Angeles: New Leaf, 1998.

INDEX